Cambridge 2002

Dear Dad,

Hope you enjoy this. It is the first thing of mine that was accepted for publication.

Love, Nicholas.

Modern French Identities

Edited by Peter Collier

Volume 17

PETER LANG
Oxford · Bern · Berlin · Bruxelles · Frankfurt a.M. · New York · Wien

Simon Kemp & Libby Saxton (eds)

Seeing Things

Vision, Perception and Interpretation
in French Studies

PETER LANG
Oxford · Bern · Berlin · Bruxelles · Frankfurt a.M. · New York · Wien

Die Deutsche Bibliothek – CIP-Einheitsaufnahme

Seeing things : vision, perception and interpretation in French studies /
Simon Kemp & Libby Saxton (ed.) . – Oxford ; Bern ; Berlin ; Bruxelles ;
Frankfurt a.M. ; New York ; Wien : Lang, 2002
(Modern French Identities ; Vol. 17)
ISBN 3-906768-46-5

British Library and Library of Congress Cataloguing-in-Publication Data:
A catalogue record for this book is available from *The British Library*,
Great Britain, and from *The Library of Congress*, USA

ISSN 1422-9005
ISBN 3-906768-46-5
US-ISBN 0-8204-5858-9

© Peter Lang AG, European Academic Publishers, Bern 2002
Hochfeldstrasse 32, Postfach 746, CH-3000 Bern 9, Switzerland
info@peterlang.com, www.peterlang.com, www.peterlang.net

All rights reserved.
All parts of this publication are protected by copyright.
Any utilisation outside the strict limits of the copyright law, without
the permission of the publisher, is forbidden and liable to prosecution.
This applies in particular to reproductions, translations, microfilming,
and storage and processing in electronic retrieval systems.

Printed in Germany

Contents

LIBBY SAXTON AND SIMON KEMP
Introduction 9

Part 1: Captured Images

MARTIN CROWLEY
'Que pourrait-on montrer d'autre que ce qu'on voit?':
 Duras and the Photography of the Real 25

NICK HANLON
Baudrillard's Aesthetic 43

PATRICK SHEIL
Neither Here nor There:
 Merleau-Ponty on Vision and Existence 61

Part 2: The Surrealist Gaze

STAMATINA DIMAKOPOULOU
On Seeing in Surrealism: Max Ernst's Objects of Vision 83

RAKHEE BALARAM
Eyes Wide Open, Eyes Wide Shut: Defining the Surrealist Eye 99

HANNAH WESTLEY
Visions of the Muse in Michel Leiris's *L'Âge d'Homme* 123

ALISTAIR SWIFFEN
Seeing Double/Hearing Things:
 In(s)anity in the *Aumonymes* of Robert Desnos 139

Part 3: Limits of the Visible

CLAIRE BOYLE
Resisting the Whole Picture: The Gaze, and Reading
 Autobiographies by Nathalie Sarraute and Georges Perec 161

SONYA STEPHENS
Baudelaire and Courbet: The Art of the Unfinished 177

ARIANE SMART
Hugo *Visionnaire*:
 Realism and Symbolism in the Myth of Paris 193

BLANDINE CHAMBOST
The Mesmerizing Muse:
 Salome seen by Moreau and Mallarmé 209

Part 4: Between the Frames

JEAN KHALFA
Seeing the Present 235

EMMA WILSON
Screening Pleasure: Touch and Vision in Contemporary
 Cinema (Krzysztof Kieslowski's *Trois Couleurs: Blanc*) 251

CAROL O'SULLIVAN
Picturing Characters: Zazies *à gogo* 263

Acknowledgements and Contributors 281

Index 285

List of Illustrations

Figure 1: Duras and Bamberger, *La Mer écrite*, (p. 51) 36

Figure 2: Duras and Bamberger, *La Mer écrite*, (p. 59) 41

Figure 3: Baudrillard, *Las Vegas, 1996* 49

Figure 4: Baudrillard, *Paris, 1996* 51

Figure 5: Baudrillard, *Patagonie, 1995* 53

Figure 6: Ernst, *La Femme 100 Têtes*, plate 90 90

Figure 7: Ernst, *La Femme 100 Têtes*, plate 133 91

Figure 8: Ernst, *La Femme 100 Têtes*, plate 140 92

Figure 9: Man Ray, *La Marquise Casati* 107

Figure 10: Magritte, *Je ne vois pas la ... cachée dans le forêt* 111

Figure 11: Dalì and Buñuel, *Un chien andalou* (still) 116

Figure 12: Brauner, from *L'Œil du Peintre* 119

Figure 13: Cranach, Lucretia Judith diptych 129

Figure 14: Moreau, *L'Apparition* (oil) 213

Figure 15: Moreau, *Salomé à la panthère* 215

Figure 16: Moreau, *Salomé tatouée* (detail) 221

SIMON KEMP AND LIBBY SAXTON

Introduction

To look is to read. Such a contention might be the germ for many of the ideas in this volume, which explores the points at which the visual and the textual intersect within the area of modern French studies. From the specifically literary to the broader regions of culture and society, and the theoretical realms of philosophy and psychoanalysis, questions of vision and visual representation have played a central role in French intellectual and artistic life. The points of contact between vision and text have proved most elusive and fertile at the stage of interpretation, where visual perception is imbued with meaning through the processes of spectating or reading. But despite their interaction, these two processes are not entirely commensurate: while the mechanisms of fascination that sustain the gaze exceed the scope of the text, the pleasures and displeasures available to the reader remain unaccounted for by spectatorial models. Acknowledging the possibility that visual experience may not be explicable within a textual model (or vice versa), this volume aims to chart the complex patterns of fears and longings that fuel and disrupt the negotiations between viewing and reading, image and text. The chapters to come examine how French thought has figured vision in the psychic development of individual identities, in their relationship to the world and society around them, and in the network of language and image that is the culture they are steeped in. Through this introduction, we hope to sketch in a little of the theoretical and cultural framework from which these ideas have arisen, and offer a preliminary investigation into the encounter of the gaze and the text.

Within the act of seeing are combined those of vision, perception and interpretation, working together to form an understanding of the world in a manner that has been considered analogous to the reading process's conversion of language to meaning in the text. As we look at an object, neural signals of light intensity and wavelength, created by

the stimulation of the photoreceptors on our retinas, are sent via the optic nerves into the brain. Here a complex process of combination, organization, decipherment and symbolic reconstruction is carried out to produce a virtual mental image, coded by colour, coherent in its distribution of forms, and mapped out in three dimensions. Sight can no more be characterized as an unmediated reception of light by the optical system than reading can be understood as a passive osmosis of signification into the mind. As Nobel laureate Francis Crick writes:

> It is difficult for many people to accept that what they see is a symbolic interpretation of the world – it all seems so like 'the real thing'. But in fact we have no direct knowledge of objects in the world. This is an illusion produced by the very efficiency of the [visual] system.[1]

Counter-intuitive as it may be, the symbolic nature of visual consciousness is easily demonstrated, as in the following well-known experiment, from which science, philosophy and psychoanalysis have all drawn implications. Fix a point on the far side of the room with your right eye, keeping the left one closed. Cover this point with a raised index finger, held up thirty centimetres or so in front of your face. Keeping your gaze fixed on the original point, move your hand slowly away to the right. After five or ten centimetres, the tip of your finger should disappear behind a patch of indeterminacy of approximately the same colour and consistency as the general background. This is (of course) your blind spot, the gap in the retina where the optic nerve meets the eyeball. The absence of photo-receptors makes it a hole in your visual field, which ought logically to be complemented by a dark void in the perceived image. The fact that it is not, that the blind spot is filled in by the mind with a 'best guess' as to its contents, based on the neural data from the surrounding area, suggests two fundamental points: that perception is not necessarily a direct and faithful reflection of exterior reality, and that seeing is not a passive reception, but an active, constructive process.

The peculiarities of the blind spot are only one element among many that are leading cognitive scientists into the interpretative complexities of visual perception. (Other elements include, for

1 Francis Crick, *The Astonishing Hypothesis: The Scientific Search for the Soul* (London: Simon and Schuster, 1995), p. 33.

example, the considerable neural reaction to spatial and temporal change in the visual field and the corresponding lack of brain activity in the perception of 'redundant' visual information, or the disproportionate amount of mental capacity which seems to be given over to the detection and processing of the human face within the systems of perception.)[2] It is an area of study that Crick and others hope will lead eventually to a greater understanding of the workings of consciousness: from how we perceive to how we think, and from there, possibly, to a glimpse of the nature of the self.

The link between vision and self was a major preoccupation of Maurice Merleau-Ponty, whose phenomenological inquiries dominated French philosophy in the mid-twentieth century. In Merleau-Ponty's writings perception, inextricable from vision, is given primacy by virtue of its being a pre-theoretical contact with reality and thus being necessarily central to any account of our relation to the world. In this volume Patrick Sheil revisits the phenomenology of perception, arguing that Merleau-Ponty's conception of vision as existing neither in the viewing subject nor in the object viewed, but in a simultaneous combination of both, comes close to breaking down the distinction between the self and external reality.

French psychoanalysis, too, gave the visual new prominence at this time in its model of the construction of the subject, albeit with a less benign inflection than that of phenomenology. Jacques Lacan's famous 'mirror stage' in psychic development concerns the moment at which the child arrives at an appreciation of its own self as distinct from others. This appreciation comes from the subject's identification with an external image of itself, such as its reflection in a mirror. Conflict arises, however, from the gap between the ideal image – focused, coherent and whole – and the subject itself, which is none of these things; knowing itself through an external image, the subject comes to define itself through self-alienation.[3] Such problematics of

2 See, for example, Richard Dawkins, *Unweaving the Rainbow* (London: Penguin, 1998), pp. 257–285, or Steven Pinker, *How the Mind Works* (New York: Norton, 1997), pp. 211–298.

3 For a general introduction to visual aspects of Lacanian thought, see Kaja Silverman, 'The Subject', in *Visual Culture: the Reader*, ed. by Jessica Evans and Stuart Hall (London: Sage, 1999), pp. 340–355.

visual self-definition in the subject are discussed in two chapters of the present volume on vision and autobiography, by Claire Boyle and Hannah Westley. With the mirror stage as elsewhere, Lacan viewed the impact of the visual on the psyche with suspicion, if not outright hostility. In *Les Quatre concepts fondamentaux de la psychanalyse*, for example, he observes, 'il est frappant, si l'on songe à l'universalité de la fonction du mauvais œil, qu'il n'y ait trace nulle part d'un bon œil, d'un œil qui bénit'.[4]

Lacan's influence on post-Freudian psychoanalysis served to focus its attention not only on the visual, but also on the textual, with his emphasis on the quasi-linguistic structure of the unconscious and his frequent use of literature to illustrate his theories (such as his famous seminar on Edgar Allan Poe's *The Purloined Letter*, dissecting the power relations between the characters according to the different epistemological status of their gazes).[5] However, his interest in cultural and artistic matters rested largely with their potential as exemplars of the universals of the human psyche. To trace the ways in which Merleau-Ponty's and Lacan's theories of vision and self have informed more culturally-oriented visual theory, we must turn to other thinkers.

Slavoj Žižek directs our attention away from the more structured articulations between viewer and viewed, symptomatic of a phenomenological or traditionally psychoanalytic project to generalize individual experience into that of an abstract and universal subject. By employing the tools of Lacanian theory to explain popular culture (and vice versa), he points us instead towards the centrality of the visual in contemporary western society. Amongst a series of proliferating electronic distractions, the visual media – from Alfred Hitchcock's classic cinematic narratives to the current deluge of virtual images – are re-examined as stages for the oscillations between gaze and voice as they are absorbed into the great mass of the visual. As the Lacanian Real, a realm resistant to linguistic or visual symbolization, erupts into reality, traumatically exposing the circumscription of our freedom in

4 Jacques Lacan, *Le Séminaire, livre XI* (Paris: Seuil, 1973), p. 105.
5 See especially *The Purloined Poe: Lacan, Derrida and Psychoanalytic Reading*, ed. by John P. Muller and William J. Richardson (Baltimore: Johns Hopkins University Press, 1988), for Lacan's seminar, Derrida's riposte, and a full account of the ensuing controversy.

political choices in an age of fabricated realities, in Žižek, an ocular culture takes the ethical turn.

Such a move locates Žižek in the fertile margins of a prolific strand in current theoretical discourse which seeks to diagnose and redeem a visuality in crisis. Besides those for whom this crisis acts as point of departure (Guy Debord, Jean Baudrillard, Paul Virilio, even artists such as Jean-Luc Godard), the generative role of the visual in some of the most important recent French thought (Jacques Lacan, Michel Foucault, Roland Barthes) testifies to the urgency of interrogating the drives and desires behind our obsessive preoccupation with the specular. Historically a source of spiritual and philosophical anxiety, the ethical charge of the image became a central concern with the advent of technologies of mechanical reproduction, which, as Walter Benjamin realized almost a century ago, marked a repositioning of the image as object for consumption.[6] Today the informational and visual overload of endlessly reproduced images has created a space of hyper-reality, a space which exceeds representation. Here the image can no longer claim the real, relegating truth to the back-benches, and casting retrospective doubt upon the epistemological or mimetic claims of the visual arts. From the affinities posited by Gilles Deleuze between Hitler and Hollywood to the intimate relationship of visual spectacle and destruction identified by Virilio, Baudrillard and Žižek in media coverage of the Gulf War, theory has called into question the bonds between seeing and knowing.[7]

But the collapse of a stable and transparent relationship between reality and representation which places the visual under suspicion – what Martin Jay calls the 'crisis of ocularcentrism'[8] – has spawned a

6 Walter Benjamin, 'The Work of Art in the Age of Mechanical Reproduction' (1936), in *Illuminations*, ed. and introduction by Hannah Arendt, trans. by Harry Zohn (London: Fontana, 1992), pp. 211–44.
7 Deleuze describes 'une sorte de fascisme qui unissait Hitler à Hollywood, Hollywood à Hitler', leading him to suggest that 'jusqu'au bout le nazisme se pense en concurrence avec Hollywood'. Gilles Deleuze, *Cinéma 2, L'Image-temps* (Paris: Minuit, 1985), pp. 214, 344.
8 Martin Jay, *Downcast Eyes. The Denigration of Vision in Twentieth-Century Thought* (Berkeley and Los Angeles: University of California Press, 1993), p. 236.

search for interstices, subversive rifts or sites of refuge in the discourses and practices of visuality that have shaped our society. Each of the chapters that follows explores the conflicts which inhabit one of these points of resistance. More specifically, many encounter each other at the site where the visual intersects with the textual, in the attempt to unpack the mutual entanglement of seeing and reading that has intrigued modern thought and continues to fuel the current visual overload. At stake in this encounter is the very place of the text when the visual intrudes to disrupt and challenge attempts to define culture within purely linguistic terms.

Paradigmatic of such attempts is Barthes's project. The visual encounters the textual throughout his theoretical career, most notably in his semiological analyses of contemporary culture. As Barthes disentangles the coded messages behind advertising imagery or uncovers hidden ideology in 'objective' news photography, he examines their interactions with textual accompaniments (captions or slogans), which guide the viewer towards a particular interpretation of the image, and work to exclude other, undesired connotations.[9] In his last major work, *La Chambre claire: Note sur la photographie*, Barthes ventures a more personal exploration of the photographic image and its links to memory and absence, reflections whose influence is explored in the two opening chapters of this volume.

Other thinkers, however, have drawn our attention towards aspects of the visual which resist integration within linguistics-based Structuralist or Post-Structuralist models of reality as textual. Producing an excess which eludes the reader/spectator as textual semiotician, the ubiquity of spectacle and the pathologies of the spectacular encounter lend themselves to discussion within the seminal framework outlined by Debord. In a probing critique, self-consciously articulated through both filmic and literary media, he diagnoses a society in which every relationship and transaction has been systematically reduced to spectacle, to the pure consumption and contemplation of images, relegating the individual subject to the role of spectator.

9 See Roland Barthes, 'Rhétorique de l'image', in *L'Obvie et l'obtus: Essais critiques III* (Paris: Seuil, 1982), pp. 25–42.

Introduction 15

For Foucault, however, the contours of intersubjective space are charted not by spectacle but by surveillance, a mechanism he describes in *Surveiller et punir: naissance de la prison*. Taking as point of orientation the model of modern penal architecture, Foucault's critical exposure of the omnipresence of the gaze invests it with structures of knowledge and power that dominate, discipline and subdue from the inside. Here the ethical risks Debord finds inherent in spectatorship are explored from the perspective of the object of the gaze. The panoptic metaphors Foucault borrows from Jeremy Bentham are reinvented in cyberspace, where, in the guise of digital security systems, genetic screening, or news networks with aerial cameras surveying for crisis, the invisible threat of the gaze is less feared than welcomed as a guarantee of stability.

Probing the limits of the Foucauldian critique, Virilio ups the ethical stakes as he relocates the enquiry from the metaphorical violence of surveillance (Big Brother's all-seeing eye) to the physical territory of war, positing perception and destruction as coterminous. One of his most recent works, *Stratégie de la déception*, discusses the Kosovo conflict as a lens through which to explore the interrelation of scientific advances, such as the militaristic real-time visualization afforded by satellite and the manipulation of perception via the mass media's visual feed-back to the public. Throughout Virilio's work the fatal interdependence of technologies of warfare and cinema offers a model for social and urban evolution where mediated perception spawns real and sometimes deadly consequences. Here virtual images have begun to put the real itself at risk.

Virtuality as consumer of reality is also catalyst for the thought of Baudrillard. The postmodern theorist fixates on the visual in contemporary western culture as a bewildering and ever-expanding profusion of images disseminated by the various forms of mass media. In his theory of the 'orders of simulacra' he argues that art, which in earlier forms of society was understood to occupy a distinct and reflective role with regard to reality, has in our society infused and been infused by reality to such an extent that both art and reality have collapsed into universal simulacra, a set of signs that have been cut off from their referents and now exist only in and for themselves. Nick Hanlon's chapter in this book focuses on Baudrillard's *violon d'Ingres*, photography, and discerns a paradox between the theorist's

general attitude to mediated reality, and the almost mystical, pre-intellectual directness that he appears to find in the photographic view of the world.

One consequence of the realm of pure simulation described by Baudrillard is the reduction of the subject to voyeur, whose expectancy of satiation of and through the image is merely fed by a contemporary culture which – as the historian and mediologist Régis Debray has lamented in his discussion of the realm of the 'videosphère' – is currently tyrannized by the ubiquitous visual. Taking its cue from positions such as those outlined above, the defence of the image proposed by Debray in his *Vie et mort de l'image* argues instead for a reawakening of our ethical obligations towards the image and the fraught processes of its decipherment. Tracing the shifts from a culture of the word to one of the image to one where both are overtaken by the 'visual', Debray directs our search once again towards the interstices, stressing the need for appreciation of otherness and incompleteness in an era 'qui a désacralisé l'image en faisant semblant de la consacrer', producing images which open onto nothing but themselves: '*l'image comme déni de l'autre*, et jusque de la réalité'.[10]

This search for sites of resistance in an historical narrative of the tensions between *logos* and icon as vehicles for thought, communication and beauty coincides with the central point of departure of the present volume. While the sensual immediacy and potency of the image is unlikely to be matched by language alone (as the stricter censorship of cinematic violence or visual pornography than of their written counterparts would seem to testify), the possibility that the visual and the textual inhabit, and yet are irreducible to, one another has intrigued cultural critics and theorists alike. It is the mechanisms of representation and interpretation within this intimate but conflictual cohabitation of sight and language that these chapters work to decipher, inviting us to read and view against the grain.

The first section of the book, 'Captured Images', examines the role of visual perception in the relationship between the self and

10 Régis Debray, *Vie et mort de l'image: une histoire du regard en Occident* (Paris: Gallimard, 1992), pp. 61–62.

exterior reality, and considers varying opinions as to the direct or mediated nature of this relationship. Particular attention is paid to the case of photography, a visual art that gives the deceptive impression of offering unmediated reality to the eye. Martin Crowley's examination of Marguerite Duras's photography and related writings explores a conjunction of the banal and the mystical in her views of the everyday. Her pictures seem to deny the possibility of any transcendent truth behind external appearance, while acknowledging a desire to decrypt a 'beyond' from the unyielding surface of the image. The deserted spaces of her photographs, which defy interpretation, are complemented by the literal desert-space in Baudrillard's photography, which is the subject of the second chapter. Here, Nick Hanlon reads Baudrillard's images to find a mystical return to Nietzschean primal reality within them. The section is concluded by Patrick Sheil's critical reappraisal of Merleau-Ponty's thoughts on vision, questioning the phenomenological idea of perception as nothingness, sited neither in the perceiver nor in the thing perceived.

The second section, 'The Surrealist Gaze', intervenes at a specific and particularly fertile moment in the debate to consider the disruptions that may impede the attempt to capture or explore a reality beyond the text from contrasting perspectives within French Surrealism. The chapters examine tensions in the movement between the search for new visual experience and its suspicions of the privileging of the visual, tensions which have had lasting implications for thought on vision. To this end Stamatina Dimakopoulou compares Surrealist with Post-Structuralist understanding of visual perception. Max Ernst's work forms a focus for discussion of Surrealism's simultaneous preservation of the epistemological validity of perception and critique of constitutive subjectivity.

This theoretical investigation of Surrealist perception paves the way for three chapters exploring these tensions within the visual interventions in the construction of identity or subjectivity, in relation to gender, the self, and mental (un)health. In Rakhee Balaram's 'Eyes Wide Open, Eyes Wide Shut: Defining the Surrealist Eye', André Breton serves as point of departure for a study of the Surrealist representations of the eye, which, in its affinities with the feminine, emerges as a mirror of Surrealist identity and a crucial figure in the rethinking of the movement's misogynistic tendencies. Relocating the

interplay of vision and identity to the terrain of autobiography, Hannah Westley identifies the central role of the uneasy encounter of visuality and textuality in the shaping and representation of the self. Tracing Michel Leiris's evolution of a visual imagination through textual self-portraiture, the inscription of the visual into the verbal, she queries the extent to which his identity is formed through pre-existing visual images, and the implications of his positioning of Cranach's diptych as authorization and catalyst for his autobiographical quest. But while visual imagery is privileged as a mnemonic vehicle in the retrospective construction of subjectivity, it is equally subject to gaps and disruptions, leading Leiris to present eclectic, sometimes contradictory images which both mark and attempt to bridge the gulf between past and present selves. In line with such refusals of unified identity, Alistair Swiffen shows how the intersection of language and vision in Surrealism may hold darker implications for the construction of the psyche. 'Seeing Double/Hearing Things: In(s)anity in the *Aumonymes* of Robert Desnos' explores written language as a visual artefact and considers the interplay between seeing and hearing in the reading process. The success of the pun, a single graphic form that can generate different meanings, depends upon our understanding of language as both a visual and an aural phenomenon. Involving as it does the ability to see and hear double, Swiffen shows how the pun, in Desnos, treads the line between sanity and insanity, a lens through which to interrogate the prevalent definitions of social and psychological normality and their relationship to language.

The next section, 'Limits of the Visible', explores the mobile boundaries of what can be seen, dealing first with lack, then with excess, in visual and textual representation. Lack is the subject of Claire Boyle's discussion of the autobiographical writing of Nathalie Sarraute and Georges Perec, and of Sonya Stephens's investigation into incompleteness as a mode of representation. In the former the Lacanian gaze is invoked to describe the power relations between reader and writer of the autobiographical text. Boyle identifies an anxious desire on the part of the narrator to control the self-image presented for the reader's scrutiny, which leads the autobiographer to assert the existence of an extra-textual selfhood inaccessible to the reader. The autobiographical text is thus deliberately offered to the reader as an incomplete picture in order to preserve the writing subject

Introduction 19

from the disempowering effect of the other's gaze. Focusing on the nineteenth century, Stephens also examines unfinished pictures, both literal in the case of Courbet's paintings and figurative in the case of Baudelaire's collections of poetry. She argues that for these and other creative artists incompleteness was an aesthetic necessity, demanding a participatory interpretation in their expression of a continual becoming, and that this apparent lack should therefore be read as a form of hermeneutic plenitude.

We remain in the nineteenth century for the two other chapters in this section: Ariane Smart's discussion of Hugo's visionary depiction of Paris, and Blandine Chambost's consideration of Salome as seen by Moreau and Mallarmé. Smart follows Hugo's texts into the city's darkest depths, exploring the ways in which they transform wretchedness and criminality into an urban metaphysic. She sees in the symbolism which pervades his visual representation an attempt to penetrate beyond surface appearances and discover the monstrous and the transcendent in the city's essential nature. Chambost's Salome is equally excessive, transgressing human boundaries into impossible myth in Moreau's and Mallarmé's enraptured painterly and poetic representation of her. Chambost examines the paradox inherent in their attempt to evoke through her an eternal feminine, which is itself characterized by its refusal of fixed definition or stable representation.

If these four chapters map visual limits blurred by excess and lack, the final section, 'Between the Frames', concludes with a look at the ways discourses which combine word and image may be caught up in a questioning of their own limits. Probing the boundaries between vision and other senses, cinema and other media, the last chapters seek and expose points of contact between vision and temporality, touch, and finally, translation. Jean Khalfa explores the relation of temporality to visuality in a medium whose specificity stems from its mobilization of time, to propose a model of the mechanisms which structure the cinematic regime and organize our vision of a reality beyond the text. Interrogating the differences between cinema and photography, he argues that cinema's moving images link through time what photography has framed in the present and therefore disjointed. Khalfa shows how directors such as Robert Bresson, Jean Eustache or Claude Lanzmann have reflected on this model and made films which break the expected continuity of

unfolding – the homogeneity of duration – to obscure the difference between representation and presence, fiction and non-fiction.

In 'Screening Pleasure: Touch and Vision in Contemporary Cinema', Emma Wilson develops a theme which implicitly underpins many of the earlier contributions: the relation of vision to pleasure and its frustration. The habitually melancholic cinema of Krzysztof Kieslowski serves as point of orientation for discussion of the interplay of visual and haptic (tactile) pleasures in relation to the challenge to represent *jouissance* – (female) sexual pleasure. Wilson argues that tactile pleasure must remain illusory in the work of contemporary filmmakers who are concerned as much with showing the impossibility of touch within the visual medium, as they are with exposing the limits of the visual. The exposure of limits, this time between image and text, is also the focus of Carol O'Sullivan's examination of the challenging process of projecting the literary into cinema and art, or into different languages. Her chapter discusses a series of 'visualizations' of Raymond Queneau's novel *Zazie dans le métro*, including Louis Malle's film and Duhème's illustrations. Querying the extent to which these visualizations, of Zazie as well as *Zazie*, can be seen as translations, O'Sullivan considers the play of power as a written text is 'visualized' into different media, exploring the uncertain place of truth in the passage between the textual and the visual.

Suggested Reading

Roland Barthes, 'Rhétorique de l'image', in *L'Obvie et l'obtus: Essais critiques III* (Paris: Seuil, 1982), pp. 25–42
—— *La Chambre claire: note sur la photographie* (Paris: Gallimard, 1980)
Francis Crick, *The Astonishing Hypothesis: The Scientific Search for the Soul* (London: Simon and Schuster, 1995)
Guy Debord, *La Société du spectacle* (Paris: Buchet-Chastel, 1967)

Régis Debray, *Vie et mort de l'image: une histoire du regard en Occident* (Paris: Gallimard, 1992)

Michel Foucault, *Surveiller et punir: naissance de la prison* (Paris: Gallimard, 1975)

Martin Jay, *Downcast Eyes: The Denigration of Vision in Twentieth-Century Thought* (Berkeley and Los Angeles: University of California Press, 1993)

Baudrillard: A Critical Reader, ed. by Douglas Kellner (Oxford: Blackwell, 1994)

Jacques Lacan, *Le Séminaire, livre XI: Les Quatre concepts fondamentaux de la psychanalyse* (Paris: Seuil, 1973)

Maurice Merleau-Ponty, *Phénoménologie de la perception* (Paris: Gallimard, 1945)

Paul Virilio, *Guerre et cinéma* (Paris: Éditions de l'Étoile, 1984)

Slavoj Žižek, *Looking Awry: An Introduction to Jacques Lacan through Popular Culture* (Cambridge, MA and London: The MIT Press, 1991)

Part 1

Captured Images

MARTIN CROWLEY

'Que pourrait-on montrer d'autre que ce qu'on voit?': Duras and the Photography of the Real

> *The fairies are on the plate!*
> Elsie Wright, Cottingley, July 1917

As everybody knows, and as the Cottingley fairies showed us, photography reveals what is there. Even the magical arrival of guests from another dimension might just be a matter of hatpins and bits of paper. To put this the other way around, however (and to grant the fairies their magic, which after all duped cleverer people than you or me): the everyday scraps whose emanations produce the alchemy of photography give, by virtue of this process, onto a beyond which seems compellingly bound to the banality it also exceeds.

Such, at least, would be some of the implications of the thoughts on photography to be found scattered around the work of Marguerite Duras. As her work was increasingly accompanied by fetishistic photographic representations of the author and her world (say, from the late 1970s on), Duras took an increasing interest in the business of photography; not least because the magic of its indexal relation to the real provided the ideal context in which to develop the sublime aesthetic she was at the time perfecting in her cinematic and, especially, her literary work. What I propose to do here, then, is to look at the role of photography in and around Duras's work, considering in particular some of her thoughts on photography and the operation of the photographic in one of her texts, in order to suggest some of the most magical – because also most banal – aspects of this aesthetic.

For over twenty years, Duras's career (which continues, now, posthumously) has been accompanied by photographs. In 1977, the Éditions de Minuit published *Les Lieux de Marguerite Duras*,

interviews with Duras by Michelle Porte broadcast on French television in May 1976. With this book, a certain Durassian iconography is born. For here we find not only the text of these interviews, but also a series of photographs. There are images related to Duras's films (*India Song, Nathalie Granger*, and *La Femme du Gange*), taken by her son, Jean Mascolo; images of Duras and of her house at Neauphle-le-Château, taken by Michelle Porte and others; and, notably, images of Duras's childhood in Indochina. Here we see pictures of Duras's family, her mother, father, brothers, and their servants; all of which will be enormously important in and around the success of *L'Amant*, whose scenery they concretize. But here we also have pictures of Duras as an adolescent, which begin a process of the doubling of Duras's work by her photographic representation which will continue until her death – and even beyond. And of course, the most significant of these images is that of the eighteen-year-old Marguerite Donnadieu.[1] Around *L'Amant*, this image has itself enjoyed considerable success; notably, it is reproduced on the cover of certain translations of *L'Amant*, where it comes to figure the text's autobiographical, scandalously revelatory dimensions. It would, of course, be impossible to deny that this aspect of the text has been in part responsible for its extraordinary worldwide success. But within the media exploitation of this image, there is a slight gap, which opens the way to a more general consideration of the role of photography in Duras's career. For here – to reiterate, and as Duras herself notes in *Les Lieux de Marguerite Duras* – we have a photograph taken when she was eighteen years old. Which means that this is not simply an authentic image of 'l'enfant' of *L'Amant*, whose transgressive affair begins when she is approximately sixteen; rather, this image is closer in time to that of the older self who, towards the end of the text, leaves Indochina for Paris. We are here confronted by an image which figures less the autobiographical truth of this story than its fading. This is already the face of the girl who is distancing herself from her lover, looking in the direction of his shadowy form until she can no longer see anything:

1 This image may be found in Marguerite Duras and Michelle Porte, *Les Lieux de Marguerite Duras* (Paris: Minuit, 1977), p. 43.

> C'était lui à l'arrière, cette forme à peine visible, qui ne faisait aucun mouvement, terrassée. Elle était accoudée au bastingage comme la première fois sur le bac. Elle savait qu'il la regardait. Elle le regardait elle aussi, elle ne le voyait plus mais elle regardait encore vers la forme de l'automobile noire. Et puis à la fin elle ne l'avait plus vue. Le port s'était effacé et puis la terre.[2]

The face which has become the very symbol of the autobiographical truth of this story is the face of the self who can no longer see: the emblem of visibility (i.e. the authenticity, the readability of this 'confession') in fact figures its limit, where vision and understanding are beginning to blur. Which is hardly unusual, in a Duras text – especially an autobiographical text famously established on the basis of the lack, not the presence, of an originary image, that of the first meeting between the young girl and her lover.[3] But this aesthetic of loss has of course itself been lost in the commercial success of *L'Amant*, which therefore ruptures this image of confessional plenitude. It would have been possible to choose an image of Duras at sixteen to crown her autobiographical revelations: such images exist, not least in *Les Lieux de Marguerite Duras*. Happily, this was not the case. Because the gap thus established is in fact perfectly faithful to Duras's sublime aesthetic, in which the point of representation is precisely to fix the blind spot where representation falters – while never, of course, pretending to have grasped this limit. If we are to discuss the presence of photography in and around the work of Marguerite Duras, we will thus have to talk about the presence of prolonged work on the question of presence itself, the elaboration of a representation of the limits of representation – and beyond.

We are faced, then, with a clear contradiction: on the one hand, photography has always functioned to shore up Duras's fame, accompanying and advancing the career of 'Marguerite Duras' This tendency, which has its origins in *Les Lieux de Marguerite Duras*, reaches its apotheosis at the moment of her death, which saw the press (particularly magazines) collate vast quantities of images of the author, from her childhood through to her old age. After her death, this is still going on: the posthumous career of 'Duras' was launched

2 Duras, *L'Amant* (Paris: Minuit, 1984), p. 136.
3 See Duras, *L'Amant*, pp. 16–17.

by the publication by her son, Jean Mascolo, of a collection of photographs entitled *Marguerite Duras: vérité et légendes*.[4] On the other hand, the role of photography within Duras's work appears to subvert this media circulation, shifting and puncturing the myth of presence on which it is based. But this contradiction has its sense: for the gap it marks is no other than that between representation and its lack, which therefore picks up at a further level the problematic which is already at the heart of this work. Let us, for example, consider the relationship between *Marguerite Duras: vérité et légendes* and the family photograph album apparently at the origin of *L'Amant*. The latter was abandoned in the writing of the text, which becomes in part an interrogation of the presence of the past of which such an album might have constituted both a more flat and a more fascinating representation; its absence resonates in the text in the invisibility of the founding photograph which was not taken of the young girl and her future lover on the ferry. Mascolo's album moves to fill this gap, finally delivers the text which *L'Amant* could not become. And yet this collection is itself also punctured by the absence it might redeem, exists only to affirm its mourning of its object, the loss inscribed (if only as potential) in what Barthes gives as the name of the *noema* of photography: '*Ça-a-été*'.[5]

It would appear that almost any photograph entering into contact with Duras's work will be marked by this problematic of the limits of representation. Even when, at the beginning of the 1990s, it is a matter

4 *Marguerite Duras: Vérité et légendes*, photographies inédites, collection Jean Mascolo; texte, Alain Vircondelet (Paris: Éditions du Chêne, Hachette Livre, 1996).

5 See Roland Barthes, *La Chambre claire. Note sur la photographie* (Paris: Éditions de l'Étoile-Gallimard-Seuil, 1980), pp. 120 ff. On the respective rôles of photography in the work of Barthes and Duras, see Victoria Best, 'Mastering the Image: Photography and the Elusive Gaze', *French Cultural Studies*, 8/2 (June 1997), pp. 173–8. I am extremely grateful to Victoria Best for the chance to see a copy of this article prior to its publication. Whereas her piece demonstrates how the notion of photography as indexal emanation is complicated by its aesthetics and the phenomenology of its reception, I will here, as it were, be proceeding in the opposite direction, by considering how, for Duras and for Barthes, this aesthetic complication is itself punctured by the indexal qualities of photography, and investigating the notion of the real this implies.

of the work of different photographers, to which Duras merely provides a commentary. Around this time, she provides prefaces to four collections of photographs: *Yves Saint Laurent et la photographie de mode*; *L'Histoire de la France*, by Ralph Gibson; *France*, by Janine Niepce; and *Maisons d'écrivains*, by Erica Lennard.[6] The first and last of these collections need not concern us here, as Duras's contributions – though interesting in other ways – do not particularly address the question of photography. But in the texts which she wrote for Ralph Gibson and Janine Niepce, Duras develops a particular photographic aesthetic, which takes up some of the most banal ideas about this medium, yet arrives at an attitude which is all but mystical. (Mysticism and banality being, in Duras, inseparable.)

We have already seen that a notion of photography as raw, authentic truth is placed in question by the operation of photography in and around Duras's work. And yet it is precisely in terms of this notion that Duras's photographic aesthetic establishes itself. Discussing the work of Janine Niepce, for example, Duras uses the figure of revelation in a way which seems to rely on an uncomplicated model of representation: 'Je ne peux m'empêcher de croire que Janine Niepce montre dans ces photographies ce qui d'habitude n'est pas montré'.[7] The fact that this affirmation presents itself as a rather cautious confession ('Je ne peux m'empêcher de croire...') is no doubt related to the rather conventional nature of this apparent aesthetic of revelation. And at the end of her text, Duras states simply: 'Il faut voir les photographies de Janine Niepce. On est ramené à la vérité.'[8] The documentary side of photography is thus affirmed: the function of photography would be to represent what is there, really there – what *is*, in fact. But this is not, of course, the whole truth of this Durassian model. Even while remaining within the banal – which is extremely

6 *Yves Saint Laurent et la photographie de mode*, préface de Marguerite Duras (Paris: Albin Michel, 1988); Ralph Gibson, *Histoire de la France* (Paris: Paris Audiovisuel, 1991); Janine Niepce, *France*, texte de Marguerite Duras (Arles: Actes-Sud, 1992); Erica Lennard, *Maisons d'écrivains* (Paris: Éditions du Chêne, 1994). (Duras's contributions to Lennard's text comprise extracts from *Écrire* (Paris: Gallimard, 1993).)
7 Duras, 'Janine Niepce', in *Le Monde extérieur* (Paris: P.O.L., 1993), pp. 58–61 (p. 59).
8 Ibid., p. 61.

important here – Duras manages to hymn the mystery and the passions of this everyday banality, praising the ability of photography to reach not a truth which might have been slumbering beneath the surface of things, waiting to be brought to the surface by artistic means, but rather a truth which would be this surface itself, in all its obvious indecipherability. And the Durassian name of this truth is: the real. (Which is not quite a Lacanian use of the term – but does present interesting points of contact with such a use, as may become apparent.)[9] When she evokes the photographic representation of reality, it is in fact to its mystery that Duras claims to be attracted; elsewhere in her discussion of Niepce's photographs, she writes, 'toujours elles procèdent d'un don miraculeux, d'un sens du réel, inné pourrait-on dire, et qui ignore sa puissance'.[10] Even as they retain the simplicity of the things they represent, these photographs thus avoid reduction to a simple transcription of a preceding external reality – but at the same time, they also avoid the critical revelation of a deep truth hidden by everyday appearances. Paradoxically perhaps, we are dealing with a truth which would remain stuck to the surface of everyday life, while revealing the beauty of this surface – which would, moreover, be a form of beauty whose force would derive from its very obviousness, from the fact that, rather than rising up from hidden depths, it remains bound into the surface of the most trivial things, that it is, even, the force of this very trivia, always there, too present to be seen.

So what about Ralph Gibson?

> On se dit: ce qu'on voit là, c'est peut-être ce que voient les enfants, ce qu'on appelle du mot mirobolant: le réel. Tu l'as pris le réel de toi, R.G., et tu es parti avec, sur la terre française, sur le sol de Paris, la nudité de la terre entre les rangs de vigne, ce qui ne s'énonce jamais, sauf de rares fois, dans la poésie.[11]

9 On the connection between photography and the Lacanian Real, see Barthes, p. 15. In terms of Duras's aesthetic, the link might be established with reference to the notion of the Real as that which is both inescapable and inaccessible, the 'unassimilable' and the 'impossible'. (See Jacques Lacan, *The Four Fundamental Concepts of Psychoanalysis*, ed. by Jacques-Alain Miller, trans. by Alan Sheridan (Harmondsworth: Penguin, 1986), pp. 55, 167.)
10 Duras, 'Janine Niepce', p. 59.
11 Duras, 'Ralph Gibson', in *Le Monde extérieur*, pp. 34–36 (p. 34).

That which is revealed is thus that which was hidden ('ce qui ne s'énonce jamais'), but which is as banal as can be – 'la terre entre les rangs de vigne'. The direction of this revelation is thus the opposite of what one might expect: rather than having deep truth burst through the hole of the aesthetic into the everyday, the startling truth of the banal detail punctures this everyday, creating a fascinating gulf on whose edge the spectator remains stuck, absorbed by the beauty of this banality. The emblem of this aesthetic – which Hélène Cixous, talking about Duras, called un 'art de la pauvreté'[12] – might be found in a photograph by Ralph Gibson which Duras seems to remember even as she writes her text:

> Il y a aussi des objets pris au vol. Je pense à cette photo de toi, où l'ai-je vue, qui m'émeut toujours quand j'y pense. Voilà: c'est une marche d'un escalier extérieur qui devrait mener à un parc, très légèrement déformée par le temps, peut-être des siècles – et sur laquelle, le jour et l'heure de ton passage, il y a eu, sur cette marche immaculée, un objet perdu, minuscule et de nature vulgaire, pratique: je parle du bouton qui ferme les chemises des hommes et les blouses des femmes. Ce bouton est là depuis très peu de temps, quelques heures, et toi, tu as vu ce détail nacré. Tu l'as photographié très petit dans la marée blanche de la marche. Tu as photographié l'éternité de ce détail avant que les bennes à ordures l'emportent loin de tout. Il n'était, sur cette marche, que pour quelques heures et toi, tu as signé son éternité de 'bouton perdu par un inconnu, dans une ville de douze mille habitants'.[13]

What matters to Duras is thus what she calls 'ce détail nacré', which, in its opacity and its resistance to interpretation, and in the affective response it provokes, recalls the *punctum* analysed by Barthes in *La Chambre claire*.[14] But we should note that, whereas for Barthes the *punctum* marks that aspect of the photograph which resists and escapes the ideological codes governing the rest of the image, according to what he calls the *studium*, Duras adopts the most naive position possible, not only in relation to this detail, but in relation to photography as a whole. The urgent hole created by Barthes's *punctum* spreads, for Duras, until it covers and, in fact, becomes the

12 Hélène Cixous and Michel Foucault, 'A propos de Marguerite Duras', *Cahiers Renaud-Barrault*, 89 (1975), pp. 8–22 (p. 9).
13 Duras, 'Ralph Gibson', p. 36.
14 See Barthes, *La Chambre claire*; the notion of the *punctum* is introduced gradually from p. 40, and makes its first appearance on p. 49.

space of photography. (As can also be the case for Barthes, indeed: at which point the effect of the *punctum* becomes, as he puts it, 'un éclair qui flotte'. Thus, for Barthes, occasions emerge in which 'tout en restant un détail, le *punctum* emplit toute la photographie'.)[15] Like Barthes gripped by images in which the wild irruption of the *punctum* (beyond any cultural code) comes for him to dominate, Duras scorns the properly artistic aspects of the image – the fact that it has been produced, structured, arranged, and presented in a particular relationship to the conventions of its genre. For readers who – thanks largely to the Barthes of the *Mythologies* – can no longer look at an image without immediately reflecting on its ideological frame, Duras's aesthetic (like Barthes's, incidentally, as he provocatively acknowledges) cannot but appear naive.

Which, of course, it is. About Janine Niepce, Duras writes that 'Le sujet n'est jamais enfermé dans un champ photographique, médité, calculé. Autrement dit, ici, rien n'est provoqué, "arrangé".'[16] It is not that Duras is unaware of the composition of the images she discusses: in her text on Ralph Gibson, this composition is at times precisely what she praises. But the banal beauty she celebrates in these texts makes its frame more or less irrelevant. For Duras, in fact, the force of the 'détail nacré' is not simply that it resists ideological codes: it is, rather, that it allows the photograph as a whole to escape the grasp of any code, any frame:

> Les photographies de Janine Niepce ont été faites en France. Parce qu'elle est française. Moi, je les vois venir du monde entier, elles restent universelles, d'une beauté et d'une vérité inépuisables. Pourquoi sont-elles insondables, on ne le sait pas immédiatement. Il y en a dont jamais on n'a épuisé le sens, la portée. Jamais le cadre ne barre la route à l'envol de la photographie.[17]

Meaning, here, is bottomless, mysterious – precisely because this meaning remains, obvious, in the unfathomable beauty of the everyday. (We might recall that for Blanchot, for example, 'le

15 Barthes, pp. 87, 77.
16 Duras, 'Janine Niepce', p. 58.
17 Ibid., p. 58.

quotidien échappe. C'est sa définition.')[18] The detail, for Duras, is thus the paradox of a flat hole in which interpretations are lost, whose meaning is entirely located within the inexhaustible fascination it imposes in its exorbitant banality. In the face of this detail, there is nothing to be said; all one can do is to acknowledge (in awe) its existence – and that it thus represents the limits of representation, no kind of a sign, drowning not waving. And the task of photography, according to Duras, would be to map the edges of this hole, to sketch the limits of representation by trying to capture that detail which renders the mimetic project impossible by means of its very indexal platitude, which robs it of depth to open up, precisely, the gulf of fascination, of the beyond – i.e. of the real, of that which is, just, there. For both Duras and Barthes, in fact, the indexal quality of photography is of interest precisely inasmuch as it allows the presentation of the ungraspability of the real, the paradox of a medium offering contact with, touching on (as 'une peau que je partage avec celui ou celle qui a été photographié') a real defined as 'intraitable'– as Duras puts it, 'peut-être parce qu'on ne sait pas "attraper" le réel, comment le voir et le prendre, je ne sais pas'.[19] And yet a real which is nonetheless there, its rays touching my retina 'comme les rayons différés d'une étoile'.[20] As Barthes says, a photograph is not a copy, but an emanation; not an art, but a kind of magic.[21]

To see how this aesthetic functions in relation to photography within Duras's own work, we have only to look at her first posthumous work: *La Mer écrite*. This little book is made up of photographs and accompanying texts; the photographs were taken at Duras's direction by her friend, the photographer Hélène Bamberger, over some fourteen years. Bamberger explains:

> J'ai rencontré Marguerite Duras à Trouville pendant l'été 80.
> Nous avons pris l'habitude de nous promener tous les après-midi.
> Pendant ces promenades, je faisais des photos.
> Peu à peu, Marguerite s'est mise à me diriger.

18 Maurice Blanchot, 'La Parole quotidienne', in *L'Entretien infini* (Paris: Gallimard, 1969), pp. 355–66 (p. 359).
19 Barthes, pp. 126, 184; Duras, 'Janine Niepce', p. 59.
20 Barthes, p. 126.
21 Ibid., p. 138.

> D'année en année, les photos sont devenues indispensables à nos promenades, comme un devoir de vacances, sur lequel Marguerite manifestait des exigences de plus en plus précises.
> Peu à peu on en est venu à parler d'un album.[22]

The text is constructed around a series of divisions which pick up the motif of the hole to be found within the photographs themselves. First, it has two authors: Bamberger, responsible for the photographs, and Duras, for the text. But this division is itself divided: the photographs were taken by Bamberger, but arranged by Duras. (Which is hardly a surprise, given the similarities of tone and of composition between these images and certain shots from the films made by Duras in Trouville, particularly *Agatha*.) Beyond these architectural, or paratextual, divisions, the internal composition of the work displays a similar gap: between text and images. Each double page is composed of a text to the left, which comments on an image to the right. But there is no reason to believe that the repetition of all these divisions would represent a simple *mise en abyme* which, articulated by the opposition inside/outside, would allow the multi-layered reproduction of the hole at the centre of the images, which would for their part represent the heart of the work. Being already punctured, this heart allows itself to be repeated only by means of a reproduction which agrees to lose its object in the very act of reproducing it. The gap between text and image, for example, picks up the fascinating gulf at the core of each image – but is thereby itself rendered invisible, silent. The price of the repetition of fascination is the loss of any meaning which would claim any other status than that of the left-overs which mark the edge of the beyond. And the same is true for the tone of the texts: their mystical platitude sketches the limits of comprehension by slipping away from any interpretation – apart from one which would be happy to join this text as the residue on the edge of the abyss. When, commenting on an image of the shore, Duras avows her ignorance, and invites her readers to supply their own multiple (and so habitual) interpretations, her gentle irony suggests the folly of any reader who would see in this an invitation to which s/he might respond:

[22] Marguerite Duras and Hélène Bamberger, *La Mer écrite* (Paris: Marval, 1996), back cover.

Duras and the Photography of the Real 35

Je ne sais plus rien.
C'est peut-être le Chili ou un Japon très revu et très corrigé.
Ça dépend de vous, cher spectateur. (p. 26)

The pictures included in this volume take in much of the familiar late Durassian imaginary: images of cemeteries, of churches, of Christ; of deserted buildings, industrial sites, the Hôtel des Roches Noires; of the countryside, of children, of the beach – and of course of the sea. The emphasis is on melancholy, on mourning; Duras refers more or less explicitly to certain of her previous works; the figure of residuality is more or less constantly present. There is here a handy, economical indication that that which remains is Duras's preferred approach to the representation of that which exceeds representation; not quite, in Derridean terms, the trace as mark of that which has never been present, but rather a residue which constitutes the edge of that of which the absence is all too present. We are here face to face with the Durassian sublime: debris which represent the ruin of representation before the invisible beyond.[23] I propose, then, to consider here two images in which I hope to be able to identify the workings of this aesthetic; first, one taken beside the sea at Hennequeville (see figure 1).

The image is structured by a series of lines: the horizon, the edge of the cliff, the path, the edge of the shadow. Against the more or less horizontal plane of these lines, there rises a monument, reminiscent of a tomb not only in its form, which resembles a funerary urn, but also in its ruined state. And Duras's text remarks upon this state, the collapse of an architectural order and the continued presence of a supposedly 'wild' nature: 'Tout s'est effondré. On a seulement gardé le désordre de la nature, sa folie'.[24] The theme of this image would, then, be collapse, and what remains. And it is possible to note the

[23] This way of thinking about the sublime (and that this gives onto the impossible Lacanian Real) is also suggested, for example, by Žižek: 'The wreck of the *Titanic* therefore functions as a sublime object: a positive material object elevated to the status of the impossible Thing' (Slavoj Žižek, *The Sublime Object of Ideology* (London: Verso, 1989), p. 71).

[24] Duras, *La Mer écrite*, p. 50.

Figure 1: Duras and Bamberger, *La Mer écrite*, (p. 51)
© Hélène Bamberger / Cosmos
by permission of the Syndics of Cambridge University Library

mimetic repetition of this structure in the text-image relation: a tiny text – one might almost say a scrap – beside the striking beauty of the image, the two separated by the white gulf into which that which has collapsed (architecture, order, understanding) has already disappeared. Duras is here making contact with some of her earliest concerns, in a way which, on the edge of this particular abyss (before and after her own death) is movingly vigorous: she is once more (as she does in her earliest texts) interrogating the possibility of representing the beyond by setting up the notion of a symmetry between the representation and its impossible object. But the symmetry, as one might expect, wobbles: for the gulf is already present in the image, precisely as that which cannot be reached (symbolized, understood) – except as that which we have already lost.

Clearly, this image sets up a three-way – and utterly grandiose – symbolism: underworld, earth, heavens. The underworld is suggested by the shadowy area in which this quasi-funeral monument is anchored; the earth, by the ground which surrounds its body; which allows its head (and the flowers which crown it) to reach the heavens. And this symbolism is structured by the lines we have already met, certain of which (the horizon and the edge of the shadow) thus come to represent the edges of the world, the boundaries of the beyond. Which is all very well, and all very well indicated by the structure of the image. But what about the other lines? This symbolic structure openly invites its own ruination by the excess which it introduces into its constituent elements. Interpretation – which, incidentally, imposes itself as inevitable – reveals its own incompletion. The edges observable within the image refuse to be limited by an interpretation which would see in them the limits of a beyond which might be reached by anyone with his or her feet on the ground. At once called forth and ruined, interpretation collapses, precisely – but on condition that it should not therefore be interpreted as having grasped the meaning of the image. For nothing is attained, here: the heavens are not penetrated by the head of the monument, this is just an effect of perspective. No boundaries are crossed; the transgression of the limit is never realized, is always, in Blanchotian fashion, still to be accomplished, as the limit constantly moves beyond

the grasp of interpretation. The beyond remains beyond – not incarnated in a particular part of the image, but everywhere at once, a black hole which drains the image of its sense, without letting this drained meaning escape as a positive interpretation. Here is the beyond, the sublime at work: the photograph reveals what is not there.

By way of commentary on an image of the countryside, marked not only by a second series of lines stretching to the horizon, but also by a few tranquil cows, Duras writes: 'Les champs du Débarquement des armées françaises. Les morts sont invisibles. Là' (p. 44). And here is the whole paradox of this aesthetic. It is here that the dead are invisible; which means that, invisible, the dead are here. As in the section of *Écrire* entitled 'La Mort du jeune aviateur anglais', history, on the basis of the melancholy it inspires, opens onto an entirely mystical beyond. But this mysticism, which has its origins in a kind of generalized and endless mourning, also has a socio-cultural dimension, which will critique a purely theoretical relationship to the disasters of history (a key name here might be that of Baudrillard) – a relationship which sees, and thus fails to see, the invisible which, for Duras, is unavoidable:

> La guerre est devenue lointaine comme l'âge des enfants, comme la guerre, le temps passé en guerre. On ne sait pas où elle a lieu. Parfois on va jusqu'à ne plus savoir s'il y a encore des guerres, aujourd'hui ou hier.
> On ne sait plus rien, presque, à force de savoir Tout. Tout comme on croit savoir. C'est ce qu'on appelle un état avancé du désespoir. (p. 20)

An aesthetic of edges, this mysticism is thus not to be separated from the social; but it nevertheless constantly underlines that which, inhabiting the social in the most banal way possible, manages to exceed it by means of this very banality. When Duras returns to her own aesthetic, it will, accordingly, be in the mode of paradox: 'Que pourrait-on montrer d'autre que ce qu'on voit? Ce qui est simplement vrai et qui échappe à l'homme' (p. 38). The truth, which photography has to show, is that which is lost; that which is present without being seen, not as a detail which has gone unnoticed, but as a detail which opens the world onto a beyond which was already there.

So what is the relationship of these images to this beyond? First, we must note that this beyond is not realized in the images, which can only affirm its flight into an invisible presence. We are not dealing

with an art of transgression, if by this we understand (as, unfortunately, we generally do) an art which claims to realize the excess with which it is fascinated in the aesthetic object itself, without glimpsing the ridiculous hypocrisy this would entail. It is, rather, an art which sketches out the encounter with the beyond in the only way possible, namely by marking the hole left by this encounter within the fabric of the day-to-day – a fabric in which this beyond was already present in its very banality. At the end as at the beginning of her career, Duras – with Blanchot, with Bataille – goes beyond the rhetoric of transgression (demonstrating its insufficiency in the structuration of the images she glosses, as we have briefly seen), and so reaches an impossible encounter with the other side of representation which is both more patient and more disturbed. When she hooks up with the history of her own work, accordingly, she offers an image which, while recalling the deserted tennis courts of the *India Song* cycle, displaces this work to open up a space which is, simply, deserted (see figure 2). The meaning of this space? Plainly: the invisibility of the beyond which inhabits the banality of the everyday. But, if it does not want in this way to betray its object, interpretation must itself, here, desert, become deserted. How are we to understand the desertion of understanding? 'Plus on les regarde,' says Duras of the tennis courts, 'plus il sembleraient qu'ils soient déserts' (p. 58). The absence of meaning also implies the absence of the meaning of this interpretation; as if by contagion, the desert is never sufficiently deserted, is always also stripped of its own emptiness: 'Déserts d'eux-mêmes, désertés.' The desert of interpretation – which we cannot avoid as the interpretation of this image – will never manage to constitute itself as an interpretation. There is nothing to be seen on the empty courts – which means that this means nothing. But it is not for all that an enclosed space (we are, after all, outside these courts): this impossibility of interpretation gives nonetheless, as we have seen, onto history and onto a certain modest ethics of knowledge. Fascination does not lead to indifference; on the contrary, it imposes a profound tenderness for the poor details in which that which cannot be represented manages nonetheless to declare itself, a pathos which is also a patience and a kind of compassion. But in the Durassian aesthetic as it reveals itself both in this volume and elsewhere, these

elements have to remain so many left-overs, irreducible residues which mark the absence of this beyond which is all too present, which fascinates, and which, even after her death, continues to resonate throughout Duras's texts.

> Les vrais tennis déserts. Ça existe. On ne sait jamais pourquoi ils sont déserts.
> On regarde et plus on les regarde, plus il semblerait qu'ils soient déserts.
> Déserts d'eux-mêmes, désertés.
> Ça s'arrête là. (p. 58)

Figure 2: Duras and Bamberger, *La Mer écrite*, (p. 59)
© Hélène Bamberger / Cosmos
by permission of the Syndics of Cambridge University Library

Suggested Reading

Roland Barthes, *La Chambre claire. Note sur la photographie* (Paris: Éditions de l'Étoile-Gallimard-Seuil, 1980)
Walter Benjamin, 'The Work of Art in the Age of Mechanical Reproduction' (1936), in *Illuminations*, ed. and introduction by Hannah Arendt, trans. by Harry Zohn (London: Fontana, 1992), pp. 211–44
Marguerite Duras, *L'Amant* (Paris: Minuit, 1984)
—— 'Janine Niepce', in *Le Monde extérieur* (Paris: P.O.L., 1993), pp. 58 61
—— 'Ralph Gibson', in *Le Monde extérieur*, pp. 34–36
Marguerite Duras and Hélène Bamberger, *La Mer écrite* (Paris: Marval, 1996)
Ralph Gibson, *Histoire de la France* (Paris: Paris Audiovisuel, 1991)
Erica Lennard, *Maisons d'écrivains* (Paris: Éditions du Chêne, 1994)
Janine Niepce, *France*, texte de Marguerite Duras (Arles: Actes-Sud, 1992)

NICK HANLON

Baudrillard's Aesthetic

> *Chaque pression sur le déclencheur met simultanément fin à la présence réelle de l'objet, et à celle du sujet, et c'est dans cette disparition réciproque que s'opère une transfusion des deux.*[1]

Through a consideration of Baudrillard's photographs in their relation to his theory, this chapter seeks to expose in each the presence of a Nietzschean 'primal oneness' and to consider the implications for an interpretation of Baudrillard of such a presence. Photography is an activity that he took up relatively recently in his career – i.e. the mid-eighties. Since this beginning, which he describes as accruing from a desire to divert himself from theory and before which he was 'indifferent' to photography, Baudrillard has been exhibited, and in 1998 published a book of one hundred photographs with the title *Car l'illusion ne s'oppose pas à la réalité*. In the preface to this book and in assorted texts and interviews Baudrillard sets out his theoretical position in relation to photography. It is significant that he says he begins by considering photography to be unrelated to his theoretical endeavour, but then changes his mind and decides that it is the same thing.[2] Such a radical shift may be indicative of an initially relatively instinctive/emotional activity becoming assimilated (whether consciously or not) into a more rational/analytic framework as more thought is inevitably devoted to the matter. Baudrillard's theory is in general marked by an anti-establishment subversion (or 'theoretical terrorism' as he puts it)[3] which is connected to his avowed distaste for

1 Jean Baudrillard, *L'Échange impossible* (Paris: Galilée, 1999), p. 180.
2 *Jean Baudrillard: Art and Artefact*, ed. by N. Zurbrugg (London: Sage, 1997), p. 34.
3 See M. Gane *Baudrillard Live* (London: Routledge, 1993), pp. 169–70 ; Jean Baudrillard, *La Pensée radicale* (Paris: Sens & Tonka, 1994), pp. 5–36, Jean Baudrillard, *Simulacres et simulation* (Paris: Galilée, 1981), p. 233: 'je suis terroriste et nihiliste en théorie comme d'autres le sont par les armes.'

art and the artistic establishment (a position contradicted by his frequent praise for artists such as Bacon, Warhol, Hopper, who are all now firmly part of the establishment). In addition there is a clear onus on analysing the contemporary (e.g. Disneyland, the Gulf war, Demi Moore). These easily discernible traits run counter to my argument here (something which will be addressed later), an argument which will align Baudrillard's theory (in connection with his photography) with *The Birth of Tragedy*, a seminally Romantic text which affirms art as the highest human pursuit. The connection of Nietzsche with Baudrillard might seem an obvious one, considering Nietzsche's crucial influence on that elusive, yet pervasive, contemporary cultural logic which is postmodernism, of which many would see Baudrillard as a primary proponent (though he denies this). Yet we should bear strongly in mind that *The Birth of Tragedy* is *early* Nietzsche, *Romantic* Nietzsche, a text which affirms aesthetic and philosophical positions which are critiqued by Nietzsche himself sixteen years later, and which are certainly in tension with much of the force of Baudrillard's texts. This, therefore, is the interest of discerning a primal oneness, for it is in many senses *against* Baudrillard.

In *L'Échange symbolique et la mort* (1976), the text where Baudrillard establishes his three orders of simulacra, much time is also spent comparing what he describes as primitive, tribal man with contemporary Western society. The main fruit of this comparison is a sense of their different respective understandings of, and means of appropriating, reality. The primitive appropriation being seen as one that is much less divorced from the originary. Where *our* narratives have become polluted with an overweening rational-scientific imperative, a desire to explain, *they* are more prepared to accept nature in its flux and contingency: 'tout ce qui est de nature [...] n'a pour eux [les sauvages] tout simplement pas de sens. C'est le désordre absolu [...]. Ce sont les forces irréconciliées.'[4] There is an acceptance of essential flux; the symbolic exchange on which their society is founded is not a structure which is supposed to have the capacity to provide answers, and neither is it one which continually posits boundaries (between different individuals, man and nature, and life

4 Baudrillard, *L'Échange symbolique et la mort* (Paris: Gallimard, 1976), p. 202.

and death): 'Ceci est le fait fondamental qui nous sépare des primitifs, l'échange ne cesse pas avec la vie. L'échange symbolique n'a pas de cesse, ni entre les vivants, ni avec les morts (ni avec les pierres, ni avec les bêtes).'[5] There is a parallel here, in the conflation of living and dead, and subjects and objects, with the notion of primal oneness as expressed in *The Birth of Tragedy*. Primal oneness is a mystical state or realm posited by Nietzsche, which may be achieved/accessed through a dissolution of boundaries and all those structures imposed by the human intellect in its conventional appropriation of reality (such as what Schopenhauer describes as the *principium individuationis* – the principle of individuation). Primal oneness is seen as some sort of unity with a Schopenhauerian Will or essence:

> Now all the rigid, hostile barriers, which necessity, caprice, or 'impudent fashion' have established between human beings, break asunder. Now, hearing this gospel of universal harmony, each person feels himself to be not simply united, reconciled or merged with his neighbour, but quite literally one with him, as if the veil of maya had been torn apart, so that mere shreds of it flutter before the mysterious primordial unity (*das Ur-Eine* [primal oneness]). [...] [Man] has forgotten how to walk and talk and is on the brink of flying and dancing, up and away into the air above.[6]

Throughout *L'Échange symbolique et la mort*, primitive man is seen to attach less importance to the individual (although their oneness with nature is not *complete* because it is mediated by symbolic exchange). Thus, in this early text, there is already a firm grounding for an understanding of Baudrillard through primal oneness.

Baudrillard's preoccupation with the primal is in evidence in his 1986 text *Amérique*, an autobiographical travelogue describing his experiences of the U.S.A.. Here, the desert plays a crucial role. In a far more lyrical and less analytic gesture (compared with *L'Échange symbolique et la mort*), Baudrillard sets up the primal instantiation of the desert as a counterpoint to the civilization of enormous American cities which he finds to be starkly geographically juxtaposed. In answer to his own question of 'pourquoi les déserts sont-ils si

5 Ibid., p. 207.
6 Friedrich Nietzsche, *The Birth of Tragedy & Other Writings* (Cambridge: Cambridge University Press, 1999), p. 18.

fascinants?' he suggests: 'C'est que toute profondeur y est résolue – neutralité brillante, mouvante et superficielle, défi au sens et à la nature et à la culture, hyperespace ultérieure, sans origine désormais, sans références.'[7] Thus in one sense the desert may be seen as a counterpoint of absence to the signification-laden realms of Western (hyper)reality. Typically for a Baudrillard text though it is not so clear-cut because the deserts also designate something at the heart of that Western reality:

> la culture américaine est l'héritière des déserts. Ceux-ci ne sont pas une nature en contre-point des villes, ils désignent le vide, la nudité radicale qui est à l'arrière-plan de tout établissement humain. Ils désignent du même coup les établissements humains comme une métaphore de ce vide, et l'œuvre de l'homme comme la continuité du désert, la culture comme mirage, et comme perpétuité du simulacre.[8]

For Baudrillard, the desert is not only an image of contrast with the bustling cities, but a natural phenomenon which functions as primal evidence of the distant, but at the same time immanent origins of the culture and civilization we have imposed on nature, and through the lens of which we view that nature. The role accorded to the desert by Baudrillard recapitulates that given by Nietzsche to tragedy or to the Dionysiac dithyramb (a choral song, originally part of the cult of Dionysos)[9] – that is, as a means of piercing the Schopenhauerian 'veil of Maya' (the false realm of everyday illusion or appearance) and accessing the more authentic primal oneness.

My focus thus far on the desert has been designed to illustrate Baudrillard's preoccupation with the primal. Both desert and primal

7 Baudrillard, *Amérique* (Paris: Livre de poche, 1986), p. 119.
8 Ibid., p. 63.
9 Nietzsche's notion of the Dionysiac arises out of his interpretation/extrapolation of the myth of Dionysos. Like its counterpart the Apolline (to which it stands both in opposition and as complement), it is never crisply defined. However, it may be conceived of as a primal state (non-representational, non-rational), associated with *Rausch* (intoxication, and, in Nietzsche, a heightened sense of being), and also pain and horror (the essence of existence) and entailing destruction of individuation and dissolution of boundaries. It is through the Dionysiac that one might access the realm of primal oneness or Schopenhauerian Will.

are key elements for an understanding of Baudrillard's photographic endeavour. He says of the photo: 'it recreates emptiness, it recreates the desert, the equivalent of the desert.'[10] With the desert/photo equivalence in mind we should appreciate the prominence of Baudrillard's *aesthetic* appreciation of deserts – their beauty important enough to move him to open the first book (out of three) of his autobiographical fragments, *Cool Memories* with the following words:

> Le choc primal de l'éblouissement des déserts [...] – y a-t-il raisonnablement quelque chose de plus beau au monde? Ce n'est pas vraisemblable. Il faut donc penser que j'ai rencontré, once in my life, l'endroit le plus beau que je verrai jamais.[11]

Whilst it is undoubtedly accurate to describe Baudrillard's appreciation here as aesthetic, we should be wary about the connotations of such an assignation. For Baudrillard would not want his views to become part of the tradition of aesthetics or any canon of establishment (artistic) thinking. He says in an interview: 'the viewpoint which is internal to aesthetics has never been acceptable to me. I've never adopted it. I find it extraordinarily affected, but that doesn't stop me from being able to enjoy or judge things from an aesthetic point of view.'[12] Here Baudrillard seems to want to have his cake and eat it, rejecting aesthetics at the same time as asserting his right to view things from an aesthetic point of view. This points us towards two problems worth noting for Baudrillard the revolutionary (or 'theoretical terrorist'). The first being that as a successful subversive it is difficult *not* to become part of the establishment, since a successful subversive narrative will become generally accepted and thereby part of the establishment it was formerly subverting. The second problem, more directly illustrated by this quotation, is the question of whether it is possible to escape the epistemological structures imposed by or pre-existent within the dominant establishment narratives of a particular epoch? This is a problem raised by Foucault's notion of the *épistémè*, which despite his resistance is not something that Baudrillard ever succeeds in

10 Zurbrugg, p. 31.
11 Baudrillard, *Cool Memories I et II* (Paris: Galilée, 1987), p. 9.
12 Gane, p. 23.

completely overcoming.[13] Despite these theoretical difficulties, the fact remains that Baudrillard is dissatisfied with what he describes as the 'aestheticization' of the photograph (by which he means the bringing of the photograph into the realms of the artistic establishment and traditional interpretation).[14] He speaks of the photo as having been 'ravalée au niveau d'une pratique esthétique'.[15] Yet this is the narrative one is inclined to employ with regard to Baudrillard's photos for on the whole they *are* beautiful in all the conventional senses (form, composition, colour etc.).[16] He asserts that he wants his photos to be without 'meaning',[17] that he wants to avoid an 'aesthetic' understanding of them, that *objectalité* and *détail* are the most important features, yet for all the theorizing with which Baudrillard has now surrounded his photography, the fact remains that his photos give much cause to be described as beautiful, and this fact cannot be completely divorced from the subject who took the photographs, who thereby, whether he likes it or not, becomes entailed in a conventional aesthetic narrative. This is particularly the case with commentators like Susan Sontag around, who attempt to close off the possibility of seeing photography in anything like the terms that Baudrillard, and, as we will see, Barthes suggest: 'the photograph is not, even ostensibly, meant to lead us back to an original experience.'[18]

Baudrillard's commentary on photography is much indebted to Barthes's *La Chambre claire: Note sur la photographie* (1980) published before Baudrillard became interested in photography. Their positions are extremely close in a number of areas. They both speak of death as being inherent in photography; of the contingency of the photo; of the difficulty of photographing the subject; of the subject as

13 Michel Foucault, *Les Mots et les choses* (Paris: Gallimard, 1966), p. 13; see *Oublier Foucault*, (Paris: Galilée, 1977).
14 Baudrillard, *Car l'illusion ne s'oppose pas à la réalité* (Paris: Descartes & Cie, 1998), p. 20.
15 Baudrillard, *Le Paroxyste indifférent* (Paris: Grasset, 1997), p. 165.
16 The fact that most of his photos are doing striking things with colour means that the monochrome reproduction here reduces their impact.
17 Steven Poole, 'Meet the David Bowie of philosophy', *The Guardian*, 14 March 2000, pp. 14–15.
18 Susan Sontag, *On Photography* (London: Penguin, 1979), p. 148.

Figure 3: Baudrillard, *Las Vegas, 1996*
Photo de Jean Baudrillard; *Car l'illusion ne s'oppose pas à la réalité*
© Descartes & Cie, 1998

being transformed into object by the photo; of photography as being nothing to do with a corpus of work. Barthes also describes the possibility of a certain 'essence' arising from the referent.[19] This possibility grounds his notions of the *studium* and the *punctum* which are also taken up directly by Baudrillard (e.g. in the preface of *Car l'illusion ne s'oppose pas à la réalité*) and have important links with primal oneness. Barthes defines the *studium* thus:

> le *studium*, qui ne veut pas dire, du moins tout de suite, 'l'étude', mais l'application à une chose, le goût pour quelqu'un, une sorte d'investissement général, empressé, certes, mais sans acuité particulière. [...] c'est culturellement (cette connotation est présente dans le *studium*) que je participe aux figures, aux mines, aux gestes, aux décors, aux actions.[20]

Of the *punctum* he says: 'ce n'est pas moi qui va le chercher [...] c'est lui qui part de la scène, comme une flèche, et vient me percer.'[21] Both Barthes and Baudrillard speak of the detail in the photograph as being the key to the successful operation of the *punctum*. This detail may facilitate a piercing of usual, culturally-programmed responses (*studium*), thereby providing a more authentic insight into, or perhaps beyond, reality/existence. One might say here that Baudrillard's explicit affirmation of the existence of the *studium* is an implicit acknowledgement of the validity of Foucault's notion of the *épistémè*, where one cannot avoid the impression of the epistemological structures of a particular epoch.

In *La Chambre claire* Barthes makes an association between photography and theatre:

> Ce n'est pas (me semble-t-il) par la peinture que la Photographie touche à l'art, c'est par le Théâtre. [...] si la Photo me paraît plus proche du Théâtre, c'est à travers un relais singulier (peut-être suis-je le seul à le voir): la Mort. [...] la Photo est comme un théâtre primitif, comme un Tableau Vivant, la figuration de la face immobile et fardée sous laquelle nous voyons les morts.[22]

19 Roland Barthes, *La Chambre claire: Note sur la photographie* (Paris: Gallimard, 1980), pp. 17–18.
20 Ibid., p. 48.
21 Ibid., pp. 48–9.
22 Ibid., p. 55.

Figure 4: Baudrillard, *Paris, 1996*
Photo de Jean Baudrillard; *Car l'illusion ne s'oppose pas à la réalité*
© Descartes & Cie, 1998

In its alignment of the photo with theatre, this statement reminds us (through mention of 'la face fardé', the primitive and 'les morts') of what Nietzsche describes as a possible effect of (Dionysiac) tragedy: 'state and society, indeed all divisions between one human being and another, give way to an overwhelming feeling of unity [oneness] which leads men back to the heart of nature.'[23] Later in the text, to confirm this association with Nietzsche, Barthes states that the photo is *not* 'un morceau de Maya' – *Maya* being a key term in *The Birth of Tragedy*, and this statement implying that the photo is something beyond this superficial veil.[24] The Nietzschean associations present in Barthes are to be found in Baudrillard, but in a less explicit way. The primal oneness is certainly buried or veiled, but not to the extent that it is unexhumable, or no longer present. We see a sense of it when Baudrillard speaks of the possibility of accessing *objectalité*:

> L'intensité de l'image est à la mesure de sa dénégation du réel, de l'invention d'une autre scène. Faire d'un objet une image, c'est ôter toutes ses dimensions une à une: le poids, le relief, le parfum, la profondeur, le temps, la continuité, et bien sûr le sens. C'est au prix de cette désincarnation que l'image prend cette puissance de fascination, qu'elle devient médium de l'objectalité pure.[25]

This conception of the value of photography to access what is generally presented as a privileged object world seems to be a replaying of Nietzsche's vision of the role of music or of Greek Tragedy which are both seen as means to accessing the primal oneness. The music in *The Birth of Tragedy*, in a similar manner to the *punctum* in Baudrillard (and Barthes), facilitates a surpassing of the conventional (Apolline) representation and (Socratic)[26] rationality to

23 Nietzsche, p. 39.
24 Barthes, p. 130.
25 Baudrillard, *Car l'illusion ne s'oppose pas à la réalité*, p. 3.
26 In a similar fashion to the Dionysiac, Nietzsche's notion of the Apolline arises out of his extrapolation/interpretation of the myth of Apollo. The Apolline stands for representation, appearance, individuation, and provides, through appearance, a respite from human suffering in its veiling of the painful reality of the innermost core of things. Nietzsche also posits the existence of a Socratic tendency in opposition to the Dionysiac. He is very much against the Socratic faith in knowledge and rationality as sole means of understanding existence.

Figure 5: Baudrillard, *Patagonie, 1995*
Photo de Jean Baudrillard; *Car l'illusion ne s'oppose pas à la réalité*
© Descartes & Cie, 1998

a more primal realm. In an interview on his photography Baudrillard makes the following statement:

> Métaphoriquement, c'est l'idée qu'il ne reste plus de notre côté qu'un monde matériel, visible, identifiable, parfaitement identifié. Pourtant, quelque part ailleurs (derrière le miroir) il y a une sorte de matière noire infinie, non identifié, dont on imagine qu'elle pourrait être un jour notre destin.[27]

Baudrillard has here posited the existence of a realm 'ailleurs', he also speaks of the photographic image as being 'une forme sauvage' and 'plus proche de l'origine et les affres de la représentation'.[28] He even says that when taking photographs: 'I enter into this second state – this kind of rapid ecstasy – much more easily in my photography than in my writing.'[29] This description is reminiscent of the state of Dionysiac *Rausch* which Nietzsche describes as creative and as facilitating access to primal oneness.

In *The Birth of Tragedy*, Nietzsche speaks of 'Apolline deception' as a 'persistent deception'.[30] The Apolline may be seen as closely related to Baudrillard's simulacra. At the end of *The Birth of Tragedy* Nietzsche describes how the primal Dionysiac has been subsumed by Apolline and Socratic tendencies (e.g. in Euripidean tragedy), but however suppressed or subsumed, the Dionysiac is seen to always eventually rise up and pierce this veil (in the manner of the *punctum*, originary or *objectalité*). The simulacrum, which conceals the primal, may therefore be seen as an Apolline tool in which we are perfectly happy to immerse ourselves because of the relief it affords us (i.e. when absorbed in Apolline simulacra we no longer have to confront the horror of Dionysiac essence). Baudrillard's endeavour may be conceived of as a (Dionysiac) dissatisfaction with an overly Apolline- and Socratic-oriented cultural milieu (in the manner of that which occurs in *The Birth of Tragedy*). The beauty that one might find in Baudrillard's photos, if the *punctum* and *objectalité* operate successfully, should be accompanied by a Dionysiac horror, as one glimpses or momentarily accesses the primal oneness. Similarly, the

27 Baudrillard, *Le Paroxyste indifférent*, p. 181.
28 Ibid., pp. 162, 163.
29 Zurbrugg, p. 37.
30 Nietzsche, p. 103.

act of photographing for Baudrillard must be, as far as is possible, a Dionysiac act entailing a dissolution of individuation and rationality. The primal oneness in Baudrillard may be conceived of as being antithetical to the simulacral. Yet, as in Nietzsche where the Dionysiac is inextricably bound up with the Apolline, in Baudrillard the simulacral is formative of our consciousness to the extent that its relationship with any primal oneness or essence is ambivalent ('images have passed over into things. They are no longer the mirror of reality, they are living in the heart of reality').[31] This is the nature of Baudrillard's *hyperreality*, which refers not only to a media-laden exteriority, but also a media-laden and, more importantly, media-*constructed* interiority.

Employing the constructs of interiority and exteriority points us in the direction of the problem of immanence and transcendence. Baudrillard generally affirms that transcendence is no longer possible, e.g. '[the image] can no longer transcend reality [...] because it has become its own virtual reality'.[32] In *L'Illusion de la fin*, he writes that any *arrière-monde* that one might formerly have conceived of is now no longer *arrière*, but is contained within the *monde réel*.[33] In an early essay he states: 'L'immanence et la transcendence sont également impossibles: ce sont deux aspects d'un même rêve.'[34] At first sight this might seem to undermine an argument affirming a Nietzschean primal oneness, since one might be inclined to understand primal oneness, in its association with Schopenhauerian Will, as a form of transcendence. Yet Nietzsche evinces an indication to the contrary – that the key to accessing the realm of primal oneness is the Apolline domain of semblance: 'I feel myself driven to the metaphysical assumption that that which truly exists, the eternally suffering and contradictory, primordial unity [primal oneness], simultaneously needs, for its constant release and redemption, the ecstatic vision, intensely pleasurable semblance.'[35] This perspective in Nietzsche is

31 Zurbrugg, p. 12.
32 Ibid., p. 12.
33 Baudrillard, *L'Illusion de la fin* (Paris: Galilée, 1992), p. 142.
34 Baudrillard, 'Le Gestuel et la Signature' in *Pour une critique de l'économie politique du signe* (Paris: Gallimard, 1972), pp. 114–126 (p. 123).
35 Nietzsche, p. 26.

relevant to a consideration of the aporia that we may discern in Baudrillard's presentation of the immanent and the transcendent, in particular with regard to photography. In *L'Échange impossible* Baudrillard hints at a certain transcendence ('au-delà'): 'C'est la technique [photographique] qui nous porte au-delà de la ressemblance, au cœur du trompe-l'œil de la réalité', but this is undermined by 'au cœur du' which suggests immanence.[36] Two pages later he hints at a certain immanence: 'Le regard photographique *ne sonde* ni n'analyse une "réalité", il se pose "littéralement" sur la surface des choses et illustre leur apparition sous forme de fragments.'[37] Yet here, 'sur la surface' contradicts the sense of immanence of 'ne sonde'. Baudrillard is deliberately evading an incorporation into his theoretical structures of either of these terms, each of which carries significant philosophical/terminological baggage. Yet his dancing in and out of their theoretical space leaves an aporia as regards the position of the photograph and how one should conceive of his insistence on *objectalité* and the *punctum*. This aporia may be, if not resolved, then at least illuminated by reference to Nietzsche's primal oneness, a contradictory state which entails a unification and at the same time a piercing of appearance into essence, image into object.

At the beginning of this paper I suggested that Baudrillard's 'theoretical terrorism' along with his predilection for analysing the contemporary (as part of a negation of history)[38] ran counter to my argument. My discernment of a primal oneness in Baudrillard would seem to defy his textual practice of negating history and subverting the establishment in the sense that it constitutes an attempt to understand Baudrillard through an established historical narrative (one could safely describe Nietzsche's *The Birth of Tragedy* as an established canonical text within the history of literature, philosophy and aesthetics). I now wish to suggest a mode of understanding the presence of primal oneness which might be more consonant with

36 Baudrillard, *L'Échange impossible*, p. 175.
37 Ibid., p. 177, my italics.
38 Here, consider in particular *L'Illusion de la fin* which opens with the statement: 'Il y a diverses hypothèses plausibles quant à cet évanouissement de l'histoire.' In this text Baudrillard puts forward the idea of *circularité*, a notion opposed to a conventional linear conception of time.

Baudrillard's textual strategy, and at the same time affirms the relevance of relating his theory to an established historical narrative. Gianni Vattimo, in *The End of Modernity: Nihilism and Hermeneutics in Postmodern Culture*, puts forward the Heideggerian notion of *Verwindung* as a means of understanding the force of the postmodern and post-metaphysical era (i.e. an era which no longer preoccupies itself with knowing 'truth' or 'things in themselves').[39] Through *Verwindung*, Vattimo engages the problem, mentioned earlier, existent for Baudrillard the revolutionary of (paradoxically) becoming part of the establishment through the act of subversion, and in addition of always already being imbued with pre-existent epistemological structures. He defines the term as follows: '*Verwindung* indicates something analogous to *Überwindung*, or overcoming, but is distinctly different from the latter [...] because it contains no sense of a "leaving-behind" of a past that no longer has anything to say to us' (p. 164). '[It] is both an acceptance and a deepening' (p. 172). The *Überwindung* is the disingenuous and implausible attempt of Modernity to overcome and make a clean break from former narratives. For Vattimo, *Verwindung* is the very condition of postmodernity. His presentation of this notion is much in line with Foucault's notion of the *épistémè*, yet it incorporates a postmodern ironic twist (of subversion/distortion). He writes:

> It is very likely that the idea of thought's progress and emancipation through 'critical overcoming' is closely related to a linear conception of history; when critical overcoming is 'distorted' into the notion of *Verwindung*, history itself can no longer appear in a linear light. History reveals its 'ironic' essence: interpretation and distortion, or dis-location, characterize not only the relation of thought to the messages of the past but also the relation of one 'epoch' to the others. Perhaps this was one of the meanings Heidegger had in mind when he spoke of the 'epochal' essence of Being. (pp. 179–80)

Vattimo thereby acknowledges the theoretical force of Foucault's *épistémè* in his presentation of *Verwindung*, but affirms in addition, as an essential element of 'postmodernity', the presence of a certain distortion or subversion.

39 G. Vattimo, *The End of Modernity: Nihilism and Hermeneutics in Postmodern Culture* (Baltimore: Johns Hopkins University Press, 1991), p. 167.

It is significant that Vattimo includes distortion as an important constitutive element of *Verwindung* (pp. 172, 179–80). One might say that Nietzsche himself engages in a sort of *Verwindung* in the philosophical repositioning evidenced in his 'Attempt at a self-criticism' which now forms a preface to *The Birth of Tragedy*. It would thus be entirely in line with the revisionist character of *Verwindung* (and of Nietzsche's own approach) for Baudrillard to have taken up primal oneness, and to not have done so in a completely direct manner. In addition, Vattimo is fairly ambivalent on the extent to which *Verwindung* is an active process. He writes:

> Metaphysics and the *Ge-Stell* [an ensemble (*Ge-*) of *stellen* ('placing'/ 'arranging'/'imposing'/etc.); a framework] may be lived as an opportunity or as the possibility of a change by virtue of which both metaphysics and the *Ge-Stell* are twisted in a direction which is not foreseen by their own essence, and yet is connected to it. (p. 173)

Therefore, if we recall the uncertainty that Baudrillard evinces in the realm of transcendence/immanence, which is an uncertainty less present in Nietzsche's presentation of primal oneness (as it is presented in *The Birth of Tragedy*, primal oneness is a state *more* connected with transcendence than anything in Baudrillard), then we see a distortion (a key sense of *Verwindung*) in the presence of primal oneness in Baudrillard. This distortion need not be one that is actively intended, indeed neither necessarily should the presence of primal oneness be a presence that is actively intended.

A discernment of the presence of a primal oneness in Baudrillard's photographs and theory is supported by his preoccupation with the primal, deserts, primal beauty, nature (as revealed through texts such as *L'Échange symbolique et la mort* and *Amérique*), also by his affirmation of the Barthesian *punctum* and his own *objectalité* (each of which are closely bound up with each other, and in the case of Barthes, there are overtly Nietzschean connections in evidence). To have related Baudrillard's *simulacra* to Nietzsche's Apolline might seem to overly Romanticize a Baudrillard who attempts to present himself as resolutely ahistorical, *un*Romantic, and anti-Foucauldian. Yet such a correlation, combined with a discernment of primal oneness, usefully points us towards not only an

important Romantic strand, of nostalgia for a more primal state and a love of nature, but also an understanding (*against* Baudrillard) of his endeavour in terms of Foucault's *épistémè* and, more particularly, of Vattimo's Heideggerian conception of postmodernity, embodied in *Verwindung*, which effectively hypostatizes Baudrillard's distaste for a linear conception of history in its propounding of history's 'ironic' essence; a denotation of history as 'ironic' being a distinctly Baudrillardian rhetorical move.

Suggested Reading

Roland Barthes, *La Chambre claire: Note sur la photographie* (Paris: Gallimard, 1980)
Jean Baudrillard, *L'Échange symbolique et la mort* (Paris: Gallimard, 1976)
—— *Amérique* (Paris: Livre de poche, 1986)
—— *La Transparence du mal* (Paris: Galilée, 1990)
—— *L'Illusion de la fin* (Paris: Galilée, 1992)
—— *Le Paroxyste indifférent* (Paris: Grasset, 1997)
—— *Car l'illusion ne s'oppose pas à la réalité* (Paris: Descartes & Cie, 1998)
—— *L'Échange impossible* (Paris: Galilée, 1999)
Jean Baudrillard: Art and Artefact, ed. by N. Zurbrugg (London: Sage, 1997)
Mike Gane, *Baudrillard Live* (London: Routledge, 1993)
Friedrich Nietzsche, *The Birth of Tragedy & Other Writings* (Cambridge: Cambridge University Press, 1999)
H. Staten, *Nietzsche's Voice* (London: Cornell University Press, 1990)
Gianni Vattimo, *The End of Modernity: Nihilism and Hermeneutics in Postmodern Culture* (Baltimore: Johns Hopkins University Press, 1991)

Patrick Sheil

Neither Here nor There:
Merleau-Ponty on Vision and Existence

Vision is the concept that Maurice Merleau-Ponty chose to make central to his philosophy and to his writing on art, psychology and politics. It was to vision that Merleau-Ponty would most often turn for examples and illustrations as he unfolded his theories of perception. It was from vision that he developed an idea of how human subjectivity itself has been conceived and misconceived. To claim that no other major Western philosopher has returned with such insistence to the theme of vision would not be unreasonable.

In what follows I shall relate what Merleau-Ponty says about eyes and seeing to his general conception of subjectivity and of the world as we encounter it. I shall argue that Merleau-Ponty presents vision as an event that takes place neither *here* in the subject, nor *there* in the things themselves, but in a combination of *here-and-there*, a combination which, in the moment it occurs, threatens to collapse the very distinction between the subject in here and the world out there. While, on one hand, I hope to show that his arguments in this area are inspired and captivating, I will also propose that Merleau-Ponty has been waylaid, if not misled, in some important respects by the existentialist motto that consciousness is nothingness, a motto that distorts the Hegelian idea from which it takes its inspiration. We will look first at *Phénoménologie de la perception* and then consider the later (unfinished) work, *Le Visible et l'invisible*.[1] Connections will be made between the investigations of these two major works and the

1 *Phénoménologie de la perception*, Maurice Merleau-Ponty (Paris, 1945), hereafter abbreviated to '*PP*'; *Le Visible et l'invisible*, Maurice Merleau-Ponty (Paris, 1964), hereafter abbreviated to '*VI*'.

observations of the essay collections (such as, for example, *Signes* and *Sens et non-sens*).[2]

Confining the faculty of vision to descriptions of the optical nerve and the structure of the eye is something Merleau-Ponty is reluctant to do – 'puisque la vision des sons ou l'audition des couleurs existent comme phénomènes' (p. 264) – indeed, it is not just with reference to synaesthesia that we can question the idea of a necessary correspondence between a given organ and a particular way of perceiving. To Merleau-Ponty's example, we may add bats, who are able to model three dimensional space using their ears, as well as the phenomenon (albeit a rare one) of the deaf musician who is able to perform in an orchestra with the help of a heightened sense of touch so that the perception of vibrations to which others would be insensible becomes possible. In both the case of the bat and the deaf musician we may well ask whether they do not in fact possess at least a part of that sense in which they are said to be deficient. This is simply because the sorts of data that we would expect to be missing in the head of the blind bat, or of the deaf musician *are* actually present. What would it be like to be in the head of a bat? If we were able to navigate with our ears, would not that be, quite literally, a kind of vision? And in the case of the 'deaf' musician, it may be the case that since a pair of functioning ears would ultimately only ever perform via a monitoring of vibrations, and since the 'deaf' musician refers us to the 'tangibility' of sound, it is as if the musician's whole body as been transformed into a gigantic ear. To be sure, the deaf musician would be amazed at the difference were the ears to begin functioning again, but perhaps only in the sense that I would be amazed if I were suddenly in the brain of a person who liked a piece of music that I currently dislike.

In *Phénoménologie de la perception* (1945), Merleau-Ponty is particularly concerned about the extent to which vision is suffused with – and even organized by – expectations, memories, assumptions and appetites. If all these elements were somehow subtracted from vision, Merleau-Ponty wonders, what would be left? There would still

[2] *Signes*, Maurice Merleau-Ponty (Paris, 1960), hereafter abbreviated to '*S*'; *Sens et non-sens*, Maurice Merleau-Ponty (Paris, 1948), hereafter abbreviated to '*SNS*'.

be a vision of sorts, but things would certainly not 'look' the same. Of course, this 'not-looking-the-same' would go unnoticed by the subject who underwent such a loss of mental context, *precisely because of the loss*. But this kind of vision, experienced (if at all) only by the newly-born child, or by those suffering from certain forms of brain damage, is not what most of us experience as or mean by 'vision'.

Even the fact that in a seemingly immediate vision of the tree I am inadvertently *composing* it and situating it by fusing two retinal impressions is something that Merleau-Ponty treats as significant with regard to the role of the choosing mind in what we term 'vision':

> Comme j'ai deux yeux, je devrais voir l'objet double, et si je n'en perçois qu'un, c'est que je construis à l'aide des deux images l'idée d'un objet à distance. (*PP*, 42)

Depth is surely a component of visual perception, but while we may associate vision with the functions performed by the eye, we cannot say that the apprehension of depth is managed by the eyes alone. Merleau-Ponty reminds us of this with reference to classical theories of perception:

> [...] Berkeley montre qu'elle saurait être donnée à la vue faute de pouvoir être enregistrée, puisque nos rétines ne reçoivent du spectacle qu'une projection sensiblement plane. (*PP*, 294)

The role played by a brain in apprehending depth may be mysterious but it is not in doubt. However, the extent to which a brain becomes creative in other ways in order that vision may occur is more difficult to assess. Among these, memory, in particular, has long been a matter for debate. Merleau-Ponty is satisfied neither with the idea that perception is nothing but memory, nor with the idea that we normally have perceptions that are entirely unaided by memory. This leads him to a criticism of both empiricism and intellectualism:

> L'empirisme ne voit pas que nous avons besoin de savoir ce que nous cherchons, sans quoi nous le chercherions pas, et l'intellectualisme ne voit pas que nous avons besoin de l'ignorer ce que nous cherchons, sans quoi de nouveau nous ne le chercherions pas. (*PP*, 36)

But if Merleau-Ponty is correct in thinking that neither empiricism nor intellectualism could provide him with what he himself is looking for in terms of an explanation of experience, we can perhaps express his position simply by saying that memory is necessary but not sufficient for a perception. Generally, however, Merleau-Ponty appears to be alternating between remarks that suggest memory is both necessary and sufficient for perception – 'Mais en réalité je ne saurais pas que je possède une idée vraie si je ne pouvais par la mémoire relier l'évidence présente à celle de l'instant écoulé [...]' (*PP*, 49) – and remarks that suggest that memory is neither necessary nor sufficient for there to be perception:

> Ainsi l'appel aux souvenirs présuppose ce qu'il est censé expliquer [...]. Au moment où l'évocation des souvenirs est rendue possible, elle devient superflue, puisque le travail qu'on en attend est déjà fait. (*PP*, 27)

In a sense, we are being deliberately awkward if we do not recognize that the kind of memory Merleau-Ponty is discussing in these two extracts is not the same. In the second extract it is implicit that he means that faculty which permits us to match a present impression with one that we recollect from elsewhere, whereas in the first extract it is clearly a more local retention which he has in mind. Should we distinguish between these two forms of recall on his behalf? Or would such a distinction ultimately rest only on a contrasting degree of closeness to remembered phenomena rather than an essential difference between two kinds of recall? At any rate, Merleau-Ponty is coming unstuck, perhaps knowingly, in his attempt to clarify the level of dependency existing between memory and perception.

Take, for example, the following statement:

> Percevoir n'est pas éprouver une multitude d'impressions qui amènerait avec elles des souvenirs capables de les compléter, c'est voir jaillir d'une constellation de données un sens immanent sans lequel aucun appel aux souvenirs n'est possible. (*PP*, 30)

At a glance, Merleau-Ponty appears to be describing two theories of perception, only one of which is correct. But there is a sense in which the second could be a mere explanation of the first. Moreover, his definition of what perception properly involves actually contains a

mention ('c'est *voir* jaillir (my italics)'), of the term that the definition supposedly unpacks. Admittedly, 'voir' and 'percevoir' are not the same word, and indeed, in our everyday speech we are sometimes ready to let 'voir' connote the light which hits our retinas and to let 'percevoir' connote the ongoing decipherment of that light. But since Merleau-Ponty's whole project is to demonstrate that 'voir' and 'percevoir' are inextricably wrapped up in one another, that there exists, indeed, no absolute border between them, we are bound to suspect that in this kind of assertion Merleau-Ponty is allowing 'x' to appear on both sides of the equation. Not that 'x''s appearance on both sides of the equation necessarily amounts to a cardinal sin in the eyes of those who, with Hegel in mind, are prepared to countenance the notion that no sooner is there an impression than there is an impression *of* that impression, so that what the first impression then 'is' is an impression *plus* the material that has gathered around it as time has elapsed.

By 'impression' we understand something immediate. This is true even when, by saying things like 'my impression was…', we are conceding that our vision was partial, was not infallible. We are saying that despite the limitations upon our vision, what vision there was had a certain directness. We are acknowledging the possible interference of our prejudice, our paranoia or our indignation with what we saw and at the same time holding on to the idea that some real contact was made with something. This we call an impression. We often talk about 'immediate impressions' and at the same time we imply that impressions are immediate by their very nature. But if the recollection of an impression is itself a further impression it seems that immediacy is liable to be everywhere and nowhere.

What to count as the 'immediate' in the process of experiencing is truly a vexed question for Merleau-Ponty, as it had been for Husserl, Kierkegaard and Hegel. It is implicit, even in the early Hegel, that 'immediate' and 'mediated' are provisional concepts. Kierkegaard recognized with a characteristic touch of irony, that 'the mediated' in consciousness could equally be termed a 'later immediacy'. Husserl's views underwent (appropriately enough) constant modification throughout his career. Merleau-Ponty is often reluctant to concede that we can have a pure immediacy:

> Platon accordait encore à l'empiriste le pouvoir de montrer du doigt, mais à vrai dire même le geste silencieux est impossible si *ce qu'*il désigne n'est pas déjà arraché à l'existence instantanée et à l'existence monadique, traité comme le représentant de ses apparitions antérieures en moi et de ses apparitions simultanées en autrui, c'est à dire subsumé sous une catégorie et élevé au concept. (*PP*, 140)

Would he accept, however, that what we have *instead* of the immediacy that had been envisaged and hoped for is now, and as a consequence of the disappointment, *that which ends up getting called immediacy*? For it does seem, in Merleau-Ponty as much as in Hegel, that immediacy proper – despite its association with the present – is always what there once was, rather than what there is now:

> l'identité à elle-même, cette plénitude et cette positivité que nous lui avons reconnues, excèdent déjà l'experience, sont déjà une interprétation seconde de l'expérience. (*VI*, 214)

Merleau-Ponty uses the analogy of the burned out star whose light still reaches the earth years later to express the delay in all perception, though it must be said that he is perhaps being careless when he associates this specifically with *memory*. After all, the light of the star, however 'late' it may be, is always reaching us for the first time. In memory it is not quite the same. For even if there is a first instance of remembering a given thing, the thing itself is not what is 'new' here, but only the fact of its being recalled. To be sure, there is a form of delay in all perception, but this is not what Merleau-Ponty is trying to capture with his starlight analogy, which is just as well, for in that case the starlight would not be an analogy at all, but a real instance. In recollection, on the other hand, the delay is a distance between two points *within the perceiving subject*, and so again the starlight analogy does not quite fit. We really do not have the star until the light gets here. The poetic claim that all perception is but the memory of existence – Merleau-Ponty occasionally touches on this notion – becomes valid only to the extent that the world as such can be conceived as mind, or as the mind of God, which of course it has been for some idealist thinkers. But even Hegel only allowed that matter was mind that had yet to come to know itself. That this may also mean taking matter to be absolute mind's memory of itself does

not help Merleau-Ponty here. Berkeley's world, by lacking extension, would not have permitted impressions of things to be at the same time memories of them, even if – and just because – God is to be the content of everything.

Moreover, even within a subject, it could be reckoned that certain recollections, say those of Proust's *mémoire involontaire*,[3] though they may express a distance between two points, amount to a real transporting of the mind to another 'place', and to that extent constitute – perhaps more than anything else – the condition of living immediately. To be sure, we may say that a particular scent takes us back to a time, but it could equally be said that *it*, the scent, or better still the sense – the intuition – of a scent which almost seems to emerge in the imagination without the help of the olfactory nerve, *comes forward* to a time. This would certainly be so in cases where we smell something for the first time and yet – for what reason we cannot tell – we are instantly overcome with an imagining of what it would be like to be a person for whom this was an evocative smell. That would certainly be the scent coming forward – able to come forward only because it has been artificially pushed back by consciousness, a recollection of sorts but of a subjunctive kind.

New things, then, can pretend to be old things, but it is not always that way round. Sometimes, when we are remembering a thing, we are also remembering the whole feel of its novelty, remembering the very sense of its status as a first impression. We cannot always equate memory with latency. A recollection can *arrive on time* in a way which the object hitting my retinas may not. My first impression may be late (as with the starlight), but my revisitation of it need not be because the object is *all in the revisitation*.

So far we have been reflecting and conjecturing from within fairly conventional assumptions about what subjectivity involves. Merleau-Ponty would question some of the above remarks on the grounds that no absolute distinction obtains between the object which hits my retinas and the object I would wish to recollect in some atemporal inner life. Much of his criticism of Husserl, a philosopher on whom he was undoubtedly an expert, appears to carry the

3 Proust was a source of constant inspiration to Merleau-Ponty. Throughout *Phénoménologie de la perception* Merleau-Ponty refers to him.

suspicion that Husserl indulges a nostalgia for the inner life. But Husserl's transcendental ego may not have been as thoroughly usurped by later conceptions of subjectivity's nothingness as the exponents of this latter position suppose.

The zeal of a phenomenologist who wishes to avoid at all costs any suggestion that a noumenal in-itself has been envisaged or invoked will at times precipitate a falling back into what Husserl called the 'natural attitude' at the very moment when epistemic scrupulosity is supposedly holding sway. So eager is phenomenology to acknowledge the limitations upon what can plausibly be described or discussed, that it allows 'object' to be substituted for 'appearance'. The implied equivalence between the two terms emerges from phenomenology's wish to remind itself that any mention of a term like 'object' can only ever call forth something that is *an object for me*. In much of Merleau-Ponty's writing, 'object' may be read as a shorthand for 'intentional object' (though it is understandable that the debt to Husserl is not something Merleau-Ponty himself would wish continually to be signalling, *especially* at those points where his own policies and initiatives stand in only slight contrast to those of Husserl, and there is thus a greater risk of an uneasy coalition of doctrines). 'Il est bien vrai que nous percevons la chose même, puisque la chose n'est rien que ce que nous voyons [...]' (*VI*, 50). The suggestion that 'object' and 'appearance' are interchangeable may be provocative but it is made in good faith. It actually points to an eventual jettisoning of 'appearances' since this very term – though we may have imagined it to be the watchword of phenomenology – evokes a classical theory of perception whose separation of thing and appearance phenomenology, fundamental ontology and particularly Maurice Merleau-Ponty's version of being-in-the-world, take themselves to have repudiated. By 'classical theory of perception', at least as far as concerns Merleau-Ponty, we may understand a body of thought that draws on Plato, and typically the eighteenth-century German Idealist models, such as the Kantian one. Schopenhauer can be viewed as having inhabited a classical paradigm of sorts, in this respect at least. Among those who have assailed the notion of representation, and particularly the notion of truth as the 'agreement'

of a representation with the thing represented, is Heidegger, who asks about the ontological status of such 'agreement'.[4]

The remarkable prominence of the word 'object' in the context of phenomenological enquiries into subjectivity can be explained in other ways. But for the moment it is enough to say that the substitution of which we have spoken is a function of the understandable wish to speak only of what is visible. 'The visible' can be taken to encompass the imagined, at least for some of the time, in Merleau-Ponty, *provided* the imagining has content. So, for example, Maurice Merleau-Ponty is sitting in his room and though he does not see the Pont de la Concorde with his eyes it is nevertheless a vision for him. However, this immense preoccupation with the visible generates significant problems for Merleau-Ponty when, along with Sartre, he mounts a critique of Husserl's transcendental ego and replaces it, in *Le Visible et l'invisible*, with 'nothingness', as Sartre had done in his *L'Être et le néant*. To say 'replaces' is perhaps crude; if it was merely a matter of replacing one part of the phenomenological map, leaving everything else in place, it would, by that very fact, be a trivial amendment that was taking place.

The complaint against Husserl is this: eidetic intuition (the 'reduction' of an envisaged entity to an *eidos*, an essence, to the point beyond which further subtraction of features would destroy the object) should be the basis of all our knowledge and is said to be necessarily prior to the investigations of science, and yet, for all the proclaimed rigour of this procedure, the eidetic reduction cannot count itself in amongst those essences whose intuition is meant to be so fundamental. By proposing that the basis of subjectivity is 'nothingness', Merleau-Ponty is implying that the transcendental ego was not already that, or not already *possibly* that. But since the transcendental ego (Husserl's rational, time-conscious, world-transcending identity – to be distinguished from the *psychological ego*) is something that gets posited after, and as a consequence (though not necessarily an entailment) of, the eidetic reduction, may

4 See for example Martin Heidegger, *Being and Time*, trans. by John Macquarrie & Edward Robinson (London: SCM Press, 1962), p. 246, and especially pp. 258–260 ('Is this agreement Real or ideal in its kind of Being, or neither of these?').

we not attribute to Husserl some sense of its negativity? To be sure, the fact that the transcendental ego has been negatively defined cannot be taken as a reason for imputing to Husserl the belief in its ontological negativity. But the extent to which Husserl's residual Cartesianism has supposedly gained the upper hand with him can be over-emphasized, and we may be doing Husserl a disservice if we assume that the transcendental ego's negative construction (after the description of all other 'regions' of existence) is tantamount to its having been simply posited.

At any rate, if the dissatisfaction with Husserl's phenomenology is that the *epoché* (the provisional putting out of service, the temporary setting aside of our pragmatic assumptions about the existence of the seen) was administered by an agent whose invisibility did not prevent it from having an implicitly thing-like status, it is hardly a foregone conclusion that Sartrian nothingness or the nothingness of the late Merleau-Ponty are above criticism on that front. This is possibly because in its search for something better, phenomenology's second generation found inspiration further back in time. The disenchantment with Husserl's transcendental ego catapulted Sartre and Merleau-Ponty into the arms of another teacher out of whose shadow it is, arguably, much harder to venture: Hegel. And of course, in Hegel nothingness is such a vigorous protagonist; it is the very motor of history. In Hegel, 'something' can be very engaging and is certainly not to be sneezed at, but the feats of which *nothing* is capable defy all imagining and quite take our breath away. If the influence of Hegel's *Being-for-itself* does not exactly account for the atmosphere of presence accompanying existentialist remarks about the nothingness of the *pour-soi* then at least they may help to explain why it is that twentieth-century French nothingness tends to go about with the intrepid spirit of the hero from a Diderot novella. (Hegel admired Diderot immensely and took the latter's *Neveu de Rameau* as offering paradigmatic cases of the adventures likely to be undergone and the deceptions likely to be engineered by the *for-itself* that is Mind.)

However, what certainly does contribute to this mysterious sense of presence, what surely must lead us to suspect that 'something' has been smuggled in disguised as pure emptiness, is Merleau-Ponty's

keen wish to distinguish his own conception of nothingness from the 'nothing' which is left over by the psychological behaviourists, neurological determinists, the cognitive psychologists and anybody else who might subscribe to the notion that we are all ultimately nothing more than sets of complex responses to stimuli. Merleau-Ponty and his exegetes may habitually contend that these various schools offer nothing in the way of an explanation of that much talked-about *radical experience of subjectivity*, but if that is really what they are offering, *nothing*, and if the existentialists' version of *nothing* really has *nothing* to hide, then surely they should all be in happy agreement, should they not? Unless, of course, there are different types of nothingness. It is at this point that we begin to understand why it has been put to Sartre and whispered to Merleau-Ponty that a latent dualism is occasionally at work in French existentialism's dissection of subjectivity, its proclaimed adherence to Heideggerian being-in-the-world notwithstanding. Ironically, nobody appears so alert to the problem as Merleau-Ponty himself:

> Il y a dans la pensée du négatif un piège: si nous disons qu'il est, nous en détruisons la négativité, mais si nous maintenons strictement qu'il n'est pas, nous l'élevons encore à une sorte de positivité, nous lui conférons une sorte d'être, puisque de part en part et absolument il est *rien*. (*VI*, 96)

But it is arguable that none of this would ever have happened had the French thinkers not been so taken with visibility as the guarantor of being. Had they allowed for the possible existence of that which cannot be seen, they could have modified the Husserlian system without upbraiding its author. Even Kant, after all, left plenty of room for being to be the being that it is or, more to the point, might be. Kant, it must be said, though, made an ingenious manoeuvre – not entirely disanalogous to the ones we have been discussing – when he took the invisibility of the noumenon I am as the starting point for an affirmation of my freedom.[5] (For him this was perfect; he had already argued in the first *Critique* that time, space and, most importantly for present purposes, *causality* could only, as categories of the understanding, concern phenomena.) Indeed, just as Kant used his

5 *Critique of Practical Reason*, Immanuel Kant, trans. by Lewis White Beck (New York, 1993), p. 68.

claim that my will is not phenomenal (that it is, rather, the only noumenon that I shall ever 'have') to show that I am free (since causality concerns only phenomena), so the modern existentialists took advantage of the fact that what they found at the bottom of the perceiving subject was 'nothing'. This, curiously enough, was taken as demonstration that we are free, since only a thing can be determined. At this point, nothing is at liberty to behave as it pleases. Sartre is very Kantian in this way and indeed, all this is slightly more characteristic of Sartre than of Merleau-Ponty, or at least, of the early Merleau-Ponty. The Merleau-Ponty of *Le Visible et l'invisible*, however, does exhibit the tendency to take for granted that consciousness is a nothingness *because it takes something away*. Of the things in the world he says:

> Les comprendre, c'est les suspendre puisque la vision naïve m'occupe tout entier, et que l'attention à la vision qui s'y ajoute retranche quelque chose de son total, et surtout puisque comprendre c'est traduire [...] (*VI*, 58)

But even if we grant that to grasp an object is to remove something from it, this alone does not show that consciousness is a vacancy. 'From it' means precisely *from the object*. Even if consciousness, in being occupied by an object, *also* relinquishes something of itself as possibility, that again does not prove its nothingness, since nothingness is only what there supposedly could have been *before* such an occupation. Merleau-Ponty himself argues that we do not see the disappearance of phenomena; we see the things that replace what is now absent (*PP*, 267). It is as if Merleau-Ponty takes for granted that we are whatever Being is not. And because we *are* not the objects we see, we do not, Merleau-Ponty suggests, have real 'access' to them. Now, while it may be true that 'complete access' is a self-negating concept, since the accessor would have then become co-extensive with the accessed, this only shows that 'access' will by its very nature be partial, not that all access is forbidden, and that we are therefore nothing as Merleau-Ponty seems to suggest here:

> Un immédiat perdu, à restituter difficilement, portera en lui-même, si on le restitue, le sédiment des démarches critiques par lesquelles on l'aura retrouvé, ce ne sera donc pas l'immédiat. S'il doit l'être, s'il ne doit garder nulle trace de

> nos opérations d'approche, s'il est l'Être lui-même, c'est qu'il n'y a de nous à lui, nul chemin, et qu'il est par principe inaccessible. (*VI*, 162)

Besides, it is not as if the television ceases to exist because it pictures things that are not inside it. The reasoning above is problematic. The argument is not illogical, but it is circular. The 'c'est' in 'c'est qu'il n'y a de nous à lui, nul chemin' amounts to the positing of a mere equivalence between a pure access to Being and no access to Being. No deduction is being made here. If Being counts as that which is inaccessible by definition, does that not mean that the game is up from the start?

One can of course go to the other extreme and maintain that Being is everywhere (so that Being would encompass our perspectives, operations, mediations and secondary reflections as well as further reflections on these latter and so on). It looks as if Being will have to be either everywhere or nowhere. However, Merleau-Ponty will not allow Being to be everywhere; he feels that this would be to deny consciousness: 'Il faut que vienne au monde une absence d'être d'où l'être sera visible, un néant' (*SNS*, 115). It is as if Merleau-Ponty is assuming that consciousness must be a vacuum in order, as it were, to *make room* for the objects that are in the world. But the objects that are in consciousness were never the same, or at least never the same *parts* of the objects that might be in the world (so not the same in the sense that in the world the left hand side of a thing is not the same as the right hand side; the thing in my vision – literally *in* my vision – may be a real concrete attribute of the thing as such, let us say *the thing as a whole*, part of its real history and so on (even if there is considerable 'distortion'), but it is not all there. Much of it is, as Husserl would say, 'emptily intended', though curiously enough even these empty intentions may count as part of the object's reality through time – but that is another story). The argument that consciousness must be judged vacant in order, precisely, to explain why it is *not* vacant would seem ham-fisted.

Hegel's negativity denotes becoming or labour; Merleau-Ponty's willingness to make himself the advocate of existentialism's move to requisition the Hegelian concept may not be auspicious. For in *Sens et non-sens* at least, nothingness tends to get presented as a static readiness of consciousness rather then an implied logical principle. It

is as if consciousness would be poised at some starting line *before* the appearance of the things. This is strange because elsewhere Merleau-Ponty, and *especially* Merleau-Ponty, would be quick to insist that the appearance of the things *is* no more and no less than what consciousness may be defined as.

That said, consciousness is often more than the straightforward matter of an encountered exterior, according to Merleau-Ponty. The likelihood that encountering is just what constitutes a distinction between outer and inner makes that kind of summary quite empty. For Merleau-Ponty, subjectivity will not be a doomed protagonist strapped into a recalcitrant body whose gestures perpetually fail to convey some true inner self 'correctly' to others. Instead of this, consciousness would be an interaction; we act with our minds and understand with our bodies. Merleau-Ponty criticizes the idea that there is a pure introspection which could amount to some kind of special access which I have in relation to myself:

> Si j'essaye d'étudier l'amour ou la haine par la pure observation intérieure, je ne trouve que peu de choses à décrire: quelques angoisses, quelques palpitations de cœur, en somme des troubles banaux qui ne me révèlent pas l'essence de l'amour ni de la haine. (*SNS*, 93)

Merleau-Ponty has a strong case here. For even if it were objected that the witnessing of various 'symptomatic' behaviours on the part of another person would not lead to an absolute proof of their loving or hating, Merleau-Ponty could retort that a similar inconclusiveness of the evidence could not be averted in the case of what is called introspection. Yes, I might not know for certain that the other person is angry, but does the extra information I have about myself really assist me in ascertaining that *I* am definitely angry? And this is just the point: what we are talking about here is merely 'extra information'. It may be true that I do not have the 'pangs' that the other has, and that he does not have the 'pangs' that I have. But the difference is not qualitative. We deal here with distinct *amounts* of sensory data. This does not force us to deny the much talked of 'irreducibly subjective nature' of my pangs. For we never claimed that the sensory data concerning the other person, my witnessing of his behaviour, my collation of those possible symptoms of his anger was

not *also* 'irreducibly subjective'. His anger, in the form of a red face, is given to me via my eyes; my own is given to me, perhaps, by the feeling that my blood is racing. But both experiences can be called subjective.

These are things than we can say while remaining agnostic about what the subjective really is, while being undecided, even, as to whether it exists. My subjectivity may well exist, but it is not *demonstrated* to me with a definitive assurance that is somehow lacking in my apprehension of *his* subjectivity, simply because I can feel my pangs. To be sure, he does not have my pangs, but there are things about *me* to which he has access and I do not, such as a vision of the back of my head, or the things I talk about in my sleep. It is not as if he should then conclude that he has some special *kind* of access to my existence. The difference between what I know about myself and what I know about him is not, at this stage at least, a different kind of difference from the one between what I can see about him – he who is standing close by – and what I can see about another person who is walking on a hilltop a long way off.

> Il nous faut rejeter ici ce préjugé qui fait de l'amour, de la haine ou de la colère des 'réalités intérieures' accessibles à un seul témoin, celui qui les éprouve. (*SNS*, 94)

Merleau-Ponty's argument is not ignorant or forgetful of the fact I might successfully conceal, say, my anger, but he would contest the idea that this anger is in an essential way a sovereignty of the subject, and that this may be deduced from this concealment, which is, on the contrary, a mere contingency. Just as we would give little credence to the notion that a chest of treasure counts as an inner reality because I can bury it in a secret place, so Merleau-Ponty enjoins us to give slight regard to the notion that 'psychic facts' are constitutive of what is singular and irreducible in subjectivity. There is no radical difference between pangs and visions, for Merleau-Ponty, no qualitative distinction between thought and feeling. Pangs may hurt me, but so might visions. Or, pangs may be *the way* a vision comes to me. I may not be able to feel another person's pain, but only in the way that my left hand may not be able to feel the pain in my right hand. The fact that what I feel is not identical with what the other

person is feeling, does not mean that I *merely observe* their pain. I may experience a pain of my own as a result of their pain. The observation may come in the form of pain. Merleau-Ponty writes:

> [...] et si nous faisons paraître la pensée sur une infrastructure de vision, c'est seulement en vertu de cette évidence incontestée qu'il faut voir ou sentir de quelque façon pour penser, que toute pensée de nous connue advient à une chair. (*VI*, 191)

Remarks like these promise to undermine or at least make problematic the Kantian distinction between the sensuous and the intelligible. And when Merleau-Ponty tells us that 'le corps sent le monde en se sentant' (*VI*, 158), we begin to develop the sense that life is neither here (in a subject) nor there (in a world), something which contrasts with what Merleau-Ponty regards as our ordinary inclination to treat life as *either* here *or* there. Merleau-Ponty encourages us to reject what he calls:

> les préjugés séculaires qui mettent le corps dans le monde et le voyant dans le corps, ou inversement, le monde et le corps dans le voyant, comme dans une boîte. (*VI*, 182)

Vision is like a merging of ourselves with the things. We are a way in which the world sees itself. Of Cézanne Merleau-Ponty writes: 'Le paysage, disait-il, se pense en moi et je suis sa conscience' (*SNS*, 30). Merleau-Ponty also makes reference to the fact that many painters feel themselves to be *looked at by the things* (*VI*, 183). In a sense, vision may be a kind of going-to-and-fro between subject and world 'de sorte qu'il faut dire que les choses passent en nous aussi bien que nous dans les choses' (*VI*, 165), but only to the extent that subject and world thereby become ambiguous terms, and Merleau-Ponty warns us away from the philosophy which is 'oscillant de l'une à l'autre, disant tour à tour que ma vision est à la chose même et que ma vision est mienne ou "en moi"' (*VI*, 49). The idea that we have a tendency to bounce to and fro between what we take to be 'world' and what we take to be 'self' is one Merleau-Ponty traces back to Pascal and Montaigne. In *Signes* he writes of Montaigne:

> Pour lui comme plutard pour Pascal, nous sommes intéressés à un monde dont nous n'avons pas la clef, également incapables de demeurer en nous-mêmes et dans les choses, renvoyés d'elles à nous et de nous à elles. (*S*, 251)

But if Merleau-Ponty seems at times to be lamenting the fact that consciousness finds a resting place neither *here* in the subject, nor *there* in the world, and if there is at times the suggestion that both this 'here' and this 'there' are imaginary, it is also the case that he takes this restlessness to be inevitable.

> Le visible autour de nous semble reposer en lui-même. [...] Et pourtant, il n'est pas possible que nous nous fondions en lui, ni qu'il passe en nous, car alors la vision s'évanouirait au moment de se faire, par disparition ou du voyant ou du visible. (*VI*, 173)

In this chapter I have tried to show that Merleau-Ponty's account of perception as nothingness is questionable and that he himself provides many of the possible objections. Merleau-Ponty is at his most persuasive, it seems to me, when he presents vision as being situated neither 'here', in a subject, nor 'there' in a world. Indeed, he often seems to be steering us *away* from the conception of nothingness as the key idea for perception. Certainly, when he writes about Pascal, Merleau-Ponty is often apparently under the spell of Sartrian teaching:

> En face du monde des objets ou même des animaux qui reposent dans leur nature, la conscience est creuse et avide: elle est conscience de toutes choses parce qu'elle n'est rien, elle se prend à toutes et ne tient à aucune. (*S*, 252)

However, he occasionally aligns nothingness with a conception of subjectivity he implicitly intends to leave behind:

> Le visible ne peut ainsi me remplir et m'occuper que parce que, moi qui le vois, je ne le vois pas du fond du néant, mais du milieu de lui-même, moi le voyant, je suis aussi visible [...] (*VI*, 152)

Now in the last part of this extract it could well be that Merleau-Ponty is not writing specifically about my being seen in the sense of being fixed by the other's gaze (though of course he is not uninterested in this theme). Rather, when he says 'moi le voyant, je suis aussi visible', he means that 'to see' is *transitive in two directions at once*.

It could be that he means I am seen in the sense that I am *subjected* to the vision I have. And in that sense, that sense of being *subjected*, I am the *object* of a vision. I am seen by the things in the sense that in relation to them I am an *acted upon* as much as I am an actor.

With Merleau-Ponty we are being invited to understand our lives as ways in which the world sees itself. There is a kind of validity in all apprehension, however far-fetched an apprehension might seem. However misguided an ensuing assertion might be, there is always something true *about* it, if one knows where and how to look. Concretely, even a wrong assertion points to some impingement on the asserter of that part of the world about which something is being asserted. Pascal lamented that we constantly live through the eyes of others,[6] but when Merleau-Ponty claims that we are literally what others think of us (*PP*, 124), he is saying that there is a sense in which we are not misled when we live through the eyes of others, since the future exists and the perception of us by others is, really and truly, the world with which we must reckon.

Merleau-Ponty's contention, furthermore, that our being is like an instrument upon which the other plays (*VI*, 27) can be understood in the following way: even the conveying of something that *is* the case is an impingement upon, or a subtracting from, the consciousness of another, and requires a certain amount of manipulation. Telling the truth is a manipulation of sorts. As soon as there is communication, the Other is partly in us and we are partly in the Other. Our total being is neither here nor there. But now we are moving beyond the discussion of perception and vision pure and simple into a consideration of how living subjects see and 'become' one another, a topic with which Merleau-Ponty was intensely preoccupied, as the glowing tribute paid to him by none other than Emmanuel Levinas will confirm.[7] This, of course, must be saved for another occasion. What I have offered above is really just the very beginning of an account of Merleau-Ponty's work on vision and perception, and an

6 See the section in Pascal's *Pensées* (Paris, 1962) entitled 'Misère de l'homme: les puissances trompeuses', and within that, the forth section entitled 'L'amour-propre' (pp. 77–83).

7 See *Hors Sujet*, Emmanuel Levinas ([Fontfroide-le-Haut]: Fata morgana, 1987), p. 148.

imperfect one at that. But an imperfect beginning is better than nothing and if the reader has now been encouraged to go and discover, or perhaps to go and re-discover Maurice Merleau-Ponty, then this chapter has served a good purpose.

Suggested Reading

Martin Heidegger, *Being and Time*, trans. by John Macquarrie & Edward Robinson (London: SCM Press, 1962)

Immanuel Kant, *Critique of Practical Reason*, trans. by Lewis White Beck (New York, 1993)

Emmanuel Levinas, *Hors Sujet* ([Fontfroide-le-Haut]: Fata morgana, 1987)

Maurice Merleau-Ponty, *Phénoménologie de la perception* (Paris, 1945)

—— *Sens et non-sens* (Paris, 1948)

—— *Signes* (Paris, 1960)

—— *Le Visible et l'invisible* (Paris, 1964)

Part 2

The Surrealist Gaze

STAMATINA DIMAKOPOULOU

On Seeing in Surrealism: Max Ernst's Objects of Vision

Much Post-Structuralist thought in criticizing transcendental subjectivity has also criticized the role of seeing as a primary instrument of mastery of both self and world: Foucault, for instance, turned to the links between sight, knowledge and power.* Drawing on Sartre, Nietzsche and Bataille, he showed how 'anti-ocularist' discourses opposed historical structures of domination. As Martin Jay points out, Foucault redeemed the visual only as antidote to 'the alleged coherence of linguistic systems', while he 'resisted exploring' the possibilities of the 'reciprocal', 'intersubjective' glance against the disciplinary power of the gaze.[1] In more general terms, the Post-Structuralist critique of representation sought its antidotes inside the realm of discourse: as discourse is all there is, its inconsistencies or blind spots may be the only catalysts for breaking through language.

Both the negation and the redemption of seeing as a form of knowledge are at stake in Surrealism: in his analysis of the critique of vision in contemporary French culture, Martin Jay, describing Surrealism's ambiguous involvement with vision, asks whether 'the Surrealist search for new visual experience, for what may well be called visionary redemption, paradoxically contribute[s] to the crisis of ocularcentrism'.[2] This 'paradox' also involves the recent debate on Georges Bataille's break from Surrealist orthodoxy in the late twenties

* I would like to thank Tim Mathews and Ayman Salem for their help and criticism.
1 Martin Jay, 'In the Empire of the Gaze: Foucault and the Denigration of Vision in 20th Century French Thought', in *Postmodernism*, ed. by Lisa Appignanesi. (London: Free Association Books, 1989), p. 72.
2 Martin Jay, *Downcast Eyes The Denigration of Vision in Twentieth-Century French Thought* (Berkeley and London: University of California Press, 1993), p. 236.

and thirties: Bataille's critique of seeing and of the subject as agent of vision seems to have anticipated the most thorough Post-Structuralist attacks on representation. On the other hand, Surrealist orthodoxy, generally identified with André Breton's thought, resisted negating subjective categories altogether and sought its critical correctives in the category of the object.

In what follows I will turn to Max Ernst's work during the twenties and thirties to see how Surrealism's links to the fundamental categories of modernity on the one hand, and to Post-Structuralist concepts on the other, take on a pessimistic, negative character: immersed in representation, the Surrealists sought catalysts for a break from the Symbolic both inside and outside it. Ernst, for whom '"Voir" était ma préoccupation première', engaged with the relations between seeing and being seen, the subject and the object of vision. Sharing the Surrealist critique of subjective rational faculties, he sought the disruptive potential of objects, real or imagined: explaining in a tongue-in-cheek manner why collage is an appropriate way to face the world as a whole, he wrote that in collage, 'on s'insurge ainsi contre les rapports, les fonctions et l'échelle hiérarchique entre les objets. On fustige le monde en renversant l'ordre qu'il avait établi entre ses produits'.[3] Yet although he expressed the wish to recover a more reciprocal relationship between the viewing subject and the objects of perception, his work leaves us with a fundamental ambivalence as to the outcome of the subject/object conflict inside and outside representation. Famously, he spoke of his dissatisfaction with realist representation in the following ironic incident: in his *Notes pour une biographie*, he reminisces how his father, teacher of sign language for deaf-mute and an amateur painter, suppressed a tree in one of his paintings because it disturbed the composition. He writes:

> Si ton arbre t'agace, arrache-le et jette-le. Philippe [Ernst's father] se décide à éliminer l'arbre du tableau. Mais non content de supprimer l'image de ce détail dans son tableau, il se précipite au jardin pour y arracher et détruire l'innocent arbuste qui a offensé son sens de la probité dans l'art.[4]

3 Max Ernst, *Écritures* (Paris: Gallimard, 1970), pp. 12, 34.
4 Ibid., p. 16.

Ernst's irony targets his father's will to correct reality and his faith in the identity between reality and representation.

As Ernst's father resorted to violence for the sake of identity, Ernst, in his own work, posited violence as able to reveal the discrepancy between the real and the represented. One is as arbitrary as the other, and this also allowed Ernst to destabilize the dichotomy of the seen and the unseen. As we shall see, violence does not only sustain a representational system like his father's, but also exposes its repressive aspects. Rather than affirming the subject's mastery over the world, violence in Ernst disempowers the seeing subject.

Sight in Ernst involves the effect of the object on the subject: the subject's coherence is shattered by the incursion of objects that are not identical to mental images or to concepts. Ernst recalled how in discovering a supplier's catalogue of teaching aids in 1919, the absurdity of the taxonomic principle upset both his intellect and sight:

> leur accumulation trouble son regard et ses sens; suscite des hallucinations et donne aux objets représentés des sens nouveaux qui changent rapidement. Max Ernst sent ses 'facultés visionnaires' si soudainement accrues qu'il voit apparaître sur un fond inattendu les objets qui venaient de naître.[5]

It is not only the cumulative effect that is disconcerting, but the fact that any object bears both manifest and hidden contents in a manner that undermines rational categories. The contents of the world and the contents of the unconscious mind bear no fundamental differences in kind: individual hallucinations and chimeras take the same forms as objects like the tree in his father's garden. Similarly, the faculty of vision and the power of mental speculation on the one hand, and irrational visionary faculties on the other, come to the aid of objects, real or imagined. In such instances, visual perception affects the constitution of both subject and object. it is this reciprocal effect that may or may not result in more equitable, non-hierarchical relationships.

Ernst's involvement with various techniques aimed at the external and latent properties of objects in order to eliminate fixed subject/object positions in seeing. The claim he makes of his

5 Ernst, *Écritures*, p. 31.

technique of rubbing with a pencil against textured surfaces is also valid for his collages: 'la technique de frottage n'est rien d'autre que le moyen de porter les facultés hallucinatoires de l'esprit à ce dégré où les "visions" s'y imposent automatiquement; c'est un moyen de se délivrer de l'aveuglement.'[6] Moreover, the actual act of cutting and pasting in collage is also a metaphor of the violence underlying our relation to the realm of commodities. The attractiveness of commodities lies in the effacing of all traces of the process of their making. Ernst sought to turn the most fundamental aspect of the commodity against itself: the seamless appearance of the collages is undermined by the incongruity between objects brought together in the most unpredictable contexts. Their forced coexistence is also emphasized through dissonance in scale.

Moreover, a certain mode of seeing (not only cutting and pasting) brings about such effects and regulates our relations to objects. Following Rimbaud, he tells us that the collage is 'LE MIRACLE DE LA TRANSFIGURATION TOTALE DES ÊTRES ET OBJETS AVEC OU SANS MODIFICATION DE LEUR ASPECT PHYSIQUE OU ANATOMIQUE'.[7] Ernst's optimism that a 'total transfiguration' may occur without any physical traces of change is not dissimilar to his hope that non-hierarchical relationships would abolish and transcend cultural divisions, the linguistic disjunction of signifier and signified, and the duality between the identical and the different in representation. Sitting ambivalently between process and product, his collages represent and aspire to such transfigurations. In the terms offered by the Surrealist ethos, the arbitrary relations between objects brought together in the collages are also a metaphor of how all processes are open to chance.

His first collage-novel *La Femme 100 Têtes* (1929) bears the marks of the tension between fragmenting, yet culturally cohesive 'visions' on the one hand, and juxtapositions expected to restore a sight capable of 'total transfigurations' on the other. It consists of 147 plates where Ernst pasted cut-outs from nineteenth-century illustrated popular novels. Instead of inserting fragments of reality into drawings or paintings, he takes on the practice, common to serialized popular

6 Ibid., p. 50.
7 Ibid., p. 253.

novels, of including pictures accompanied by captions. The cut-outs are seamlessly pasted onto whole pictures and their intrusion may be menacing, enigmatic, passive, inflicting and inflicted by violence.

Reminiscent as they are of Lautréamont's famous encounter of the umbrella and the sewing machine on the dissecting table and its effect of *dépaysement*, Ernst's collages are in a state of suspension. The actual 'transfiguration' or its effect are not always visible and there is no clear distinction between cause and effect. Similarly, the suspended moment and its aftermath are not sequential: they coexist. The 'novel' is populated by female torsos, neoclassical statues in varied poses, human bodies, dead or in trance-like states, strange beasts, archbishops, optical and other mechanical devices, either in motion or oddly unperturbed. The backgrounds are as varied as the pasted objects and the figure/ground distinction has no interpretative consequences as it seems that contexts and objects are unaffected by, even unaware of each other's presence; in Ernst's collages, passive and active elements are reversible as it is ambiguous who acts and who is acted upon. Therefore, backdrops as varied as nineteenth-century interiors, laboratories, natural or urban spaces, in states that range from uncanny stillness to apocalyptic cataclysms, may haunt and be haunted by the 'figures'. The collages involve both the 'seen' and the projected, the unseen and the invisible, matter and concept: organic and inorganic, mechanical and natural elements arrest each other in a convulsion which disturbs the Symbolic. Yet Ernst leaves equally ambiguous just who 'sees' this disturbance.

La Femme 100 Têtes opens and ends with the image of a man descending from an egg-shaped structure pulled with great effort to the ground by two agitated groups of men; or conversely, it may also be that the giant-egg pulls them upwards. The plate is accompanied by the caption, 'Crime ou miracle: un homme complet. Fin et suite'.[8] For either an end or a continuation, there has to be a beginning in the first place and Ernst seems undecided as to whether a 'complete man' is the beginning of things as we know them, or whether the way we know them is actually the way things are. The plates that enclose or open up the 'end and continuation' pursue this ambiguity into the

8 Reproduced in Werner Spies, *Max Ernst: Collage: The Invention of the Surrealist Universe* (New York: Harry N. Abrams, 1991), fig. 272.

realms of what escapes from what we think we know or see, and what actually occurs. This ambivalent sense of elements returning to the Symbolic or attempting to flee away occurs most strikingly in public spaces. On plate 81 there are no explicit effects of violence: we get the hints of conflict and struggle only in the disembodied interlaced figures of the hovering Titans. Ernst writes: 'Tous les vendredis, les Titans parcourront nos buanderies d'un vol rapide avec des fréquents crochets.'[9] This is followed by a restaurant scene on plate 82 where 'rien ne sera plus commun qu'un Titan', followed by 'la tranquillité des assassinats anciens…', '…et futurs', on plates 90 and 91.[10] In the 'tranquility of ancient assassinations' an avenging androgynous figure is about to pierce a human body that has a dishevelled mesh of long hair instead of a head, whereas in the foreground a man teaches a child the language of the deaf-mute. It is unclear whether it is Ernst's past that erupts into a collective unconscious or whether it is the popular imaginary that brings up a personal memory. Either way, where and whether the leap from the Symbolic into the Real occurs remains uncertain. Such is also the case with the 'future assassinations' where the neoclassical idealized female seems just as oblivious to the stabbings that are about to happen in the background as both perpetrators and victims seem unaware of her.

The marks of violence in the flight from the Symbolic become visible and 'experienced' paradoxically when 'la femme sans têtes' keeps her secret, as Ernst puts it in the caption. This she does either at the price of depriving others of the faculty of sight on plates 133–136 or at the price of violent deaths as on plates 140 and 141.[11] Her secret will not be known; only its mark will remain seen or unseen. Seen or unseen, the object is evidence of the existence of the Real: it is irreducible to language alone. Hence the difficulty of preserving such marks without resorting to representation. Moreover, objects that bear such marks can only be perceived as such outside of the Symbolic. Ironically, the dichotomy between the seen and the unseen, the known and the unknown, the manifest and the repressed, the real and the

9 Spies, fig. 319.
10 Spies, figs. 320–22.
11 Ibid., pp. 349–52, 355–56.

represented both generates and represses the need for what may or may not lie beyond them.

The suspended states that Ernst arrests and (re)constructs raise scepticism as to whether these dualities could ever be overcome: looking affects what we see and the seen alters the structure of seeing. Both conscious and unconscious energies are involved: this is why Ernst uses organic and inorganic elements as allegories for the organ of sight alongside scientific instruments and optical devices. Both the objects of vision and the instruments of sight activate processes critical of subjectivity: the recovery of sight necessitates the violation of the cultural contents of vision. Ernst's work bears the conflict of its dual intent, doubly destructive and redemptive. The same goes for seeing: demystifying as it may be, ironically, it undermines as much as it preserves representation. Seeing becomes the threshold between the Real and the Symbolic and the entry or return into either is marked by explicit or latent violence.

In the context of the generalized turn to the object in Surrealism during the late twenties and thirties, Ernst's optimism is more nuanced. Against the modernist tendency to abstract the forms underlying cultural content and use, 'found objects' in Surrealism became repositories of unconscious forces in states of dysfunction and disuse.[12] At the same time, cut off from rational purpose, such objects also reflected the dislocation of subjectivity in modernity. The subject/object antagonism remains unresolved, as does the contested territory between the Real and the Symbolic, the territory par excellence of Surrealist works. As Ernst put it in 1934:

> ils se meuvent librement, hardiment et tout naturellement dans la région frontière du monde intérieur et du monde extérieur qui, bien qu'elle soit imprécise encore, possède une complète réalité ('surréalité') physique et psychique; qu'ils enregistrent ce qu'ils y voient et qu'ils interviennent énergiquement là où leurs instincts révolutionnaires les poussent à le faire.[13]

12 Ernst in his 1934 *Qu'est-ce que le Surréalisme?* opposed Surrealism to abstract art 'qui, au contraire, borne intentionnellement ses possibilités aux actions réciproques et purement esthétiques de couleurs, surfaces, volumes, linges, espace, etc.', Ernst, *Écritures*, p. 232.

13 Ernst, *Écritures*, p. 232.

Figure 6: Ernst, *La Femme 100 Têtes*, plate 90
© ADAGP, Paris and DACS, London 2001
by permission of the Bibliothèque Nationale Française

Figure 7: Ernst, *La Femme 100 Têtes*, plate 133
© ADAGP, Paris and DACS, London 2001
by permission of the Bibliothèque Nationale Française

Figure 8: Ernst, *La Femme 100 Têtes*, plate 140
© ADAGP, Paris and DACS, London 2001
by permission of the Bibliothèque Nationale Française

Yet, as discussed, when a violent act signals a flight from the Symbolic, the longed for liberating effect cannot be maintained. Ironically, although seeing offers glimpses of the Real that disrupt space through time, Ernst also shows how the temporal aspects of violence are ultimately integrated inside the space of representation. Differently put, Ernst seems to be pessimistic as to whether reciprocal relationships can be prolonged either inside or outside language and representation. This is why such liminal experiences occur only in the instance of the eruption of the past into the present.

In Breton's thinking, an impulse similar to that of collage was realized in the principle of objective chance, where seeing the object and laying bare the subject was grounded in a mutual recognition. In seeking the object that would fulfil a projective desire, as Breton and Giacometti set out to do in Breton's 1937 *L'Amour fou*, the Surrealists aspired to overcome culturally-imposed divisions in our experience of self and world so as to restore them on non-hierarchical grounds (to put it in Ernst's terms).[14] Yet while it is only through the object that such a reciprocal relation could be restored, it is also through the object that it is undermined. Ernst's thought, and much Surrealist thought in general, is marked by an anxiety over mobility and fixity in the Symbolic. In recognizing a paradoxical utopianism in their attempt to preserve an unfathomable element in subject/object relations, the Surrealists resist eliminating either category.

It is on the basis of such a utopian pessimism that an affinity between Surrealist and Post-Structuralist concepts can be drawn in retrospect, in the light of the possibility of defeating structures of domination in the Symbolic. Such an intent underlies readings of Surrealist, and in general, anti-modernist work from a Post-Structuralist perspective. Rosalind Krauss sees certain artworks and techniques as revealing rifts between otherwise seamless discourses, reminiscent of Ernst's attempt to mark ephemeral breaks from representation in his collages. Her notion of the 'optical unconscious' points to such possibilities. The 'optical unconscious' is the site of the antagonism between continuity and discontinuity, ruptures and metaphysical closures, slippages over the threshold between the

14 André Breton, *Œuvres complètes* (Paris: Gallimard (Pléiade), 1992), II, pp. 675–785.

Symbolic and the Real. These traces are non-subjective, yet not entirely given over to the object: they are shared between subject and object.

After situating Ernst's work historically and biographically in the context of Freudian theory, Krauss turns to Lacan's work on how the structure of visual perception and sensory experience at large is patterned on the structure of discourse: the unstable links between perception and language, she argues, are anticipated in works such as Ernst's collages. Following Lacan, she says that experiencing something as being simultaneously 'both outside himself and *his* [...] turns this bric-a-brac [the different elements of the collages] into the deictic markers of the subject's own being, the evidentiary signposts that appear to him the indices of his own history, his own identity, the touchstones of his most intimate connections to the real'.[15] Krauss also notes that these 'markers' are 'erected after the fact to commemorate an event that never happened, an encounter whose traumatic effect on him arise from the very fact that he missed it'. Krauss predicates her reading of Ernst on the disruptive potential of 'missed' events, the 'lost objects' that produce the 'gap of the trauma': this gap is 'the already occupied meaning of that opening onto a spatial beyond'.[16] This 'beyond', which is what we normally think of as the determining character of vision, is already filled in by signifiers which can be fleetingly identified with the object of the subject's lack.

Krauss links this 'break in the field of vision' to a 'break from the flow of language', seeing in the marks of both the subject's desire to 're-realize' itself by lapsing from the Symbolic back to the primal, pre-linguistic Real. In drawing this parallel, Krauss opposes a 'space of light' to the culturally-determined spaces of vision and visuality. This 'space of light' is a space outside structures of power, a space of unmediated immersion. Yet in being 'caught within the onrush of light', the subject also 'blocks the light'.[17] The subject can only stay

15 Rosalind E. Krauss, *The Optical Unconscious* (Cambridge MA and London: MIT Press (October Books), 1996), p. 71. Krauss here ambivalently refers both to the Lacanian Real and to the subject's entry into language.
16 Ibid., pp. 71, 72.
17 Ibid., p. 87.

inside the 'picture' at the price of blocking the field of vision and becoming invisible to himself; yet in his inability to see himself, the subject may also miss 'the source of light'. What may become a catalyst of the subject/object conflict is also what preserves the Symbolic.

While these signifiers/lost objects may be disruptive of the existing structures regulating visual and 'Symbolic' relations, as Ernst's work also suggests, the aftermath is as ambiguous and as precarious as the 'gap' that initiated the disturbance in the first place. While Ernst's collages enact such attempts at recovering signifiers 'open' to repressed subjective contents, the gap is never filled. In relation to this, Krauss's optimism leaves us with a fundamental uncertainty: Ernst's collages may well be evidence of the potential of objects which 'inaugurated on the site of that gap of the missed encounter will both mark that spot and attempt to fill it, to produce from its grab bag of readymades the stopgaps presumed by the subject to be made to the measure of his own desire'; but all one is left with is the trace of the temporal break.[18]

In an earlier critique of modernist visuality and its illusions or delusions of pure presence in the dissolution of the physical marks of time in timelessness, Krauss also resorts to a discussion of Ernst's example. In his collages, Ernst criticized the modernist intent, also by turning to modes of seeing in popular culture. Reappropriated and manipulated by the artist, Krauss argues, these modes and their devices may become as critical of the aspirations of high art as they are alienating of the subject's relation to objects in mainstream culture. The optical devices of the late nineteenth century to which Ernst 'returns' in the twenties and thirties show the production and effects of optical illusions.[19] This also, Krauss argues, implicated the viewer who is encouraged to identify and simultaneously distanced. In this instance Krauss refers to plate 34 in the 1930 collage-novel *Rêve d'une petite fille qui voulut entrer au Carmel*,[20] where the 'girl' in a gesture of trance or despair happens to be inside the drum of a

18 Ibid., p. 72.
19 Rosalind Krauss, 'The Im/pulse to See', in *Vision and Visuality*, ed. by Hal Foster (Seattle: Bay Press, 1988), pp. 51-60.
20 Spies, fig. 370.

zoetrope, a cutout from the nineteenth-century popular magazine *La Nature*. Looking through the slits of the zoetrope's drum, a succession of birds are flying while one of them flees outside the drum. Krauss stresses that subject and object are doubly inside and outside the scene and that the two experiences are united in a 'flicker', in a 'beat' or 'pulse'. Yet as in *La Femme 100 Têtes*, it is uncertain whether the girl's intrusion in the drum is intended or accidental and whether she is aware of the bird interrupting the mechanical flight. Krauss stressed how the uncanny effect of repetition disrupts linear time. Yet as argued, Ernst's work raises ambivalence as to whether such disruptions are perceived and whether their effect can be maintained. In allowing for discontinuity, the Symbolic seems to create and assimilate such 'pulses'.

The utopian drive in modernist art is as doubly potent as the twofold alienating and alienated aspects of mass-produced culture. Against either, Surrealist thought is as utopian as it is pessimistic when it comes to the outcome of such ambiguities. In Krauss's description of the subject/object dialectic, conflict becomes synonymous with an impossible unity in discontinuous relations in both space and time. As discussed, in Ernst's work, only through violence, which is irreducible to a spatial movement alone, do the marks of the 'gap' and the failed attempts to fill it become visible. Therefore, the fact that vision is determined by 'the always-already occupied meaning of that opening onto a spatial beyond' is both curative and traumatic, potentially emancipatory but at the same time sustaining the Symbolic.[21]

Ernst shared Surrealism's intent to intensify a generalized crisis in subjective consciousness and knowledge; his alternatives are dissimilar to Post-Structuralist principles at the level of intent, and of the relation between time and language. It is tempting to remind ourselves of Breton's own ambivalent relationship with language and his search for the missing link between representation and reference, in thinking in 1925 that 'la médiocrité de notre univers ne dépend-elle pas essentiellement de notre pouvoir d'énonciation? [...] Je crois qu'il n'est pas trop tard pour revenir sur cette déception inhérente aux mots

21 Krauss, *The Optical Unconscious*, p. 72.

dont nous avons fait jusqu'ici mauvais usage'.[22] Breton implies that language deceptively encompasses and transcends the world as much as the pre-linguistic 'survives' only as language. Similarly, that which transcends both intellect and sense perception comes across only through the intellect and senses.

Much Surrealist work, in making its speculative dimension explicit and in thematizing its reflexive character, opposed the representation of an inadequate reality. It is with a demystifying and oppositional intent towards the Symbolic that we have to understand Breton's 1928 injunction to visual artists to turn to a '*modèle purement intérieur*'.[23] Surrealist thought relates ambivalently to the promises of modernity, in that beyond representation, it also sought ways to expose and transcend the mutual inadequacies in the real and the represented. The critique of the subject targeted conceptual categories as much as the real and historical relations involved.

The destructive and pessimistic aspect of Post-Structuralist concepts can also be seen as an avatar of the utopianism and the discontents underlying much modern thought in general and its particular inflection in Surrealism. It seems that what underlies Surrealist experiments with collage – the image, objective chance, psychic automatism, to mention but a few from a larger spectrum of concepts and practices, the anti-humanist flight from representation or the Lacanian Real – is the wish to transcend or alter the given, in other words the real, through the represented. Ironically, Surrealist practice neither eliminates the cultural elements of the physical and mental faculty of vision, nor does it always salvage the pre-linguistic residues in social and discursive patterns of seeing. In staging the conflict between the Symbolic and the glimpses of the Real that Surrealist categories may afford, the dichotomy remained unresolved. The Surrrealist emphasis on seeing involved hesitation as to whether vision had to be redeemed as a primary faculty that breaks through a representational culture, or carry on working through and against its 'Symbolic' function. Ernst's collages enact how the duality between the seen and the unseen, the visible and the invisible, is neither

22 André Breton, 'Introduction au Discours sur le peu de Réalité', *Point du Jour*, in *Œuvres complètes*, II, p. 276.
23 André Breton, *Le Surréalisme et la Peinture*, (Paris: Gallimard, 1965), p. 4.

resolved beyond representation, nor totally assimilated by it. These dualities become manifest and are repressed through violence which may simultaneously come from both the subject and the object of vision. Ironically, the dichotomy between the real and the represented both generates and represses the need to attain what may lie beyond them.

Suggested Reading

André Breton, *Le Surréalisme et la Peinture* (Paris: Gallimard, 1965)
Max Ernst, *Écritures* (Paris: Gallimard, 1970)
Vision and Visuality, ed. by Hal Foster (Seattle: Bay Press, 1988)
Martin Jay, *Downcast Eyes The Denigration of Vision in Twentieth-Century French Thought* (Berkeley and London: University of California Press, 1993)
Rosalind E. Krauss, *The Optical Unconscious* (Cambridge MA and London: MIT Press (October Books), 1996)
Werner Spies, *Max Ernst: Collage: The Invention of the Surrealist Universe* (New York: Harry N. Abrams, 1991)

Rakhee Balaram

Eyes Wide Open, Eyes Wide Shut: Defining the Surrealist Eye

> *Elle a toujours les yeux ouverts*
> *Et ne me laisse pas dormir.*[1]
>
> *Qui me dit que l'angle sous lequel se présente cette idée qui le touche, ce qu'il aime dans l'œil de cette femme n'est pas précisément ce qui le rattache à son rêve, l'enchaîne à des données par sa faute il a perdues? Et s'il en était autrement, de quoi peut- être ne serait-il pas capable? Je voudrais lui donner la clé de ce couloir.*[2]

What is troubling the Surrealist eye? The question can be thought out through a study of the eye in key Surrealist texts and images. When the Surrealist eye is examined in relation to the feminine as presented in literature and in art, the question of Surrealist self-identity emerges through the nature of the feminine 'seen'. (I use the term *feminine* in a dual aspect, that is not only to suggest the presence of the female, but also the larger notion of an aspect of femininity within the Surrealists themselves, i.e. a consciousness). For, as I argue, where there is an *insertion of the eye*, there is an *assertion of the 'I'*. The eye then, becomes much more than a physical presence, but also a mirror of Surrealist identity. This is what Mary Ann Caws terms the 'private eye,' as she conceives 'the visual object not as an exterior element, but rather inside the subject in what [she thinks] of as an inner seen'.[3] Imbued with power, the feminine is critical in reading Surrealism for not only defining Surrealist masculinity, but also sustaining

1 Paul Éluard, 'L'Amoureuse,' *La capitale de la douleur* (1926) (Paris: Gallimard, 1966), p. 56.
2 André Breton, 'Manifeste du surréalisme' (1924) in *Œuvres complètes* (Paris: Gallimard, 1988), I, p. 318.
3 Mary Ann Caws, *The Eye in the Text: Essays on Perception, Mannerist to Modern* (Princeton, NJ: Princeton University Press, 1981), p. 4.

ideological positions. It is in this vein that I hope to present a more subtle account, a re-thinking of Surrealist misogyny, not to overtly deny it, but rather to question the Surrealist 'vision' of femininity through the vehicle of the eye. Through the creation and preservation of identity by the Surrealist males, the feminine becomes subject to manipulations of Surrealist ideology and self-definition. Some critics have considered the feminine in Surrealism as referring only to real women:

> Women are to the male Surrealists, as in the longstanding traditions of patriarchy, servants, helpers in the forms of child muse, virgin, *femme-enfant*, angel, celestial creature who is their salvation, or erotic object, model, doll – or she may be threat of castration in the forms of ubiquitous praying mantis and other devouring female animals.[4]

However, reading Surrealism with the presence of the eye reveals that the feminine in Surrealism acts more as a function of Surrealist self-identification with their 'use' of the feminine to define their literary, political, and artistic goals. (In any case, Surrealists were never entirely successful in controlling the real women connected to the movement, as testified through the creative output of the more talented women involved with the male Surrealists, sometimes later gaining recognition as artists and writers in their own right.)[5] Limiting my scope to the period of the 1920s and 1930s, with special attention to the pivotal year of 1929, I will show how the eye both creates the

4 Rudolf Kuenzli, 'Surrealism and Mysogyny', in *Surrealism and Women*, ed. by Mary Ann Caws, Rudolf Kuenzli, and Gwen Raaberg (Cambridge, MA: MIT Press, 1991), p. 19. Originally published as the journal of *Dada/Surrealism* no.18 by the Association of the Study of Dada and Surrealism, University of Iowa, 1990. For further analysis of the roles of women in Surrealism from a feminist perspective, see Xavière Gauthier's *Surréalisme et Sexualité* (Paris: Gallimard, 1971).

5 Much critical attention has been devoted to this topic in recent years. As I focus solely on the male Surrealist subject in this article, I refer the reader to Georgiana Colvile, *Scandaleusement d'elles: 34 femmes surréalistes* (Paris: Jean-Michel Place, 1999), Penelope Rosemont, *Surrealist Women an International Anthology* (Austin, TX: University of Texas Press, 1998) and the classic study by Whitney Chadwick, *Women Artists and the Surrealist Movement* (New York: Thames and Hudson, 1985) for anthologized accounts of women defining Surrealist practice.

feminine and reveals the male Surrealist subject within the context of the 'official' movement, lead by André Breton, as well as with those defining Surrealist practice in the margins of this group, specifically Georges Bataille. A focus on the three major texts, Breton's *Nadja* (1928), with support from Louis Aragon's *Le Paysan de Paris* (1926), and Bataille's *Histoire de l'œil* (1928) will enable me to bring together the dual aspects of seeing which reflect the male authors' vision of the eye and the feminine and discuss what it means for reading Surrealism.

Breton v. Bataille

Despite Breton's idealistic assertion that 'l'œil existe à l'état sauvage',[6] the eye proves itself coloured by the philosophical, political, and social beliefs of each of the writers and artists portraying it. Thus, it is both an easy and difficult task to pair André Breton and Georges Bataille together, for in spite of their philosophical disputes (in this era Breton held faith in a Hegelian-based resolution of contradictions and Bataille in dialectical materialism which Breton thought inconceivable for being a negation of a negation),[7] their work contains a similar engagement with the eye and the feminine – even if invested in different ways. Never an official member of the Surrealist movement, Bataille shared similar interests with the 'official' Surrealists in the 'desire for modernity, a desire to shock and for revolt, [and] a distaste for "literature"'.[8] On February 12, 1929, Breton issued a letter to all supporters of Surrealism (sparking what Surrealist historian Maurice Nadeau terms the 'crise de 1929') testing the members' and supporters' loyalty to the movement in demanding a statement of their current ideological position and whether it entailed individual or collective political action. Bataille immediately reacted

6 Breton, *Le Surréalisme et la peinture* (1928) (Paris: Gallimard, 1965).
7 See Breton, 'Second Manifeste du surréalisme', *Œuvres complètes*, I, p. 794.
8 Patrick ffrench, 'The Cut / Reading Bataille's *Histoire de l'œil* (Oxford: Oxford University Press, 1999), pp. 62–63.

by dismissing the Surrealists as 'beaucoup trop d'emmerdeurs idéalistes,' taking other former adherents such as Michel Leiris and others with him.[9] A split notorious for the amount of spite it produced, with Breton pointedly attacking Bataille in the 'Second Manifeste du surréalisme' (1930), and Bataille responding in turn.[10]

Whereas Breton held to the idea of a Freudian process of sublimation to work through sexual impulses to arrive at higher (non-sexual) levels of consciousness through the creation of art,[11] Hal Foster points to a reversal of this process which also exists where the sexual confronts art through 'desublimation':

> In art this may mean the (re)erupting of the sexual, which all surrealists support; but it may also lead to a (re)shattering of object and subject alike, which only some surrealists risk. It is at this point where sublimation confronts desublimation that surrealism breaks down, and I mean this literally: such is the stake of the split between official Bretonian and dissident Batailleen factions circa 1929. [...] Although both groups recognize the uncanny power of desublimation, the Bretonian surrealists resist it, while the Batailleen surrealists elaborate it.[12]

Though Foster extends this idea to link Surrealists irreversibly with the Freudian death drive, I wish to show here how the eye and the feminine are constructed along such an ideological divide, i.e. how Breton places the sexual back in art through erotic desire as manifested in the eye and the feminine, but always under 'controlled' circumstances, while Bataille also employs the sexual, but with deliberate intention toward liberation of both subject and object. Thus, my reading is less about the possible shattering of the male subject that Foster predicts above, but rather the very protection against such a shattering through the manipulation of the feminine by the

9 See Maurice Nadeau, *Histoire du surréalisme* (Paris: Éditions du Seuil, 1964), pp. 118–30, 121. (Bataille also took with him Robert Desnos, Roger Vitrac, André Masson, etc.)
10 See Breton's 'Second Manifeste du surréalisme', *Œuvres complètes*, I, as well as Georges Bataille's 'La "vielle taupe" et le préfixe *sur* dans le mots *surhomme et surréaliste*' (1930) in Georges Bataille, *Œuvres complètes* (Paris: Gallimard, 1970), II, pp. 105–106.
11 Breton, 'Second Manifeste du surréalisme', *Œuvres complètes*, I, p. 808.
12 Hal Foster, *Compulsive Beauty* (Cambridge, MA: MIT Press, 1993), p. 112.

Surrealists according to the dictates of their ideologies that serve to preserve their identity. The rest of this article will focus on this question of how the Surrealists Breton, Bataille, and respective followers use the eye and the feminine to sustain their beliefs and determine self-identity.

I. The Exalted Eye

The Surrealist fascination with the eye is evident in images and texts. Whether it be outsized as in René Magritte's *Faux Miroir* (1935), a detached and floating eye reminiscent of a moving consciousness such as in Max Ernst's *The Wheel of Light* (1926), or smaller and pluralized as in 'les yeux de fougères' from the plate in *Nadja* (1928), the eye is scattered throughout Surrealist imagery and reference is readily found in texts of Surrealist writers. The eye finds itself important enough for an extended definition within André Breton and Paul Éluard's *Dictionnaire abrégé du surréalisme* (1938):

> Œil.– 'Les yeux sont les fous du cœur.' (Shakespeare). 'L'œil est un organe superficiel.' (Novalis). 'Le blanc – lait ou squelette – des yeux.' (Jarry). 'Des yeux de chandelier.'(Saint-Pol Roux). 'L'œil existe à l'état sauvage.' (A.B.) 'Les yeux cernés à la façon des châteaux dans leur ruine.' (P.E.) 'Ma femme aux yeux d'eau pour boire en prison.' (A.B.) 'J'ai vu les plus beaux yeux du monde – dieux d'argent qui tenaient des saphirs dans leurs mains.' (P.E.) 'Elle aura de grands yeux de boomerang.' (B.P.) 'Tes yeux étaient tellement des yeux.' (V.N.) 'Forme tes yeux en les fermant.' (A.B.et P.E.) 'Voir est un acte: l'œil voit comme la main prend.' (P.N.)[13]

Through multiple evocations of the eye, taken from statements earlier published by the Surrealists, the eye is formed collectively through an array of meanings which define the aspects of the eye for the Surrealists: from the sublime 'chandelier', 'dieux d'argent', 'l'état sauvage', to the slightly teasing 'boomerang', from love and

13 Breton, *Œuvres complètes*, II, p. 827–28; (A.B) André Breton, (P.E.) Paul Éluard, (B.P.) Benjamin Peret, (V.N.) Vitezslaw Nezval? (P.N.) Pierre Naville.

statements of passion, 'cœur', 'organe superficiel', and 'tes yeux étaient tellement des yeux', in addition to 'ma femme aux yeux d'eau pour boire en prison', to the grandiose, 'les yeux cernés à la façon des châteaux dans leur ruine', and the mysterious, 'forme tes yeux en les fermant'. The Surrealists (and their named predecessors) work together in moving the eye from its visual domain to its verbal one, redefining the eye and vision through written statements attempting to embody the eye. Such an eye is defined and redefined in order to elaborate a position of a Surrealist 'vision' through the transformation of the eye from physical organ into abstract states of mind or feeling, as witnessed in the definition above. The transformation of the eye from the physical realm to its various verbal guises recalls Surrealist interest in altered states of consciousness, to experience the commonplace, as 'other,' or 'more'. This Surrealist exaltation evokes earlier troubadour poetry, as in the following lines, where the feminine eye is confronted by a (sexual) love:

> Dame, pour qui je chante et siffle.
> Vos beaux yeux sont pour moi des verges
> qui fouettent mon cœur en joie
> et je n'ose mes désirs rustres.[14]

Here, through the eyes of a woman, the visual meets the sexual and the material eye moves to an abstract consciousness that finds expression in Surrealist work as we shall see below.

Eyes Wide Open

The eye for André Breton is a vehicle of his idealism. His texts are replete with descriptions of the eye, most frequently with regard to women. When the eye encounters a woman, his idealism takes on the aspect of the 'point de l'esprit' as Breton elaborates in the 'Second Manifeste du surréalisme', a search for the theoretical point in which

14 Raimbaut d'Orange (1147–73), from Jean-Claude Marol, *La Fin'Amor: Chants de troubadours: XIIe–XIIIe siècles* (Paris: Éditions du Seuil, 1998), p. 76.

all contradictions resolve.[15] In this sublime moment all contradictions are resolved through the mixing of sexual attraction and sexual danger in the eye recreated into a 'point' of light, to which Breton subjects himself:

> Les yeux conservent la trace de ce qu'ils ont su voir. Et la femme étant naturellement en communication avec les forces naturelles, la lumière de ses yeux est une lumière d'au-delà.[16]

Here, the woman and the eyes act as an inspiration, a 'lumière d'au-delà' In such a move of submission, Breton attempts to master both the eye and the woman through this moment of recognition as he is always entirely conscious of this power and of his submission to it:

> Par ailleurs il exige que, par le chemin inverse de celui que nous venons de les voir suivre, ceux qui possèdent, au sens freudien, la 'précieuse faculté' dont nous parlons, s'appliquent à étudier sous ce jour le mécanisme complexe entre tous de *l'inspiration*, et à partir du moment où l'on cesse de tenir celle-ci pour une chose sacrée, que, tout à la confiance qu'ils ont en son extraordinaire vertu, ils ne songent qu'à faire tomber ses derniers liens, voire, – ce qu'on n'eût jamais encore osé concevoir – à se la soumettre.[17]

This belies a need, found more widely in Breton, both to possess and be possessed in a very deliberate moment and making the conscious seem unconscious. Breton describes Nadja's eyes and their attraction in some detail:

> Curieusement fardée, comme quelqu'un qui, ayant commencé par les yeux, n'a pas eu le temps de finir, mais le bord des yeux si noir pour une blonde. Le bord, nullement la paupière. (Il est intéressant de noter, à ce propos, que Blanche Derval, dans le rôle de Solange, même vue de très près, ne paraissait en rien maquillée. Est-ce à dire que ce qui est très faiblement permis dans la rue mais

15 'Tout porte à croire qu'il existe un certain point de l'esprit d'où la vie et la mort, le réel et l'imaginaire, le passé et le futur, le communicable et l'incommunicable, le haut et le bas cessent d'être perçus contradictoirement. Or c'est en vain qu'on chercherait à l'activité surréaliste un autre mobile que l'espoir de détermination de ce point.' Breton, 'Second Manifeste du surréalisme', *Œuvres complètes*, I, p. 781.
16 Jean Roudaut, 'Un geste, un regard', *La Nouvelle Revue française*, 1968, pp. 834–35.
17 Breton, 'Second Manifeste du surréalisme', *Œuvres complètes*, I, p. 809.

est recommandé au théâtre me vaut à mes yeux, qu'autant qu'il est passé outre à ce qui est défendu dans un cas, ordonné dans l'autre. Peut-être.) Je n'avais jamais vu de tels yeux.[18]

The make-up of Nadja's eyes fascinates Breton in this conscious moment of seduction. The defining eyeliner, of which he comments, 'si noir pour une blonde', immediately evokes the elements of the sublime angel (blonde) and the terror of the seductress (si noir) creating the dual elements of the classic paradigm of the virgin/whore. Breton slips into a reverie about the eyes of Blanche Derval who although an 'actress' maintains a verbal purity (Blanche), whose eyes never revealed the black liner in her role of Solange (Sun Angel). The setting of the stage versus street becomes interesting as Breton collapses the distance between them in an unresolved way creating a momentary instability of place. This imbalance extends into the doubling of women's eyes where one woman's eyes (Nadja's) become, through insertion of thought, those of another (Blanche Derval's). Such a move exhibits the way in which the eye slips between borders (unlike the eyeliner precisely controlling and defining the eyes of Nadja) and substitutes the eyes of one woman for the other, thus the power of the eyes are multiplied, leaving the narrator slightly off-balance and momentarily hypnotized: 'Je n'avais jamais vu de tels yeux.'

This doubling of vision is repeated visually in Man Ray's photograph, 'La Marquise Casati' (1922, see figure 9), in which sets of eyes are super-imposed on one another giving the feeling of two or three sets of eyes in the face of one woman. The eyes of the woman challenge the sight of the viewer through her almost monstrous regard. This dizziness causes a fleeting loss of stability in the viewer. Rosalind Krauss marks this instant: 'For it is doubling that produces the formal rhythm of spacing – the two step that banishes the unitary condition of the moment, that creates *within* the moment an experience of fission.'[19] This fission, I would like to argue, takes place

18 Breton, *Nadja* (1928), (Paris: Gallimard, 1964), pp. 71–72.
19 Rosalind Krauss, 'The Photographic Conditions of Surrealism,' in *The Originality of the Avant-garde and other Modernist Myths* (Cambridge, MA: MIT Press, 1985), p. 109.

Figure 9: Man Ray, *La Marquise Casati*
© Man Ray Trust / ADAGP, Paris DACS, London 2002

within the subject/viewer. Breton's imagining of Nadja/Blanche Derval (echoed in the image of the Marquise Casati) causes a slippage between the identity of the two figures and himself. If in the moment of the gaze, there is a fission in the subject in regarding the doubled gaze, the feminine is looked upon in horror. (Breton writes that he was not the only one rendered dizzy by the powerful gaze of Nadja, when in a restaurant the male waiter has the same reaction: 'il lève les yeux sur Nadja et paraît pris de vertige.')[20] Barthes, citing Lacan, encapsulates this moment:

> Revenir, cependant, au regard direct, impérieux: qui ne fuit pas, s'arrête, se fige, se bute. L'analyse a aussi prévu ce cas: ce regard-là peut être le *fascinum*, le maléfice, le mauvais œil, qui a pour effet 'd'arrêter le mouvement et de tuer la vie' (Lacan, *Séminaire XI*, p. 107).[21]

The dual impulse of seduction and fear generate a power for Nadja, but the moment passes, Breton has found his 'point de l'esprit' in his 'mastery' of the errant Nadja and the earlier promise of death in the terrifying gaze becomes the promise of life; while Nadja is driven mad, her eyes left wide open like a cadaver:

> Je me souviens aussi – rien à cet instant ne pouvait être à la fois plus beau et plus tragique – je me souviens de lui être apparu noir et froid comme un homme foudroyé aux pieds du Sphinx. J'ai vu ses yeux de fougère *s'ouvrir* le matin sur un monde où les battements d'ailes de l'espoir immense se distinguent à peine des autres bruits qui sont ceux de la terreur et, sur ce monde, je n'avais vu encore que des yeux se fermer.[22]

This consciously controlled feeling between power and its loss was defined earlier by Aragon in *Le Paysan de Paris*, where like Breton he begins his quest of self-discovery on the streets of Paris. His feeling of power and self is again reflected through the eye of the other:

> Dans tout ce qui est bas, il y a quelque chose de merveilleux qui me dispose au plaisir. Avec ces dames, il s'y mêle un certain goût du danger: ces yeux dont le

20 Breton, *Nadja*, p. 113.
21 Roland Barthes, 'Droit dans les yeux.'(1977) in *Œuvres complètes*, (1974–80) (Paris: Éditions du Seuil, 1995), III, pp. 737–40.
22 Breton, *Nadja*, p. 128.

> fard une fois pour toutes a fixé le cerne et déifié la fatigue, ces mains que tout abominablement révèle expertes, un air enivrant de la facilité, une gouaillerie atroce dans le ton, une voix souvent crapuleuse, banalités particulières qui racontent l'histoire hasardeuse d'une vie, signes traîtres de ses accidents soupçonnés, tout en elles permet de redouter les périls ignominieux de l'amour, tout en elles, en même temps, me montre l'abîme et me donne le vertige, je leur pardonnerai, c'est sûr, tout à l'heure, de me consumer.[23]

Like Breton, Aragon begins his description of women with their eyes, commenting explicitly on the make-up, the made-up aspect of the eye whose artificiality overshadows the real, the fatigue; these are eyes which will remain open at all costs. The rest of the features of the prostitutes enchant him as well, producing the sensation of dizziness, of vertigo, the sensation of being both high and low. Once again the mix of raw sexuality and danger provide allusion to a Bretonian sublime: 'Dans tout ce qui est bas, il y a quelque chose de merveilleux', and: 'tout en elles, en même temps, me montre l'abîme et me donne le vertige', all of which give the narrator a sense of pleasure, the promise of finding himself lost in the other, in the unknown. Breton later elaborates in the 'Second Manifeste du surréalisme':

> Rappelons que l'idée de surréalisme tend simplement à la récupération totale de notre force psychique par un moyen qui n'est autre que la descente vertigineuse en nous, l'illumination systématique des lieux cachés et l'obscurcissement progressif des autres lieux, la promenade perpétuelle en pleine zone interdite.[24]

Here too, the eye becomes a function of what is prohibited, a forbidden territory. The eye works as a sexual organ, like those of the prostitutes whose 'eyes', like the promise of their sex, are always open. Through the eyes of the feminine that will not close, Aragon desires the sexual encounter with the 'banned' women, with the conscious loss and regaining of the self through pleasure and fear bringing him closer to true 'Surrealist' identity: 'c'est sûr, tout à l'heure, de me consumer.'

23 Louis Aragon, *Le Paysan de Paris* (1926) (Paris: Gallimard, 1953), pp. 48–49.
24 Breton, 'Second Manifeste du surréalisme', *Œuvres complètes*, I, p. 791.

Eyes Wide Shut

In the famed photomontage by René Magritte, 'Je ne vois pas la ... cachée dans le forêt' (1929, see figure 10) the painting of a naked woman is placed in the centre of 16 surrealist males who have closed their eyes. There is an assertion, 'Je ne vois pas', a collective statement made by the Surrealists. Like the eye of the male Surrealists, the woman's eyes are downcast. There is no confrontation of sexuality, instead a withdrawal from what lies in the centre of the image: naked, vulnerable, and without the artifice of make-up as found earlier in both Nadja and the prostitutes of *Le Paysan de Paris*.

Of course there is the element of dream and reverie, of self-internalization, but the eyes are closed, proclaiming a refusal to see, a refusal to confront the feminine. Such a standpoint recalls a rejection of the defined eye of the woman that forces dizziness and vertigo, feelings of love and sexuality, loss and gain of power and identity. The Surrealists are now in mathematically precise grids separating them from the feminine within. How do we interpret such an image, which at first seems to contradict earlier Surrealist involvement with the feminine? Here the eyes are closed as protest, however lightheartedly. Perhaps the image can be read as a comic stance against Œdipal blinding, for as Freud notes, 'the blinding in the legend of Œdipus, as well as elsewhere, stands for castration,' claiming both eye-symbolism and eye-dreams as the disguised Œdipal dream.[25] With closed eyes, the Surrealists avoid the threat of castration, and thus preserve their male (phallic) identity.

Though this image has been the object of much critical speculation, often in terms of supporting Surrealist misogyny,[26] I would like to reframe it in terms of historical context and the use of it as a promotion of individual identity within a collective identity. The image was first published in *La Révolution surréaliste* 12 (December 1929), ten months after Breton had sent out the fateful letter asking for

25 Sigmund Freud, *The Interpretation of Dreams*, p. 398n.
26 See for example work by Rudolf Kuenzli, and Susan Rubin Suleiman, 'A Double Margin' in *Subversive Intent: Gender, Politics, and the Avant-Garde* (Cambridge, MA: Harvard University Press, 1990).

Figure 10: Magritte, *Je ne vois pas la ... cachée dans le forêt*

renewed faith in the movement. This image constructs the feminine as an object of self-denial and resistance, and with the participants acting collectively together with closed eyes, creates a joint statement, a recommitment to the movement. Therefore, if earlier the feminine was being defined by 'open eyes' in order to support one type of male Surrealist identity, in times of crisis, the closed eyes of the feminine act to redefine this identity: both individually, as in the grids of the photograph, and more importantly, collectively as a group which surround the feminine. Such a confrontation between the masculine and feminine is one where the male can define identity in opposition to the other:

> Telle est l'origine d'une identité masculine plus négative que positive, qui met l'accent sur la différenciation, la distance à l'égard des autres et le déni de la relation affective. Alors que les processus d'identification féminine sont relationnels, ceux de l'identification masculine sont oppositionnels.[27]

I also believe this is initially why there were no women in the Surrealist movement. The exclusion of actual women from the early stages of the movement helped define members of the movement in a clearer fashion. This is to say that having a unified male front allowed Surrealists to circumvent any challenges that might have been posed by women partners in the 1920s to both their ideology and work. Women officially barred from acting as members of the movement provided a more cohesive, if limited sense of both the 'self' and its essential 'other'. Thus, we see that the open eye and the closed eye in relation to the feminine construct a self-definition and/within a collective definition for the Surrealists in the face of a changing ideology and a movement in flux.

27 Elisabeth Badinter, *XY: De l'identité masculine* (Paris: Éditions Odile Jacob, 1992), p. 88.

II. The Blinded Eye

For Georges Bataille the eye is not used with the same idealism as for the Bretonian Surrealists. Instead, as critics have pointed out, the Bataillean eye is possibly linked to the memory of his blind father, the haunting 'visual experience' of the First World War, and in philosophy, to the breakdown of a Cartesian system of thought.[28] As a result, for Bataille the eye has a terrain of meanings, a link to the past and the present and one which cycles in to the future with a violence which is at once physical and psychic as well as experiential, displacing the reader with the multiple levels of blindness effected in his work. If for Breton and his circle there is a use of the eye as a 'point' in which to encounter the other while preserving a fixed identity, for Bataille there is a distinct move towards the contrary. The eye becomes subversive, an ideological form of rebellion which liberates masculine identity through the feminine.

Eyes Wide Shut

If Breton's and Aragon's vision of women is justified through eyes permanently open or eyes completely closed, the receptivity and rejection of the feminine reveals contradictory impulses in the group. Georges Bataille, one of the most adamant against the Surrealist group and their desire to resolve all contradictions in an imaginary 'point', creates an engagement between the eye and the feminine which counters all Surrealist categories. In terms of Œdipus, the Surrealists could be judged as avoiding the Œdipal blinding, or pain and punishment, through an eye constantly in flux between eyes open (all-seeing), or closed (shut-out), however Bataille, in his *Histoire de l'œil* (1928) embraces the blinded eye – both repulsive and seductive in its power. This eye, in conjunction with the heroine of the novel, Simone,

28 For a detailed history of the philosophical and political aspects of the eye in French thinking, see Martin Jay's *Downcast Eyes: The Denigration of Vision in Twentieth Century French Thought* (Berkeley and London: University of California Press, 1993).

destroys any vision of a Bretonian Surrealist feminine. If the mainstream Surrealists strive for a marvellous moment, a 'point d'esprit', Bataille challenges such a notion of a fixed point with a 'wheel', a series of repetitions. This is to say that the eye is constantly rolling, metamorphosing from 'œil' to 'couille', to 'œuf' both literally and linguistically as Barthes asserts through the transformation of the objects and the words themselves.[29]

In the cycle of mainstream Surrealist seeing which is locked between pain and pleasure in response to the castrating Œdipal eye, Bataille liberates himself from such a cycle, with the acceptance of the blinded eye. The enucleated eye in *Histoire de l'œil* breaks free of any Œdipal associations by the removal of both pain and punishment:

> ŒDIPUS: Do not counsel me any more. This punishment
> That I have laid upon myself is just
> If I had eyes,
> I do not know how I could bear the sight
> Of my father, when I came to the house of Death,
> Or my mother: for I have sinned against them both.[30]

If Œdipus's blinding suggests a moment of repentance on the part of Œdipus, if the removal of the eyes suggests a punishment for sins, Bataille takes this moment and literally plays with it, as does his heroine Simone in the novel. In this way Bataille rejects not only Œdipus's mythic blinding, but also Freudian Œdipal implications. If the Surrealists use the eye as a site/sight of a feminine consciousness that can be manipulated to fit the needs of the group, whether that be through erotic desire which sustains their identity or their resistance to it which also sustains identity, Bataille uses the eye as a site/sight that cycles further into what is repulsive, transgressive, and forbidden. Bataille writes of the seductive and horrific lure of the eye:

> On sait que l'homme civilisé est caracterisé par l'acuité d'horreurs souvent peu explicables [...] Il semble, en effet, impossible au sujet de l'œil de prononcer un autre mot que séduction, rien n'etant plus attrayant dans les corps des

29 Roland Barthes, 'La métaphore de l'œil' in *Essais critiques* (Paris: Éditions du Seuil, 1966).
30 Sophocles, 'Œdipus Rex', in *The Œdipus Cycle*, trans. by Dudley Fitts & Robert Fitzgerald (New York: HBJ Press, 1939), p. 71.

animaux et des hommes. Mais la séduction extrême est probablement à la limite de l'horreur.[31]

If the eye's shift between sex and fear is also evident with the Surrealists as the earlier examples in this article have suggested, Bataille pushes this duality further through the eye's liberation by rewriting the boundaries of sexual freedom and violence. Such a moment of violence is best witnessed in the famed still from the film *Un Chien andalou* (1929, see figure 11) by Salvador Dalì and Luis Buñuel (latecomers to the Surrealist group and pictured in the earlier image, 'Je ne vois pas...'), in which the eye of an alluring young girl is being slit open with a razor. Though this image can be read ideologically as a call for a change of consciousness through a change of vision, what is interesting is the eye's investment in the feminine. The fact that a woman is used for this scene of blinding reverses the myth of Œdipus (it is a woman's eye that is blinded) while promoting a seduction to the limits of horror of which Bataille alludes to above. In this way, the woman takes on the same properties as the eye, becoming a site of both attraction and repulsion. The violent cutting of the eye produces a momentary stop to this cycle of horror and seduction through the very fulfilment of the blinding which Bataille proposed earlier in *Histoire de l'œil*, although he elaborates the moment in a different way from that of Dalì and Buñuel through Simone's embracing of the blinded eye.

Eyes Wide Open

It is the moment of the 'cut' that Patrick ffrench designates as the defining moment where the organ severed from the body gains a freedom of movement with which to see the narrator and to access Simone's body.[32] The eye becomes both mobile and free, an all-seeing power which Simone realizes:

31 Georges Bataille, 'L'Œil' (1929) in *Œuvres complètes*, I, pp. 187–89.
32 ffrench, p. 22.

Figure 11: Dalí and Buñuel, *Un chien andalou* (still)

Eyes Wide Open, Eyes Wide Shut

> — Ecoutez, Sir Edmond, dit-elle, il faut me donner l'œil tout de suite, arrachez-le.
> Sir Edmond ne tressaillit pas mais prit dans un portfeuille une paire de ciseaux, s'agenouilla et découpa les chairs puis il enfonça les doigts dans l'orbite et tira l'œil, coupant les ligaments tendus. Il mit le petit globe blanc dans la main de mon amie.
> Elle regarda l'extravagance, visiblement gênée, mais n'eut pas d'hésitation. Se caressant les jambes, elle y glissa l'œil. La caresse de l'œil sur la peau est d'une excessive douceur... avec un horrible côté cri de coq!
> Simone cependant s'amusait, glissait l'œil dans la fente des fesses. Elle s'étendit, releva les jambes et le cul Elle tenta d'immobiliser le globe en serrant les fesses, mais il en jaillit – comme un noyau des doigts – et tomba sur le ventre du mort...
>
> — Mettez-le moi dans le cul, cria Simone.[33]

In an act of violence, in a cut that Simone orders, Bataille transfers power to the feminine, and in doing so, liberates both the eye and the feminine through spectacle. Simone plays with the eye openly, running it along her, inside her, outside of her. In another reversal of the Œdipal eye, the feminine is empowered by the fusion of the scopic eye to the feminine sexual body with the eye's invasive entrance into the vagina suggesting an inversion of the Œdipal blinding. The cycle of horror and seduction accelerate in the moment the eye has become feminine sex, with an exiting of the masculine subject altogether.

This return of the eye to the vagina, that is the eye to feminine sexuality, is repeated in the image by Victor Brauner whose drawing of the eye as the vagina between amorphous legs (1927, see figure 12) physically links the eye with the woman's body.[34] The accompanying text in *Minotaure* by Pierre Mabille further defines the relation between the eye and the feminine:

33 Georges Bataille, *Histoire de l'œil* (1928) (Paris: Gallimard, 1967), p. 98.
34 Romanian Victor Brauner, who joined the Surrealist movement officially in 1933, was famed for his portrait of eyes. A self-portrait in 1931 shows Brauner with a missing eye; strangely he predicted his own enucleation as he lost his eye in an accident in 1938. For further information, see Sarane Alexandrian, *Surrealist Art* (London: Thames and Hudson, 1970), pp. 113–14. (I have not found any evidence to suggest that Bataille was familiar with Brauner's drawing.)

A n'en pas douter, l'œil est dans le visage une partie de nature féminine. Les plus anciennes traditions de l'astrologie, de la morphologie en témoignent au même titre que de nombreux aphorismes que le sexe féminin a été parfois représenté comme un œil. Un dessin de Brauner, exécuté en 1927, publié en 1928, fait apparaitre clairement que cette valeur symbolique n'échappait pas à l'artiste.[35]

L'obsession qui, au début, tendait à la destruction simple de l'œil, se complique d'années en années. L'équivalent de l'organe sexuel femelle doit être remplacé par un attribut masculin–la corne–signe d'érection, de puissance, d'autorité et même de brutalité animale. L'être ainsi transformé sera devenu un surmâle. [...] Les mouvements sociaux qui s'affrontent à notre époque témoignent de la volonté des nouvelles générations d'accéder à une surmasculinité héroïque. Cependant l'originalité de la figure mythique tracée par Brauner tient moins à la présence de cornes, qu'à leur valeur de remplacement à l'égard des yeux.[36]

Here, the eye as a vagina establishes a link between the eye and female sexuality at the threat of male identity. The image is suggestive of castration – the shapeless legs do not define a sex and could represent a castrated male. However, Bataille flirts with this castration anxiety by literally placing the eye into the feminine organ. This weaving of the eye with the woman, or the eye becoming part of the woman's sex, is interesting in that a traditionally 'passive' organ (eye) meets a traditionally 'passive' organ (vagina) in a dynamic moment which re-formulates the feminine in terms of power and male fantasy in terms of eye. Michel Leiris signals the relationship of the blinded eye to the feminine as abject through disgust, attraction, and fear:

La signification de l'"œil crevé" est très profonde pour moi. Aujourd'hui, j'ai couramment tendance à regarder l'organe féminin comme une chose sale ou comme une blessure, pas moins attirante en cela, mais dangereuse par elle-même comme tout ce qui est sanglant, muqueux, contaminé.[37]

This link between passive organs creates an active eye and an active female whose power could be thought out through the horror and seduction that frightens Leiris. If critic Mabille registers the need for a

35　Mabille refers to the above Brauner drawing here.
36　Pierre Mabille, 'L'Œil du Peintre', *Minotaure* 12–13 (May 1939), p. 54.
37　Michel Leiris, *L'Age d'homme* (1939) (Paris: Gallimard, 2001), p. 80.

Figure 12: Brauner, from *L'Œil du Peintre*

'surmâle' in society, Bataille has created something different. The narrator's eye is also free through the novel and willingly submits to Simone. However Simone is not Simone, but a series of her actions (she is also, for example, Marcelle).[38] The threat of such a female does not affect the narrator's seeing of Simone's actions – *it is never the male narrator's eye that is blinded*. This passivity on the part of the narrator inverts traditional formulations of the masculine and the feminine:

> L'homme viril incarne l'activité. Mais cette activité n'est en vérité qu'une réaction contre la passivité et l'impuissance du nouveau né [...] La peur de la passivité et de la féminité est d'autant plus forte que ce sont là les désirs les plus puissants et les plus refoulés de l'homme.[39]

Yet Bataille does not end by simply inverting the formula of masculine-feminine/active-passive, rather he transgresses the formula in a way that the mainstream Bretonian Surrealists cannot. In avoiding fixed meanings, Bataille establishes a network of a moving eye and a moving feminine which he tightly controls through linguistic meaning and appearance. Therefore, unlike the Bretonian Surrealists who accept or reject this moment, Bataille does not resist it, but rather provokes the moment through the text with the intention of escaping the castration moment (thus preserving identity) through the very transformation and manipulation of the main elements: eyes, eggs, testicles, Simone, Marcelle.[40] Through his text, Bataille counters castration through an eye that is not only an eye, but also an egg and

38 Simone and Marcelle share identities through various moments in the text, such as their mutual masturbation and mimicry (p. 38) and the evocation of Marcelle's name at the end of the text where the narrator states: 'Mes yeux, me semblait-il, étaient érectiles à force d'horreur; je vis, dans le vulve velue de *Simone*, l'œil bleu pâle de *Marcelle*' (p. 99).

39 Elisabeth Badinter, *XY: De l'identité masculine* (Paris: Éditions Odile Jacob, 1992), p. 89.

40 According to Susan Rubin Suleiman, the narrator finds himself involved deeper into the Œdipal drama within the text when his father tells him that his mother was being screwed by the doctor, thus becoming aware of his mother's sexual body. However, I think that any hint of a legitimate Œdipal drama in the text is counteracted by the placement of the eye in Simone's vagina for the reasons stated above. See 'Transgression and the Avant-Garde: Bataille's *Histoire de l'œil*' in *Subversive Intent: Gender, Politics, and the Avant-Garde*, pp. 73–87.

testicles, as well as through Simone who is not only Simone, but also the dead Marcelle, and to some extent the narrator as well in his identification with her. This instability in terrain allows a male identity to be formed in response to that which is constantly changing, providing the moment of escape from castration.

Thus, male identity is not formed in opposition/contradiction as for Breton, but rather through transgression, through provoking the eye and the feminine through the manipulation of their categories. This fear and seduction ultimately ends as a cycle with no stability – even the fusion of eye to sex is only temporary as Simone urinates on the eye as her final act, showing her ultimate power through her ultimate rejection of the eye. In this way Bataille manages to surpass the elements in the text he constructs. Susan Suleiman questions, 'Why is it a woman [...] in whose body [...] the contradictory impulses toward excess are played out?' I would answer by saying the body of the woman is 'the feminine' which is not a woman's body at all, but like the eye itself, a slippery terrain, a series of metamorphoses which is determined through all of her encounters, recorded and preserved faithfully through the narrator's eye.

Suggested Reading

Louis Aragon, *Le Paysan de Paris*. (1926) (Paris: Gallimard, 1953)
Elisabeth Badinter, *XY De l'identité masculine* (Paris: Éditions Odile Jacob, 1992)
Georges Bataille, *Histoire de l'œil*. (1928) (Paris: Gallimard, 1967)
André Breton, *Nadja*. (1928) (Paris: Gallimard, 1964)
—— 'Second Manifeste du surréalisme' (1930), in *Œuvres complètes* (Paris: Gallimard, 1988), I
Mary Ann Caws, *The Eye in the Text: Essays on Perception, Mannerist to Modern* (Princeton, NJ: Princeton University Press, 1981)
Patrick ffrench, 'The Cut / Reading Bataille's *Histoire de l'œil*' (Oxford: Oxford University Press, 1999)

Hal Foster, *Compulsive Beauty* (Cambridge, MA: MIT Press, 1993)

Sigmund Freud, *The Interpretation of Dreams*, trans. by James Strachey (New York: Basic Books, 1960)

Martin Jay, *Downcast Eyes: The Denigration of Vision in Twentieth Century French Thought* (Berkeley and London: University of California Press, 1993)

Maurice Nadeau, *Histoire du surréalisme* (Paris: Éditions du Seuil, 1964)

Susan Rubin Suleiman, 'A Double Margin' and 'Transgression and the Avant-Garde: Bataille's *Histoire de l'œil*' in *Subversive Intent: Gender, Politics, and the Avant-Garde* (Cambridge, MA: Harvard University Press, 1990)

Hannah Westley

Visions of the Muse
in Michel Leiris's *L'Âge d'homme*

Michel Leiris's *L'Âge d'homme* is an exploration into the plasticity of memory. It is at once confession, catharsis, classical childhood memoir and representative of the avant-garde crisis in self-representation. If autobiography prior to Leiris and as opposed to autobiographical fiction (such as Proust's enterprise) was regarded as a retrospective moulding and ordering of the past, in order to convey upon it a teleological coherence, Leiris reveals both the fallibility of memory and self-knowledge and the mutual desire that propels an autobiographical text.

 The distinction between 'historical' and 'visual' memory is overschematic. There is a visual quality to our recollections about the past, and we experience images from our past in a historical context. Memory has traditionally been conceived as visual: classical mnemonic strategies for rhetoric (*mnemonic* deriving from Mnemosyne – goddess of memory and mother to all muses) depended upon a visualization of architectural or spatial structures. Much modern self-narrative draws upon the mnemonic power of visual imagery often leading the autobiographer to include photographs (see Barthes and Breton) or to adopt a fragmented text, analogous to a collection of snapshots (see Walter Benjamin). From the outset *L'Âge d'homme* reveals itself to be a highly visual undertaking. Leiris announces his desire in the introductory essay to group together the images which have contributed to his sense of identity. He draws constant analogies between his writing and the visual art of self-portraiture. He refers to 'les traits qui [...] donnent sa ressemblance au portrait', 'un tableau de moi, peint selon ma propre perspective', 'une telle galerie de souvenirs'.[1]

1 Michel Leiris, *L'Âge d'homme* (Paris: Gallimard (Folio), 1995), pp. 29, 26, 41.

In the prologue, Leiris commences with an intricate description of his physiognomy. In textualizing his physical presence, Leiris renders it as sign, and thus his body becomes a metaphor in the text, standing in for something that is not there. *L'Âge d'homme* begins with an exterior vision of Leiris, the detailed description of his person, and concludes with the interior visions of his subconscious, the dream descriptions. This framework represents the corporeality of existence, the external representation of the self, and the quest for an interior identity. Leiris's rule of composition reflects this symbolic framework: 'Identité [...] de la forme et du fond.' He seeks simultaneity in the conjunction of interior and exterior vision. The conspicuous lack at the heart of *L'Âge d'homme* is a material image of the autobiographer. This lack of an image – of the body that is a sign of desire and of agency in the world – places the emphasis of the writing upon the constructed nature of identity, how the presence of the writer is both evoked and dispersed throughout the text.

L'Âge d'homme and *La Règle du Jeu* have been subject to innumerable critical appraisals and analyses.[2] Many of these investigations of the texts have focused upon the psychoanalytic elements of Leiris's writing and the significance of both his experience of psychoanalysis and his position as a Surrealist dissident upon the style and structure of his writing. While these factors remain integral to a comprehension of *L'Âge d'homme*, they do not concern my own exploration of the text. I wish to reveal how Leiris evolves a visual imagination by inscribing the visual into the verbal, the extent to which he develops a 'plastic' self-retrospective and to what extent his identity is formed through pre-existing visual images or projections.

2 See Philippe Lejeune, *Lire Leiris: Autobiographie et Langage* (Paris: Klincksieck, 1975), Robert Bréchon, *L'Âge d'homme de Michel Leiris* (Paris: Hachette, 1973), and Roland Simon, *Orphée Méduse* (Lausanne: L'Age d'homme, 1984).

A Visual Memory

As Leiris's description of and references to images reveal, he is fully aware of their power to frame and objectify, therefore he attempts to resist photographic stasis in his writing. Instead of reproducing the images which haunt him – the schoolbook illustrations, the photographs of his aunt – Leiris reconstructs them in the narrator's memory, a reconstruction of images in which the reader necessarily colludes. Leiris describes the power that images hold for him as he sets out the metaphysics of his childhood in the prologue; for example, the recursive image on the tin of cocoa that indicates the mystery of infinity, the pictures in journals and textbooks that contribute to his understanding of ageing, maturity and death. Through his associative method, the image on the cocoa tin also becomes a *mise en abyme* of Leiris's autobiographical œuvre – representative of the open-endedness of the quest for identity.

The emotional intensity with which Leiris reconstructs such images opens up the possibility for his subjective re-entry into the objectified past. But this sometimes runs the risk of breaking the rigidly imposed stylistic framework of the narrative. Leiris expresses the desire, in laying down his tauromachic code (his set of aesthetic guidelines), for a 'cadre rigide imposé à une action où, théâtralement, le hasard doit apparaître dominé'. However, he later admits that, having presented the reader with a gallery of childhood recollections:

> Je n'attache pas une importance outrancière à ces souvenirs échelonnés sur divers stades de mon enfance, mais il est d'une certaine utilité pour moi de les rassembler ici en cet instant, parce qu'ils sont le cadre – ou des fragments du cadre – dans lequel tout le reste s'est logé.[3]

Rather than presenting an incomplete framework, Leiris seems to explode the limitations of the temporal frame as the past confronts the present in the realm of subjective experience. James Olney reminds us that the integration of past and present represents a hallmark of autobiographical narrative: 'Memory can be imagined as the narrative

3 *L'Âge d'homme*, pp. 40–41.

course of the past becoming present and [...] it can be imagined also as the reflective, retrospective gathering up of that past-in-becoming into this present-in-being.'[4]

Visual memories from childhood reveal to Leiris certain mysteries of life and serve to shape his views, his metaphysics. Leiris explains the formative images of his childhood as due to the inability, common to most children, to grasp abstract concepts, the need to visualize these ideas in order to comprehend them: 'Cette identification de l'âme à un colifichet [...] reposait, je crois bien, sur ma croyance en l'existence substantielle de mon âme, que je ne pouvais m'imaginer que comme un corps solide.'[5] So deeply ingrained in his memory are these images that he writes, for instance, of the image that formed his notion of suicide: 'cette association s'est tellement ancrée dans mon esprit qu'aujourd'hui encore je ne puis écrire le mot SUICIDE sans revoir le radjah dans son décor de flammes' (p. 31). This particular passage also reveals the extent to which these visual memories are synaesthetic. The word *suicide* is broken down by Leiris to expose the visual, oral and sensual connotations that it holds for him:

> il y a l's dont la forme autant que le sifflement me rappelle, non seulement la torsion du corps près de tomber, mais la sinusoïdalité de la lame; U I, qui vibre curieusement et s'insinue, si l'on peut dire, comme le fusement du feu ou les angles à peine mousses d'un éclair congelé, C I D E, qui intervient enfin pour tout conclure, avec son goût acide impliquant quelque chose d'incisif et d'aiguisé.

The sense of the word is contained in the shape of the syllables and the experience of memory which it evokes.

Leiris's account of his childhood metaphysics and the catalogue of images which gave rise to them serves as an introduction to the image which he claims inspired *L'Âge d'homme*: Cranach's painting of Judith and Lucretia (see figure 13):

> De ces deux créatures – auxquelles j'ai attaché, arbitrairement peut-être, un sens allégorique – il y a quelques années la vue m'a bouleversé [...] Et de là

4 *Autobiography: Essays Theoretical and Critical*, ed. by James Olney (Princeton: Princeton University Press, 1980), p. 241.
5 *L'Âge d'homme*, p. 38.

> m'est venu l'idée d'écrire ces pages, d'abord simple confession basée sur le tableau de Cranach et dont le but était de liquider, en les formulant, un certain nombre de choses dont le poids m'oppressait; ensuite raccourci de mémoires, vue panoramique de tout l'aspect de ma vie. (p. 41)

Leiris's impulse to write a 'confession' affirms his desire to write the truth, yet as *L'Âge d'homme* reveals, it is never as simple to confess as one might expect. Because the subject of autobiography is a self-representation and not the autobiographer himself, most contemporary critics describe this self as a fiction. When we locate the pressure to tell the truth in the context of the fictive self that is accountable for producing the truth, the problematical alliance between fact and fiction in autobiography begins to emerge. Confession, and consequently autobiography, is of a relational nature. The relational nature of the autobiographical pact depends on the authorization of the reader and the trust that the reader places in the 'truth' of the autobiography. Leiris perceives certain truths relating to his sense of identity within the Cranach painting. This external representation gives the reader an opportunity to locate the 'truth' of Leiris's subjectivity within a pre-existing material image. It is the authorization as well as the catalyst for the confession to follow.

In Leiris's writing, as in the work of his favourite painters (Masson and Bacon, amongst others), there is a constant oscillation between form and formation. He draws our attention to the process of writing, the subject engaged in the process of the remembering, but is simultaneously bound by necessary, self-imposed rules of form and style. As his life becomes literature, it is caught in the dialectic of tradition and innovation and this tension remains unresolved. Leiris's reading of the Cranach painting is a highly subjective one and is located in the eroticism of the image. Leiris forms his relationship to the painting through what he perceives as the reality of the image as it connects or relates to him:

> Le réalisme artistique ou littéraire ne 'chosifie' pas ce que de nos jours on appellerait le référent. Loin de rejeter celui-ci dans la froideur d'une prétendue objectivité, il s'efforce de traduire la relation concrète que nous avons avec lui et implique donc une large part de subjectivité! ce que je nomme la 'présence' n'est peut-être pas autre chose que la capacité que cet objet d'art plastique ou

d'écriture a de faire sentir avec force, par le spectateur ou le lecteur, l'existence d'une telle relation entre l'auteur et son referent.[6]

This passage not only reveals the nature of the relationship between Leiris and the painting but also what he perceives to exist between Cranach and his painting (thereby, also implicating Leiris's relation to his own writing).

In its production as well as in its consumption, the work of art confronts the spectator and the reader with difference, with the failure of interpretation to appropriate the art-object itself. As s/he interprets, the interpreter is confronted with a repeated failure and a continual desire to take possession of otherness and difference. The experience of difference is not only ever-present but also elusive and unlocatable. Leiris's transcription of Cranach's painting from the spatial sense of pictorial imagery into the temporal process of a written text is his attempt to subsume the 'difference' of the picture, to bring it into his own sphere of experience in an act of interpretative appropriation.

Projecting Identity

It is worth considering Leiris's descriptions of Judith and Lucretia in some detail:

> la première, Lucrèce, appuyant au centre de sa blanche poitrine, entre deux seins merveilleusement durs et ronds (dont les pointes semblent aussi rigides que des pierres ornant au même endroit un gorgerin ou une cuirasse), la lame effilée d'un poignard au but duquel perlent déjà, comme le don le plus intime pointe à l'extremité d'un sexe, quelques gouttes de sang, et s'apprêtant à annuler l'effet du viol qu'elle a subi, par un geste pareil; celui qui enfoncera dans une chaude gaine de chair et pour une mort sanglante l'arme bandée au maximum, telle la virilité inexorable du violeur quand elle était entrée de force dans l'orifice béant déjà entre ses cuisses, douce plaie rose qui peu d'instants après restituait la libation à pleines gorgées, exactement de même que la blessure – plus profonde, plus méchante aussi, mais peut-être encore plus

6 Leiris, *Journal 1922–1989* (Paris: Gallimard, 1992), p. 751 (23 January 1982).

Figure 13: Cranach, Lucretia Judith diptych
© Staatliche Kunstsammlungen, Dresden

enivrante – faite par le poignard laisserait jaillir, du fin fond de Lucrèce pâmée ou expirante, un flot de sang;
 la seconde, Judith, á la main droite une épée nue comme elle, dont la pointe meurtrit le sol à très peu de distance de ses orteils menus et dont la lame très large et très solide vient de trancher la tête d'Holopherne, qui pend, débris sinistre, à la main gauche de l'héroïne, doigts et cheveux mêlés pour une atroce union, – Judith, parée d'un collier aussi lourd qu'une chaîne de bagnard, dont le froid autour de son cou voluptueux rappelle celui du glaive près de ses pieds, – Judith placide et ne paraissant déjà plus songer à la boule barbue qu'elle tient à la main comme un bourgeon phallique qu'elle aurait pu couper rien qu'en serrant ses basses lèvres au moment où les écluses d'Holopherne s'ouvraient ou encore que, ogresse en plein délire, elle aurait détaché du gros membre de l'homme aviné (et peut-être vomissant) d'un soudain coup de dents.[7]

Both descriptions reveal the horrified fascination with which Leiris perceives the two women. They are devoid of feminine charm; his use of adjectives evokes monsters of nature, possessing more masculine than feminine attributes. The description of Lucretia, her breasts described as hard and round, no beguiling curves, likens her to the instrument of death that she holds in her hand. The act of penetration, like the thrust of the dagger, lends a rhythm to the description that climaxes with the 'flot de sang.' Far from an objective transcription of the painting, Leiris's art appreciation comes closer to that of Baudelaire's in its evocation of images, allusion and analogy. His subjective input is evident in the adjectives, similes and metaphors: the drops of blood on the tip of the dagger are like the gift 'à l'extremité d'un sexe,' the stiffness of the dagger is the same as 'la virilité inexorable du violeur.' In drawing this parallel between the act of rape and the act of suicide, Leiris imaginatively recreates and anticipates the past and future of the static image, re-animating the petrified heroine with the projective force of his imagination and lending attributes to the picture, such as sensual adjectives, that the medium of paint cannot convey and that were perhaps unintended by the artist. Similarly, the description of Judith recreates a woman whose deeds render her, in Leiris's eyes, barely human. She is an 'ogresse en plein délire', whose nudity, compared to the sword she holds, is infinitely more menacing than seductive. The horror of the act she has perpetrated is accentuated by the apparent nonchalance

7 *L'Âge d'homme*, pp. 142–43.

with which she holds the bloody head in her left hand. Again, Leiris's use of adjectives reveals the multisensual nature of his pictorial appreciation; the necklace Judith wears is both heavy and cold. Leiris's imaginative recreation of the painting's history also involves the participation of Holofernes – a drunken, perhaps vomiting victim.

Leiris acknowledges his subjective interpretation of Cranach's painting when he writes that his description leaves the women 'encore plus dépouillées qu'elles ne sont chez Cranach'. This is shortly followed by Leiris likening himself to Holofernes: 'Tel Holopherne au chef tranché, je m'imagine couché aux pieds de cette idole.' This recurring parallel is first drawn at the conclusion of the prologue when Leiris describes himself as Holofernes the hero: 'il me semble que le sujet pourrait se résumer ainsi: comment le héros – c'est-à-dire Holopherne – passe tant bien que mal (et plutôt mal que bien) du chaos miraculeux de l'enfance à l'ordre féroce de la virilité' (p. 42). The psychoanalytic implications of this identification have been commented on by previous critics and do not concern me here; what is significant is how this parallel, established from the outset, allows Leiris's subjective entry into the painting that is the source of his inspiration, and how this characterizes his emotional re-creation of the visual memories throughout the book.

Leiris's self-exploration is always in part an extension of his Surrealist nominalism, a quest for an intensity experienced within the act of writing and within the *fureur* of poetry. This is also reflected throughout his art criticism; Leiris admires artists who he feels share his aesthetic quest – the moment of tauromachic truth, confrontation with the self, a drive against the void: 'tentant de ramasser ma vie en un seul bloc solide (objet que je pourrais toucher comme pour m'assurer contre la mort, alors même que, paradoxalement, je prétendais tout risquer).' In an article of 1929, Leiris defines what it is he admires in Giacometti's sculpture:

> Il n'y a cependant rien de mort dans cette sculpture; tout y est au contraire, comme des vrais fétiches qu'on peut idolâtrer (les vrais fétiches, c'est-à-dire ceux qui nous ressemblent et sont la forme objectivée de notre désir), prodigieusement vivant, – d'une vie gracieuse et fortement teintée d'humeur,

belle expression de cette ambivalence sentimentale, tendre sphinx qu'on nourrit toujours, plus ou moins secrètement, au centre de soi-même.[8]

The parenthetical explanation reveals what Leiris seeks in the art he admires – an objective expression of his own subjective desires. Leiris seeks an art that appears to reconcile the objective or external expression of subjective longing with the evocation of that longing in the viewer. It is such a role that Cranach's painting plays in *L'Âge d'homme*.

Portraiture sets up a perpetual oscillation between observer and observed. The artist and his/her subject, whether it be another or the self, create a representation that combines the dual positions of passivity and activity. The notion of an intersubjective relation between subject and object, artist and sitter, makes possible the conceptualization of an interactive relationship – an oscillation which might eventually conflate object and subject. As a Surrealist, Leiris was aware of the apparent heterogeneity of the self that *écriture automatique* was intended to reveal; as a veteran of psychoanalysis, he was aware of the intersubjective components in the formation of identity. The collaborative or interactive nature of the relation between analyst and analysand is reflected in the dialogic nature of Surrealist enterprises. At the origin of the Surrealist movement is a collection of automatic texts, *Les Champs magnétiques* created by André Breton and Philippe Soupault writing in tandem with each other. With that experience still fresh in his mind, Breton, writing in the Surrealist manifesto, was adamant that Surrealist language was best adapted to dialogue and that it was committed to re-establishing the truth of dialogue.[9] This view of Surrealist automatism bears close similarities with Lacan's insistence upon the essentially dialogical nature of psychoanalysis. Leiris's knowledge of psychoanalysis, combined with his experience of Surrealism, where the technique of automatic writing was understood as fracturing an illusory unity of the self (the automatic message giving proof of an irreducible

8 Leiris, 'Alberto Giacometti', in *Documents* 4 (Paris: September, 1929), p. 210.
9 André Breton, *Manifeste du surréalisme* (1924) in *Œuvres complètes* (Paris: Gallimard, 1988), I, pp. 335–36.

heterogeneity within the self), prevents him from seeking to create the reassuring fiction of an autonomous ego.

The techniques of thematic association, discontinuity and disruption which Leiris retrospectively described as his *règle tauromachique* lead to a certain symbiosis of style and content: 'Identité, si l'on y tient, de la forme et du fond mais, plus exactement, démarche unique me révélant le fond à mesure que je lui donnais forme.'[10] However, this description of his technique is deceptively simple, belying the stylistic rigour that Leiris brought to his writing. It does nevertheless confirm Leiris's desire for an impression of spontaneity, whether real or contrived, his desire to render his experiences present to the reader. To create an 'authentic' self-portrait, Leiris realizes that the intimacy with one's self, which the term 'identity' presupposes, must be broken down and along with it, the cohesiveness of the self-image. The onus lies with the reader to reconstitute both the self-image and the identity of the writer.

Leiris's technique of discontinuity and fragmentation undoes the tradition of self-representation within autobiography that attempts to represent the subject as a coherent, specular entity. Such a specular subject – the result of pure deception – belongs to the Lacanian order of the imaginary. Lacan contends that formal stagnation marks all the portraits which the subject produces of itself in the imaginary. The task of the analyst is to erase these false icons, to suspend the subject's certainties and thereby free up desire. As a 'photomontage' of images, memories, dreams and extracts – a network of signifiers – Leiris's subjectivity manifests itself through a series of provisional self-portraits.

The intensity of experience revealed by Leiris in *L'Âge d'homme* is most often related to an interruption of the continuum of the consciousness brought about through the unexpected collision of the object/subject. The importance of this experience, or the vision of this ideal experience, and its relevance to Leiris's work is defined in his notion of *le sacré*, which he developed with Georges Bataille and to whom *L'Âge d'homme* is dedicated. The significance of *le sacré* is explored in the 1929 Giacometti article:

10 *L'Âge d'homme*, p. 21.

> Il y a des moments qu'on peut appeler des crises et qui sont les seuls qui importent dans une vie. Il s'agit des moments où le dehors semble brusquement répondre à la sommation que nous lui lançons du dedans, où le monde extérieur s'ouvre pour qu'entre notre cœur et lui s'établisse une soudaine communication [...] La poésie ne peut se dégager que de telles 'crises', et seules comptent les œuvres qui en fournissent des équivalents.[11]

In the sculptures of Giacometti, the paintings of Picasso, Masson and Bacon, Leiris admires the artists' ability to disrupt a sense of continuity and to shatter the apparent homogeneity of the quotidian.

The entirety of Leiris's art criticism is united by a few specific essential criteria. Above all, the trait Leiris exalts in his art criticism is realism, 'ce qu'est au vrai notre condition propre'.[12] In his *Journal*, he writes of Bacon, 'un portrait peint par Bacon semble montrer, d'emblée, son modèle en tant que créature rongée. Réalisme, certes, mais réalisme en quelque sort *prophétique*'.[13] It is this sense of reality that Leiris seeks to convey by imposing his tauromachic code in an effort to communicate a truth that is as objective as possible.

In order that *L'Âge d'homme* conform to Leiris's self-imposed tauromachic code, it has to involve the taking of risks, to present a challenge not only to the reader but also to the author. Leiris perceives this sort of risk in the art of André Masson, 'guerre inexpiable du créateur avec lui-même et du sujet avec l'objet, dichotomie féconde, joute sanglante dans laquelle l'individu entier est engagé, ultime chance pour l'homme – s'il consent à y risquer jusqu'à ses os – de donner corps à un *sacré*'.[14] This notion of an art in which the artist is fully engaged – mind and body – is elaborated upon in the prologue to *L'Âge d'homme*: 'Il s'agissait moins là de ce qu'il est convenu d'appeler "littérature engagée" que d'une littérature dans laquelle j'essayais de m'engager tout entier. Au-dedans comme au-dehors.'[15] Leiris seeks to imbue his autobiography with the sort of realism that he admires in Bacon's work, a realism that is subjective because he is wholly engaged with his narrative, and a realism that involves the

11 Leiris, 'Alberto Giacometti', p. 209.
12 Leiris, *Francis Bacon* (Paris: Albin Michel, 1983), p. 46.
13 *Journal 1922–1989*, (21 January 1981).
14 Leiris, *André Masson* (Rouen: Imprimerie Wolf, 1940) p. 63.
15 *L'Âge d'homme*, p. 15.

taking of risks because of the intensity of that engagement. The visual manner in which Leiris evokes and reconstructs his past facilitates the technique of stream-of-consciousness memory association but it also allows the reader to enter into and participate in the pictures of his past. These pictures are all the more potent for their textual reconstruction, which, as opposed to any form of static image, are multisensual or synaesthetic in their evocations of the past.

The Fallibility of Self-Representation

Autobiography, however 'authentic', fragmented, or faithful to the discontinuity of experience, remains an exertion of control over self-image. In writing an account of his/her life, the writer 'authorizes' the life – an *aura* of authenticity surrounds the autobiographer's tale because the identification between writer and text is explicit. Nevertheless, in writing the life, the autobiographer must also stand apart from the self, trying to envisage and read the self from a distance imposed by the passage of time. *L'Âge d'homme* reveals how a creative, constitutive relationship exists between image and identity in autobiographical writing; how the visual memory, the reading of images from the past – be they fixed in an external materiality or fluid in the imagination – is integral to Leiris's construction of identity. Leiris's fixation upon the Cranach painting unfolds in a series of readings of that image – readings that structure the text because the painting comes to structure Leiris's self-identity. These readings are concerned with the act of interpreting visual memories in a way that becomes integral to the very construction of identity. Both his sense of self-identity and the narrative he recounts about the formation of that identity are evoked in repeated attempts to fix and understand that image, which expands and shifts as he returns again and again to read its significance.

Leiris establishes the necessary distance between himself and the self in formation on the page through his projective identification with Cranach's painting. In the attempt to represent, and perhaps reconcile,

the apparently contradictory facets of his character, the figures in the painting become his alternative 'doubles'. Freud, in the essay on *The Uncanny*, recounts an incident that occurred on a train journey when he caught sight of his face reflected in a swinging glass door and, for an instant, failed to recognize it as his own. He recalls having a hearty distaste for the bearded stranger lurching towards him and wonders if his reaction was not 'a vestigial trace of the archaic reaction which feels the 'double' (the mirror reflection) to be something uncanny (*unheimlich*).[16] Leiris recognizes his 'doubles' within the three images contained within the painting: the self-sacrifice of Lucretia, the bloody bravery of Judith, and Holofernes's severed head.

The quotation that Leiris selects to head the chapter entitled 'Tragiques' is indicative of the role that the Cranach painting plays in the construction of *L'Âge d'homme*. Goethe's Faust sees in the Medusa the image of his beloved Margaret. Mephistopheles warns him, 'c'est de la magie, pauvre fou, car chacun croit y retrouver celle qu'il aime'.[17] In the figures of Lucretia and Judith, Leiris perceives the characteristics of the women whom he has known and loved. He projects onto these women the entirety of his sexual history, and thematically the painting serves as the structuring pivot of the autobiography. The image of Lucretia in tears gives rise to the section on wounded women; Judith is the figure around whom are gathered the images of death and tragedy. 'La Tête d'Holopherne' groups a series of recollections ostensibly inspired by the theme of wounded men. This, however, provokes one of the author's critical interventions in the text with the fear that 'ce classement n'était en fin de compte qu'une sorte de guide-âne abstrait' (p. 128). Leiris finally combines the names of Lucretia and Judith to write a chapter which begins with the tale of Cleopatra, whom Leiris considers as uniting the characteristics of the other two women, 'non plus seulement en tant que femme à vie déréglée [...] mais en qualité de créature se supprimant, l'on s'aperçoit qu'elle résume ces deux aspects de

16 Sigmund Freud, 'The Uncanny' (1919), in *The Standard Edition of Complete Psychological Works,* trans. by J. Strachey (London: Hogarth Press and the Institute of Psycho-Analysis, 1953–74), XVII, p. 248.
17 *L'Âge d'homme*, p. 43.

l'éternel féminin, ma Lucrèce et ma Judith, avers et revers d'une même médaille' (p. 142).

These passages, linked as they are to the Cranach painting, underscore how the visualization of his memory is integral to the formation of Leiris's identity as he writes. Both the subject of the book and his present subjectivity seem embodied in this image. If the image incarnates Leiris's self, what is required of him now in the autobiographical act is to read into this image a meaning and an identity. Leiris orients his book around an image because what that image evokes for him can say more about his life than any conventional autobiographical narrative might. Leiris makes the reader aware of the inherent open-endedness of the quest for identity; in so doing he makes autobiography a process that spawns self-estrangement as much as self-retrieval. The juxtaposition and layering of visual memories sets aside the story as narrative progression, or the straight line that leads to a centre. The way is through the Cranach painting, or rather, the story evolves out of the painting that is its centre. Event and identity unfold in a fragmented, non-chronological way as evocations born of an image. The reading of the image entails that self-representation becomes a form of self-analysis which turns on the retrospectively constructed meaning of an image. The visual image is privileged over narrative.

Leiris admits the inevitable fallibility of his visualization of the past. After relating his memory of the *Contes d'Hoffmann*, he writes:

> J'arrive à le reconstituer ici d'après mes souvenirs, y joignant l'observation de ce que je suis devenu depuis lors et comparant entre eux les éléments anciens ou récents que me fournit ma mémoire. Une telle façon de procéder est peut-être hasardeuse, car qui me dit que je ne donne pas à ces souvenirs un sens qu'ils n'ont pas eu, les chargeant après coup d'une valeur émotive dont furent dépourvus les événements réels auxquels ils se réfèrent, bref, ressuscitant ce passé d'une manière tendancieuse? (p. 51)

Such self-doubts and questioning permeate Leiris's text, highlighting the distinction between the past self of memory and the present writing self. Leiris uses Cranach's painting as a reference point to draw together his memories and classify them in a manner which, he feels, best demonstrates the contradictory elements of his personality, thus attempting to breach the divide between past and present selves.

Suggested Reading

Michel Beaujour, *Miroirs d'encre: Rhétorique de l'autoportrait* (Paris: Seuil, 1980)
Michel Leiris, *L'Âge d'homme* (Paris: Gallimard (Folio), 1995)
—— *Bacon le hors-la-loi*, including the essay 'Le Grand Jeu de Francis Bacon' (Paris: Fourbis, 1989)
Philippe Lejeune, *Le Pacte Autobiographique* (Paris: Seuil, 1975)
Catherine Maubon, *Michel Leiris: en marge de l'autobiographie* (Paris: J. Corti, 1994)
Michael Sheringham, *French Autobiography: Devices and Desires* (Oxford: Clarendon Press, 1993)

ALISTAIR SWIFFEN

Seeing Double/Hearing Things: In(s)anity in the *Aumonymes* of Robert Desnos

Our felicitous understanding of wordplay relies upon the comprehension of language as both a visual and an aural phenomenon. To follow the pun, the reader must have the mental capacity to hear a single sound and to visualize it in two different graphic forms. At the same time, s/he must be able to derive a particular sound pattern from two different graphical structures. Yet for all the sophistication of its auditory-ocular interplay, the pun still constitutes one of the most inane forms of humour known to the western world. It elicits groans almost everywhere, and nowhere more so than in France. There, as elsewhere, its effects have been banalized, because the form in which it is presented has been standardized. (Just think of the banks of ready-made 'M. et Mme. et leur fils' jokes and the syllabic riddles in the form, 'Mon premier est...', etc.)[1]

However, the works of Robert Desnos in the early 1920s recognize the virtues of the pun or *homonyme*.[2] They use it to magnify

1 Of the former, the most original example encountered by the author is as follows: 'David Bowie et Lady Di ont deux fils. Comment s'appellent-ils? Bowie, Ken et Alain Di.' (*Bon weekend et à lundi.*) This is an exceptionally subtle variant on the standard theme. Most cases are less complex. Take for example this gem, which relies upon pronunciation *à la rouennaise* to work at all: 'M. et Mme. Savoiture d'Anson-Garage ont un fils. Comment s'appelle t il? Igor.' (*Y gore* [il gare] *sa voiture dans son garage.*) An apt example of the latter for a discussion of inane language is the following: 'Mon premier est une salade, mon deuxième est une salade, mon troisième est une salade, mon quatrième est une salade, mon cinquième est une salade, mon sixième est une salade, mon septième est une salade et mon huitième, également, est une salade. Les huit scarolles.' (*Lewis Carroll.*) Mes remerciements à Camille et à Fred.
2 Robert Desnos (1900–1945), early surrealist, poet, pioneer in radio entertainment, novelist, painter, sometime screenwriter, art critic, resistance member, victim of Nazi deportation. Without Desnos's extraordinary performances under

the hidden aspects and amplify the unconscious resonances of everyday language. The texts, *Rrose Sélavy*, *L'Aumonyme* and *Langage cuit*, stand out in particular.[3] They revitalize the pun as an apparatus of investigation. Through wordplay, the texts explore the prevalent definitions of social and psychological normality. They also examine the relationship between those definitions and linguistic patterns, visual and aural.

Rrose Sélavy famously takes its title from Marcel Duchamp's female alter ego.[4] In this text, Desnos imitates the anti-aphoristic wordplay of the dragged-up Duchamp. The maxim is the form *par excellence* of received wisdom. Here however, it is subverted by its combination with the pun, the epitome of the inane in language. As a result of this stylistic blend, proverbial knowledge is twisted to offer a more disconcerting vision of the world. And this process of subversion is nothing if not self-reflexive. The fourth warped aphorism of *Rrose Sélavy* takes the rogue form of a pointed question. It knowingly asks, 'La solution d'un sage est-elle la pollution d'un page?'.[5] The relationship of difference and proximity between meaningful discourse and meaningless babble is here taken up as the

apparent hypnosis, it is unlikely that André Breton would have kept his faith in Surrealism or that the adjective *surrealist* would have entered common usage in English.

3 These texts were written in 1922–1923. They were not published collectively until 1930, when they appeared in the book, *Corps et biens*. See Robert Desnos, *Corps et biens* (1930), (preface by René Bertelé) (Paris: Gallimard, 1968). All other references are to this edition, unless otherwise stated. For *Rrose Sélavy*, see pp. 31–46. For *L'Aumonyme*, see pp. 47–68. For *Langage cuit*, see pp. 69–86. Excerpts from all three texts appeared between 1922 and 1928, in the revues, *Littérature* (*nouvelle série*) and *La Révolution Surréaliste*, together with variants which were cut in the 1930 versions. For further details of the publishing history of *Corps et biens*, see Marie-Claire Dumas's notes in Desnos, *Œuvres* (Paris: Gallimard, 1999), pp. 144–150, 166–177, 490–491 and 588–591.

4 Marcel Duchamp (1887–1968), avant-garde artist associated with Cubism, Futurism, but above all Dada. Famously photographed in drag as Rrose Sélavy by Man Ray, 1920–1921. (See Desnos, *Œuvres*, p. 146.) In the early twenties, Duchamp composed a number of subversive aphorisms as Rrose. André Breton championed these productions in the fifth edition of *Littérature* (*nouvelle série*) (1 October 1922), pp. 7–11.

5 *Corps et biens*, p. 33.

text's overt subject matter. The open discussion of these concepts underscores the work's implicit formal exploration of the limits of Reason. Indeed, at this point in the text, both form and content go so far as to suggest that the definitions of good sense and gibberish may be imploded.

Wisdom is here seen as a pollutant, a harmful addition to a healthy area. More often it is inanity which is defined as the undesirable supplement to normative discourse, the archetype of linguistic pollution. However, the fourth aphorism of *Rrose Sélavy* dismisses the usual opposition between learned advice and logorrhœa. Instead, it establishes an equivalence between supposedly wise words and nonsense, between serious philosophy and the flippant pun. Yet inanity can also be an attribute of thought and thus of the mind. It is notable that Desnos does not ask, 'La solution d'une sagesse est-elle la pollution d'une page?' Desnos humanizes his page and matches him with a human sage rather than an impersonal 'sagesse'. In so doing, the poet brings a psychological aspect to the question of what distinguishes significant discourse from meaningless babble. Desnos effectively dissects the impersonal force of inanity with an 's' for subject and invokes the notion of insanity.

In this maxim, the constitution of nonsense and sense is perceived as inextricably linked to the composition of their homologues in psychological terms: madness and sanity. If there is an equivalence between wisdom and inanity, there is also one between psychological normality and madness. In elevating the pun to the same level as the philosophical dictum, Desnos also brings the asylum into a conversation with the university. It comes as no surprise, then, that motto number eight of the sequence affirms an interest in lunacy and does so with the eloquence of a professor of rhetoric: 'Au pays de Rrose Sélavy on aime les fous et les loups sans foi ni loi.'[6]

However, if *Rrose Sélavy* sets out the field of philosophical investigation proper to Desnos's poetry, it does little more than that. Here there is very little thematic exploration of insanity beyond its mention. As such, this collection of anti-aphorisms scarcely moves beyond the conventional wisdom of the proverbs which it lampoons;

6 *Corps et biens*, p. 34.

pick up any *dictionnaire de proverbes et dictons* and under 'la folie' you will see almost nothing but witty paradoxes extolling the wisdom of the mad. So much for the content of Desnos's maxims. Perhaps the form of *Rrose Sélavy* offers a more substantial insight into madness – say, from a linguistic perspective.

As we shall see later, certain psychotic conditions involve a use of language which privileges sound patterning over standard syntax. The pun does repeat this tendency to varying degrees. Its defining feature is its unusually acute attention to sound. We consider the pun to be so inane, precisely because it indulges the aural features of language more than we normally do. Yet in *Rrose Sélavy* the pun does not reject syntax altogether. In this concession it is less extreme than many sound-driven texts from the asylum. The form of *Rrose Sélavy* may touch on the limits of Reason. Its combination of the pun and the maxim may suggest that the line between pertinent insight and impertinent prattle is less clearly drawn than we might commonly assume. It does not, however, take us very far along the wards of the mental hospital.

Nevertheless, *Rrose Sélavy* is just the beginning of Desnos's exploration of madness, sanity and the areas in which these two categories might meet. *L'Aumonyme* and *Langage cuit* offer a far more significant investigation into prevalent definitions of social and psychological normality and into their relationship to language. In these later texts, Duchampian puns are finally set to work in an unusual context, in much the same way as Duchamp's urinal was turned into a fountain by its inverted placement in an art gallery.[7]

In the 'Élégant Cantique de Salomé Salomon' (see appendix to this chapter) Desnos famously puns on the opposition, 'Aime haine'.[8] Love and hate are recast in the thirteenth line as 'aimai ne' or '[I] loved not'. They are also reversed in the twelfth line as 'haine aime'. This alternative order is suggested in the eleventh line by its

7 *Fountain, by R. Mutt* remains Duchamp's most notorious work. It was rejected by the committee of the 1917 Salon of independent artists in New York. That rejection, however, secured the piece's notoriety and assured it future museum space.

8 All references to 'Élégant Cantique de Salomé Salomon' are as follows: *Corps et biens*, p. 77.

homophonic double, 'Et n'aime' or 'And do not love'. At this stage, it might seem that Desnos has exhausted the possibilities for homophonic play which are offered by his initial pair of words. However, after this exercise, Desnos takes the pun where it has never before been taken, at least in the world outside the madhouse.

He now reduces wordplay to one of its basic components, phonetic duplication. The poet transforms the monosyllabic French words which signify love and hate into single letters. Those letters present the phonetic values of 'aime' and 'haine' in the most uncomplicated, non-specialist way. Thus the quatrain, 'Aime haine | Et n'aime | haine aime | aimai ne' is rewritten as a *chassé croisé* of 'M's and 'N's: 'M N | N M | N M | M N'. These letters may have a clear phonetic value. They do not, however, have any immediate semantic worth. Through the visual play of the pun emotional concepts are placed on the same level as nonsensical babble. Desnos shows us visually that meaning must be expressed through phonemes, which can just as easily convey no meaning at all.

Desnos here goes some way in deconstructing the opposition of logorrhœa and sense. At the same time, however, he also recreates the association between these perceived categories of language and matters of psychology. The very title of 'Élégant Cantique de Salomé Salomon' is a clear reference to the *Song of Songs*. Although the authorship of that biblical classic is disputed, it remains firmly linked with the figure of King Solomon.[9] By naming the king in his title, Desnos makes that association explicit. Yet despite the enduring myth of Solomon as author, the truly popular Solomon legend is still centred on the good sense of the man rather than on the wisdom of writings attributed to him apocryphally. Indeed, Desnos seems to concur with this received view to some degree; his title may spell out the king's links with literature, but it also emphasizes the importance of Solomon himself. By referring directly to Solomon in his title, Desnos shifts the main focus of his allusion from the text of the *Song of Songs* to the man wrongly accredited with its authorship.

9 For details of the disputed authorship of *The Song of Songs*, and for a clear assessment of Solomon's reputation, see the *Dictionnaire de la Bible*, ed. by André-Marie Gérard with Andrée Nordon-Gérard (Paris: Robert Laffont, 1989). The relevant entry is under 'La Cantique des Cantiques'.

By invoking Solomon, then, Desnos reminds us of the realm where meaningful discourse comes into contact with the subjective mind. Language is humanized when the poet attributes it to an anthropomorphic character, just as it was in the puns of *Rrose Sélavy*. Moreover, another strategy of *Rrose Sélavy* is repeated here, when the signifier of human wisdom is subverted by a play on words. In this case Desnos reminds us that the *Song of Songs* is narrated from at least two different gender positions. It is the confused gender of that narrator which makes the authorship of the text uncertain. Desnos magnifies this trait in his response to the song.

In his version, the name, Salomon, generates an association with its feminine equivalent, Salomé. The two names then combine to form a title which loudly proclaims the song's origin in an uncertain gender. (Here Salomé is to Salomon what Rrose Sélavy is to Duchamp.) This act of linguistic transvestism subverts the notion that King Solomon might have a stable identity. It thus also undermines the idea of the king's reliable status as a wise man, which lies at the very heart of his legend. In his 'Cantique', then, Desnos promotes a vision of Solomon as confused, but occasionally lucky in making useful decisions.

According to Desnos, Solomon is in two minds as to his name. By the same dint, he is unsure whether he is a man or a woman. Two important markers of his identity are thereby changeable. Yet Desnos does not stop his subversion of Solomon's psychological reliability here. If the language of sense and wisdom can be linked by a proper name to the psychological category of sanity, nonsensical babble can equally be related by two names to questions of mental health. What goes for the so-called norm also goes for the supposed aberration. Following this principle, Desnos fills his song of a troubled Solomon/Salomé with seeming gobbledegook.

Desnos's monarch assaults us with a text composed largely of syntactic irregularities and unyielding alliteration. According to the young Jacques Lacan, such linguistic traits can be presented by the texts of certain psychiatric patients. Regarding one case, Lacan states that 'le lien syntaxique est détruit et les termes forment une suite

verbale organisée par l'association assonantielle du type maniaque'.[10] Desnos could not have read this text-based diagnosis before writing his 'Cantique'. The poem itself first appeared in 1923, almost a decade before Lacan's article on psychotic writing. However, Desnos seems to have anticipated Lacan's diagnosis: the poet is a point of reference in the then psychiatrist's article. Lacan apparently considers *Corps et biens* to offer worthy examples of simulated psychotic 'automatism'.[11] Moreover, even in the twenties, Desnos seems to have been aware of the proximity of his work to psychotic writings.

The poem which follows the 'Cantique' in *Corps et biens* is called 'Le Bonbon'.[12] It involves a similar rejection of normal syntax and an analogous fascination with repetitive sounds. It also concerns a king in two minds; it opens with the double proclamation: 'Je je suis suis le le roi roi | des montagnes.' The formal and thematic similarities between the poems, together with Desnos's decision to place them side by side in *Corps et biens*, would suggest that they form a pair. What is true for 'Le Bonbon' is likely to be true for the 'Élégant Cantique de Salomé Salomon'. Elsewhere Desnos presents 'Le Bonbon' as the work of a psychotic Polish woman.[13] Clearly, even in 1924, Desnos associates the poems of *Langage cuit* with madness. And if the king-king of 'Le Bonbon' is psychotic, we can reasonably hypothesize that Salomon/Salomé is presented to us as insane.

The expression of that insanity predicts Lacan's description of psychotic writing to the letter. To the thirteenth and fourteenth letters of the alphabet, to be precise. The rewriting of 'aime' and 'ainc' as letters is echoed in the first half of the 'Cantique'. The opening of the poem is constructed by the alliterative patterning of words whose predominant consonant sounds are 'M' and 'N'. Viewed semantically, the links between these words are often unclear without considerable interpretative work on the part of the reader. If the opening line, 'Mon

10 Jacques Lacan, 'Écrits "inspirés": Schizographie' (1931), in *De la psychose paranoïaque dans ses rapports avec la personnalité* (suivi de *Premiers écrits sur la paranoïa*) (Paris: Seuil, 1975), p. 378.
11 Ibid., p. 380, n. 9.
12 All references to 'Le Bonbon' are as follows: *Corps et biens*, p. 78.
13 See 'Le génie sans miroir', attributed to Éluard to bypass an editorial moratorium on Desnos, in *Feuilles libres*, 35 (January–February 1924). The article is reprinted in Desnos, *Œuvres*, pp. 223 ff.

mal meurt mais mes mains miment', does make semantic as well as grammatical sense, the following sentence, 'Nul nord | Même amour mol?' presents itself as pure nonsense. That is, at least to begin with. The least that we can say is that the process of alliteration here takes precedence over the clear arrangement of signified concepts into something approaching a dictum. We have now left the clear aphoristic forms of *Rrose Sélavy* far behind us. Instead, we are confronted with the strange and compulsive language of the psychotic.

Yet twice within this mass of 'M's and 'N's, a self-reflexive reference is made to the neural system. This network is supposedly the site of troubles which generate, among other effects, strange and compulsive linguistic behaviour in the individual. If the poem's ninth line, 'Néant nié nom ni nerf n'ai-je!', denies the existence of a neural network, it nevertheless brings up such a phenomenon by opposition to it. Furthermore, the comprehensible opening line of the poem is completed by a second line of easily understood language, to give the following proposition: 'Mon mal meurt mais mes mains miment | Nœuds, nerfs non anneaux.' The idea that pain can be relieved by the miming of neural knots recalls Freud's observations of his hysterical patients' talking hands. It is also reminiscent of the symptoms displayed by certain psychotics who walk in circles and twist their bodies into knots. The poem's opening gambit clearly associates the linguistic cascade which follows with the *délire* of the insane.

From puns based on the words, 'haine' and 'aime', Desnos produces apparent linguistic incoherence which recalls the psychotic symptom of 'hearing things' or 'hearing voices'. The exemplary cases of President Schreber and Louis Wolfson demonstrate how the so-called voices encountered by some psychotics are clearly a reaction to the phenomenon of meaningful language in the external world. The linguistic productions of these voices make no sense to most people, but do to the psychotic who can sometimes make sense of them using recognizable language: both Schreber and Wolfson have effectively published a grammar of their private language.[14] In a similar way

14 Daniel-Paul Schreber, *Denkwürdigkeiten eines Nervenkranken, von Dr. jur. Daniel-Paul Schreber, Senätspräsident beim kgl. Oberlandsgericht Dresden a-D.-* (Leipzig: Oswald Mutze, 1903). English translation: *Memoirs of my nervous illness*, Ida Macalpine and Richard Hunter (London: W.M. Dawson and Sons,

Desnos's puns reflect the productions of normative language, but turn them into seeming nonsense. The radical breakdown of abstract concepts to their constituent phonemes in *L'Aumonyme* and *Langage cuit* brings this transformation much closer to the disturbing linguistics of the insane than do the perfectly balanced witticisms of *Rrose Sélavy*.

Desnos's programmatic poem, 'P'Oasis' (see appendix), makes the most direct association between this extreme form of punning and insanity.[15] Here again, words from normal French are rewritten as a combination of letters and other words. New visual forms are found, which re-present the constituent phonetic values of the initial words. Yet this time they are most definitely attributed to a character who is certified insane.

Early in the poem, Desnos assumes the role of the curious heroine from Perrault's fairytale, *La Barbe Bleue*.[16] In the original fairytale, the heroine's curiosity is one-sided: she is almost fatally inquisitive. Her desire to look into the forbidden final room of her husband, Bluebeard's castle nearly costs her her life. She nevertheless has enough common sense to enlist the help of a very practical, clear-sighted sister, 'Sœur Anne', and two powerful brothers in making her escape. In Desnos's text, however, the heroine is rendered doubly curious. She has most uncommon sense as well as a thirst for knowledge.

When she first appears in 'P'Oasis', the heroine is evidently already in trouble. Her first utterance imitates the famous cry for help which punctuates Perrault's tale: '— Sœur Anne, ma Sainte Anne, ne vois-tu rien venir...'. She is in danger, but at least she seems to be working sensibly towards her escape. Her call diverges slightly from the version in Perrault. The original contains no invocation of Saint Anne. However, if anything, this divergence should strengthen the heroine's chances of escape in the eyes of traditionalists. Saint Anne

1955). Schreber's famous *Grundsprache* reacts to normal German by offering an alternative language of supposedly greater clarity and purity. Louis Wolfson, *Le Schizo et les langues* (Paris: Gallimard, 1970). Wolfson's bizarre French offers a way of circumventing an aversion to his mother-tongue, English.

15 All references to 'P'Oasis' are as follows: *Corps et biens*, p. 65.
16 Charles Perrault, *La Barbe Bleue*, in *Histoires ou Contes du temps passé*, published in Paris in 1697.

is the mother of the Virgin Mary and thus the grandmother of Christ.[17] In other words, she offers a direct line to Catholic salvation. Yet Desnos is no Catholic. He apparently remembers Rimbaud's subversion of Perrault's cry in the poem, 'Fêtes de la Faim'.[18] Rimbaud suggests that if Sœur Anne were really far-sighted, she would save herself and not wait in peril with her sister: 'Ma faim, Anne, Anne | Fuis sur ton âne.' Rimbaud implies that if Sœur Anne can be relied upon to help her sister, she must be mad.

Desnos learns from Rimbaud, but he also moves past the latter's cynicism. Rather than scorn the figure of a mad, but helpful Sœur Anne, he champions her in her useful insanity. Desnos recognizes that her very name connects her to the asylum. His invocation of Saint Anne is not an act of devotion, but an excuse to allude to another famous 'Sainte-Anne' – the famous mental hospital in the fourteenth *arrondissement* of Paris. Thus, after the ellipsis Desnos's call for Sœur Anne diverges significantly from Perrault's. It effectively sends Sœur Anne to the institution where the young Lacan worked: 'Sœur Anne, ma Sainte Anne, ne vois-tu rien venir... vers Sainte-Anne?' Sœur Anne's lookout tower is now the madhouse, but it is precisely her position among the insane which makes her see things so clearly. As we shall see, a philosophical Bluebeard threatens Desnos's heroine. She risks suffocation in Cartesian logic, unleashed as a consequence of her intellectual prying. In this situation, only the visions of a psychotic can save her.

For the most part, Sœur Anne replies to her sister's first call in comprehensible, normal language. Yet she does use an unusual archaism in a rather odd metaphorical construction: 'Je vois les pensées odorer les mots.' The verb *odorer* did exist in medieval French, but it has long been obsolete. In its day, it was usually employed in the intransitive, to indicate the scented quality of its subject. Sœur Anne's use of the verb in a transitive form is therefore odd. Indeed the verb's use here is particularly disconcerting, because it is used to convey the most abstract of notions – the relationship

17 I am very grateful to Dr. Sarah Kay for pointing out the genealogy here.
18 All references to 'Fêtes de la Faim' are as follows: Arthur Rimbaud, *Œuvres Complètes*, ed. by Antoine Adam (Paris: Gallimard (Pléiade), 1972), pp. 83–84. The poem itself probably dates from 1872.

between language and thought – in a very concrete, sensorial manner. Even when she makes apparent sense to the most rational reader, this character has a troublesome relationship to language.

Sœur Anne is later asked, in a slightly altered form, '— Sœur Anne, ma sœur Anne, que vois-tu venir vers Sainte-Anne?'. This time, her reply is even stranger: 'Je vois les Pan C'. Her extraordinary answer continues by referring to 'crânes KC', and to 'mains DCD'. However, this bizarre language differs only from normal text in its visual form. Behind her replies, we can easily recognize phonetic patterns which are known to us in connection with other visual forms: 'pensées', 'cassés' and décédées'. Phonetically, Sœur Anne uses an absolute copy of rational language. Its graphic form, however, can only make sense if the reader understands it on a phonetic level and revisualizes it using officially recognized words.

Desnos here reveals the workings of the pun as they are described in our opening comments. His reader must negotiate the complex interplay of aural and graphic structures which make wordplay possible. In her mind, s/he must be used to hearing the phonetic pattern associated with each visual form on the page. In her mind's eye, s/he must be in the habit of envisaging all other possible graphic representations of the same phonetic pattern. In other words, s/he must hear things and see double whenever s/he reads a text.

What differentiates Sœur Anne from the successful navigator of Desnos's puns – at least ostensibly – is her inability to see double or hear things with sufficient clarity. She can apparently only conceive of the sounds she makes as a collection of fragments, such as short words or letters. She can seemingly visualize them in loose conglomerations, but not as longer words. Alternatively, we might suggest that she has only been able to derive those sounds from certain visual forms. Perhaps she cannot glean them from other graphic structures, whose appearance on the page she nevertheless recognizes. Either way, this lack of mastery over the visual or aural side of language not only sets her apart from felicitous readers of Desnos. It also places her in the asylum. She seems unable to conceive of the elements, air and water, when she hears the phonetic productions 'RLO'. This apparent incapacity is the symptom which separates her from the sane.

The sane are not obliged to see double. It is sufficient that they share their visual and phonetic conception of language with the ruling majority. Being able to discriminate between meaningful and nonsensical graphic denotations of any given sound pattern, the sane appear to control both the visual and aural aspects of language. However, it is the amateur of wordplay who most evidently demonstrates his or her control of language. The creation and appreciation of the pun involves an active demonstration that one can manipulate language in its aural and visual dimensions. Such active control is particularly present in the linguist who likes traditional wordplay. From a single phonetic pattern, s/he can extract two graphical constructions which are acceptable to linguistic norms. However, the same active linguistic control is also present in the reader of Desnos. S/he can decipher poems where only the implicit visual form is acceptable to the norm. S/he can interpret the form on the page which might be stigmatized as pathological.

It might seem that the reader of Desnos comes dangerously close to insanity in her ability to find meaning in ostensibly abnormal language. S/he is, however, saved from the madhouse, because s/he obtains a meaning from the eccentricities of the text which sane people can understand. Indeed, they can quite easily understand how s/he obtains that meaning, even if they themselves could not decipher the language of Sœur Anne without help. With hindsight, all sane people can understand the reader's translation of Desnos's puns. In this poem-programme, however, Desnos does not stop at offering a practical demonstration of the difference between the pun and the verbal *délire* of the psychotic. By entitling the piece 'P'Oasis', he turns it into the statement of his poetics. Here is a description of poetry conceived of as fertile discourse, the greenery in an expanse of desert. That description implies the entirety of the poem, which combines moments of classical rationalist discourse alongside Sœur Anne's apparent insanity.

What Desnos seems to be proposing is nothing short of a general aesthetic theory developed from his particular experience of the pun. The artist should be free to study and try to understand apparently irrational discourses as well as the canonical texts of Reason. Art should combine these discourses. On their own both are ultimately

unproductive. Without the consensual discourse of rationalism, no link exists between individuals. Every psychotic becomes trapped in his or her own private language. As a result, society loses the potential conceptual wealth that each hermetic discourse might contain. Without a common discourse Sœur Anne's writing is reduced to pure babble. On the other hand, if the common discourse dominates to such a degree that it physically silences all alternative linguistic productions, then society again loses the ideational potential of every Sœur Anne. Her language is again treated unequivocally as nonsense.

Desnos shows that linguistic or discursive inflexibility produces a circularity and repetitiveness of ideas. Such uniformity eventually provokes frustration within the subject. The inclusion of moments of Cartesian rationalism in 'P'Oasis' indicates its importance for Desnos's aesthetics. Nevertheless, his portrayal of that discourse in itself is far from affirmative. Desnos presents the language of Reason through the classic Cartesian *topos* of thought as a tree. He thereby reminds us just how fixed in cliché rationalism has become.

The opening line of the poem is a philosophical assertion. Its language is precise and elegant, yet irritatingly absorbed in itself: 'Nous sommes les pensées arborescentes qui fleurissent sur les chemins des jardins cérébraux.' The self-reflexive concerns of Cartesian thought seem to be doubly represented here. Not only is this a philosophical statement about thought. It is also a statement which is aware of its own abstract quality. The proposition makes quite clear that the flourishing which it represents is metaphorical and not literal. It concerns 'pensées arborescentes' and not actual 'arborescences'. In Desnos's version of Cartesianism, the reader is not granted the capacity to distinguish metaphorical from literal language. This discourse valorizes the transparency of the metaphorical process, to the point where the only valid form of metaphor is effectively the simile.

Desnos underscores the circular quality of rational discourse by evoking what Marie-Claire Dumas calls 'l'alternative philosophique traditionnelle'.[19] What Dumas means here is the age-old debate as to whether thought has primacy over language or vice-versa. In Desnos's

19 Marie-Claire Dumas, *Robert Desnos ou l'Exploration des Limites* (Paris: Klincksieck, 1980), p. 336.

poem the arborescent thoughts claim superiority over words: 'Les mots sont nos esclaves.' The arborescent words assert their anteriority over thoughts: '— Nous sommes les mots arborescents qui fleurissent sur les chemins des jardins cérébraux. | De nous naissent les pensées.' Both categories display the same self-consciousness concerning their figural nature. Both rely upon *a priori* statements. Consequently, neither displays a greater degree of philosophical awareness than the other. Neither succeeds in having its proposition prevail to the detriment of the other. Together they perpetuate a discursive self-absorption which grows stale. They bring us no nearer to any form of truth. Perhaps the only truth is the unknowability of truth. If this is so, however, philosophical debate becomes obsolete and inane when that anti-truth has been reiterated a few times. Silence then offers a better philosophical strategy.

Faced with the arid navel-gazing within rationalist discourse, Desnos rejects intransigent silence as no less arid and socially divisive. Instead, he calls upon the language of the asylum to enrich the conceptual domain. The subject matter of his poem only moves beyond the circular self-referentiality of the Cartesians when Sœur Anne pushes past the arborescent words and thoughts, into the realm of letters and monosyllables. Sœur Anne cracks open the circle formed by the words and thoughts when she violently transforms the latter. She reduces them to the basic phonetic values by which they are represented. Sœur Anne is therefore able to see thoughts as ideational guns – 'Pan C' – and she uses them to break through the hypothetical 'skulls' which limit thought to a circular process. She leaves the Cartesians with 'crânes KC'. Both thought and language are visually metamorphosed into vital forces which create new ideas. Faced with an impasse in understanding, they no longer dwell on it. Instead, they endeavour to circumvent it. They multiply the forms and concepts which might offer a route to a new perception of the world.

Nevertheless, this new tactic does not imply the utter rejection of reflexivity. Desnos is careful to indicate the self-awareness of the letters upon which Sœur Anne seizes, as she moves away from an obsession with self-consciousness. The letters introduce themselves thus: '— Nous sommes les lettres arborescentes qui fleurissent sur les chemins des jardins cérébraux. | Nous n'avons pas d'esclaves.' They

may distance themselves from the words and thoughts by renouncing claims to a privileged position in a conceptual hierarchy. The letters nevertheless remain in the same knowingly figural space as the other two categories. They refuse to be considered the carriers of a literal truth, even if Sœur Anne uses them as the concrete tools in her attempt to explode the self-consciously metaphorical realm. Her efforts can still be reappropriated by reflexive rationalism, because they use one of its forms – albeit in an unconventional manner.

Indeed, if Sœur Anne's letters were to remain an absolute negation of the self-conscious language of the Cartesians, they would carry literal truth only for her. Their concrete message would become untranslatable because it would be unrepresentable in other terms. The letters would be the truth in themselves. They would thus reduce everything to themselves. The rejection of any discourse which is open to figurative use is a rejection of intersubjective communication. It imposes form as the unique level of meaning and thus blocks the progression of forms and ideas. The content of any utterance thus becomes limited to its initial formal structure. Any interpretation which rephrases or re-expresses the utterance becomes unacceptable. The addressee of the utterance is forbidden to relate it to personal experience and is thus excluded from an authentic understanding of its signification. S/he can only repeat the utterance as a sort of mantra with mystical power. In such conditions, meaning is only permitted on a concrete level and not on a metaphorical one. Such a reduction of language to the concrete forms of the psychotic is no less restrictive than the complete rejection of such forms by Reason.

A special synthesis occurs when the reflexive qualities of rationalism are combined with the psychotic's untrammelled drive to mould aural and visual phenomena into unconventional forms. Only then can both poles of language be moved beyond the obsessive repetition of their own specificity. Such a fusion does not destroy reflexivity or its lack, but rather attenuates both. It thus allows language and thought to move into new areas. Marie-Claire Dumas argues that Desnos is ultimately aiming at a concrete truth beyond language: 'la végétation pure – ou le pur végétatif – où prendrait

racine toute dynamique intellectuelle'.[20] I would suggest that the memory of reflexive language is too strong in the poem for such a reading to be completely convincing.

The final line of the poem does apparently give the teleology of the poem as a shift away from the figural and into the literal. Yet that line, '— Nous sommes les arborescences qui fleurissent sur les déserts des jardins cérébraux', is so close to the self-conscious statements which it transforms that we would have difficulty in ignoring its status as language. Desnos's poetics do not seem to prepare a move beyond representation and into materialism. Rather, they still seem to aim at a system of representation. Yet such a system can calmly assume that those who use it know it to be just representation and not the truth itself. It implies an involvement with representation which does not waste time with incessant disclaimers of its difference from reality.

Interestingly, it is through Sœur Anne that Desnos expresses his frustration with circular forms of representation. We have seen that it is she who makes the decisive move to prevent reflexivity from becoming the primary concern of thought and language. Yet it is also she who tires of her own psychotic language. She herself considers the repetition of its methodology to be as unproductive as the repetition of Cartesian *topoi*. She ends her intervention with the clarion call, 'Mais la minute précédente est déjà trop AG'. She considers her own innovation to be already obsolete. She thus ushers in the synthesis of reason and unreason which constitutes the poem's final line. Perhaps the diagnosis of Sœur Anne's psychosis was over-hasty. We have seen the apparent irregularities in her language which have presumably led her to Sainte-Anne. Yet behind Sœur Anne's insane appearance, there might lie a more complex reality. In her desire to move beyond over-anxious rationalism and hermetic concretism she seems to grasp the spirit of Desnos's puns.

Sœur Anne displays an awareness that it is important to understand both rational and irrational forms of language. Indeed, I have been a little unfair in hypothesizing that she can only associate aural productions with a single, abnormal visual form. She demonstrates an ability to write 'pensées' as well as 'Pan C'. Her

20 Ibid., p. 337.

association of 'RLO' with the words 'poumons noyés' suggests that she can indeed recognize the habitual visual forms associated with those sounds – 'l'air et l'eau'. Maybe Desnos has Sœur Anne demonstrate an understanding of her own productions as puns for a practical reason. We might suggest that by doing so, Desnos allows himself to make a claim that we should re-examine our definition of psychosis when we adopt his aesthetics of the pun. We should ask whether we often confuse highly knowing linguistic and philosophical experimentation with the symptoms of insanity. It would thus seem that Desnos's puns take on an ethical dimension, suggesting that society might benefit from the integration of its so-called mentally ill.[21]

An item of literary trivia reveals the extent of Desnos's desire to apply the double logic of the pun in the social realm. Desnos planned to publish *Rrose Sélavy*, *L'Aumonyme* and *Langage cuit* as a themed collection. He rejected several titles for this project. *Désordre formel* was the final candidate, but Desnos only chose it when he had decided against the name, *Sainte-Anne hors les murs*. The change of title marks a significant shift of emphasis. A call for radical social development is transformed into a reflexive interest in language. The disruption he creates at the visual/aural interface of seen and spoken words is channelled away from connotations of insanity, towards calmer regions of linguistic play. Could that change stem from a fear that sophisticated, but revolutionary wordplay might be diagnosed as pathological? It seems that Desnos considered at least a proportion of the insane to be misunderstood philosophers. Perhaps he feared that he too might be misunderstood by society. After all, the opening of *L'Aumonyme* culminates in a plea that we should show 'pitié pour l'amant des homonymes'.[22] Desnos asks that we should not sequestrate him because of his puns. Yet that line is perhaps more than

21 In this context, see also the infamous surrealist 'Lettre aux médecins-chefs des asiles de fous' (1925), which calls publicly for the release of the insane into society.
22 *Corps et biens*, p. 50.

a supplication to be left in peace. It might also be a revolutionary call for the release of certified psychotics into society.[23]

Suggested Reading

Robert Desnos, *Corps et biens*, (preface by René Bertelé) (1930) (Paris: Gallimard, 1968)
―― *Œuvres*, ed. by Marie-Claire Dumas (Paris: Gallimard, 1999)
Marie-Claire Dumas, *Robert Desnos ou l'Exploration des Limites* (Paris: Klincksieck, 1980)
―― *Étude de 'Corps et biens' de Robert Desnos* (Paris: Champion/Unichamp, 1984)
Jacques Lacan, *De la psychose paranoïaque dans ses rapports avec la personnalité* (suivi de *Premiers écrits sur la paranoïa*) (Paris: Seuil, 1975)
David Wills, *Self-de(con)struct: Writing and the surrealist text*, (preface by Mary Ann Caws) (Townsville, Australia: James Cook University of Northern Queensland Press, 1985)

23 I am grateful to the Arts and Humanities Research Board of the British Academy for their generous support in funding the research which has led to this article.

Appendix

ÉLÉGANT CANTIQUE DE SALOMÉ SALOMON

 Mon mal meurt mais mes mains miment
 Nœuds, nerfs non anneaux. Nul nord
 Même amour mol? Mames, mord
 Nus nénés nonne ni Nine.

 Où est Ninive sur le mammemonde?

 Ma mer, m'amis, me murmure:
 «nos nils noient nos nuits nées neiges».
 Meurt momie! Môme: âme au mur.
 Néant nié nom ni nerf n'ai-je!

 Aime haine
 Et n'aime
 haine aime
 aimai ne

 M N
 N M
 N M
 M N

P'OASIS

Nous sommes les pensées arborescentes qui fleurissent sur les chemins des jardins cérébraux.
— Sœur Anne, ma Sainte Anne, ne vois-tu rien venir... vers Sainte-Anne?
— Je vois les pensées odorer les mots.
— Nous sommes les mots arborescents qui fleurissent sur les chemins des jardins cérébraux.
De nous naissent les pensées.
— Nous sommes les pensées arborescentes qui fleurissent sur les chemins des jardins cérébraux.
Les mots sont nos esclaves.
— Nous sommes
— Nous sommes
— Nous sommes les lettres arborescentes qui fleurissent sur les chemins des jardins cérébraux.
Nous n'avons pas d'esclaves.
— Sœur Anne, ma sœur Anne, que vois-tu venir vers Sainte-Anne?
— Je vois les Pan C
— Je vois les crânes KC
— Je vois les mains DCD
— Je les M
— Je vois les pensées BC et les femmes ME
et les poumons qui en ont AC de l'RLO
poumons noyés des ponts NMI.
Mais la minute précédente est déjà trop AG.
— Nous sommes les arborescences qui fleurissent sur les déserts des jardins cérébraux.

Part 3

Limits of the Visible

CLAIRE BOYLE

Resisting the Whole Picture: The Gaze, and Reading Autobiographies by Nathalie Sarraute and Georges Perec

Portrait of the Artist as a Failing Subject

It is a commonplace in autobiographical criticism, and in autobiography itself, that the author cannot produce a thorough, entire and accurate representation of his/her selfhood. In twentieth-century French literature, autobiographies by Jean-Paul Sartre and Roland Barthes have been highly influential in shaping how autobiography is conceived, owing to the self-conscious writing styles they both employ, which, through irony in Sartre's work, or through Barthes' fragmentary structure, undermine entirely the notion that an autobiographical portrait aims for completeness. Instead, French autobiographies of the latter half of the twentieth century frequently point up precisely their *incomplete* natures, and how the author responds to this incompletion.[1] This article examines these responses in the works *Enfance* (1983) by Sarraute and *W, ou le souvenir d'enfance* (1975) by Perec.[2]

1 For a discussion of the issue of self and other in French autobiography, see Michael Sheringham, *French Autobiography: Devices and Desires: Rousseau to Perec* (Oxford: Clarendon Press, 1993). For further important contemporary autobiography scholarship, see *Autobiography: Essays Theoretical And Critical*, ed. by James Olney (Princeton: Princeton University Press, 1980) and Philippe Lejeune, *On Autobiography*, ed. by Paul John Eakin, trans. by Katherine Leary (Minnesota: University of Minnesota Press, 1989).
2 Nathalie Sarraute, *Enfance* (1983), *Œuvres complètes* (Paris: Gallimard, 1996), pp. 987–1145; Georges Perec, *W, ou le souvenir d'enfance* (Paris: Denoël (Collection Gallimard Imaginaire), 1975).

In common with their contemporaries, Sarraute and Perec evince doubt about the proposition that an autobiography may provide a 'whole picture'. This article will discuss *why* they cannot supply a whole picture, and what the consequences of this failure to present an integrated picture of the subject are for the writer and the reader. The psychoanalytical concept of the Lacanian gaze, particularly as read by Slavoj Žižek, will give a productive theoretical basis for this examination, since it too is concerned with the problems and effects of an inadequate picture.[3] Our interest will centre around how the mechanism of the gaze implies in advance the failure to produce a complete self-portrait, suggesting a loss of independent control by the subject, and how the operation of the gaze challenges the integrity of more than the author's subjectivity.[4]

Both *W, ou le souvenir d'enfance* and *Enfance* attempt to find a new written form that can rise to the challenge of representing what the authors perceive as a new mode of reality.[5] Each text is preoccupied with the difficulty of uncovering the self's origins in childhood. Both texts conclude that ultimately the textual format is, of its very nature, incapable of capturing the self that exists at the moment of writing, just as it is incapable of resurrecting the childhood self.

Enfance is known for its innovative structure: the narration consists of two nameless voices in dialogue with each other. These voices are assumed by the reader each to belong to Sarraute, and between them, in disjointed fragments, they analyse and call into question childhood incidents that they recount. One of these is

3 Jacques Lacan, *The Four Fundamental Concepts of Psycho-Analysis*, ed. by Jacques-Alain Miller, trans. by Alan Sheridan (London: Vintage, 1998) and Slavoj Žižek, *Looking Awry: An Introduction to Jacques Lacan through Popular Culture* (London: MIT, 1991).

4 I refer to a writer or reader as a 'subject' in this article in a psychoanalytical context, but also use 'subject' in the sense of being the primary focus in a text, e.g. the subject of an autobiography. I use 'self' or 'selfhood' to refer to individuals at all other times.

5 For Sarraute's views on poetics and realism, see especially Sarraute, *L'Ère du soupçon* (1964), in *Œuvres complètes* (Paris: Gallimard, 1996), pp. 1551–1620, and Stella Béhar, *Georges Perec: écrire pour ne pas dire* (New York: Peter Lang, 1995), pp. 1–6 for Perec's thoughts on poetics and the *nouveau roman*.

Resisting the Whole Picture 163

Natacha's visit to her mother in Paris, where the first voice remarks on the strangeness of hearing herself pronounce her mother's Russian name with a French accent: the split narration emphasizes the uncertainty over whether the event was dramatic because it had never previously happened, or whether all previous occurrences had simply been forgotten:

> — [...] comme ce nom sonne bizarrement, il me semble que c'est la première fois de ma vie que je l'entends...
> — Pourtant autrefois, rue Flatters, c'est déjà ainsi que ce nom se prononçait, à la française...
> — Mais il y a de cela tellement longtemps, un si immense espace de temps s'est écoulé entre l'âge de six ans et celui de onze ans...[6]

W, ou le souvenir d'enfance is also written in discrete fragments, and consists of two separate, parallel *récits*: the first recounts Perec's childhood through the traditional autobiographical medium of a first person narrator. However this enterprise produces a *negative* autobiography, for the narrator emphasizes the sparsity of his childhood memories:

> Il y eut la Libération; je n'en ai gardé aucune image, ni de ses péripéties, ni même des déferlements d'enthousiasme qui l'accompagnèrent et la suivirent et auxquels il est plus que probable que je participai.[7]

The second *récit* takes the form of an action-detective novel, concerning a child's disappearance in a shipwreck. The narrator traces the missing child as far as an island called W, and at this point he is sidetracked into reporting life on the island, whose entire society revolves around participation in Olympic-style games. The descriptions of the games become steadily more reminiscent of accounts of life in an extermination camp, such as Auschwitz, where Perec's own mother was sent; this incident is not explicitly recounted, but is alluded to in the autobiographical sections.

Sarraute's and Perec's common concern, to draw attention to the inadequacy and unreliability of their childhood memories through self-reflexive narration and formal devices, springs from their

6 Sarraute, *Enfance*, p. 1129.
7 Perec, *W, ou le souvenir d'enfance*, p. 183.

inevitable exposure as twentieth-century writers to psychology, and particularly the discipline of psychoanalysis. Perec received courses of psychoanalytic therapy three times: *W, ou le souvenir d'enfance* has been described as the fruit of his sessions with Michel de M'Uzan.[8] For Sarraute, her interest in human psychology (widely apparent throughout her work) leads to the development of her characteristic tropistic writing style, that attempts to convey the reality of psychic life through the concentration on events that may appear as nothing more than minutiae, but whose impact is great.[9]

Recognising the difficulty in communicating their individual memories to us, our narrators are aware that their authority risks being compromised: Perec's preference in his autobiographical fragments for reporting documentary evidence attesting to particular events, rather than relying exclusively on his own memory, serves as an acknowledgement that authority over one's self does not extend to being a guarantor of its own true history. To establish the individual's truth, secondary evidence may have to be called in to offset the inadequacy of testimonials. This appeal beyond the self to find the complete self echoes the Lacanian understanding of the human subject, whereby the subject always comes into being through negotiating its identity with others, or 'the other'. The limits of subjectivity are framed in advance by walls, erected in the form of cultural taboos, which structure our society. Only within this framework is the subject recognized as such: at the point where it transgresses these taboos, it becomes desubjectivized, and a candidate for rehabilitation. The subject undergoes analysis, where yet again an other – the analyst – collaborates with it to reconstruct its subjectivity in a form that is intelligible in the symbolic, that is, in the psychoanalytic domain of the lacking subject.

Acknowledging the role played by others in the make-up of one's selfhood is clearly incompatible with any claim to a unique, privileged insight into one's individuality, particularly since the other great revelation of psychoanalysis concerns how we repress

8 Cf. David Bellos, *Georges Perec: A Life In Words* (London: Harper Collins, 1993), pp. 150–54.
9 On this connection between psychology and Sarraute's writing, see Sarraute, *L'Ère du soupçon*.

memories, for the sake of fitting into the social structure to which we belong. Thus we understand why, post-Freud, an autobiographer might produce a self-consciously inadequate text: the benefit of creating a fragmentary autobiography is to give a plausible image of oneself to one's contemporary audience.

A side-effect that we might anticipate to the portrayal of this more plausible, lacking self might be an accompanying loss of narrative authority, yet this is not inevitable: a textual analysis of *W, ou le souvenir d'enfance* and *Enfance* will show how it can be possible to impose narrative authority without requiring the narrative function to include the imparting of authoritative truth. The narrator's authority may persist, owing to a second benefit of the knowingly incomplete autobiography. By writing such a work the author can resist being known, becoming an object for the consumption of the reader. This authorial resistance to being captured in a written representation shares an ethical motivation with the post-structuralist critique that relativizes the potential of our knowledge by showing up its boundaries. We will see this self-protective motivation for writing a fragmented autobiography in evidence in *Enfance*. Alternatively, narratorial authority may derive, not from the achievement of the production of a whole and accurate picture of the self, but rather from undertaking the task of re-constructing the self in collaboration with an other, which may constitute an ordeal for the author.

Sarraute: Piercing the Gaze

Having considered how the other is already implicated in the writing self, working jointly with it to produce a self-portrait, and having touched on the power relations that arise out of a collaborative production of the self, it will now be useful to focus on the gaze, a psychoanalytical concept thusfar seldom applied to the analysis of autobiography, but which elucidates the play of power dynamics operating as the subject is constructed. What produces the gaze is desire and lack. For Lacan, the situation of the subject in the symbolic

as a lacking subject is manifested in a number of ways, which reveal its desire (desire is something the subject has deriving from its lack). One of the ways in which the split, which causes lack, may be perceived is in the split between the subject who sees, and the object which looks, gazes at him or her. This gap is known as 'the gaze', for the gap itself is a manifestation in the visual field of *objet a*, the name given by Lacan to the object we are bound to desire. According to the theory of the gaze, the subject is always already being viewed *before* s/he views, and the possibility of viewing one's own self viewing another object is impossible, although it is also a delusion of consciousness that one can achieve this, for the law of the symbolic is that knowledge of the gaze must be elided. Nevertheless, all subjects must sometimes acknowledge their underlying awareness of the gaze which scrutinizes them, for to allow oneself to be surprised by the gaze is to sustain oneself as a desiring subject who lacks. The gaze then marks a lack of mastery in the contemplative and visual fields; when it is acknowledged it renders it impossible to derive any pleasure from the subject's activity of observing, as Žižek notes:

> The gaze as object is a stain preventing me from looking at the picture from a safe, 'objective' distance, from enframing it as something that is at my grasping view's disposal.[10]

Pleasure can be derived from the existence of the gaze as *objet a* only when we renounce our desired objective of contemplating our own contemplation. This has acute implications for those who write the self, for it undermines their ability to seize control of their subjectivity through textuality. The spectre of the other who reads the finished work will always obstruct the potential harmony and perfection of the writer's self-portrait. What is of interest is whether the presence of the reader as the speck in the writer's perceiving eye will pollute, or taint, the whole enterprise of writing autobiography.

Both *Enfance* and *W, ou le souvenir d'enfance* overtly engage with the reader on this point. In *Enfance* we find evidence of a narrative manoeuvre seemingly designed to protect Sarraute from the force of the reader's sceptical gaze: the split in the narrating subject is

10 Slavoj Žižek, *Looking Awry*, p. 125.

Resisting the Whole Picture

an artifice the writer creates to show up a gap she herself locates between the essence of the subject and textuality. Sarraute's self is at the root of both narrators, however, suggesting a desire to master the split in subjectivity by always being at the heart of even the split subject. Furthermore, incidents in *Enfance* alert us to her desire not to reveal to her audience the full understanding she has of her own self through her remembered personal history: the fragment devoted to the child Natacha's homework task, 'mon premier chagrin', sounds warning bells:

> — De retrouver un de mes chagrins? Mais non, voyons, à quoi penses-tu? Un vrai chagrin à moi? vécu par moi pour de bon... et d'ailleurs, qu'est-ce que je pouvais appeler de ce nom? Et quel avait été le premier? Je n'avais aucune envie de me le demander... ce qu'il me fallait, c'était un chagrin qui serait hors de ma propre vie, que je pourrais considérer en m'en tenant à bonne distance...[11]

The suspicious reader may ask if it is not conveniently helpful as a means of neutralizing the reader's scrutiny that Sarraute postulates through her writing a fundamental disjuncture: namely that producing a narrative of one's memories is comparatively easy, but achieving fidelity to lived experience requires a level of effort that the narrator may be unwilling to make. This thwarting of the reader's desire for a definitive autobiographical portrait is an index of authorial displeasure at being subject to a reader's gaze, a judging gaze over which Sarraute can ultimately have no control.

Sarraute's reader is able, nonetheless, to construct an image of the author from the incidents described by the narrator. However, at the end of *Enfance* our reading experience is arbitrarily curtailed: the principle narrating voice decides to reclaim her subjectivity for herself, and no longer share it:

> Je ne pourrais plus m'efforcer de faire surgir quelques moments, quelques mouvements qui me semblent encore intacts, assez forts pour se dégager de cette couche protectrice qui les conserve, de ces épaisseurs blanchâtres, molles, ouatées qui se défont, qui disparaissent avec l'enfance... (p. 1145)

11 Sarraute, *Enfance*, p. 1103.

With this expressed preference for keeping her childhood reminiscences contained in the privacy of her own (albeit failing) memory, rather than solidify them in writing, Sarraute reveals a persistent desire for some superiority, some advantage over her readers. Without this advantage, she appears to feel threatened in her subjectivity. She achieves the upper hand by renouncing the activity of narration, revoking the reader's licence to construct a picture of the autobiographical subject at the point where s/he has been successfully enticed into doing so.

Whilst a potential transgression of the author's intention may be a mere detail and not bother the contemporary reader who cuts his/her teeth on Roland Barthes' famous article 'La Mort de l'auteur', it nevertheless affects the type of picture we compose of Sarraute. The reader of the series of seventy disjointed fragments that constitute *Enfance* will take away from his/her voyage images of the autobiographer, but will be conscious that Sarraute has not given away to her reader any authority to manipulate or develop them. As such, any reader who wants to maintain any kind of authenticity for their image of the author by respecting her expressed desires will be able to do no more than take the fragments as static, dead, and assemble them into a two-dimensional collage, which may be contemplated, but not interrogated nor moved; and which must, under all circumstances, defer to the superiority of the original subject, of whom it can only ever be a failing representation.

Perec: Dropping One's Guard

By comparison, *W, ou le souvenir d'enfance*, whilst revealing on the part of its author a similar degree of reaction to the influence of the other, responds with a productive defiance. The requirement the ever-present other has for intelligibility apparently motivates an effort to conquer the 'indicible' that threatens to suppress Perec's autobiographical endeavour. In *W, ou le souvenir d'enfance*, the narrator of the childhood fragments, having already proclaimed 'je

n'ai pas de souvenirs d'enfance', justifies to an unconvinced implied reader his project to recount his childhood life thus:

> je n'écris pas pour dire que je ne dirai rien, je n'écris pas pour dire que je n'ai rien à dire. J'écris: j'écris parce que nous avons vécu ensemble, parce que j'ai été un parmi eux [...] l'écriture est le souvenir de leur mort et l'affirmation de ma vie.[12]

This response to an anticipated reader reaction makes the reader realize how s/he is observed, anticipated, before s/he even opens the book to contemplate the textual image the autobiographer creates. Such anticipation by the writer indicates how already he sees himself through the eyes of the sceptical other.

In Perec's text however, a recognition of the limitations of memory and writing are not accompanied by a self-defensive writing strategy. Positing at the outset the fundamental unknowability of his own subjectivity, given the eternal absence of his childhood narrative, Perec instead invites and feeds his readers' desire for more information, rather than using this lack to stave off readers' attempts to attain this knowledge. Thus Perec practices a generous writing that *gives away* his control over his self-produced images to the reader, allowing him or her to construct an image of the author. This occurs despite the fact that, unlike Sarraute, Perec is faced with a lack of raw material (in the form of memories) that would preserve his origins, the key to his selfhood.

If the reader of *W, ou le souvenir d'enfance* is given more freedom to develop his or her own image of the author from his text, it is nonetheless true that ultimately Perec guides this construction. Knitting the two series of fragments together is overtly presented by Perec as the only certain way of reconstructing his past:

> W ne ressemble pas plus à mon fantasme olympique que ce fantasme olympique ne ressemblait à mon enfance. Mais dans le réseau qu'ils tissent comme dans la lecture que j'en fais, je sais que se trouve inscrit et décrit le chemin que j'ai parcouru, le cheminement de mon histoire et l'histoire de mon cheminement.
> (p. 18)

12 Perec, *W, ou le souvenir d'enfance*, p. 64.

Perec invites his reader to generate a portrait of him, which, owing to lack of evidence, will be necessarily imperfect. This is unimportant however, as we already know that Perec's enduring wound is the knowledge that even his *own* self-portrait is necessarily imperfect: a self-reflexive aside commenting on the writing of the *récits* that become *W, ou le souvenir d'enfance* reveals the extent of Perec's difficulties in producing his autobiography:

> Quinze ans après la rédaction de ces deux textes, il me semble toujours que je ne pourrai que les répéter: quelle que soit la précision des détails vrais ou faux que je pourrais y ajouter, l'ironie, l'émotion, la sécheresse ou la passion dont je pourrais les enrober, [...] il me semble que je ne parviendrai qu'à un ressassement sans issue. (p. 62)

The problems of presenting himself in literary form are 'lié à la chose écrite elle-même, au projet de l'écriture comme au projet du souvenir' (p. 63). Yet despite this parity between the author's faulty self-image and the reader's faulty image of him (an equivalence between reader and writer that Sarraute finds troubling), Perec encourages the reader to fill in the gaps by means of reading obliquely through the two separate series of fictional and autobiographical fragments. The fact that the reader reconstructs Perec's mother's past (and by extension, Perec's origins) unencumbered by explicit textual detail, in the knowledge that it is precisely this free reading practice which the author solicits, leads to the creation of a more mobile image of the writing subject. Instead of a picture in the form of a flat collage, Perec's reader creates a succession of images derived from both halves of *W, ou le souvenir d'enfance*. These representations are capable of being manipulated, potentially constructing various images of the author. This produces a kaleidoscopic image of Perec that – whilst flawed – has the potential to be interrogated, to develop and, most importantly, to provoke interaction between the reader's and the writer's subjectivities, as they are constructed.

The Reader: Joining the Dots

Having so far dwelt on how our writers reveal an awareness of being subject to the gaze and how this is manifested textually, it is now time to turn our attention to the subjectivity of the reader. We have seen that in both *W, ou le souvenir d'enfance* and *Enfance* the reader plugs gaps – whether this is desired or not by the autobiographer – in order to make a sequence of disjointed fragments into an image of the author. As a representative of the other, the reader stands in for the system that confers identity onto both Sarraute and Perec: without readers for their texts, they cannot be recognized as the literary figures we know them as. However, the reader has a further role to play, and in performing it, s/he must allow his/her own subjectivity to be implicated.

The gaze of the other constitutes the desiring and lacking subject that inhabits the symbolic, for the gaze discloses *objet a*, the object of desire that raises the phantom of plenitude only to show us that we cannot attain it. Lacan maintains that the symbolic is universal, and that therefore we are all, writers *and* readers, liable to its law. Thus if our investigation of *Enfance* and *W, ou le souvenir d'enfance* has shown up the self-acknowledged lack in our two autobiographical subjects, then the reader must conclude that s/he too is also inevitably lacking. Like the writing self, the reading self is subject to the gaze and is *also* reliant on the other to confer onto him or her an identity. This other, for the reader of *W, ou le souvenir d'enfance* and *Enfance*, is none other than the writer. Sarraute and Perec, having anticipated their readers' reactions, manipulate the narration, attempting to achieve the response they desire by forming their readers.

The reason why this desired response may not match the reader's, in spite of narrative devices employed by the writers, is the same reason that prevents the reader from reading totally freely. Just as the mechanism of the gaze causes a subject's identity to be negotiated between self and other, forcing the reader to perform in a way that makes his/her identity intelligible for the other, if s/he wants to be recognized as a reader, it also ensures that this negotiated identity will never be secure. Due to the mechanism of the gaze, the

reader's subjectivity will never exactly match either the picture the writer attempts to construct, nor the reader's own self-image, for:

> You never look at me from the place from which I see you. Conversely, what I look at is never what I wish to see. And the relation [...] between the painter and the spectator, is [...] a play of *trompe-l'œil*.[13]

Thus the reader too is made to acknowledge how his/her identity is not discrete, but is the result of interactions with others. The reader's identity cannot be considered in good faith as single or unified, the exclusive property of the reader. Instead, it must be thought of as fragmented and shared between reading self and the writing other.

To diagnose a disintegration of the selves of both reader and writer, suggesting that in each case identity is not only the identity that the self claims, but that which the other is prepared to confer on him or her, is a move inviting a sceptical reaction. By emphasizing how selves fit in with others, we may overlook the parts of those selves which others do not *want* to recognize: there is a risk of silencing utterances which ought to be heard. *W, ou le souvenir d'enfance* is a text which raises precisely this ethical issue with respect to the suffering inflicted during the Holocaust. The text's priority is to communicate the inhumanity of which the orphaned Perec had been a victim, even if this means searching for a new mode of discourse to express it. Perec does not see this ethical imperative as incompatible with a non-unified subjectivity, and offers a positive interpretation of the fragmentation of the subject. For him, the necessary failure of each instance of autobiographical discourse to capture the essence of a writing self serves as an impetus, encouraging the production of autobiographical utterance through the technique of interwoven parallel narratives, since the memories Perec has are exhausted before his desire to write them down is (and hence he records some of them more than once, as in the example of the moment when he is left by his mother at the Gare de Lyon).

This positive result, whereby the fracture in the scrutinized subject engenders textuality, is only possible where the reading and

[13] Jacques Lacan, *The Four Fundamental Concepts of Psycho-Analysis*, p. 103 (emphasis Lacan's).

writing selves will fail to elide the presence of the gaze when attempting to construct a picture of a subject from an autobiographical narrative (thus performing a necessary transgression of the law of the symbolic). Allowing oneself to be open to the presence of the gaze is a situation charged with resonances for the individual self, for an acknowledgement of the gaze requires the suppression of a desire for a perfect, accurate self-image, for where the gaze is perceived, a troubling, unbalanced image results:

> The gaze *qua* object functions like a blot that blurs the transparency of the viewed image. I can never see properly, can never include in the totality of my field of vision, the point in the other from which it gazes back at me.[14]

There is a benefit to compensate both reader and writer for deviating from the automatic reaction, which is to elide the gaze. By 'looking awry' to recognize the presence of the uncanny blot, and thus accepting the fissure in our subjectivity, we generate in ourselves the continuing desire to produce and perceive images to fill in the gaps – in short, to continue interacting with the other. A sustained interaction that promotes this production of images is fruitful and will enhance our knowledge, for certain things can only be expressed by means of 'parler à côté'.[15] The more images that go into our kaleidoscopic representation of subjectivity, the closer we come to a definitive representation of a human self. Furthermore, unless we are prepared to use partial, 'un-realistic' images that are punctuated by the unintelligibility of the Lacanian real in this way, there are aspects to the human self that we will not be able to represent. These aspects may be precisely those that are the most influential, and which are most in need of being transmitted to the other. However, in order to reap the benefits of this approach to reading, a certain fragmentation and disintegration of the subject have to be allowed for in advance.

As a member of Oulipo, the surrender of secure, autonomous individual subjectivity is a gesture Perec is easily able to make, if it will result in the success of his troubled and frequently unfinished

14 Žižek, *Looking Awry*, p. 114.
15 This term is borrowed from a discussion by Philippe Lejeune, *La Mémoire et l'oblique: Georges Perec autobiographe* (Paris: P.O.L., 1991).

endeavours to write the self for others.[16] Perec's eagerness to write the self under these conditions is revealed by further published autobiographical works, which also require the reader to acknowledge the incompleteness of the static written self-portrait, and to lend his/her creativity to the piecing together of a more three-dimensional picture.

Perec's reader then has little choice but to consent to operate according to Perec's conception of universally fractured subjectivity, if s/he wishes to derive any further knowledge of the author from his texts. Thus we are faced with a post-structuralist reader riven with contradictions, due to his/her submission to the gaze. Whilst admitting the validity of contemporary diagnoses of an always already split selfhood, the reader of autobiography must persist in his/her desire to extract a whole picture of the author from his/her self-writing. Our reading of Sarraute, an author who tries to refute the consequences of the gaze, shows that such a contradictory position is inescapable, even when the subject does not will it.

Sarraute's *Enfance* does not advocate the embrace of the fractured subject. Yet Sarraute cannot do otherwise but acknowledge the role of the other in the production of subjectivity, but since ultimately she is most interested in mastering the representation of her own subjectivity at the expense of the reader's contribution, she attempts to prove that the only other she needs is the other already contained within herself. This motivates her handling of the questions raised by her memories: should she retain her own history in her head, where it is precariously stored and liable to disappear? Or, should she risk solidifying her memories on paper, a course of action which will distort them, will allow them to become the property of the other as well as the self, be exchanged as tokens of communication, thus knitting together her selfhood with the selfhood of others, and thereby losing control of it?

16 Oulipo (founded by Raymond Queneau as an *OUvroir de LIttérature POtentielle*) was renowned for promoting modes of writing whereby texts almost wrote themselves. Mathematical and literary patterns were used to direct the production of unending chains of signifiers, thus undermining traditional notions of inventive authorship. The emphasis on the mechanism producing writing was accompanied by a correlative lack of interest in promoting the individual author.

Drawing on the status of *any* subject as subject to the gaze, Sarraute makes tactical use of the gaze to render the reader less potent and threatening to her self-produced portrait. By so doing, she reveals her recognition of the subject's lack. This wires her into the symbolic since she accepts the principle of its operation, and so she manoeuvres herself into a position of non-self-mastery. This would seem to be the price of acknowledging with ill grace the impossibility of producing, alone, a whole picture.[17]

Selected Reading

Roland Barthes, 'La Mort de l'auteur' (1968), in *Essais critiques IV: Le Bruissement de la langue* (Paris: Seuil, 1984), pp. 61–7
—— *Roland Barthes par Roland Barthes* (Paris: Seuil, 1975)
Cathy Caruth, *Trauma: Explorations in Memory* (London: Johns Hopkins University Press, 1995)
Serge Doubrovsky, *Autobiographiques: De Corneille à Sartre* (Paris: P.U.F., 1988)
Philippe Lejeune, *La Mémoire et l'oblique: Georges Perec autobiographe* (Paris: P.O.L., 1991)
Emer O'Beirne, *Reading Nathalie Sarraute: Dialogue and Distance* (Oxford: Clarendon, 1999)
Georges Perec, *Je me souviens*, (Paris: Hachette (Textes du XXe siècle), 1978)
—— *Espèces d'espaces* (Paris: Galilée (L'Espace critique), 1974)
Nathalie Sarraute, *Œuvres complètes* (Paris: Gallimard, 1996)
Jean-Paul Sartre, *Les Mots* (Paris: Gallimard, 1964)
Michael Sheringham, *French Autobiography: Devices and Desires: Rousseau to Perec* (Oxford: Clarendon, 1993)

17 I acknowledge financial support from the UK's Arts and Humanities Research Board. The conference paper and this article, which has developed from it, were written whilst I was in receipt of their Studentship award. I would also like to thank Emma Wilson for her comments on the draft version of the conference paper.

SONYA STEPHENS

Baudelaire and Courbet: The Art of the Unfinished

The aspects of *seeing things* that will be the focus of this essay are those of perception and interpretation, specifically a perceived finishedness or incompletion and the possible interpretations of that (un)finishedness. It goes without saying that any discussion which focuses on the aesthetics of the incomplete, or the erased, and on absence, is adressing questions of vision on two levels. First, it is a matter of the visual forms that such unfinishedness might take (pictorially or typographically) – the kinds of forms that genetic criticism has actualized – or the alternative forms which define a project never brought to completion (the drafts of projects, for example, or epitextual elaboration on ideas for projects). This notion overlaps with a second conception of vision which is less to do with extant visual or visible material and more to do with seeing things in some anticipated (and visualized) ideal form. What this essay sets out to do is to explore certain notions and effects of aesthetic incompleteness or incompletion in works that are, to use Crouzet's terms, 'inachevés ou inachevables'.[1] In so doing, it will examine Baudelaire's definitions of beauty in relation to his notion of an ideal in art – an ideal he describes in the *Salon de 1846* as an 'absurdité' and an 'impossibilité'. The *non finito*,[2] I shall argue, is a sort of aesthetic necessity which brings into question forms of closure and the

1 See *Stendhal: Romans abandonnés* (Paris: U.G.E., coll. '10/18', 1968), p. 35.
2 The term is defined by A. Chastel as follows: '*Non finito* (terme italien; mot à mot: inachevé): caractère de l'ouvrage ou des parties d'ouvrage laissées à l'état d'*abbozzo*. La notion est d'abord négative, mais à la suite des initiatives de Michel-Ange, après 1500, elle tend à être associée à la vigueur de l'inspiraion (*furor*) et se trouve ainsi valorisée. Une querelle académique sur l'inachevé se déroulera autour de 1550 avec sa conclusion chez Vasari, *Vie de Luca della Robbia*, éd. de 1568'. *Le Grand Atelier d'Italie* (1460–1500) (Paris: Gallimard, 1965), XII, p. 374.

deferral of closure. It is evidence both of purposiveness and of errancy and, perhaps most significantly, it represents, in the ways it demands a participatory or constructive reading, a form of hermeneutic plenitude rather than a lack. The hermeneutic lack, which is unfinishedness, becomes plenitude in reception, engaging the reader-viewer's imagination in discovering and finishing things which may be ascribed to the artist, though in fact they proceed mostly only from itself.[3] This notion of filling gaps, imagining meanings or elaborating narratives is, of course a key component of the aesthetic of unfinishedness, and of Baudelaire's aesthetic of the modern in art. Here, with reference to Baudelaire and Courbet, I want to examine artful unfinishedness and, through their work, to suggest ways in which excision and incompletion become a mode of representation in a period in which the bafflement of the actual challenges the reassurance of design.

Irresolution, then, is a feature dialogically dependent on an idea of completion and varies in accordance with a *particular* idea of resolution felt to be relevant. Should we, then, consider the 1857 publication of *Les Fleurs du mal* as complete or incomplete? We know from correspondence, and from the subsequent editions of the work published in 1861 and 1868, that Baudelaire and Poulet-Malassis had already decided to excise a number of poems; these Baudelaire refers to as the 'pièces sacrifiées'.[4] He nevertheless wanted these set up in print so that he could later decide whether to include them and how otherwise he might present them for publication.[5] We do not know how many poems were 'sacrificed' at this stage and our attempts to to trace or name these missing pieces is hampered by

3 This idea is expressed in the 18th century by Roger de Piles in *Cours de peinture par principes* (1708) (Nîmes: Éditions Jacqueline Chambon, 1990).
4 See letter of 10 February 1857 to Auguste Poulet-Malassis, in Baudelaire, *Correspondance*, texte établi, présenté et annoté par Claude Pichois avec la collaboration de Jean Ziegler (Paris: Gallimard (Bibliothèque de la Pléiade), 1973), I, p. 374. All references to Baudelaire's correspondence are to this two-volume edition and will henceforth appear in parenthesis using the abbreviation *C*, followed by the volume number and page numbers.
5 See Baudelaire, *Correspondance générale*, in *Œuvres complètes* (Conard), ed. by Jacques Crépet (1947), II, p. 13, n. 1.

Baudelaire's tendency to exaggerate. In a letter to his mother (9 July 1857), he writes of the excision as a form of self-censorship:

> [C]e livre, dont le titre: *Fleurs du mal*, – dit tout, est revêtu, vous le verrez, d'une beauté sinistre et froide; il a été fait avec fureur et patience. D'ailleurs, la preuve de sa valeur positive est dans tout le mal qu'on en dit. Le livre met les gens en fureur. – Du reste, épouvanté moi-même de l'horreur que j'allais inspirer, j'en ai retranché un tiers aux épreuves. (*C* I, 410–11)

As Pichois notes, Baudelaire originally penned the excision as 'two thirds' and these were removed long before proof stage (*C* I, 935). Greater exaggeration still is to be found in a letter to Alphonse de Calonne (fin 1863 ou début 1864): 'A l'époque où j'ai publié ma première édition, j'ai détruit des masses de vers dont quelques-uns dataient de 1837, et je les ai oubliés' (*C* II, 344). This statement, initially promising in terms of missing pieces and thus incompletion, is fairly categorically rejected by research carried out by Felix Leakey, who through stylistic and thematic analysis, recovers the lost 'third' from poems included in later editions and dismisses Baudelaire's statement to Calonne, saying that 'if any poems *were* destroyed at that date [i.e. 1857], in an actual rather than retrospectively theatrical holocaust, they can only have been of a more youthful composition still'.[6] According to Leakey, then, the missing pieces (approximately thirty-nine of them, the 'tiers') are later restored to the work and only sixteen of the fifty-six poems added to the 1868 edition were newly composed after 1857, though others would, of course, have been modified by Baudelaire's later reworking.[7] The imposed expurgation of six poems as a result of the trial also raises questions about incompletion, especially as Baudelaire specifically refers to an

6 '*Les Fleurs du mal* (1857–1865): The Resuscitation of the "pièces sacrifiées"', in F. W. Leakey, *Baudelaire. Collected Essays* (1953–1988) (Cambridge: Cambridge University Press, 1990), pp. 53–59. This essay is based on an earlier version which appeared in *French Studies Bulletin*, 27 (Summer 1988), 7–11. See also Burton's response to this, 'The "Pièces sacrifiées" of 1857 and the Later Editions of *Les Fleurs du mal*', also in *French Studies Bulletin*, 30 (Spring 1989), pp. 16–21.
7 Ibid., pp. 57–58.

impulse to replace these in a letter to Poulet-Malassis (30 December 1857):[8]

> Vous savez d'ailleurs que j'ai résolu de me soumettre complètement au jugement, et de refaire six poèmes nouveaux beaucoup plus beaux que ceux supprimés. Mais quand la disposition poétique me reviendra-t-elle? (*C* I, 441)

That inspiration was to return about a year later and to last just over a year, making 1859, as Richard Burton's book has shown,[9] a year in which Baudelaire's creative output was exceptional not only in its quality, but in its quantity. More important in terms of our concerns here is that Baudelaire wished to replace the expurgated poems by the same number of new poems, suggesting that he had a sense both of the number of poems required for completion as well as a *particular* idea of resolution. Indeed, even with a number of poems excised at the manuscript stage, Baudelaire was able to protest in the 'Notes pour [s]on avocat' that 'le livre doit être jugé *dans son ensemble*, et alors il ressort une terrible moralité' (*OC* I, 193), a point that had been forcefully argued by Barbey d'Aurevilly in a piece intended for *Le Pays*:

> Elles sont moins des poésies qu'une œuvre poétique *de la plus forte unité*. Au point de vue de l'Art et de la sensation esthétique, elles perdraient donc beaucoup à ne pas être lues *dans l'ordre* où le poète qui sait bien ce qu'il fait, les a rangées. Mais elle perdraient davantage *au point de vue de l'effet moral* que nous avons signalé au commencement de cet article.[10]

[8] The poems expurgated, as is well documented, were as follows: 'Les Bijoux', 'Le Léthé', 'A celle qui est trop gaie', 'Femmes damnées' ('A la pâle clarté des lampes languissantes...'), 'Lesbos', and 'Les Métamorphoses du vampire'. See *Œuvres complètes*, texte établi, présenté et annoté par Claude Pichois, 2 volumes (Paris: Gallimard (Bibliothèque de la Pléiade), 1975–76), p. 1182. Henceforth, all references to Baudelaire's work will be to this edition, unless otherwise stated, and will appear in parenthesis in the body of the text, abbreviated as *OC*, followed by the volume number and page numbers.

[9] Richard D.E. Burton, *Baudelaire in 1859. A Study in the Sources of Poetic Creativity* (Cambridge: Cambridge University Press, 1988).

[10] See 'Le Procès: Articles justificatifs' (*OC* I, 1191–6). The article was requested by Baudelaire and refused for publication by Le Pays, as Barbey's accompanying letter explains (*OC* I, 1191).

The argument was also heavily relied upon by Baudelaire's defence lawyer who attacks the very (reading) process on which the trial is based:

> Eh bien, qu'a fait le ministère public? de cet ensemble dans lequel tout se tient, il a détaché quelques morceaux, puis, dans chacun de ces morceaux, il a pris quelques lignes, quelques phrases, ou même quelques lambeaux de phrases, il les a rapprochés, réunis, groupés dans une habile et dangéreuse énumération, de façon que vous n'apercevez que ce qui est mauvais, et cela avec une continuité qui vous frappe, qui vous saisit, qui vous révolte; vous n'avez que le poison sans le remède, vous n'avez que des extraits âcres, violents, concentrés, isolés de tout ce qui devait les atténuer ou les adoucir... Est-ce juste, messieurs? est-ce là un procédé acceptable ou du moins qui soit de nature à vous donner le point de vue véritable et exact auquel l'œuvre de l'écrivain doit être considérée? (*OC* I, 1215)

Here the particular idea of resolution is brought to the fore in an attempt to prove that the prosecution's emphasis on excised fragments amounts to a sort of irresolution which is experienced against an ideal integrity and extensiveness that the reader could or should have realized. It should be remembered that Maître Senard's defence of *Madame Bovary*, in January of the same year, takes a similar line, insisting that Flaubert 'n'est pas l'homme que le ministère public, avec quinze ou vingt lignes mordues çà et là, est venu vous présenter comme un faiseur de tableaux lascifs'.[11] The line of defence is more readily accommodated with respect to a novel, however, and one is tempted to wonder whether Baudelaire, with knowledge of the earlier Flaubert trial, seeks to emphasize, in 1857, the notion of an order and

11 See the 'Plaidoirie', in Flaubert, *Œuvres complètes*, édition établie et annotée par A. Thibaudet et R. Dumesnil (Paris: Gallimard (Bibliothèque de la Pléiade), 1951), I, p. 635. Indeed, the defence opens with a similar attack on reading: 'M. Gustave Flaubert est auprès de moi; il affirme devant vous qu'il a fait un livre honnête; il affirme devant vous que la pensée de son livre, *depuis la première ligne jusqu'à la dernière*, est une pensée morale, religieuse, et que, si elle n'était pas dénaturée (nous avons vu pendant quelques instants ce que peut un grand talent pour dénaturer une pensée), elle serait (et elle redeviendra tout à l'heure) pour vous ce qu'elle a déjà été pour les lecteurs du livre, une pensée éminemment morale et religieuse pouvant se traduire par ces mots: l'excitation à la vertu par l'horreur du vice' (p. 634, my emphasis).

of a particular reading which, for Flaubert, had worked so well.[12] It is in his notes for his defence counsel, after all, that the most positive statements about the work's 'parfait ensemble' are to be found. What is more, in a note added to Dulamon's 'article justificatif', it seems that Baudelaire is indeed applying the principle of the Flaubert trial to his own work, when he asserts that 'plusieurs morceaux non-incriminés réfutent les poèmes incriminés', adding that 'un livre de poésie doit être apprécié dans son ensemble et *par sa conclusion*'.[13]

This is not to say that Baudelaire had not previously evoked the notion of *Les Fleurs du mal* as an organized work, but when he first does so in 1856,[14] it is, as has been pointed out, with a *selection* in mind, rather than an arrangement.[15] The 'architecture secrète' emphasized by Barbey elaborates a principle of thematic cohesion, a 'plan calculé' to which Baudelaire does not necessarily fully subscribe. All of these comments relate to the 1857 edition, with its excised 'pièces sacrifiées'. What, then, of the 1861 edition, with all its additions? Is that complete? Is 'more complete' a meaningful concept? Baudelaire's letter to Vigny (December 1861) is often cited as evidence of the work's resolution and the significance of its order:

> Le seul éloge que je sollicite pour ce livre est qu'on reconnaisse que ce n'est pas un pur album et qu'il a un commencement et une fin. Tous les poèmes nouveaux ont été faits pour être adaptés au cadre singulier que j'avais choisi. (*C* II, 196)

This confirms a trajectory and a broad framework, without defining the nature of that framework other than to insist upon its flexibility, its ability to accommodate additional poems written, in part at least, to its specification. What the different editions of *Les Fleurs du mal*

12 For detailed discussion of Flaubert's trial, see Dominick LaCapra, *'Madame Bovary' on Trial* (Ithaca: Cornell University Press, 1982).
13 See 'Notes pour mon avocat' (*OC* I, 193–96) and Baudelaire's note added to Dulamon's article (*OC* I, 1190, n. 1).
14 Letter to Poulet-Malassis (9 December 1856): 'nous pourrons disposer ensemble l'ordre des matières des *Fleurs du Mal*, – ensemble, entendez-vous, car la question est importante. Il nous faut faire un volume composé seulement de bonnes choses, peu de matière, qui paraisse beaucoup, et qui soit très voyante' (*C* I, 364).
15 F. W. Leakey, 'Poet – or "Architect"?', *op. cit.*, p. 63.

suggest, rather than any sort of completion, is a form of undecidability, an interim organization for the purpose of publication and with that, an openness to supercession which the framework makes possible but which cannot be foreseen. Leakey argues, much as I have done, that the textual evidence for resolution (or a *particular* idea of resolution) in the form of a highly integrated and completed poetic scheme, or an architecture, is weak and concludes that, for him, the most cogent reason for rejecting such a notion is one of temperament:

> Undoubtedly, throughout his career, Baudelaire did aspire to mastery of the larger literary forms; his notes and letters abound with projects for novels, for plays, for large-scale critical works. But none of these (and this is the essential point) were ever brought to fruition – and indeed the whole history of Baudelaire's creative life is one of procrastination, inertia, unfulfilled promises, endlessly receding deadlines, impressive yet abortive pronouncements, with desire and ambition continually, alas! outrunning performance. [...]

Leakey continues:

> To me, it seems quite inconceivable that the writer whose creative life was so fragmentary and disordered, and who devoted so much attention to the endless revision and retrospective organisation and reorganisation of individual poems, should in his mid-thirties have suddenly conceived and secretly nursed and realized a highly integrated poetic scheme of quite epic proportions for which nothing he had previously achieved in any way prepares us.[16]

Whilst I do not wish to dwell on the temperament argument, the issues Leakey raises are directly relevant to my own concerns here. First, the endless reorganization of material is prompted by deadlines and declares an interest in creating a certain effect by a certain organization. This does not mean completion, or even a particular idea of resolution. Baudelaire, at the same moment he evokes large-scale projects which are other than poetry, speaks of his weariness of *Les Fleurs du mal*: 'Redevenir poète, artificiellement, par volonté, rentrer dans une ornière qu'on croyait définitivement creusée, traiter de nouveau un sujet qu'on croyait épuisé, et cela pour satisfaire à la volonté de trois magistrats niais' (*C* I, 451). This is in 1858; the rest is

16 Ibid., p. 68.

history and belies this notion of exhaustion. The point is precisely that the development of *Les Fleurs du mal* is chronicle and not history. Its completion lies only in the mind's commentary on these and other events which have composed it and from which it has rescued itself. Organization is not the same as completion, for there cannot be a poetics, even of the unfinished, to which the search for organization is not admitted.

Furthermore, whatever Baudelaire's temperament, the fact remains that he was a poet in an era of the grand-scale project, in the era of the novel, and his ambitions, I would suggest, were of his time, and not simply of his nature.[17] Incompletion, then, is not a peculiarly Baudelairean *weakness* but rather an *aesthetic determination* shared by others, in other arts. Baudelaire did, it is true, conceive of a number of large-scale projects, ideas for 'une vingtaine de romans et deux drames' which he claims to have carried in his head.[18] In addition to the works listed but never written, there are other missing pieces to which the correspondence alludes, but which are now lost to us (or not yet, at least, found).[19] There is a need to distinguish, of course, between fragments excised, lost and found, and sometimes reintegrated, and items that never existed. Or is there? The status of missing pieces is itself uncertain, interim. They are themselves a sort of irresolution, both in nature and in time and their absence is either filled in by memory, reproductions, or imaginative power, or it is ignored, making it possible to say that virtually every Pléiade *Œuvres complètes* is, in some ways, incomplete (though it may still be the *most* complete). We do not agonize over whether *Les Fleurs du mal* is a complete work, because we can ascertain the spatial logic and generative principle that organizes the work. It is, in other words, complete enough.

Actually – and rather paradoxically – the same is true of *Le Spleen de Paris*. Because of the fragmentary nature of the work's organization, the difference between the form of the collection and the extrinsic concept of wholeness with which the text identifies its imperfection, we can mentally complete, or rather construct, a work

17 See Pichois's remarks to this effect (*OC* I, 1402–405).
18 See letter to Madame Aupick (*C* I, 451).
19 See *C* I, 187, 202, 222, which allude to *nouvelles*.

without reference to or regard for any missing pieces. Baudelaire's statement in the letter to Houssaye, now attached to the work, takes the opposite line to the one pursued in his 1857 defence:

> Enlevez une vertèbre, et les deux morceaux de cette tortueuse fantaisie se rejoindront sans peine. Hachez-la en nombreux fragments et vous verrez que chacun peut exister à part. Dans l'espérance que quelques-uns de ces tronçons seront assez vivants pour vous plaire et vous amuser, j'ose vous dédier le serpent tout entier. (*OC* I, 275)

In fact, *Le Spleen de Paris* could be said to be an unfinished work only in the sense that the fifty poems that might have made up the final collection may not have been the fifty we have today, had Baudelaire completed the hundred poems he had intended to write.[20] Poulet-Malassis, in a letter to Asselineau, states that, the day before he died, Baudelaire had seventy prose poems written and that he intended to write a hundred 'pour choisir, car sur les 70 il y en avait de faibles et d'autres qui faisaient double emploi'.[21] If this is true, and one suspects that it might not be, where are the missing pieces? The existence of a 'liste de projets' and various 'brouillons' does not amount to 20 more complete poems, but it does suggest well in excess of another 50 ideas, excluding those titles which Baudelaire indicates as potentially longer *nouvelles*.[22] These 'listes' have been examined and dated by a number of critics, all of whom suggest the importance of further analysis. Kopp concludes his own study of these lists by asserting the importance of 'un travail qu'il faudrait entreprendre un jour sur "Baudelaire et ses projets inédits"'.[23] Hiddleston offers a

20 Despite the numerical 'completion', Baudelaire states, as late as February 1866, that he has tried to get back into ('me replonger dans') the prose poems 'car ce n'était pas fini' (*C* I, 583).
21 Cited by Henri Lemaître in Baudelaire, *Petits Poèmes en prose* (Paris: Garnier, 1958), p. xvi.
22 *OC* I, 366–74. The titles which are indicated as *nouvelles* occur particularly on p. 369.
23 Robert Kopp, *Petits Poèmes en prose* (Paris: José Corti, 1969), p. 380. For discussion of these lists, see especially Kopp, ibid., pp. 377–401; F. W. Leakey, *Baudelaire and Nature* (Manchester: Manchester University Press, 1969), pp. 362, 369; and A. W. Raitt, 'On Le Spleen de Paris', *Nineteenth-Century French Studies*, 18, nos 1&2 (Fall–Winter 1989–90), pp. 150–64.

word of warning, though, which, in fact, amplifies the problem of unfinishedness and of missing pieces and alerts us to the risks of such an enterprise, urging that 'we must treat with prudence a manuscript whose status is uncertain and which has survived while many others, possibly as relevant or more relevant, were lost'.[24]

Le Spleen de Paris offers itself up as an unfinished work, though, rather like some of the apparently consciously 'unpolished' pieces it contains. It is, if we are to believe Baudelaire's simultaneously self-deprecating and self-valorizing remark to Houssaye, both inferior to and singularly different from his 'mystérieux et brillant modèle'. Baudelaire, in fact, plays around with this notion of the model, saying that it is 'le plus grand honneur du poète d'accomplir *juste* ce qu'il a projeté de faire'. This could represent an ideal of completion (or completeness), or it could – and Baudelaire's ironic manoeuvres here suggest that it should – suggest an ideal of the open-ended work. The snake metaphor invoked in the same letter to Houssaye moves towards this, and these peritextual remarks suggest an approach to the work of art (and to the reading process) which is in a perpetual state of becoming. Adorno describes this aesthetic problem in a way which is applicable to Baudelaire's ambivalence:

> But a work that in its own terms, in its own texture and complexion, is only possible as emergent and developing, cannot without lying at the same time lay claim to being complete and 'finished'. [...] The ideological, affirmative aspect of the concept of the successful artwork has its corrective in the fact that there are no perfect works. [...] the turn to the friable and the fragmentary is in truth an effort to save art by dismantling the claim that artworks are what they cannot be and what they nevertheless must want to be.[25]

The boundaries of the missing are, as has already been said, uncertain and interim, and whilst we can work only with what we know to be missing, usually as a result of epitextual information, the suggestiveness of potentially endless lacunae offers alternative critical perspectives to those derived from closure. This research is just the

24 '"Chacun son Spleen". Some Observations on Baudelaire's Prose Poems', *The Modern Language Review*, 86 (January 1991), p. 66.
25 Theodor W. Adorno, *Aesthetic Theory*, ed. By Gretel Adorno and Rolf Tiedemann, trans. by Robert Hullot-Kentor (London: Athlone, 1997), pp. 26, 189–90.

beginning of a project on the unfinished in the nineteenth century, but like the large-scale works we are now to come to, it has a broader critical goal. It seeks not only to place Baudelaire's 'projets inédits', but other unfinished works, too, in an aesthetic of unfinishedness and absence which represents an historical reality as well as a particularly modernist perspective on artistic process and reception.

Before returning to the Baudelairean projects, I want to place his aspirations in the context evoked earlier, a context of aspirations on a grand scale which, more often than not, might be said to come to nothing. As evidence of that broader context, we should turn to Courbet. As Petra Chu has shown, unfinished and unexecuted paintings play a large role in Courbet's work.[26] There is evidence of fourteen such unexecuted paintings, and many others were left unfinished in a conventional sense.[27] Indeed, Linda Nochlin has referred to the *Atelier du peintre* as 'an allegory of the unfinished, of the impossibility of ever finishing in the sense of imposing a single coherent meaning on a work of art'.[28] Courbet's long title for this painting explicitly states that the painting represents seven years of his artistic life, symbolized by the *production* of those years, the paintings, which act as a backdrop. Although Courbet's letter to Champfleury names the paintings to be represented here, they are barely visible,[29] and the Quillenbois caricature of the painting shows them as empty frames.[30] In fact, the paintings in *L'Atelier* are so unfinished that the canvas shows through. If further evidence were needed about the purposeful representation of the *non finito*, material unfinishedness, one can also invoke, as Nochlin does, the bright, unmanipulated pigment of the paints on the palette (where production originates and where unfinishedness is most flagrant), for this palette

26 See Petra Ten-Doesschate Chu, 'Courbet's Unpainted Pictures', *Arts Magazine*, 55 (September 1980), pp. 134–41.
27 The evidence for these fourteen paintings is presented as an appendix by Chu, ibid., pp. 139–41.
28 Sarah Faunce and Linda Nochlin, *Courbet Reconsidered* (New York: The Brooklyn Museum, 1988), p. 23.
29 The paintings were to be *Les Baigneuses* and *Retour de la foire*. See Benedict Nicolson, *Courbet: The Studio of the Painter* (London: Allen Lane, 1973), p. 18.
30 *L'Illustration*, 21 July 1855.

is what is most unfinished about the painting, and yet it is where it is most complete.[31] The unfinishedness of this – and other works – can be explained away by empirical accidents in the history of production, but mostly these are excuses, smokescreens even, which divert critical attention away from the significance of the missing or incomplete.

And so it is that in *L'Atelier du peintre*, what we have is a case of seeing things almost unlike any other. A case of now-you-see-it-now-you-don't. For when one looks closely, there are other kinds of material unfinishedness. In the far right of the picture, just behind where Baudelaire sits on a table, framed in the darkness of a mirror, there is a shadowy presence, or rather the discernible shadow of an absence. Most critics pass rapidly over Jeanne Duval's disappearance from Courbet's *Atelier*, treating the expurgation of her presence as no more significant than the painting out of the Louis XV-style legs which previously supported the table on which Baudelaire sits.[32] A break in their relationship not only justifies Baudelaire's request that Duval be removed after the painting was first hung,[33] it also seems to justify critical silence on this act of considerable violence. It has been said that Baudelaire demurred at having his private life on public display, but *demurred* is surely no word to describe a deletion of this kind. This missing piece has much more to disclose and we should not collude further in its expurgation by failing to recognize the significance of the act of removal. Here, seeing what remains enables us to see Courbet's painting, like *Les Fleurs du mal* – (and as indeed Courbet's own title suggests) – as ongoing chronicle, as the impossibility of ever finishing such a representation of artistic production, or indeed of ever completing it through the act of interpretation.

The *Atelier* is only a relatively unfinished painting, like Baudelaire's own poetic works, but both poet and artist share a passion for grand-scale projects which are never brought to fruition.

31 Faunce and Nochlin, pp. 24–25.
32 See Lola Faillant-Dumas, 'Examination by the Laboratoire de Recherche des Musées de France', in *Gustave Courbet 1819–77*, catalogue of an exhibition held at the Royal Academy of Arts (1978), p. 284.
33 See *L'Artiste*, 15 April 1899, where Edouard Houssaye makes reference to Jeanne's presence.

For both artists, imagination (defined differently by each of them) played an important role in the conception of works, often resulting only in their conceptualization, rather than their materialization. One of these, and probably the most famous of Courbet's unpainted pictures, is *La Source d'Hippocrène* in which Baudelaire was again to feature (or featured). The work is, like the *Atelier*, designed on a grand scale, panoramic and satirical – 'un tableau *épique*', says Courbet, 'c'est-à-dire une satire de ma façon'.[34] The reflexive nature of the enterprise is telling, focussing as it does on Courbet's manner, or aesthetic, and this only contributes to the enigma. What is perhaps most alluring about this invisible painting, though, is its relationship with the *Atelier*. Both paintings are panoramic, both have a similar composition: an allegorical nude at the centre, with groups of individuals on each side. It is almost as if *La Source d'Hippocrène* is offered as a parodic version of *L'Atelier*, a kind of *pendant* which would bring into sharper focus the particular *enjeux* of both paintings. During composition, however, the painting is destroyed in a domestic accident, although a description of it exists in the form of a letter to Castagnary. The almost flippant tone of the letter reveals little trace of genuine regret on Courbet's part, in fact, its flippancy is disconcerting. For having bid each figure adieu in turn, he writes:

> Que de choses je perds d'un seul coup! Adieu les récriminations des amis; adieu les invectives de la critique; adieu les fureurs des poëtes contre l'odieux réalisme. L'exposition prochaine manquera encore une fois de gaieté. Mais on m'accordera ceci: c'est que si j'enlève une belle occasion à mes détracteurs, ce n'est pas de ma faute, la volonté y était.[35]

This statement, when set alongside the large numbers of unfinished works and unwritten or unpainted projects gives cause to question the ludic nature of such incompletion. The last clause, 'la volonté y était', is particularly troubling in its ambiguity.

A number of other unpainted paintings by Courbet could be invoked if space allowed, and analysis of the epitextual material in conjunction with the titles proves revealing. Baudelaire, like Courbet, who envied the serial nature of the Balzacian *Comédie humaine*, seeks

34 *Nouvelle Revue de Paris* (1864), I, p. 190.
35 Ibid., p. 191.

the grand-scale project. For Courbet, this meant generating designs of a similar kind, envisaging different works complementing each other, contrasts and sequels, all participating in a grand scheme or series. For Baudelaire it meant more and more titles, more projected novels when not one was written. For both, in other words, it means the pre-eminence of process over product, which is why the product is often reviewed and reorganized – or definitively deferred.

As Baudelaire and Courbet develop their aesthetic, separately but in parallel ways, both move increasingly towards such deferral of closure and towards openness and a lack of figural and formal clarity. The prose poems, though numerically complete, perhaps, do not, by the very nature of their organization and resonances, allow any illusion of completion; the *Journaux intimes* are left as fragments and, in some cases, designed as the most fragmentary of *formes brèves* (microscopically complete and hermeneutically suggestive). Each missing piece or unfinished fragment seems to detail a strategy which defies closure. These are deeply illusionary (and elusive) forms, provisional versions of unfulfilled intentions which establish a false and confusing symmetry between production and reception. Missing and unfinished pieces are allusive lacunae and invite a reception that, by proceeding far beyond, behind, before, between and beneath the text or canvas discovers a complementarity (or even identity) of artist and reader. Criticism cannot restore those pieces, but it can actualize them and, in so doing, it can engage productively with the role of the non-aesthetic and the ideologically unaccommodated. If we focus upon unfinishedness, upon missing pieces, erasures and excisions, we are confronted with the authorizing and symbolizing power of the artist engaged in a particular, constrained and directed act of production.

Unfinishedness and absence are resistance to closure carried to the extreme of denying closure. They are the developmentally continuous. If we divert our attention to the primacy of the missing pieces, we engage in what Barbara Hernstein Smith has called *apertures*, 'not in the sense of openings, but rather of unendings, interminables, indeterminacies'.[36] Such missing pieces engage our

36 *Poetic Closure* (Chicago: University of Chicago Press, 1968), p. 261.

attention to display what, in a later book, she calls 'the infinitely open curve of parabola', forming 'parables for an infinite number of propositions'.[37] It is in this conceptual framework that we can best understand the connection between the motivation for elaborating 'listes de projets' and describing unpainted pictures and the speculative critical possibilities that such unfinishedness and absence invite.

Suggested Reading

Charles Baudelaire, *Oeuvres complètes*, ed. by Claude Pichois, 2 vols (Paris: Gallimard, Bibliothèque de la Pléiade, 1975–6)
Petra Ten-Doesschate Chu, 'Courbet's Unpainted Pictures', *Arts Magazine*, 55 (September 1980), pp.134–41
Sarah Faunce and Linda Nochlin, *Courbet Reconsidered* (New York: The Brooklyn Museum, 1988)
Barbara Hernstein Smith, *Poetic Closure* (Chicago: University of Chicago Press, 1968)
—— *On the Margins of Discourse* (Chicago: University of Chicago Press, 1978
Claude Lorin, *L'Inachevé. Peinture. Sculpture. Littérature.* (Paris: Grasset, collection 'Figures', 1984)
Guy Robert, *Art et non finito. Esthétique et dynamogénie du non finito* (Montréal: France-Amérique, 1984)

37 *On the Margins of Discourse* (Chicago: University of Chicago Press, 1978), pp. 144–45.

ARIANE SMART

Hugo *Visionnaire*:
Realism and Symbolism in the Myth of Paris

In one short, single famous sentence, Rimbaud summarized three key points regarding *Les Misérables*, and beyond it, its author, Victor Hugo: firstly, that the novel ought to be read as a poem; secondly, that Hugo had – or could have – the quality that makes a 'voyant', a seer; but also that he was probably too stubborn to make the best use of his vision: 'Hugo, *trop cabochard*, a bien du *vu* dans les derniers volumes: les Misérables sont un vrai *poeme* [*sic*].'[1] Rimbaud is right in seeing *Les Misérables* as a poem: although he excelled in all literary genres, Hugo can be seen mainly as a poet even when he writes novels. Some critics even consider him, if not as a symbolist himself, at least as a pre-symbolist who paved the way for the Surrealists.[2] This, I believe, helps to avoid common misreadings of his work based on psychoanalysis that too often underline his simplicity (the lack of inner depth of his characters, for example) and Manicheism, failing to take into account that Hugo's world is hardly a conceptual one: 'la contemplation ni le naturalisme hugolien ne sont des faits de pensée, mais des faits de *poésie*'.[3]

I would like to express my gratitude to Dr Michèle Hannoosh for the corrections and suggestions she made for this article. Some elements of this contribution are taken from a previous article, 'The Darkness and Claustrophobia of the City', *Modern and Contemporary France*, 8, no. 3, (August 2000), pp. 315–24.

1 Arthur Rimbaud, letter to Paul Demeny, 15 May 1871, also known as 'La Lettre du voyant' in *Lettres du voyant*, ed. by Gérald Schaeffer (Geneva: Droz & Paris: Librairie Minard, 1975), p. 141.
2 Victor Brombert, Pierre Albouy, Léon Paul Fargue, among others. Surprisingly, this tends to be ignored outside Hugolian studies.
3 Jean Gaudon, *Le Temps de la contemplation* (Paris: Flammarion, 1969), p. 406–407 (my italics).

Hugo sees his imagination as a revelation of reality, and thus tends to identify the expression with what is being expressed: 'comprenez que les mots sont des choses' he says.[4] He actually comes to believe in the reality of his images: 'Les images, les métaphores même tendent à être, non pas des ornements appliqués extérieurement à l'objet, mais l'expression même de son essence'.[5] Hugo chooses his metaphors with great care, repeats them throughout his work, blurring boundaries between his poetry and his prose and creating a complex symbolic system.

As we shall see, Hugo assumed the sacred mission of a modern bard, a mission that closely corresponded to the archaism of the process of mythmaking. A myth, I would argue, is more than a simple legend and the myth of Paris which was developing throughout 19th-century France, more than a mere poetic and fantastic representation of the city. Paris served as a symbol for humanity in general, and thus the choice of how to represent it – for example as a dark and evil place – revealed the fears and obsessions of a new, modern, urban society; it reflected the moral concerns of both a bourgeois society and of those who sought to undermine its apparently comforting values. Hugo would probably have agreed with the statement made by Paul Valéry about the universal status of the French capital:

> Il m'apparaît que penser Paris se compare, ou se confond, à penser l'esprit même. Je me représente le plan topographique de l'énorme cité, et rien ne me figure mieux le domaine de nos idées, le lieu mystérieux de l'aventure instantanée de la pensée, que ce labyrinthe de chemins, les uns, comme au hasard tracés, les autres, clairs et rectilignes.[6]

But more importantly for Hugo, Paris, as the capital of revolutionary revelation and a potential new Jerusalem was the natural setting of the poet's visions; the place for his revelations, and thus the encounter of the 'poëte-mage [and the] ville-mage'.[7]

4 *Les Contemplations*, Suite (Paris: nrf Gallimard, 1973), p. 49.
5 Denis Saurat, *La Religion de Victor Hugo* (Paris: Hachette, 1929), p. 13.
6 Paul Valéry, *Regards sur le monde actuel* (Paris: Gallimard, 1945), p. 127.
7 Claudette Combes, *Paris dans* Les Misérables (Nantes: CID Editions, 1981), p. 281.

If Paris generally remains known as the urban incarnation of the 19th-century's ideals of progress and modernity, the magnificent city of lights also bears a darker side. Paris is also seen as a new Babylon, a city of mystery, danger and evil. And if Hugo dreams of a new Jerusalem and a capital for the 'États-Unis d'Europe' in the future, what he sees in the present brings his attention more on the lower depths of the city, made of depravation and misery (both economic and spiritual).

Before looking at Hugo's view of the dark and evil recesses of the city, before plunging with him into the repellent and frightening *bas-fond*, I will start by developing what I mean when I refer to Hugo's function as a bard, a *poète-voyant*, and what makes him a seer in the century of modernity. I will then examine his frightful vision of the city which, as we will see, is structured according to a vertical pattern, giving the reader a vertiginous view over darkness – both concretely and metaphorically. Ultimately, the poet-seer's visions bear political implications and it is tempting, although delicate, to question Hugo's.

It has been argued that Hugo anticipated the symbolist creed in many regards; mainly because of his belief that there are semiotic links between the realms of the visible and the invisible, 'binding infinite manifestations to a single principle' and also because of the idea that there is something beyond appearance to be seen.[8] This was of course by no means new, but it had been renewed and invigorated by Swedenborg in the eighteenth century (who would have a great impact on nineteenth-century writers). Authors like Joseph de Maistre and, more importantly for Hugo, Ballanche also stated that the poet in particular, by the very act of contemplation, had to go beyond what he could physically see with his eyes, and seek to see with his soul.

This is clearly a religious process: the poet-seer starts with the contemplation of the real, then leaves the world of appearance and goes beyond the level of the object to rise to God. It is by this act of contemplation that the seer is granted by God the privilege of

8 Victor Brombert, *Victor Hugo and the Visionary Novel* (Cambridge, MA & London: Harvard University Press, 1984), p. 12.

becoming a prophet, 'le grand interlocuteur de Dieu'.[9] He will thus be able and allowed to see what ordinary men cannot. This itself isolates the poet-seer by raising him within God's hierarchy: 'il voit, quand les peuples végètent'.[10] Yet the *poète-voyant* should not become detached from common daily life. Quite the opposite: the poet's deeper visionary tendencies are determined by social and historical realities, by 'the need to relate private phantasms to the thrust of external events'.[11] To avoid the risk of being doomed by one's *rêverie*, Hugo understands the need to hold a firm grip on the real: 'ne craignez pas de vous surcharger d'humanité. Lestez votre raison de réalité', he advises, so that 'le songeur soit plus fort que le songe'.[12]

What the *poète-voyant* aims to achieve is an intermediate position between God and man. He belongs to a superior space of consciousness, while, at the same time, keeping a plunging vision over terrestrial life. The seer does not cut himself off from humanity, neither does he detach himself from matter, which is the place for revelation.[13] As a *révélateur*, capable of shedding light on deeper truth, he assumes a moral and social function; again, his mission is not just to contemplate a vague infinite but to reach what Hugo thought to be eternal: moral truth. The divine gift of seeing is given to the poet-seer to serve humanity: his *regard* is partly divine and allows him to bring back part of the light that he was allowed to see, literally to enlighten the 'Peuple universel'.

In Hugo, the theme of the eye is crucial: in the Preface to the *Feuilles d'automne*, he compares the ideal poet with an eye: 'un œil, οφθαλμός, comme dit admirablement la métaphore grecque'.[14] It is a theme that he will repeat throughout his work: 'Deviens le grand œil fixe ouvert sur le grand tout':[15]

9 Marc Eigeldinger, 'La Voyance avant Rimbaud' in Arthur Rimbaud, *Lettres du Voyant* (Geneva: Droz & Paris: Librairie Minard, 1975), p. 65.
10 Hugo, 'Fonction du poète', *Les Rayons et les Ombres* (Paris: Grands écrivains, 1984), p. 138.
11 Brombert, p. 11
12 Hugo, *Promontorium Somnii*, II, (Paris: Les Belles Lettres, 1961), p. 31–33.
13 Eigeldinger, pp. 63–67.
14 *Les Feuilles d'automne* (Paris: Grands écrivains, 1984), p. 13.
15 'A celle qui est restée en France', *Les Contemplations*, p. 418.

> Je suis le regardeur formidable du puits;
> Je suis celui qui veut savoir pourquoi; je suis
> L'œil [...].[16]

The *regard* of Hugo is by no means a calm and comforting one. It is traditionally deeply dangerous to raise one's eyes to divinity; since *voir* leads directly to *savoir*, looking directly at God or at God's truth – whether willingly or not – has always been the promise of a certain death, unless God's will allows it. Death in this case punishes both the rashness of man and human inability to bear divine light. Only the seer can be granted to survive his visions.

Moreover, not only is Hugo afraid of what he might see, or to see what he might not be allowed to see, he is equally afraid of the very act of looking which he describes as a dangerous journey downward:

> Une pente insensible
> Va du monde réel à la sphère invisible;
> La spirale est profonde, et quand on y descend,
> Sans cesse se prolonge et va en s'élargissant,
> Et pour avoir touché quelque énigme fatale,
> De ce voyage obscur souvent on revient pâle![17]

The danger does not come only from the vision itself, but equally from the sensuous visual addiction that might interfere with true vision. As Victor Brombert noted, Hugo considers eyes as 'windows opening on the spectacle of obscenity and cruelty. [They] are dangerous invitations not only to *rêverie*, but to voyeurism of all sorts' (p. 78); just as Frollo in *Notre-Dame* can no longer see God, having been blinded by his repeated, desperate looks at Esmeralda, Hugo feels a similar inclination to what I might call 'la pente du voyeurisme'.[18] To thwart this, Hugo feels the need to rely on his inner eye, rather than on his physical one. So Hugo will constantly use his imagination to articulate his visions in order not to let himself be taken over and eventually doomed by the physical act of seeing.

16 'Le Hibou', *Dieu* (Paris: Nizet, 1960), I, p. 22.
17 'La Pente de la rêverie', *Les Feuilles d'Automne*, pp. 80–81.
18 In reference to 'La Pente de la rêverie', *op. cit.*, pp. 80–84, and to Hugo's tendency to voyeurism.

Now it is interesting in this regard to take into account the place of *Les Misérables* in Hugo's work: after having turned inward for a long time, seeking for the most abstract and spiritual visions (as one can find in *Les Contemplations, Dieu* and *La Fin de Satan*), Hugo decides to inscribe his visions in something more tangible for his readers. He chooses to go back to an earlier work, a novel where the central character, Jean Valjean, is placed in real life, in an almost contemporary time and notably in a concrete city, Paris. Interestingly though, Hugo is not in Paris when he writes the novel, but in exile. He starts his journey back to the real by plunging into his memories. So he does not actually see the Paris he describes; nor does he describe the Paris of the early 1860s, as it is when he writes, for he sets the Parisian episodes in the early 1830s, although what he actually has in mind is the revolution of 1848. The apparent confusion that results from following the twist and turns of Hugo's thought is indeed misleading: chronology is actually irrelevant to the understanding of a novel whose narrative itself often resists chronological continuity. Similarly, the description of Paris, although accurate and strongly documented, is secondary for the poet who articulates his vision only according to his imagination.[19] There are no fundamental differences in Hugo's world between what he remembers and what he imagines, nor is there any difference between what he imagines, and what he sees: 'impossible de distinguer chez Hugo la part du souvenir de celle de l'imagination. Tout souvenir est immédiatement recouvert par le déploiement des images.'[20] As a seer, he is constantly aware that the world is not only made of what he can see, but also of what he can imagine out there, and consequently of what his imagination really displays to his eyes.[21]

And Hugo's imagination starts with a global view from above:

Oh! qui m'emportera sur quelque tour sublime
D'où la cité sous moi s'ouvre comme un abîme![22]

19 Gaudon, p. 286.
20 Georges Poulet, *Etudes sur le temps humain* (Paris: Plon, 1952), II, pp. 205, 313.
21 Ibid., p. 209.
22 'Soleils couchants', *Les Feuilles d'automne*, p. 99.

In *Les Contemplations* ('Ce que dit la bouche d'ombre', p. 386), the poet, like Jesus before him, is placed on top of a mountain ('sur le haut du rocher'), overlooking the world in order to be offered a better perspective, a plunging view.

> je suis monté sur la montagne
> D'où l'on peut contempler la ville en son ampleur,
> Hôpital, lupanars, purgatoire, enfer, bagne,
> Où toute énormité fleurit comme une fleur.[23]

For the prophet does not climb a mountain to be closer to God, to look up in the sky, but to see the depths of the earth, and from there, to start a journey downward. Like Jeremiah, Hugo answers the prophetic calling that first implies a plunging into mud and putrefaction, because – paradoxically – God, for Hugo, emerges from subterranean darkness, from chaotic and dynamic human suffering and human becoming.[24] And if Baudelaire is certain to find Satan on his way back down to the evil city, Hugo is equally convinced of meeting God in the darkness of the social hell, namely, the *bas-fond*.

In both *Notre-Dame* and *Les Misérables* Hugo proposes a view of Paris from above: 'Paris à vol d'oiseau' in *Notre-Dame*, 'Paris à vol de hibou' in *Les Misérables*. In both cases, what appears from this flight over the capital is a web of streets, a maze of passages, courtyards and impasses, in other words a labyrinth, an image that indicates a specific urban perception of space, consisting of an excess of both vastness and oppression: the labyrinth combines the idea of being lost in an everlasting walk and the fear of claustration, of never finding the way out. It combines horizontality (being lost in the streets of Paris) and verticality (falling into its depths). But if, as Hugo stated in *Dieu*, 'il faut bien un axe à ce qu'on voit', then clearly, his preference will be a vertical one: this is not surprising for a prophet who started his journey from above, plunging into the abyss, the 'gouffre universel'.[25]

Even a horizontal symbol like the labyrinth is described by Hugo as vertical. The maze of streets appears not merely as a surface

23 Baudelaire, 'Épilogue', *Petits poèmes en prose*.
24 Brombert, p. 114.
25 'Le Hibou', p. 35; 'Ce que dit la bouche d'ombre', *Les Contemplations*, p. 386.

labyrinth but as a depth ('profond labyrinthe' he says in 'Le Hibou', p. 18) to be plumbed, a nether region filled with mysteries and revelations.[26] Hugo's imaginary is not just a juxtaposition of vertical and horizontal movements but rather the idea of a 'surface trompeuse' which hides a secret depth to which the seer cannot resist. Entering the maze is clearly for Hugo a journey downward: when referring to the labyrinthine sewers, he qualifies them as a 'labyrinthe qui a pour fil sa pente'; he mentions a proverb according to which 'descendre dans l'égout, c'est entrer dans la fosse' and adds 'l'intestin de Paris est un précipice'.[27]

This image of the city's intestine – 'l'intestin du Leviathan' – is a good illustration of the seer's journey down to hell. Valjean is compared to a modern Jonah, moving around in the belly of the urban monster, the Leviathan. In Hugo, as in primitive thinking, the reference to the *ventre* is clearly evil, symbolising hell. This of course recalls Orpheus's journey down to the underworld. The myth prepares for the figure of the monster that the hero will have to defeat in order to be allowed to return. As always in Hugo's work, this is not a mere poetic embellishment but a transfiguration of the evil essence of the underworld into a monster: it is properly organic and alive. *Paris-matière* is not made of cold stones, it is a monster of flesh and blood in the purest Biblical tradition: gigantic, voracious, pitiless, bloodthirsty and powerful and, above all, alive. The dark recesses of Paris, the *bas-fond* is the place where 'la protestation de la matière' (II, p. 250) crawls like a hideous snake shaped monster. Hugo's recurrent use of organic metaphors serves to describe the city as being monstrously alive: Paris swallows, digests, and even vomits: 'cet estomac de la civilization digérait mal, le cloaque refluait dans le gosier de la ville, et Paris avait l'arrière goût de sa fange' (III, p. 308).

The image of the beast underlines the double abnormality of the abyss, both animal and evil (as in the Apocalypse), bestial and fantastic. The people of the *bas-fond* in *Les Misérables*, like the people of the Cour des miracles in *Notre-Dame*, are repeatedly compared to every possible infernal creature one can think of, not only animal (spiders, bats) but also supernatural (demons, devils,

26 Brombert, p. 79.
27 *Les Misérables* (Paris: Garnier-Flammarion, 1967), III, pp. 278, 302, 308.

ghouls, vampires, ghosts, spectres). The *bas-fond* is the place of regressive reduction to the animal and the primitive.[28] As for its evil, it comes from the inherent abnormality of these non-human places peopled by barely human creatures: abnormality of the places because they are dark, sick, claustrophobic and evil whereas human nature requires light, health, freedom and God; abnormality of the creatures themselves because they are trapped within urban materiality as in a cell: 'la pierre est une cave où rêve un criminel'. Their monstrosity is thus related to their carceral condition: 'l'homme a la liberté, le monstre a le carcan'.[29]

The image of a dark and evil city is dominant in nineteenth-century literature about Paris. From Balzac and Sue to Zola, authors of that time seem to have enjoyed the perverse spectacle of urban evil and human degradation. This reflects a serious bourgeois concern about the inner darkness of the city's lowest levels, a darkness that has to be eradicated by any means (urban politics, hygiene, education, police, morals, all playing their part in the process). But Hugo's fascination with the spectacle given by the underworld is rather ambiguous: it highlights both the temptation of the voyeur faced with the ugliness of what he sees and the duty of the seer to find redemption and salvation where humanity itself seems to have been denied. In both cases, the poet is attracted by the abyss, by darkness, in other words, by evil. Inevitably, if he wants to become a *visionnaire*, he first has to be a bit of a voyeur, which itself is likely to distract the seer from his mission. And indeed, evil soon appears to be even more dangerous to look at than God: instead of risking just your life, you face the more perverse danger of being seduced and doomed by Satan's illusions. Tempted Hugo certainly was, although he faced those illusions with his eyes wide open and prepared to throw light on them in a striking way.

Since Hugo follows an 'axe vertical', what he sees at the lowest levels soon appears as a reflection of the upperworld. In *Les Misérables*, the reflection is architectural, the sewers mapping the streets of the upper city: 'Paris underground is seen as an extension of

28 Christopher Prendergast, *Paris and the Nineteenth Century* (Oxford & Cambridge, MA: Blackwell, 1992), p. 87.
29 *Dieu*, p. 135; 'Ce que dit la bouche d'ombre', *Les Contemplations*, p. 398.

Paris overground'.[30] As Hugo describes the sewers as the 'succursale de la Cour des Miracles' (*Les Misérables*, III, p. 289), he thus echoes a previous attempt to plunge into the urban underworld, the city's evil twin: in *Notre-Dame*, the reflection of Paris in the Seine as in a mirror reflects the counter-society that lives below. Yet this reflection soon turns out to be an illusion, offering anyone daring to go any deeper a misleading and distorted image of the upperworld and of its rules, as Gringoire experienced: lost in his *rêverie*, the jaunty character goes from a dream to a nightmare, failing to realize that he is going beyond the 'surface trompeuse'. He then finds himself in a scene reminiscent of what he saw previously, although something has been monstrously perverted: at the opening of the novel, Gringoire is an ironic spectator waiting for a mystery play to be given at the Palais de Justice. Only once he got lost in the Cour des Miracles, is he to attend an actual trial, his own. If the upperworld has transformed a Court of Justice into a theatre, similarly, the underworld transforms a never-ending show (the Cour des Miracles itself) into a parodic trial. 'The inverted society turns law upside down', la Cour des Miracles reflecting la Cour de Justice in an ironic and grotesque way.[31] Although the general tone is humorous, Gringoire puts his life at risk by the very fact that, coming from above, he fails to respond in an equally grotesque manner to the leader (the king) of the Cour des Miracles.

The mission of the *poète-voyant* brings him back to the surface with a political message. Hugo sees the dangerous absurdity of a city that prides itself on being powerful, superb and modern, while hiding a perverse inverted image. Yet this is the place for revelation. From his exile, he denounces the deviation from the revolutionary ideal of the 'Jérusalem céleste', for which he held Baron Haussmann responsible. *Paris-matière* is absurd because it means relying on what one can see with one's eyes, and therefore being duped by appearance. It is a tragic mistake, because it does not follow the model set by the prophet. In *Paris-Guide* (1867), Hugo will vehemently denounce the doomed materialism of the Second Empire, that betrays the sacred mission of Paris as a leader of the 'Peuple universel' in its march towards progress (that is a spiritual and moral one).

30 Prendergast, p. 89.
31 Brombert, p. 80.

This is a political choice. But Hugo's vision and interpretation of Paris goes deeper than a mere conflict with 'Napoléon le Petit', and a more subtle, although equally political, orientation is revealed here. As Victor Brombert rightly noted (pp. 81–82), 'la pente de la rêverie' – consisting in a downward movement associated with pure contemplation – aims to transcend chronological and historical time: the vertical insight corresponds to the transhistorical vision of the prophet, whose atemporal perception is radically alien to the chronological, linear, progressive time of history: 'sur la mouvance universelle, le poète pose un regard immobile'.[32] This corresponds to Ballanches's conviction that a poet, as soon as he speaks the language of history, debases his Orphic calling, which is to fathom the 'causes profondes' and proclaim deeper truth.

Why Hugo tried to move out from history towards transcendence is not only explained by his duty as a seer, but also by his perception that 'history's march forward was a chancy affair, that faith in horizontal, linear progress did not necessarily correspond to the most probing vision'.[33] In 1830, just one year after having published *Le Dernier Jour d'un condamné*, a moving and powerful work against the death penalty, Hugo had to bear the angry crowd shouting in the streets of Paris, and putting pressure on French *députés* so that they would not abolish the death penalty for political crimes. The revolution of 1830 had raised great expectations and Hugo was convinced that the time to condemn the old guillotine once and for all had finally come. Although he blamed the government for blundering this historical opportunity, the popular reaction left him deeply disenchanted; 'ne demandez pas de droits pour le peuple tant que le peuple demandera des têtes', he even wrote.[34] According to Christopher Prendergast, he then started to distance himself from history, too submissive to facts and too indifferent to principles (p. 97). This experience seemed to him to demonstrate that he was right in rarely allowing 'the pressures of history and politics to take precedence over the deeper commitment of art'.[35] No doubt the bitter

32 Gaudon, p. 316.
33 Brombert, p. 77.
34 *Choses vues* (Paris: Gallimard, 1972), I (1830–1848), p. 112.
35 Brombert, p. 12.

disillusion of 1848–1851 felt by many writers did affect him in a similar way, provoking 'un désespoir à l'égard de l'histoire, et [...] une colère dont la poésie aura à remplir le programme d'action'.[36]

This eventually led Hugo to favour transhistorical moral values as being more reliable than history, with the risk of erasing history in the process. There is a striking statement made by Hugo in *Les Contemplations*: 'Voir, c'est rejeter'.[37] The very act of contemplation ultimately requires that the poet-seer free himself from the concrete object that initiated the vision in the first place. No longer useful, the 'chose vue' is now an obstacle to the poet's ultimate vision.

> Car, des effets allant aux causes,
> L'œil perce et franchit le miroir,
> Enfant; et contempler les choses,
> C'est finir par ne plus les voir.
>
> La matière tombe détruite
> Devant l'esprit aux yeux de lynx;
> Voir, c'est rejeter; la poursuite
> De l'énigme est l'oubli du sphinx.[38]

'La pente de la rêverie' ultimately leads to the erasure of the 'chose vue' from the poet's visual field, to the point where there is nothing left to be – physically – seen. As Eigeldinger puts it:

> *rejeter* l'objet perçu comme un support inutile à l'élancement de la vision, se détacher des contingences de la chose vue pour atteindre à la vision de l'absolu de Dieu, au-delà de toute frontière, dans un temps et un espace éclatés qui ne peuvent être vus que par le regard intérieur de l'âme.[39]

One could then wonder whether this might not contradict the seer's prerequisite to hold a firm grip on the real. Can the divine eye the poet identifies with still communicate with 'la foule blême'.[40] Can the new

36 Jean-Claude Fizaine, *Le Christ dans l'imaginaire de Victor Hugo, 1848–1869* (unpublished doctoral thesis, Université de Paris VII, 1979), pp. 556–57.
37 'Magnitudo parvi', p. 196.
38 Ibid., p. 196.
39 Marc Eigeldinger, 'La Voyance avant Rimbaud' in Arthur Rimbaud, *Lettres du Voyant* (Geneva: Droz & Paris: Librairie Minard, 1975), p. 68.
40 'Les Mages', *Les Contemplations*, p. 382.

Hugolian gospel find any echo in the century of revolutions? Does a seer have any place in modernity?

And this is where Rimbaud's criticism, with which we began, is so revealing; what his laconic phrase suggests is that Hugo fails as a voyant, not so much because of the visions themselves, but because of his stubbornness in remaining faithful to an archaic, biblical framework, turning his back on modernity, thus failing in his social function as a poet-seer. Although he has, and expresses, true visions, Hugo ultimately turns to tradition to make sense of them. Hence the disappointment expressed by Rimbaud: this attitude addicted to the past does not allow Hugolian visions to achieve their inner revolutionary impact. And one could indeed question whether Hugo's quest for transcendent, transhistorical moral 'truth' – which he thought to be eternal and safe to rely on – actually went anywhere beyond the common bourgeois and more 'terrestrial' set of values dominating his time. If not, then the poet ends up depending on what he had wanted so much to avoid: external, concrete, daily elements, having failed to see that morals are largely contextual and that people think and act according to historical time, because they are historical beings.

However, both Hugo's erasure of the 'chose vue' and visionary journey bear two powerful, poetically revolutionary and politically subversive consequences. We have seen how the vertical visions developed by Hugo combine with the ultimate contemplation of nothingness. In 'Magnitudo Parvi', the poet develops the theme of erasure to the point where the voyant himself disappears: only the eye remains. The total erasure of both the poet and his visual field brings Hugo to develop images of abysses and void, inviting us to a poetics of emptiness.

> Viens, si tu l'oses!
> Regarde dans ce puits morne et vertigineux.[41]

If Hugo's imaginary is well known for its richness, he is probably just as powerful when he explores the symbol of nothingness. 'Hugo atteint la plus haute poésie [...] quand il réussit à exprimer la réalité

41 'Ce que dit la bouche d'ombre', *Les Contemplations*, p. 393.

même du vide. Avant Mallarmé, Hugo avait découvert la poésie négative.'[42]

> Nuée en bas, nuée en haut, nuée au centre;
> Nuit et nuit; rien devant, rien derrière; rien entre.
> Par moments, des essaims d'atomes vains et fous
> Qui flottent; ce qu'on voit de plus réel, c'est vous,
> Mort, tombe, obscurité des blêmes sépultures,
> Cimetières, de Dieu ténébreuses cultures.[43]

However, it is to be noted that despite this, the seer's message remains embedded within a specific social framework which is both the starting point of the visions and the context in which they can reach their full meaning. Hugo blurs the boundaries between the real and fantasy, drawing a 'Goyaesque' picture of modern, urban society, thus revealing his century's deepest anxieties. The distortions he sees in the city's depths have the visionary impact of dreams, or, rather, nightmares. Yet with the accuracy of his poetic language, he manages to master those visions and express them with words, voicing his contemporaries' disquiet behind the bright façade of both modernity and bourgeois morality.

If we bear in mind that 'l'imagination assume la fonction de la raison' for Hugo, and if we subscribe to Gérard Schaeffer when he says that 'la modernité [consiste] bien à faire voir l'invisible, l'essentiel, selon ses propres données intérieures',[44] then it becomes possible to consider Hugo as a modern seer, who, in the century of rationalism and history, indeed makes the archaic choice of imagination and myth, but only to give an account of 'la réalité totale', beyond the physical appearance accounted for by history.

42 Poulet, p. 225.
43 'Le Hibou', *Dieu*, p. 35.
44 Pierre Albouy, *La Création mythologique chez Victor Hugo* (Pars: Corti, 1963), p. 497; Schaeffer, *Lettres du Voyant*, p. 176.

Suggested Reading

Pierre Albouy, *La Création mythologique chez Victor Hugo*, (Paris: Librairie José Corti, 1963)
Victor Brombert, *Victor Hugo and the Visionary Novel* (Cambridge, MA & London: Harvard University Press, 1984)
Marc Eigeldinger, 'La Voyance avant Rimbaud' in Arthur Rimbaud, *Lettres du Voyant* (Geneva: Droz & Paris: Librairie Minard, 1975)
Jean Gaudon, *Le Temps de la Contemplation* (Paris: Flammarion, 1969)
Victor Hugo, *Les Contemplations* (Paris: Gallimard, 1973)
―― *Dieu*, (Paris: J. Hetzel, n. d.)
―― *Les Misérables*, (Paris: Garnier-Flammarion, 1967), 3 vols
―― *Notre-Dame de Paris* (Paris: Librairie générale française, 1972)
Denis Saurat, *La Religion de Victor Hugo* (Paris: Hachette, 1929)
Jacques Seebacher, *Victor Hugo ou le Calcul des profondeurs* (Paris: P.U.F., 1993)
Charles Villiers, *L'Univers métaphysique de Victor Hugo* (Paris: Librairie philosophique J. Vrin, 1970)

BLANDINE CHAMBOST

The Mesmerizing Muse:
Salome seen by Moreau and Mallarmé

As a major artistic topos in late nineteenth-century France the theme of Salome has received much critical attention, yet its aesthetic dimension has been largely overlooked. The figure of Salome acts as a catalyst for the extraordinarily fertile interplay between literature and the visual arts which partakes of what I view as the aesthetics of excess elaborated in the period. As a muse she prompts a tremendous expenditure of creative energy. As a figure of excess she pushes the boundaries of form and understanding. Nowhere is this truer than in Mallarmé's *Hérodiade* and Moreau's Salome series, which both challenge conventional representations and are the product of intense aesthetic searchings. Both series were intimately connected to the poet's and the painter's overall artistic project as well as to their response to femininity. Through a close examination of these works I wish to demonstrate the originality and kinship of the artists' visions, and thus the correspondences between the poetic and the pictorial. I hope to shed light on the specific significance of the figure of Salome by examining the innovations she brings out. 'Je traduis la femme éternelle dans cette figure. Ce n'est pas une danse', observes Moreau to those tempted to view his vision of her as yet another *image d'Épinal*. This concern is echoed by Mallarmé: 'Je tiens à en faire un être purement rêvé et absolument indépendant de l'histoire.'[1] I will argue that the figure of Salome encapsulates both artists' striving towards the statement of pure beauty, liberated from narrative and formal constraints.

[1] Letter to Lefébure, February 1865, in *Correspondance*, I, p. 154.

Salome stands out as a lifelong interest and enterprise in both Moreau's and Mallarmé's œuvre.[2] For them she is not so much a set figure as a moving image. She is a source of emotional as well as aesthetic restlessness – the matrix of intense aesthetic probings which have deep emotional resonance. When examined in their entirety, the successive attempts at depicting her register both artists' experimentation in form and reflect their unrest in relation to the feminine as embodied in this bemusing figure, whose cold cruelty and beauty fascinate as much as horrify. In fact there is a creative – and inordinately pleasurable – tension between the violence contained in the story and the sumptuous evocation achieved in its treatment.[3] This tension betrays both artists' ambivalence towards the figure, who is as much an object of representation as a muse dictating innovation. It suggests that in the eyes of the poet and the painter there is more to the elusive dancer than the lustful female, often reduced by critics to a fin-de-siècle icon of perverse femininity.[4] The symbolist imagination may well have been obsessed with antithetical visions of femininity, but its most powerful creations, far from being Manichean, are characterized by oxymoronic beauty and effusive *signifiance*. A young virgin and a lethal seductress, Salome fits into the angel/demon paradigm while confounding it. Whereas some construed her as the archetypal *femme fatale*, others portrayed her as a more versatile character.[5] The restlessness she fosters is in response to her elusive

2 It is impossible to date Moreau's drawings, studies and even paintings, for he worked on them (sometimes on several simultaneously) from 1872 onwards. His first Salome paintings were exhibited at the 1876 salon. As for Mallarmé, he started working on his *Hérodiade* in 1864, first published a fragment ('Hérodiade, Scène') in 1871 and the poem was still in progress at the time of his death.
3 In view of the existing iconography on Salome (for a good contextualization, see Mireille Dottin-Orsini, *Salomé* (Paris: Autrement, 1996)), one may say that the tension between her erotic appeal and her fatal nature is present in all representations. This is what Moreau and Mallarmé tap into and problematize.
4 For a study of such icons, which I argue Salome challenges, see Bram Djikstra, *Idols of Perversity: Fantasies of feminine evil in fin-de-siècle culture* (Oxford: Oxford University Press, 1986), or Shearer West, *Fin de Siècle* (London: Bloomsbury, 1993).
5 Her radical ambiguity, the uncertainty of her intentions and her versatility are brilliantly exploited in Flaubert's 'Hérodias' (1877).

nature. In Moreau and Mallarmé she appears as a figure wrapped in complexity: an abstraction maddening the senses, a bewildering untouchable – an enigma who, charming the artist as she did Herod and stirring him out of his mind and measure, begets audacious creations. With its ancient design yet radical novelty of statement, Mallarmé's poem echoes the complexity (of both meaning and forms) manifested in Moreau's groundbreaking portrayals. These works invite a problematic reading of the intriguing figure who seems to resist containment and who generates compelling yet challenging artistic productions.

Moreau found endless inspiration in Salome for composition as well as experimentation with different media. His treatment of the theme over the years, going through successive narrative and technical variations, gives a measure of his enquiry. He first summoned her as a side figure in a *Décollation de Saint Jean-Baptiste* (1870), which in its composition still owes a lot to traditional iconography. Yet he was not content with such a stale depiction. As with other classical topoi, albeit with unrivalled insistence, he reworked it, invested it with his own subjectivity, giving free range to his visionary powers and composite talents. He produced thereby his own, idiosyncratic version of the myth. His focus soon shifted from John the Baptist to Salome, and his sustained interest in her took a particular turn. There was of course a long tradition of portraits of Salome but quite different in spirit to Moreau's depictions of her. Régnault's *Salomé* (or *Salomé la danseuse, tenant le bassin et le couteau qui doivent servir à la décollation de Saint Jean-Baptiste*) (1870), with its anecdotal gloss and allegorical keynote of malicious femininity, may highlight this difference and act as an exemplary foil in my analysis. *Salomé à la prison* (or *Salomé à la rose*) (1872) is a transitional work: it presents a dreamy Salome in centre stage while the scene of decapitation is reduced to a horrific vignette in a left-hand corner.[6] Yet soon the narrative is superseded by the evocative and Moreau moves beyond hagiography. Pierre-Louis Mathieu points out that, while Moreau

6 The catalogue of the recent Moreau retrospective provides an extensive and informed illustrated record of the Salome series. See *Gustave Moreau: Between Epic and Dream*, ed. by Geneviève Lacambre (The Art Institute of Chicago, 1999).

initially intended to represent a dance, he soon focused on the spiritual mystery in which Salome partakes – and by extension, on her riddle-like nature.[7] Indeed what seems to fascinate him and what motivates his aesthetic probings is that which, in her, escapes the grasp and exceeds traditional representation. As he put it himself, he intended to turn her into 'une figure de sibylle et d'enchanteresse religieuse avec un caractère de mystère'.[8] In *Salomé dansant devant Hérode* (or *Salomé tatouée*) (1874) the banquet hall has been replaced by a temple-like palace and the dance becomes a sacred ceremony.[9] The dancer's posture, hieratic features and dress (modelled on 'une châsse')[10] equate her with an idol, while in *L'Apparition* (c.1876) (see figure 14), she is endowed with the ancient powers of a seer. She is reminiscent of Oriental divinities, majestic in the splendour of her attire and her awe-inspiring pose. 'Le tout se passe dans un sanctuaire mystérieux, qui porte l'esprit à la gravité et à l'idée supérieure des choses.'[11] Never had Salome been taken further away from her morally connoted background into the realm of spiritual mystery and aesthetic ambiguity.

It is Moreau, then, who seems to fill the requirement Mallarmé set for his *Hérodiade*. The poet's prime concern was 'l'isoler comme l'ont fait des tableaux solitaires dans le fait même terrible, mystérieux'.[12] The princess haunted him for over thirty-five years – from the initial idea of the eponymous poem until his death, which left

7 'Au début, c'est une danse que Moreau avait l'intention de représenter [...]. Progressivement le personnage se transforme [...] et la danse devient une cérémonie sacrée.' Pierre-Louis Mathieu, *Gustave Moreau* (Paris: Garnier Flammarion, 1994), p. 124.
8 Moreau's writings have been compiled and published as *L'Assembleur de rêves: Écrits complets de G. Moreau*, ed. by Pierre-Louis Mathieu (Fontfroide: Bibliothèque Artistique et Littéraire, 1984). The quotation here is from p. 124.
9 Françoise Grauby, in *La Création mythique à l'époque du Symbolisme* (Paris: Nizet, 1994), p. 86, suggests that the setting 'ne dévoile en rien le moment historique mais il dit une expérience du sacré'.
10 *L'Assembleur de rêves*, p. 124.
11 Ibid., p. 78.
12 Preface to *Noces d'Hérodiade: Mystère*.

Figure 14: Moreau, *L'Apparition* (oil)
© Réunion des Musées Nationaux

it incomplete.[13] In his eyes the poetic creature outshone the historical character: he distanced himself from the original story, refusing its legacy. He strove to shape his own legend, and proclaimed his aesthetic *parti pris* encapsulated in the very epic-like name 'Hérodiade', which fostered his fertile reverie:

> j'ai laissé le nom d'Hérodiade pour bien la différencier de la Salomé je dirai moderne ou exhumée avec son fait divers archaïque la danse etc.[14]

> la plus belle page de mon œuvre sera celle qui ne contiendra que ce nom divin *Hérodiade*. Le peu d'inspiration que j'ai eu, je le dois à ce nom, et je crois que si mon héroïne s'était appellée Salomé, j'eusse inventé ce mot sombre, et rouge comme une grenade ouverte, *Hérodiade*.[15]

Similarly, as Moreau's paintings drawing on mythological material became less and less orthodox, Salome was gradually freed from the constraints of her biblical origins. She came to be treated as a motif in her own right, to which the numerous drawings relating exclusively to her testify.[16] Searching for the perfect arabesque, Moreau repeatedly treated the princess in isolation, like a pure form. In such drawings she appears in the full majesty of her Oriental beauty, released from the gruesome attributes of the biblical narrative. She also appears as a masterful artefact, that is a manifestation of the powers of the draughtsman. This meta-artistic dimension is evident in Moreau's repeated attempts at depicting the same subject, using the full range of his medium, displaying his skills as a draughtsman and a colourist. She was the inspiration for some of his finest and most innovative watercolours, such as *Salomé à la panthère* (c.1880) (see figure 15), which testify to the experimental dimension of his engagement with the figure while pointing to her versatile nature. The sensuous excess of matter, with its overwhelming visual and tactile appeal, intimates the seductively ambiguous and elusive quality of her

13 Incidentally, both artists died the same year (1898), leaving behind unfinished works and the still unsolved, and yet more subtle and captivating, puzzle of Salome.
14 *Les Noces d'Hérodiade. Mystère*, p. 51.
15 Letter to Lefébure, February 1865, in *Correspondance* I, p. 154.
16 The catalogue records about 120.

Figure 15: Moreau, *Salomé à la panthère*
© Réunion des Musées Nationaux

charms. The question of whether Salome is an accomplished seducer or a candid beauty become an instrument of power is eclipsed by the affirmation of her enigmatic, spellbinding might. Of all the female figures abundantly portrayed by Moreau, Salome is special in that she is an artist herself – more, it is through her artful dance that she disrupts established order. In his late writings he equates her with the ideal-seeking artist:

> Cette femme qui représente la femme éternelle, oiseau léger, souvent funeste, traversant la vie une fleur à la main, à la recherché de son idéal vague, souvent terrible, et marchant toujours, foulant tout aux pieds, même des génies et des saints. [...] C'est l'emblème de cet avenir terrible, réservé aux chercheurs d'idéal sans nom, de sensualité et de curiosité malsaine.[17]

Beyond the moralizing judgement (which comes after the creative moment and is therefore not a fair account), the painter seems to identify with the creature. Cannot Moreau himself be viewed as one of these 'chercheurs d'idéal sans nom, de sensualité et de curiosité malsaine'? Indeed he revelled in the macabre eroticism of mythology, and his depiction of *femmes fatales* is not so much forbidding as alluringly celebratory. One can even read a biographical dimension in Mallarmé's poem of a lifetime, for there are clear similarities between his own life, 'stérile et crépusculaire', and his creation.[18] They share the same anxiety regarding sterility, voiced by Salome in a paradoxical line of the 1871 fragment 'Hérodiade, Scène': 'Oui, c'est pour moi, pour moi que je fleuris, déserte!' This degree of identification with the muse and creature fits in with the restless and experimental quality of the artistic endeavour. In their lavish display of pictorial and verbal skill, in their exuberant use of imagery and effects, Moreau and Mallarmé extol the figure's sensuous powers, her aesthetic qualities and her ascendence over *l'imaginaire*. There is

17 *L'Assembleur de rêves*, p. 78. Moreau also places her on a par with another of his cherished subjects, Sappho (Ibid., p. 124).
18 The quotation is from Mallarmé's correspondence (see reference in footnote 35). Along psychoanalytic lines, Julia Kristeva reads the poem as 'La paternité symbolique et la jouissance interdite de Mallarmé' in *La Révolution du langage poétique*, (Paris: Seuil, 1974).

something mystical in their relation to her: she represents some ideal of beauty and is for both a statement of artistic freedom.

Not only did Moreau break away from traditional iconography, he even went as far as to invent a narrative and visually striking element and add it to the original scenario: in *L'Apparition* the severed head of John the Baptist appears before the eyes of the dancer. Here, as in other representations where she is depicted awe-inspiring and goddess-like, she appears as the tool of a wider power – a possible interpretation of the story being that, through her dance, the Scripture is fulfilled and God's will enacted. The motif of the floating head provided Mallarmé's inspiration for 'Cantique de Saint Jean', in which the martyr addresses she who precipitated his death, thereby freeing him from his physical self which was the last obstacle to sainthood.[19] What the Cantique voices is indeed a triumph, a liberation – which finds its pictorial statement in the carefully elaborated, icon-like brilliances of the halo:

> Et ma tête surgie
> Solitaire vigie
> Dans les vols triomphaux
> De cette faux
>
> Comme rupture franche
> Plutôt refoule ou tranche
> Les anciens désaccords
> Avec le corps

Paradoxically the decapitation amounts to a *baptême*, through which the prophetic voice finally rises to a poetic level.

Beyond the resemblance in focus and spirit of these works, there is a remarkable kinship between Moreau's Salomé and Mallarmé's Hérodiade. It is Huysmans who, through Des Esseintes, first traces the filiation between the painterly and the verbal creatures. In the semi-darkness of his study, the 'froide majesté' of the princess, whose nakedness is draped in words and colour, pervades:

19 On Mallarmé's debt to Moreau, see Sylviane Huot, *Le 'mythe d'Hérodiade' chez Mallarmé: Genèse et évolution* (Paris: Nizet, 1977).

> Combien de soirs [...] ne s'était-il point senti effleuré par cette Hérodiade qui, dans l'œuvre de Gustave Moreau maintenant envahie par l'ombre, s'effaçait plus légère, ne laissant plus entrevoir qu'une confuse statue, encore blanche, dans un brasier éteint de pierres.
>
> L'obscurité cachait le sang, endormait les reflets et les ors, enténébrait les lointains du temple [...] et, n'épargnant que les blancheurs de l'aquarelle, sortait la femme du fourreau de ses joailleries et la rendait plus nue.
>
> Invinciblement, il levait les yeux vers elle, la discernait à ses contours inoubliés et elle revivait, évoquant sur ses lèvres ces bizarres et doux vers que Mallarmé lui prête...[20]

What is striking here is the way Salome is animated with a life of her own, springing from the surface of the canvas into the house of fiction, infiltrating the page with her voiced emotion. She arches over individual artworks and thrives in cross-medium intertextuality. Truly emancipated from her origins, she is liberated from moral or aesthetic determinism, she is as a muse and a creature of perpetual renewal. So she acts as a cross-fertilizer for the poet-painter and the painter-poet, and in their works related to her, both manifest profusely their aesthetic originality. Huysmans's definition of Moreau's art as 'un art personnel, nouveau, dont l'inquiétante saveur déconcerte d'abord', so composite and singular it is, could equally apply to Mallarmé's.[21] Huysmans is particularly appreciative of Moreau's works, for they exceed the pictorial:

> C'est qu'en effet ses toiles ne semblent plus appartenir à la peinture proprement dite. [...] La seule analogie qu'il pourrait y avoir entre ces œuvres et celles qui ont été créées jusqu'à ce jour n'existerait vraiment qu'en littérature. L'on éprouve, en effet, devant ces tableaux, une sensation presque égale à celle que l'on ressent lorsqu'on lit certains poèmes bizarres et charmants...[22]

In *A Rebours*, where the pictorial presence of Salome conjures up Mallarmé's verse, Huysmans comes to define the poet's composite art in terms reminiscent of those used to define Moreau's 'magismes': '[Il] produis[ait], comme pour un tableau [...] un aspect unique et complet, un ensemble. Cela devenait une littérature condensée, un

20 *A Rebours*, Chapter XIV.
21 Huysmans on Moreau, in *L'Art Moderne,* 'Salon de 1880' (Paris: Charpentier, 1883).
22 Ibid.

coulis essentiel, un sublimé d'art.'[23] In many ways *Hérodiade* is composed like a painting, with a great concern for chromatic harmony and contrast. It is a highly visual poem which holds a stained-glassed window in its opening stanza like a miniature image of itself:

> Pourpre d'un ciel! Étang de la pourpre complice!
> Et sur les incarnats, grand ouvert, ce vitrail.

The 'Incantation' displays a rich palette of colour notations, juxtaposed like pieces of a Byzantine mosaic. There is great interplay between the sensory and the abstract throughout the poem. Moreau's more elaborate scenes thrive on such an interplay: under the sensory and the sensuous, the sense of mystery is conveyed densely.

The mystery of which Salome partakes is carefully elaborated by both the poet and the painter – cultivating aesthetic ambiguity, they endeavour to integrate ephemeral and contrasted impressions within the structuring procedures of their art form. So Moreau balances the solidity of his complex architectural compositions with a myriad of now harmonious, now clashing touches (symbols, patterns, impacts of light or colour). Mallarmé plays with syntax and metrics, audaciously combining novel effects within a framework and a diction emulating tragedy. The verbal flow in *Hérodiade* strikes the reader with an irregularity and polysemy somewhat reminiscent of Moreau's palimpsestic compositions. The mobility of the poetic syntax may be identified with Moreau's pictorial audacities, particularly in the compositions he deliberately left unfinished (*Salomé tatouée*, oil, c.1875), and more generally those bearing traces of earlier, tentative stages (*L'Apparition*, oil, c.1876). At once immediately pleasurable and endurably resisting, these works unsettle the reader/viewer by their 'inquiétante saveur'. Mallarmé's poem combines free, broken verse with perfect alexandrines and thus creates an overall impression of fracturation, opacity, *épaisseur*. Like the texture and surface of Moreau's canvasses, the verbal material – now smooth, now rough – resists instant capture. Thus we have combinations of flowing/ fractured syntax, transparent/opaque imagery, euphonic/clashing

23 *A Rebours*, Chapter XIV.

sounds, regular/spasmodic rhythms, smooth/harsh visual patterns, as in:

> Ce baiser, ces parfums offerts et, le dirai-je?
> O mon coeur, cette main encore sacrilège,
> Car tu voulais, je crois, me toucher, sont un jour
> Qui ne finira pas sans malheur sur la tour...
> O jour qu'Hérodiade avec effroi regarde!

Similarly, in a palimpsestic work such as *Salomé tatouée* (see figure 16), Moreau combines the richness of oil (impastos) with the cutting precision of pen and ink drawing. *Salomé à la fleur de lotus* (1883–85) equally demonstrates the mastery of this composite technique. On coloured paper Moreau uses delicate watercolour over graphite drawing with gold gouache heightening, producing a fresh impression on the basis of an existing composition. It is as though the aesthetic potential of Salome was endless, as though the artist was displaying the power of her charms, the sophistication of her metamorphoses, the complexity of her beauty.

Both the poem and some of the most elaborate pictures appear like Byzantine icons encrusted with gems (in particular *L'Apparition* watercolour of 1876). In fact, not only does the poem have a pictorial quality, but it appears like a string of multifaceted gems set in the polished page, now eloquently sparkling ('Ombre magicienne aux symboliques charmes!'), now mutely gleaming ('les diamants élus | D'une étoile mourante, et qui ne brille plus'). For all its evocativeness, the poem produces the same effect in the reader as do Moreau's unfinished pictures, such as the oil *L'Apparition*. Just as the poem juxtaposes sonorities, images and symbols, clashing and sparkling like metal and gems, the complex accretions on the canvas and the radiating halo cast their dazzling light against an earthy background which itself vibrates in contact with the whiteness of the skin. Contrasts (like contradictions) are cultivated and accommodated, if not reconciled, in these complex productions, and so is suggested the essential elusiveness of the figure. There are also similarities in Moreau's and Mallarmé's sophisticated treatment of light. Both the poem and the pictures are pervaded with the same *clair-obscur*

Figure 16: Moreau, *Salomé tatouée* (detail)
© Réunion des Musées Nationaux

mystery, 'orfèvrerie éteinte' giving rise to 'd'obscures épouvantes'.[24] Both set the same decor, a vault-like royal chamber, steeped in subdued light and a dawning profusion of deep tones:

> Des ors nus fustigeant l'espace cramoisi,
> Une Aurore a, plumage héraldique, choisi
> Notre tour cinéraire et sacrificatrice
> Lourde tombe [...]
> Ah! Des pays déchus et tristes le manoir!

Matching the chiaroscuro of Moreau's pictures, Mallarmé makes abundant use of oxymoronic imagery, such as black and white/colour, glossy/mat, water or ice/fire (...*l'eau reflète l'abandon | De l'automne éteignant en elle son Brandon*), cold/heat (*Le froid scintillement de ta pâle clarté | Toi qui te meurs, toi qui brûles de chasteté*). Both celebrate the triumph of 'l'imagination de la couleur', to use Mathieu's phrase, for in colour lies profusion of sensation which overwhelms sense and senses.[25] Both revel in *l'entre-deux*, between nudity and the veil.

The kinship between the poet and the painter is also to be found in their sumptuous and esoteric use of imagery and symbol. The gruesome narrative content of the story is sublimated by their decorative and imaginative talents. Moreau's oil paintings encapsulate all sorts of elements, references and symbols, conveying ambivalent, even contradictory, meanings and glorifying the artist's visionary powers as well as the muse's enthralling charms. Far from being a simple illustration of the biblical episode, Moreau's works are complex accretions of personal imagery, obsessive motifs and eclectic symbols borrowed from different traditions. The abundance and heterogeneity of symbols partly cancel their allegorical value and turn them into ornaments inviting sheer relish of textural splendour and visual profusion. For instance, *Salomé dansant devant Hérode* even includes a Buddha with a crucifix in his halo, against the rich background of what looks like a mosque. So the picture resists unified reading and disorientates the viewer the better to intimate mystery.

24 *Hérodiade*, 21, 178–79.
25 Mathieu, *Gustave Moreau*, p. 258.

Symbols proliferate then – some encapsulate, others merely insinuate meanings or values. While the lotus flower in *Salomé dansant devant Hérode* is a clearly decipherable symbol of female sexuality, other symbols used by Moreau (such as the Oriental artefacts or the grimacing head or other patterns on the dress), either escape our grasp or are combined to create a picture which is to some extent hermetic. Similarly, Mallarmé uses floral imagery while playing with its values. Thus the lilies are invoked to conjure up both virginity and deflowering: 'et j'effeuille... | Les pâles lys qui sont en moi...' The poet also makes use of idiosyncratic symbolism, which sometimes leaves us with a profusion of elusive signifieds as does, for instance, the network of bird imagery of the opening 'Incantation'.

The *jeu de signifiance* which characterizes the use of symbols is also manifest in the way each in his own medium plays on surface and depth. On a superficial level Moreau and Mallarmé lavishly exploit pictorial/poetic matter and its sensory powers, relishing the opulent pigmental and verbal texture of their creations. Thus the body of Moreau's Salome goes through various metamorphoses, from virginal alabaster (*Salomé tatouée*) to a luscious profusion of ornaments (*L'Apparition*). The sonorities of the name Hérodiade (echoed in recurring sounds) and of treasured terms such as 'rose', 'ors', 'arôme', 'azur', refine the aural texture of the poem. They endow it with its hypnotic resonance and, on a surface level, appear like embroidery on the poetic fabric. Moreau too plays on texture, thus giving free range to his composite decorative talents. Huysmans in *L'Art Moderne* marvels at the hybrid nature of his skills and effects, and suggests that he borrows his methods from mosaic, jewelry, embroidery, engraving, illuminating. Indeed, Moreau adroitly plays with the painterly matter – scratching the surface, seemingly encrusting stones and metal in it, adding intricate ink or gouache patternings to thick expanses of paint. To a certain extent, the painter uses his medium as if it were an *écriture* and the poet uses the page like a canvas. Both revel in a *jeu de transparence/signifiance* intimating the enigmatic nature of the feminine. Under the surface sensations, both artists work on the depths of the multi-layered picture they create, devising a palimpsest rich in effect and meaning. Below the sensory ice-and-fireworks lie profound depths of emotion and significance. Far from being works

squarely contained by the page or the frame then, these have excessive resonance. There is a subtle veiling/unveiling process both in the series of paintings (with their palimpsestic effects) and in the poem. Hérodiade reveals her chilling charms line after line, image after image, until the very core of her is evoked:

> ...des calices
> De mes robes, arôme aux farouches délices,
> Sortirait le frisson blanc de ma nudité.

This conditional nudity brings hypothetical death or orgasm: the exclamation, 'Je meurs!', followed by an emphatic hiatus, abrupt silence in the poem and blank in the page, is highly ambiguous. The mystery of femininity, touched upon in polysemy, paradox, oxymoron, ultimately escapes the grasp.

Left incomplete, *Hérodiade* is as captivating as Moreau's unfinished paintings of Salome, which remain open to bewildered conjecture and seem to be alive with untamed, organic matter. The *non-finito*, which is at once the manifestation of art and the suggestion of its limits, is one of the aesthetic configurations of excess. The fact that Mallarmé never got round to completing the poem may not be incidental but symptomatic. Moreau deliberately left certain paintings unfinished, as if incompletion provided the suggestiveness he was aspiring to:

> il ne faudrait pas que le peintre affirme à la manière de l'écrivain, ce serait absurde. Aussi est-il nécessaire que la pensée du peintre, quelque nette, quelque profonde qu'elle soit, ait toujours, pour la protéger et pour lui conserver son vrai caractère, une enveloppe mystérieuse qui déconcerte le spectateur et le tienne à distance respectueuse. De là ce conseil que je vous donne de traiter légèrement et comme sans conséquence la partie poétique, philosophique et morale de l'œuvre. C'est d'abord comme il vous plaira, un charme pour les yeux, si faire se peut, un agrément pour l'esprit ensuite, mais d'abord pas plus. Laissons aux plus penseurs, aux plus chercheurs, le plaisir d'y trouver leur vie...[26]

Disconcerting distance is the effect achieved by both artists through cultivating a certain opacity or *épaisseur*, weaving a veil which resists

26 *L'Assembleur de rêves*, pp. 97–98.

the eye or the understanding. In *Salomé tatouée* the white gouache superimposed onto the earthy background delineates an eerie architectonic backdrop, and the ink patterns added onto the ivory oil of the skin create the impression of nudity covered with/uncovered by an arachnid veil. Similarly, *Hérodiade* appears sometimes see-through, sometimes opaque. The poetic fabric is so dense and unpolished in places that it seems to stem, incompletely processed, from the intense creative process which generated it. So the narrative fragmentation is reinforced by that of the syntax. The 'Scène' staging Hérodiade and her nurse is framed by two pieces which conjure up the mystery. The Nurse's 'Incantation', reminiscent of the tragic chorus, is a bewitching evocation, while the hiatus between the 'Scène' and the 'Cantique de Saint Jean' has a strong dramatic effect. There is indeed an abrupt shift to a soliloquy in a startlingly different verse form, and the martyr (whose presence had only been flirted with in the poem) suddenly appears in full on the poetic stage. So the reader, disconcerted, is left 'à une distance respectucuse' from the mystery.

There is a mixture of thrill and anxiety in Mallarmé's correspondence relating to the genesis of the poem, which he referred to as 'le cher supplice d'*Hérodiade*'.[27] This oxymoronic phrase reflects his ambivalence towards the paradoxical muse and echoes the tension at work within the poem. Indeed, Hérodiade first appears on the Mallarmean poetic scene in the more conventional guise of the *fleur du mal*, intoxicating and venomous:

> ... pareille à la chair de la femme, la rose
> Cruelle, Hérodiade, en fleur du jardin clair,
> Celle d'un sang farouche et radieuse arrose![28]

The run-on line points both to her dual essence and to the poetic incisiveness used to render it: the expectation raised by 'rose' at the end of the first line is abruptly undercut by the epithet opening the following line. The antithetical semes contained here are the seeds of paradox which germinate and grow throughout the later poem. They find a pictorial echo in Moreau's combination of incisive lines and

27 Letter to Henri Cazalis, 1866 in *Correspondance* I, ed. by Henri Mondor (Paris: Gallimard, 1959), p. 208.
28 *Les Fleurs*, written in March 1864 (*Hérodiade* was begun in October).

smooth colour surfaces (as in, for instance, the *Apparition* oil). Just as Moreau's Salomé becomes more elusive, so Hérodiade comes to be elaborated as a radically ambiguous figure. She is a virginal beauty whose charms are the source of much vanity and repugnance on her part, and seduction and anxiety on the part of her creator/reader. As the metallic imagery is combined with the floral imagery, as the spectre of decapitation is superimposed onto the suggestion of fertility, the crimson pomegranate takes on the brittle coldness of frigid beauty:

> Je veux que mes cheveux qui ne sont pas des fleurs
> A répandre l'oubli des humaines douleurs,
> Mais de l'or, à jamais vierge des aromates,
> Dans leurs éclairs cruels et dans leurs pâleurs mates,
> Observent la froideur stérile du métal [...]

In a similar fashion, Moreau's successive depictions of the princess alternate or combine the cold purity of line with the warm lavishness of colour. This is particularly evident in *Salomé tatouée* in which the meticulous ink patterning acts a counterpoint to the liberal use of colour.

It thus appears that both Moreau and Mallarmé's configurations of Salome escape neat equations and tight framing, as they shun Manicheism. They seem to suggest that Salome may never be fully tamed, captured or framed. The reason why she prompts such aesthetic audacity is that she poses a challenge to representations of femininity in the Judaeo-Christian tradition. The subversive charms she incarnates – and which had been intimated in earlier depictions – are here translated in compelling experimental aesthetic terms: pictorial palimpsests, highly visual poetry. These fluid representations are evocative suggestions of the feminine, and in particular of the female desire (or *jouissance*) which, to a large extent, is a taboo in Christian ideology. For not only is Salome an ambivalent object of desire, but in Moreau and Mallarmé she is presented as an elusive desiring subject.[29] In fact, the major contribution of both to the artistic

29 On female *jouissance* as a taboo in the Judaeo-Christian tradition, see Julia Kristeva, *Histoires d'amour* (Paris: Denoël, 1983); M. Robillard in *Le Désir de la vierge: Hérodiade chez Mallarmé* (Genève: Droz, 1993) on *Les Noces*

fortune of Salome is to have turned her into a subject. Whereas she is conventionally represented as an object of male desire, lethally instrumental in the accomplishment of the fate of the prophet, in their works it is her own, complex desire which is dramatized.

This desire was present yet mute in some earlier depictions, particularly in the portraits where Salome's perplexing gaze addresses the viewer. It is precisely this enigma which Moreau and Mallarmé fathom out. Thus in *L'Apparition* the external spectator beholds what Salome alone is given to see. Neither Herod nor Herodias, riveted spectators of the dance, witnesses what might be a hallucination, a visual premonition or a fearful realization. In no other painting do the secondary characters appear as 'bien accessoires à côté du grand mystère'.[30] Our positioning as viewers/readers is therefore all the more problematic as we are made party to what we see. In *L'Apparition* as in *Hérodiade* it is Salome's own conflicting desires and anxieties which are projected onto the canvas/the page. Fathoming the mystery of femininity as incarnated by the solipsistic dancer, the male artist invests her consciousness and presents us with her imaginings. Thus Hérodiade's frigid narcissism is paralleled by Salome's self-absorption in the dance. In all the *Salomé dansant*, she appears in profile, with her eyes closed, a hieratic, enigmatic, levitating silhouette, and Mallarmé's verse may be conjured up:

> Vous errez, ombre seule et nouvelle fureur,
> Et regardant en vous précoce avec terreur;
> Mais toujours adorable autant qu'une immortelle,
> O mon enfant, et belle affreusement...
>
> Triste fleur qui croît seule et n'a pas d'autre émoi
> Que son ombre dans l'eau vue avec atonie.

Only in *L'Apparition* does she break the self-absorption of her solitary performance. With her eyes wide open, she is frozen with horror, face to face with the beheaded Baptist – fearful desired object, abject fetish – floating in the shining glory of his martyrdom.

d'Hérodiade: Mystère dwells on this aspect of the poem. This desire will be taken to its paroxysm, both verbally and visually, in Wilde's *Salomé* (1899).
30 Grauby, p. 86.

The challenge Salome poses to traditional conceptions and representations of femininity perhaps culminates in the works of Moreau and Mallarmé, in which the elusive dancer manifests her irreducibility and becomes a subject. Following Kristeva one might say that the figure of Salome resists containment within the symbolic order, in which women are reduced to the role of silent Other.[31] Salome speaks up, in the language of the erotic/esoteric body. Kristeva reminds us that the Western understanding of femininity is exemplified by canonical representations of the feminine as the maternal.[32] Yet when the feminine fails to be 'résorbé' or contained, its powers are extravagantly manifested in representations of the feminine as excess. The notion of excess which is associated with Salome characterizes her representations: in Moreau and Mallarmé it becomes an aesthetic mode. She is portrayed at once as a virgin beauty and an evil creature. In Kristevan terms, her lascivious, subversive dance can be viewed challenging the Symbolical order and effecting a castration of patriarchal authority. The most compelling representations of her seem indeed to partake of the transgressive and experimental process presented by Kristeva in *La Révolution du langage poétique*.[33] Attempting to frame excess, they defy limits, subvert established rules and explore new channels. Hence the exploratory, innovative and excessive quality of Moreau and Mallarmé's reconfigurations of Salome; reconfiguring her even necessitated for Mallarmé the creation of a new type of poetry. In a famous passage, he delivers the formula of the new poetic language he is devising in order to give verbal substance to his vision:

> J'ai enfin commencé avec *Hérodiade*. Avec terreur, car j'invente une langue qui doit nécessairement jaillir d'une poétique très nouvelle... *Peindre non pas la chose, mais l'effet qu'elle produit...* toutes les paroles doivent s'effacer devant la sensation.[34]

31 *Des Chinoises* (Paris: des femmes, 1974).
32 Kristeva argues that in the Judaeo-Christian tradition, 'la représentation consacrée de la féminité est résorbée dans la maternité' (*Histoires d'amour*, p. 310).
33 (Paris: Seuil, 1974).
34 Letter to Cazalis, October 1864, in *Correspondance* I, p. 137.

So poetic language is to intimate what is in excess of language. Thus in the poem the dance itself is not represented but its effects are everywhere to be felt – with its twirling sound patterns, intertwined imagery and enthralling rhythm, the poem dances. The 'Scène' is like a *pas de deux* in which the voices of the nurse and of Hérodiade join in a stichomythic waltz:

> N
> O mon enfant, et belle affreusement et telle
> Que...
> H.
> Mais n'allais tu pas me toucher?
> N.
> ... J'aimerais
> Être celle à qui le destin reserve vos secrets.
> H.
> Oh! Tais-toi!
> N.
> Viendra-t-il parfois?
> H.
> Étoiles pures,
> N'entendez pas!

Similarly in his Salome series Moreau seems most fascinated by the evocation of movement in his frozen art form. The numerous drawings seek to capture the perfect arabesque, while the watercolours, with their undulating lines and nervous brushstrokes, vibrate. Mallarmé's unfinished poem may be fruitfully compared to these tentative, indefinite watercolour studies. Significantly the poet uses the verb *peindre* to epitomize an *art poétique* which is to give precedence to sensations over words, to the fugitive over the fixed, to the sensory over the abstract:

> Si encore j'avais choisi une œuvre facile; mais justement, moi stérile et crépusculaire, j'ai pris un sujet effrayant dont les sensations, quand elles sont vives, sont amenées jusqu'à l'atrocité, et si elles flottent, ont l'attitude étrange du mystère. Et mon vers, il fait mal par instants, et blesse comme du fer! J'ai, du reste, trouvé là une façon intime de peindre et de noter des impressions très fugitives.[35]

35 Letter to Cazalis, March 1865, in *Correspondance* I, pp. 160–61.

So the poem is made of brushstrokes – notations endowed with such a physical quality that they are to have the sensory impact of a blade ('blesse comme du fer'). Mallarmé suggests that there is a tactile dimension to the poem, which aspires to the condition – revised and energized – of painting. Here is the 'sublimé d'art' able to capture the muse's enthralling charms.

Salome is the muse who invited the painter and the poet to break with the aesthetic conventions they inherited and devise new artistic forms in order to shape her intricate and elusive nature. There is a double movement here. A figure of excess, she provokes the devising of an aesthetic mode characterized by suggestiveness which, in turn, reveals her anew. The artist lifts the veil, while drawing attention to its complex fabric with relish. Through various liberties and innovations, Moreau and Mallarmé introduce a degree of estrangement into a paradigm connecting the aesthetic with the feminine. Drawing close to femininity as mystery, the poet and the painter attempted to communicate the 'eternal feminine' in its perplexing complexity. Beyond the anecdotal, they tried to capture an essence, caught in a dialectic of concealment and revelation. A sombrely sensuous sister of Baudelaire's *Fleurs du mal*, Salomerodiade might be the supreme muse who provoked in the poet and the painter their most powerful creations. For Kaplan, Salome marks a strong stylistic change in Moreau's œuvre and his supreme attempt to achieve a perfect synthesis between line and colour.[36] Evidence of this are the artist's relentless aesthetic searchings in relation to her: the better to capture her bewitching beauty he resorted to various media (liberal watercolour, rich oil, precise ink arabesques), exploring their possibilities and even mixing them. Driven by the same aesthetic ambition, Mallarmé strove to elaborate in *Hérodiade* 'des vers originaux... dignes de leurs suprêmes mystères'.[37] The princess thus survives as a creature of sheer beauty – virginal, sterile, fertile – who

36 Julius Kaplan, *Gustave Moreau* (Catalogue of the exhibition) (Los Angeles County Museum of Art, 1974).
37 *Documents: Stéphane Mallarmé*, ed. by Carl Paul Barbier (Paris: Nizet, 1977), pp. 285–86.

inspired the painter with the reverie of a *visionnaire* and the poet a dream of perfect poetry.[38]

Suggested Reading

Christine Buci-Glucksmann, 'Salomé ou la scénographie baroque du désir' in *La Raison Baroque* (Paris: Editions Galilée, 1994)
René Girard, 'Scandal and the Dance: Salome in the Gospel of Mark', *New Literary History*, XV (1984), pp. 311–24
Françoise Grauby, *La Création mythique à l'époque du Symbolisme: histoire, analyse et interprétation des mythes fondamentaux du Symbolisme* (Paris: Nizet, 1994)
Gustave Moreau: Between Epic and Dream, ed. by Geneviève Lacambre (The Art Institute of Chicago, 1999)
Françoise Meltzer, *Salome and the Dance of Writing; Portraits of Mimesis in Literature* (Chicago: University of Chicago Press, 1987)
R. von Holten, 'Le développement du personage de Salomé à travers les dessins de Gustave Moreau' in *L'Œil*, 78–80 (1961)

[38] Gardner Davies even suggests that *Hérodiade*, transcending the Baudelairean dichotomy between spleen and idéal, came close to being Mallarmé's œuvre, in *Mallarmé et le rêve d'Hérodiade* (Paris: Corti, 1978), pp. 283–84.

Part 4

Between the Frames

Jean Khalfa

Seeing the Present

Narration is often used as a criterion to distinguish fiction from documentary.[1] But there is a mode of film-making one could call non-narrative fictions. Such films are films of resistance in two senses: they refuse the traditional oppositions of dominant film-making, in particular the opposition between actors and 'ordinary people', forcing both ordinary people and professional actors out of their role-playing. In doing so they work on the borderline of the real and the imaginary. They also resist the separation between time represented on screen, the time of the narration, and the time experienced by the spectator. The detour through film then aims at another way of experiencing time rather than passing it, at recovering a presence rather than being absorbed in a representation. But before analysing this resistance, let us first reflect briefly on the relationship between film and narration.

With the dominance of cinema and then, more importantly, of television, the universal desire for stories, which had moved from myths and tales to novels and films, has become the object of an industry, which now seems to have almost exhausted it. In earlier times two psychological effects of fiction films could be distinguished. *Mastery*, first, as, whatever its outcome, a narration turns a sequence of events into a meaningful whole, giving the spectator an external point of view upon life. Simultaneously, the idea of a meaning of life acquires a concrete content. But, secondly, *exhilaration*, because films opened up a world of possibilities, or the possibility of different worlds. The constraints, expectations and habits of the real world suddenly dissolved when faced with an act or a decision involving a free will. This second effect has become rare

1 For a historical typology of narrativity in film, see Noël Burch, *Life to those Shadows*, (Berkeley: University of California Press, 1990).

and has been replaced with, at best, the feeling of the fulfilment of an expectation (raised and framed by all the paraphernalia of the film, articles, publicity, interviews etc.), at worst, the simple continuation of normal boredom. It is as if the extreme saturation with standard storytelling, so obvious in the correlative need for 'special effects' or for 'punch-lines', had also exhausted the desire for future and history, and thus for an invention of the self. Consciousness has been colonized by film, in such a way that the world and the self are both experienced as simply given.

Significant work has been done to explain the supreme affinity of narration and the processes of consciousness in films, in particular on the basis of a phenomenological analysis of the consciousness of time.[2] Bernard Stiegler, in *La Technique et le temps*, has reread the history of philosophy following retrospectively the thread of an affinity between the structures of consciousness and cinema, from Deleuze's analysis of *l'image-temps* to Kant's theory of the Schematicism of the Imagination. This is an important task, but one which must be complemented by an analysis of the relationships of the structures of consciousness to the practice of life.[3]

[2] This affinity between the structures of consciousness and the formal features of an art has often been noted in music, traditionally an obligatory ingredient of all rituals and ceremonies – even though in itself it is radically meaningless – and of course a necessary accompaniment to film, well before speech. See Simha Arom and Jean Khalfa, 'La Musique comme pensée pure', *Les Temps Modernes*, 609 (June–August 2000), pp. 307–25, and 'Is there something to understand?', forthcoming in *Alexander Goehr: A Festschrift*, (London: Schott, 2002).

[3] Bernard Stiegler, *La Technique et le temps*, III: *Le Temps du cinéma et la question du mal-être*, (Paris: Galilée, 2001). Stiegler's study is initially based on a reflection on Husserl's study of the consciousness of time in the experiencing of a musical object, a melody. His analysis of the different categories of retentions and protentions involved in the perception of a melody is perhaps too confined by such an object. There is more to music than the perception of temporal *objects*. Once identified, musical objects become background frames for the second-order experience of following variations and transformations. Similarly, one needs to go further in the analysis of the mental schemes at stake in the adaptation of consciousness to a world of praxis. But this criticism does not invalidate Stiegler's conclusions on the transformation of consciousness into a merchandise, via the manipulations that tertiary retentions (cultural objects, such as films and TV programmes) operate on the secondary

Life Story

Why exactly are narrative structures so congenial to consciousness? Let us consider a short story:

> Alice goes to the restaurant, orders the lobster, pays the waiter and goes.

This is easy to understand. No one in her right mind would ask: what waiter, where does the lobster come from, what does she do with the lobster, why does she pay the waiter? In other words, when I utter the word 'restaurant', the mind immediately conjures up not only the image of a place but a scenario or a script in which restaurants are places with waiters who bring food that one eats there and pays for.[4] None of this information was mentioned in my story, and still, if you understood it, you must have been aware of it, even though perhaps this awareness was unconscious.

This is why if I now write,

> Alice goes to the restaurant, orders the lobster, pays the penguin and goes,

you will probably think that the penguin is a waiter, so named because of his dress, say a dinner jacket, and therefore that 'we are in' a luxury restaurant, which is reinforced by the fact that Alice orders the lobster, a luxury food. In other words, it is very unlikely that mention of the penguin might be taken as a geographical indication (Alice is having dinner in the Antarctic). But this in turn requires some further

retentions (the stock of cultural memories) which determine the functioning of primary retentions (the structure of expectations which direct the flow of consciousness). 'La fin du XXème siècle voit ainsi se constituer un immense marché des consciences, voué à devenir mondial par-delà toutes barrieres' (p. 117). Marx spoke of a fetishism of merchandise, Sartre described at length the alienation of consciousness, but it is only in the age of the dominance of cultural industries that we realise that speaking of a 'political economy of consciousness' is no longer metaphorical.

4 These examples are freely adapted from the work of the Artificial Intelligence and Learning specialist, Roger Schank. See in particular: *Scripts, Plans, Goals, and Understanding* (Hillsdale, NJ: Lawrence Erlbaum, 1977), and *Tell Me a Story* (Evanston, IL: Northwestern University Press, 1990).

adjustments to account for the contrast between the style of the narration itself (colloquial), and its content (the lobster): perhaps we are in an American detective story. It is clear that each new element modifies the totality of a 'picture', a unity defined by a set of rules commanding the behaviour of the characters, rules also necessary for the understanding of the narration.

Let us move on:

> Alice goes to the restaurant, orders the hamburger, pays the penguin and goes.

Here, in trying to cope with these singularities, the implicit restaurant scenario is starting to creak. Even grammar is affected: one would expect '*a* hamburger'. This is because in a luxury restaurant, a menu is not an arborescence (a hamburger with or without cheese with or without fries with or without ketchup, etc.), but a list of totalities ('the rabbit on a bed of carrots', or even 'the rabbit on its bed of carrots', where the possessive stresses the wholeness of the dish, not a relationship of belonging). There is something wrong: either the register is too high for what she orders or the choice is too narrow for the place she is in. To account for the definite article, we have to modify the type of restaurant: it might be a basic one where the choice is between a hamburger and fried chicken; or Alice is abroad, and the menu has a single entry for 'international dishes'. The temporal structure of the content of the narration varies too: if she orders the lobster, there is a stronger possibility that she will stay a while before going (in order to eat the lobster). If she orders the hamburger and goes, it is quite likely that this is done in a sequence. In any case, it is difficult to match this latter solution with the presence of the 'penguin'.

Now if I said,

> Alice goes to the restaurant, orders the ice-cream, pats the penguin on the head and goes,

unless you remember *Mary Poppins*, the reality described simply does not fit together any longer. One can go further:

> Alice goes to the restaurant, orders the ice-cream, pats the penguin on the head, asks the dwarf for a light and goes.

You really are at a loss, even though, while you wonder who this dwarf is, you will not ask what the light is for nor whether the dwarf has brought it. Perhaps it would have been more understandable if Alice had asked the seventh dwarf for a mirror.

It is thus clear that our understanding of behaviour is deeply linked to the manipulation of narrative structures. Narration is to temporal existence what the horizon structure, and perspective, is to spatial existence. Living as human beings requires constantly referring sequences of events to acquired scenarios, if only to measure discrepancies. I kept on adding elements to the restaurant story, and you always tried to adjust and make sense of the detail by referring it to a background structure, either a new one or a more complex one. Some people have suggested that intelligence (in both its senses of understanding and intentional behaviour) is simply the ability to master a very large number of such scenarios. They add that the relations between intelligent beings depend on the ascription of such capacity to each other (what Daniel Dennett called 'the intentional stance').[5]

Now a scenario, in this formal sense, is a rule or a model for the unfolding of events in time, and therefore if scenarios are structural to our consciousness of human life, then, as Pascal said, we never deal directly with the present, with what is immediately given. We always immediately refer it to a future, the only time we inhabit, and to a past which informs our anticipations of the future. But the present, as it occurs, in its singularity is never faced or inhabited. Pascal called that *divertissement*, 'entertainment' or 'distraction', a concept in philosophical anthropology describing the structure of consciousness in its relationship to time, but also, and at the same time, a theological concept, an indicator of 'mankind's misery', when not only God, but also the sense of being as choice is lost, and men refuse to face this lack (in secular terms, this is what Sartre called *mauvaise foi*). Rather than to a straight line, one could compare a complex narration to a cycloid, a line of which certain points (events) open up the necessity

[5] This would make it particularly difficult to build truly intelligent machines, as long as digital machines are programmed to deal with data in a sequential and discrete manner.

of new frames, several such lines running concurrently and sometimes meeting, as in a polyphony.

Against the Grain

This perhaps helps us understand by contrast the astonishing power of photography. 'Power' here does not mean that photography is realistic or objective, but, on the contrary, that what photographs show is what one never sees, properly speaking, because one rarely sees the present, while photography fixes the present. Photography isolates, focuses on aspects, rarely on things, while perceiving is always perceiving things and therefore referring aspects to a rule of composition of objects, a category, or, if one prefers an empiricist model, inserting each aspect in a potential series of aspects, thus constituting aspects as possible objects. These objects then are like décors, props or characters within the many virtual scripts in our mind. Perceiving is this early and primordial narration of the visible, which Merleau-Ponty called the prose of the world. By contrast, what photography shows is what one would not normally *see*, in that sense, an experience unmediated by a serialization of aspects in space, of events in time.

This is why photographs always look more interesting or more beautiful than what they show, or, more properly originate from. Tourists are right: in order to see what there is to be seen, which includes for instance the grain of a stone under a particular incidence of light or shadow, they do not waste their time looking for it, as it would require a continuity of attention they precisely do not have time for. They just see things: this castle, this cathedral, this college, etc. (and families get bored: 'What, not another castle, cathedral, college...!'). Cameras fix an eternally attentive gaze. With them one can finally see what is, or rather what was, to be seen, the always-already-past becomes present and the visible becomes absolute. Absolute in two senses: vision is seen in the visible (which is no longer immediately referred to an object), in other words, vision comes to consciousness, and the visible is no longer relative to a

network of anticipations about the meaning, the functions or the behaviour of what is shown. Or at least it does not have to be. Photography in a sense carves holes or frames in the real in order to produce the visible as such.

Commenting on Mallarmé's *Igitur*, Yves Bonnefoy writes that with the invention of photography, suddenly and for the first time, detail, the contingent singularities of the real, became visible as such:

> Remarquons cette fois que celui-ci [le détail], ce n'était pas seulement ce qui pouvait inquiéter des peintres académiques, toutes les écailles sur un poisson, un bouton de guêtre de plus dans une scène d'histoire, c'était aussi et d'abord le craquèlement d'un flanc de vase, la ride sur un visage, la granulation d'une pierre, c'est-à-dire non seulement la différenciation infinie des aspects de la donnée sensorielle mais leur disposition au hasard, dans une simultanéité évidemment dépourvue de sens. [...] [La photographie] faisant entendre, si j'ose dire, le silence de la matière.[6]

Photography thus reveals the contingent simultaneity of what there is, an idea essential to Mallarmé's poetics which tries to reproduce the original acts of nomination, before meanings were solidified in things.

Passive Synthesis

> *On entre dans le bonheur à l'heure prévue par l'horaire*[7]

Compared to photography, cinema is regressive, since it involves linking up these holes (or wholes) or *frames* again, first by giving objects depth and movement, via the linkage of frames within a *sequence*, but, also, by injecting a narrative structure into the images themselves via the linking of those sequences through *editing*. One barely needs words to make a film and yet cinema is not mime, for the

6 Yves Bonnefoy, 'Igitur et le photographe', in *Mallarmé 1842–1898, un destin d'écriture*, ed. by Yves Peyré (Paris: Gallimard, 1998), p. 63. On this question, see my article 'The Discrete and the Plane', *Mantis*, 1 (December 2000), pp. 147–188.
7 Jean Epstein, *Cinéma*, (Paris: Éditions de la Sirène, 1921), p. 31.

sequences that are assembled can *visibly* come from radically different and separate spaces and times. Here the gaze and the imagination are not free of their movements and associations. Film is an art of tight linkage or synthesis, an art of suspense or diversion, a constructivism of time, in that sense closer to music than to any other form, even novel-writing. Of course, the comparison with music needs to be nuanced, as in music the perception of links and the anticipations are conditional on the knowledge of complex but clearly defined frames, such as tonalities, metric structures etc., which evolve quite slowly in history (in most cultures extremely slowly), while cinema has more freedom to invent and modify the fundamental scripts within which its flow synthesizes sequences, thus creating perceptible links. It is true that cinema, like theatre or the novel, can use the content of propositional attitudes (the expression of intentions, of knowledge, etc.) to link behaviour and events, which music cannot. But all those who invented modern cinema stressed that what makes its essence is editing, the art of producing meaning and emotions via the composition of sequences of images through time, rather than the linking of sequences into consequences through the expression of meanings and emotions. From the beginning, the discussion was only about the best way to use editing, in particular in relationship to mechanisms of fascination (see for instance the debate between Sergei Eisenstein and Dziga Vertov on truth in cinema, or the theoretical work of Jean Epstein on the consciousness of time).[8]

8 'Notre peu d'inclination à nous servir du pouvoir qu'a le cinéma de créer du beau, de l'étrange, du dramatique, par variation du rythme temporel, ne tient pas surtout à des difficultés techniques, dont il n'y a guère d'insurmontables. La vraie raison de ce désintérêt est une inexpérience, une paresse, une insuffisance de notre esprit qui se trouve beaucoup moins habile que l'instrument cinématographique à concevoir des modalités de temps, différentes de celle dans laquelle nous sommes habitués et astreints à vivre.' Jean Epstein, *Esprit de Cinéma* (Paris: Éditions Jeheber, 1955), p. 129. Epstein was optimistic: 'il faudra encore pas mal de temps pour que nous nous accoutumions à nous en servir couramment, pour que notre pensée apprenne à se jouer aussi facilement du temps que de l'espace'.

'A voir dans une hallucinante intemporalité'

> La véritable tragédie est en suspens. Elle menace tous les visages. Elle est dans le rideau de la fenêtre et le loquet de la porte. […]
> Je désire des films où il se passe non rien, mais pas grand'chose. N'ayez crainte, on ne s'y trompera pas. Le plus humble détail rend le son du drame sous-entendu […].
> Alors pourquoi raconter des histoires, des récits qui supposent toujours des événements ordonnés, une chronologie, la gradation des faits et des sentiments. Les perspectives ne sont que des illusions d'optique.[9]

Scripts are structural to the working of our mind, and cinema directly controls the flow of consciousness in the elaboration and use of such frames, which is probably a reason for its extraordinary success as a form of distraction, that is, of forgetfulness of the present. But it does not have to be that, as it is also, sometimes, an art of the present, of the still life, and of the body, of gesture rather than purpose, and in this regard it is much more powerful than photography, which could be considered as a frozen snapshot of attentiveness, and thus remains an object *for* consciousness. All films directly impose on us their own temporality and play with different modes of attention, creating different experiences of time. In this poetic mode, cinema works essentially by resisting our expectations that the real will unfold within scripts or narrative structures. This is a difficult thing to do, not because such films are usually longer or less 'captivating', but rather because the directors do not have the safety nets of expected narrative patterns and must create the conditions of what they do as they go. To clarify this point, Deleuze proposed an analogy: one can conceive of space in geometric or in dynamic terms. From the first point of view, space is an a priori framework, defined by pre-existing co-ordinates, within which objects move. From the second, the movement and relationships of objects define their space. As Deleuze suggests, we

9 Epstein, *Cinéma*, pp. 32–33. This thought is remarkably similar to that of Reverdy, who wrote at the same time that the poetic image was immediately an emotion, born of the joining of two distant realities, and who praised Cubism's freeing of painting from perspective (that is, from the organization of the space of the work according to the demands of the human eye, not of the thing itself).

could use this distinction to characterize the treatment of time in film. In the films we consider here, time is generated within the film by the pace of the elements. Deleuze writes:

> [Le] corps gardera toujours l'empreinte d'une indécidabilité qui n'était que le passage de la vie. C'est peut-être là que le cinéma du corps s'oppose essentiellement au cinéma d'action. L'image-action suppose un espace dans lequel se distribuent les fins, les obstacles, les moyens, les subordinations, le principal et le secondaire, les prévalences et les répugnances [...] Mais le corps est d'abord pris dans un tout autre espace, où les ensembles disparates se recouvrent et rivalisent, sans pouvoir s'organiser suivant des schèmes sensori-moteurs [...] [Cet espace est] comme une *fluctuatio animi* qui ne renvoie pas à une indécision de l'esprit, mais à une indécidabilité du corps. L'obstacle ne se laisse pas déterminer, comme dans l'image-action, par rapport à des buts et des moyens qui unifieraient l'ensemble, mais se disperse dans 'une pluralité de manières d'être présent au monde', d'appartenir à des ensembles, tous incompatibles et pourtant coexistants.[10]

Here Deleuze is following very closely Simondon's book *L'Individu et sa genèse physico-biologique* (1964), one of his major references. But audible too are echoes of Bergson's analysis of the nature of decision in his *Essai sur les données immédiates de la conscience* (1889).

This form of cinema does not have to be an experimental one, though most experimental cinema works on this principle. One could trace it in fairly mainstream films by Dreyer, Renoir or Mizoguchi, for instance. Let us take a look at three modern films which can be considered as great achievements of a cinema which reflects directly on time, Robert Bresson's *Un Condamné à mort s'est échappé ou Le Vent souffle où il veut*, Jean Eustache's *La Maman et la putain*, and Claude Lanzmann's *Shoah*.

Bresson's film is a model of a non-heroic fiction. Its title is significant: it is in the past while in fact the whole film is about the preparation of the escape of a *résistant* from the prison where he is regularly interrogated. It is as if he had wanted from the outset to avoid the goal-directedness of a title such as *La Grande évasion*, for instance. And indeed this is a film which focuses so much on the tools, on the bodies and on their relationships within different spaces

10 Gilles Deleuze, *Cinéma 2, L'Image-temps* (Paris: Minuit, 1985), pp. 264–265.

and micro-spaces (those of the cell and within the cell, for instance the door, and those of the prison), that these elements lose their narrative status of instruments or obstacles on the path to an intended end, the escape. The film becomes a film on the temporality of a body which inhabits and interacts with walls and doors in a prison. At the end, the escape simply seems to happen, as an almost imperceptible event, still extraordinarily intense: the triumph of a necessity at least as much as that of a will. This necessity derives from the images themselves, the persistent, obsessive dealings of the hands with the door and the walls. By refusing the dramatization of heroism, Bresson sticks to what struck him most during the war and in reading the testimonies of those who went through such experiences: this escape might be exceptional, it is nevertheless what one simply had to do, and it resulted from patient interactions with an environment. The heroic description of an opposition of a will to a reality is therefore inadequate, and as in most of Bresson's films (for instance *Pickpocket, Au hasard Balthazar, Le Diable probablement*), what we see is simply the obstinate confrontation of several contingent realities as the film unfolds.

Concerning *La Maman et la putain*, Eustache wrote: 'c'est le récit de certains faits d'apparence anodine [...], la description du cours normal des événements *sans le raccourci schématique de la dramatisation cinématographique*'.[11] Again it is about a decision – a man chooses between two women – but it is a decision which, properly speaking, he never really takes, one which seems to take the characters, rather than the other way round, and unfold from the pace at which each of the bodies interacts over the four hours of the film. As the subject of the film is the experiencing of these moments, which is the substance from which the decision grows, Eustache adopted unusual techniques, such as using only music played within the film (a 78 rpm record is played by Antoine) – while music is normally used to alter the perceived time of the narration (accelerations, suspense, surprise, etc.) – or a very close frontal shot of Veronika's face during an immense monologue, where the texture and evolution of her features is at least as important as what she says.

11 Alain Philippon, *Jean Eustache* (Paris: Cahiers du Cinéma, 1986), p. 38.

Finally, *Shoah*. In an important interview with *Les Cahiers du Cinéma*, Lanzmann declared, in the context of filming a genocide:

> Le réel est opaque, c'est la configuration vraie de l'impossible. Que signifie filmer du réel? Faire des images à partir du réel, c'est faire des trous dans la réalité. Cadrer une scène, c'est creuser. Le problème de l'image, c'est qu'il faut faire du creux à partir du plein.[12]

This is an essential film from our point of view, as Lanzmann aimed to show an event which breaks the patterns of all causal explanations: when all the conditions are known, one still is at a loss to understand the act of the extermination, or the *passage à l'acte*.[13] For him, because of their very formal properties, traditional narrative structures applied to this event would not only have been false but unethical, or, in his vocabulary, obscene, because they would have obscured the monstrosity of the act itself, in its presence. This is a point of view he defended on many occasions:

> Entre les conditions qui ont permis l'extermination et l'extermination elle-même – le *fait* de l'extermination – il y a solution de continuité, il y a un hiatus, il y a un saut, il y a un abîme. L'extermination ne s'engendre pas, et vouloir le faire, c'est d'une certaine façon nier sa réalité, refuser le surgissement de la violence, c'est vouloir habiller l'implacable nudité de celle-ci, la parer et donc refuser de la voir, de la regarder en face dans ce qu'elle a de plus aride et d'incomparable.
>
> [...]
>
> Pour qu'il y ait tragédie, il faut que la fin soit déjà connue, que la mort soit présente à l'origine même du récit, qu'elle scande tous les épisodes de celui-ci, qu'elle soit la mesure unique des paroles, des silences, des actions, des refus d'action, des aveuglements qui la rendirent possible. Le récit chronologique, parce qu'il n'est rien d'autre qu'une plate successions d'avants et d'après, est

12 Lanzmann, 'Le Lieu et la parole', *Cahiers du cinéma*, 374 (1985), reprinted in *Au sujet de Shoah, le film de Claude Lanzmann*, ed. by Michel Deguy (Paris: Belin, 1990), pp. 293–305 (pp. 298–99).

13 This is also the subject of Lanzmann's most recent film, *Sobibor* (2001), but this time seen from the other side, as it pictures the successful revolt of the inmates of a camp through the testimony of one of the actors. Like Bresson, Lanzmann is careful to resuscitate the materiality of the context and of the event.

anti-tragique par essence et la mort, lorsqu'elle survient, le fait toujours à son heure, c'est-à-dire comme non-violence et non-scandale.[14]

Let us have a closer look at a critical sequence of *Shoah*. It consists of two embedded interviews. The first is with Franz Suchomel, an SS Lieutenant who was posted to the extermination camp of Treblinka, in particular to supervise the modernization of the camp and the building of new crematoria to cope with the scale the extermination had reached there. The interview with Suchomel was conducted after months of negotiation and under false pretexts, using a concealed camera. The other character, Abraham Bomba, is a survivor of one of the Special Commandos in Treblinka, groups of inmates who were forced to do the cremation work and were also regularly eliminated. Bomba was employed as a hairdresser, cutting women's hair before the gas chamber. At first the interviews parallel each other. Both characters initially adopt the objective, detached, almost professorial or pedagogical tone of a technician explaining the operations of a mechanism. Suchomel even uses a stick and a wall chart, and one can sense a certain pride in his mastery of all the details. His tone is also sometimes a tone of compassion, but this is no more than the compassion of the enlightened observer of natural processes. Hence his odd insistence on the physiological effects of the fear of death: excrement.

The case of Bomba is different. Lanzmann uses the strategy he says is the only possible one: never ask why, but constantly ask how, produce all the details, as it is only in the experiencing of those details that reality will appear. By definition, there is no true witness of what the Nazi process was: no one who could tell us what happened in the gas chambers or in the gas vans which were first used. And all of the survivors of the concentration camps were people who had managed, through whatever reason, to avoid the total collapse into a subhuman reality which befell the majority of the inmates, and would have prevented them, through sheer inner destruction, from producing any form of testimony.

But the parallel between the two interviews soon breaks down. After giving very precise details on the procedures followed to

14 *Au sujet de Shoah*, pp. 314–316.

deceive the victims and make them believe they were going to take a shower, down to the precise technique of cutting hair (the scene is shot in a hairdresser's salon while Bomba cuts hair), there suddenly emerges one detail – the image of women from his home town, Czestochowa, amongst them close friends, and the wife and sister of a friend cutting hair with him, entering this room through which his whole people was passing – a detail which makes it impossible for him to continue speaking and which reveals the previous distant narration as a mask, a mask which was the only way this man could continue living. And here, in the breakdown of speech, and of the story, in the presence of a silence we have the production of a reality which the spectator experiences equally. The interview, which was so painstaking and slow at first, is simply cut at this point (even though it continued and parts of it are used elsewhere). The contrast then is extraordinary when we return to Suchomel and his subsuming of whatever happened there under technical constraints and general laws of biology, or, at the end, of combustion.

Now an essential point is to note that all this is false in a way. Suchomel is led to believe that he is giving a learned technical exposé to a historian, and he speaks with the proud modesty of the one who was there (even though he is sorry, etc.). The hairdressing salon was hired for the occasion and Bomba who had retired and moved from New York to Israel was asked to perform. This is not a documentary film in the ordinary sense since it uses décor and fiction, but the result of these fictions is an undeniable reality, not a myth.

This is what Lanzmann, remarkably lucid about what he did, says of this sequence:

> Au début, [Bomba] a une sorte de discours neutre et plat. Il transmet des choses, mais il les transmet mal. D'abord parce que ça lui fait mal à lui, et parce qu'il ne transmet qu'un savoir. Il échappe à mes questions. Quand je lui dis : '*Quelle a été votre première impression lorsque vous avez vu arriver toutes ces femmes nues et ces enfants pour la première fois ?*', il se dérobe, il ne répond pas. Ça devient intéressant au moment où, dans la seconde partie de l'interview, il répète la même chose, mais autrement, lorsque je le remets dans la situation en lui disant : '*Comment faisiez-vous ? Imitez les gestes que vous faisiez*'. Il attrape les cheveux de son client [...]. Et c'est à partir de ce moment que la vérité s'incarne et qu'il revit la scène, que soudain le savoir devient incarné. C'est un film sur l'incarnation en vérité. Ça c'est une scène de cinéma.

[...] Je savais que ce serait difficile et je voulais le replacer dans une situation de *gestes* identiques. Tout sentiment est monstration, mais toute monstration est sentiment.[15]

An image is truly moving when it breaks the order of a narration. This film is not about memory or memories but about the present, or, as Proust would have said, time regained.[16] That death should not be at the end, but should be present throughout the work, this, according to Lanzmann, defines an aesthetics of the tragic as opposed to that of the myth.

When cinema resists narration, the present becomes visible.

Suggested Reading

Richard Abel, *French Film Theory and Criticism: A History/Anthology, 1907–1939* (Princeton, NJ; Guildford: Princeton University Press 1988)
Au sujet de Shoah, le film de Claude Lanzmann, ed. by Michel Deguy (Paris: Belin, 1990)
Gilles Deleuze, *Cinéma 2, L'Image-temps* (Paris: Minuit, 1985)
Jean Epstein, *Cinéma*, (Paris: Éditions de la Sirène, 1921)
'L'Art et la mémoire des camps: Représenter exterminer', ed. by Jean-Luc Nancy, *Le genre humain*, 36 (December 2001)
Alain Philippon, *Jean Eustache* (Paris: Cahiers du Cinéma, 1986)
Jacques Rancière, 'L'inoubliable', in Jean-Louis Comolli and Jacques Rancière, *Arrêt sur histoire*, (Paris: Éditions du Centre Georges Pompidou, 1997)
Bernard Stiegler, *La Technique et le temps*, III: *Le Temps du cinéma et la question du mal-être*, (Paris: Galilée, 2001)

15 Ibid., pp. 297–298.
16 Lanzmann speaks of 'un passé dont les cicatrices sont encore si fraîchement et vivement inscrites dans les lieux et dans les consciences qu'il se donne *à voir dans une hallucinante intemporalité*' (ibid., p. 316). See also Jacques Rancière's essay, 'L'inoubliable', in Jean-Louis Comolli and Jacques Rancière, *Arrêt sur histoire*, (Paris: Éditions du Centre Georges Pompidou, 1997).

Emma Wilson

Screening Pleasure:
Touch and Vision in Contemporary Cinema
(Krzysztof Kieslowski's *Trois Couleurs: Blanc*)

In the films of Kieslowski there is frequently a signature scene where a protagonist lifts a finger to a photographic image – a snapshot, a television screen – and attempts to touch it, as if the gaze is insufficient for emotional, feeling apprehension of the object viewed.[1] In *La Double Vie de Véronique* (1991) we see a close up of Véronique's finger as she touches photographs in which she views her uncanny double, a woman who resembles her exactly, for the first time. In an emotive scene in *Trois Couleurs: Bleu* (1993) we see Julie reach her hand to the television screen on which her husband and child's funeral is viewed. Tenderly, as she watches wordless, her finger touches the image of her daughter's small coffin. Such fine images of touch and contact signal the film-maker's attention to sensory detail. Simultaneously they focus his attempt to question the adequacy of photographic media in the face of excess emotion: love, trauma, loss. In the following discussion I will look in particular at the representation of pleasure, an emotion and sensation often occluded in Kieslowski's melancholy cinema. This issue, pleasure, will be seen to touch on issues of the tactile and the visual, of the sensory and the phantasmatic in Kieslowski's cinema, offering a key to his thinking on desire, sexual difference and the possibility of sexual relations.

The relation between touch and vision has frequently pre-occupied contemporary theorists of spectatorship, as well as being a subject within contemporary films. Touch enters even Christian

[1] An earlier version of this article was read as a paper at the Twentieth-Century French Conference, University of Pennsylvania in April 2000. I am very grateful to Richard Stamelman for inviting me to speak on a panel on 'Pleasure' and to Micky Sheringham for his insightful comments on the paper.

Metz's seminal analysis of the passion for seeing, both identificatory and voyeuristic, upon which cinema depends. Evoking spectatorship, Metz writes: 'At every moment I am in the film by my look's caress.'[2] He goes on, however, to disembody his evocations of spectatorship, as he continues:

> This presence often remains diffuse, geographically undifferentiated, evenly distributed over the whole surface of the screen; or more precisely *hovering*, like the psychoanalyst's listening, ready to catch on preferentially to some motif in the film, according to the force of that motif and according to my own phantasies as a spectator.[3]

Recent work on haptic visuality, indebted to phenomenology and to Deleuze, for example Laura Marks's important 'Video haptics and erotics' published in *Screen*, has attempted to develop sensitivity to the sense experience, primarily touch and movement in film and video representation and reception. Marks writes eloquently: 'But the desire to squeeze the touch out of an audiovisual medium, and the more general desire to make images that appeal to the viewer's body as a whole, seem to express a cultural dissatisfaction with the limits of visuality.'[4] It is this desire, and dissatisfaction, that I explore with reference to Kieslowski, and by extension to other European art-house and American independent film-makers. My corpus would include those films which have worked to extend and critique classic cinematic representations of scopophilia, desire and sexual difference. Less affirmative than Marks, though with reference to a largely different corpus of material, I argue that contemporary film-makers (who take desire as their subject) are concerned as much with showing the impossibility of touch within the visual medium, as they are with exposing the limits of the visual. Illusory pleasures are my subject then, pleasures both undermined and underpinned by an awareness of their own impossibility. To approach ways of thinking about the

2 Christian Metz, *Psychoanalysis and Cinema: The Imaginary Signifier* (London: Macmillan Press, 1982), p. 54.
3 Ibid., p. 54.
4 Laura U. Marks, 'Video Haptics and Erotics', *Screen*, 39, no. 4 (Winter 1998), pp. 331–348 (p. 334). Marks offers excellent, extended discussion of these issues in her volume, *The Skin of the Film: Intercultural Cinema, Embodiment, and the Senses* (Durham, NC and London: Duke University Press, 2000).

impossibility of tactile pleasure in cinema, I consider the case of films where directors take on the challenge to represent *jouissance* – (female) sexual pleasure.

My choice of this subject is motivated in part by an awareness that, in Irigaray's terms at least, female pleasure is considered more tactile than scopic, that women enjoy touch more than vision. Irigaray notes, in terms which have drawn much comment: 'La femme jouit plus du toucher que du regard, et son entrée dans une économie scopique dominante signifie, encore, une assignation pour elle à la passivité: elle sera le bel objet à regarder.'[5] This proposition can appear problematic for feminist film theory and require the denunciation of a scopic economy which objectifies women (as offered forcefully by Laura Mulvey and others). My contention here, however, is that the association between touch, the tactile and female pleasure can yet be imagined and construed not as reductive or reactionary but as instructive in film theory. Irigaray draws her imagery of touch and pleasure from a rethinking of the female body, its imagined autonomy and autoerotic joy (as she writes: 'La femme "se touche" tout le temps, sans que l'on puisse d'ailleurs le lui interdire, car son sexe et fait de deux lèvres qui s'embrassent continûment').[6] The literal contact invoked in Irigaray's image quickly folds into a set of associated meanings of implicit importance to her feminist return to Freud: multiplicity, difference, diffusion. My wish is to return to the sensuality of Irigaray's image and to argue that the association of female pleasure with touch can inform the apprehension and representation of heterosexual as well as autoerotic desire. This involves a reckoning with the male subject's desire to access female pleasure, to touch as well as see the female other. In film, a non-tactile medium, this desire runs the risk of associating women once more with the unattainable, the untouchable. This is a risk I argue that contemporary films work consciously, feelingly, to explore.

Jouissance is notoriously a figure of impossibility, a figure for what lies outside, in excess, of any system of representation (hence its association with the feminine). Taking on the challenge to reconfigure cinema as system of representation, contemporary film-makers return

5 Luce Irigaray, *Ce Sexe qui n'en est pas un* (Paris: Minuit, 1977), p. 25.
6 Ibid., p. 24.

to the question of whether pleasure – *jouissance* – can be screened or known, felt, in a scopic medium.

In the following discussion my main focus is on Kieslowski's 1994 film, *Trois Couleurs: Blanc*, a bilingual French and Polish film. *Blanc* is a film which in its internal references to *Le Mépris* (1963) and the image of Brigitte Bardot, and all the more in its framing of Julie Delpy as beautiful blonde French model, inserts itself amongst French specific cinematic investigations of sexuality and female sexual pleasure. Like *Le Mépris*, *Blanc* still focuses primarily on the ways in which female sexuality is fantasized and imagined in the male psyche. Yet in the painful ways in which such male fantasies are unveiled, as I explore later through reference to Žižek, I suggest that *Blanc* should be considered in the context of other contemporary French movies that have attempted recently to rethink the cinematic representation of heterosexual desire. I think here of works such as Philippe Harel's *La Femme défendue* (1997) or Catherine Breillat's *Romance* (1999).[7] A broader, international context for these films might embrace works like Egoyan's *Exotica* (1994) or Kubrick's *Eyes Wide Shut* (1998). Such films have done much to de-naturalize and disrupt the binary of male activity and female passivity upon which classic narrative cinema, and its production of viewing positions, have been seen to depend. Integral to all these films has been the rethinking of relations between touch and vision, the possibility of their interrelation in cinema.

The second film in Kieslowski's trilogy, *Blanc* represents equality: it is a film about divorce and marriage and is dominated by the question of and quest for female sexual pleasure. Early in the film, Karol, a Polish hairdresser, is divorced by his French wife Dominique for non-consummation of their marriage. Much of the film charts Karol's attempts to redress the balance of their relationship, to satisfy

7 For further discussion of *Romance* in these terms, see my chapter, 'Deforming Femininity: Catherine Breillat's *Romance*', in *France on Film*, ed. by Lucy Mazdon (London: Wallflower Press, 2001), pp. 145–157. *La Femme défendue* is filmed entirely using a subjective camera, such that the consciousness and vision of its male protagonist supposedly coincide with those of the viewer. By such means, Harel films his protagonist's desire for, seduction and loss of his object of desire (played by Isabelle Carré). The formal constraint of the film underlines the tactile presence yet ungraspability of the female object of desire.

Dominique and to restore his marriage. In staging Karol's desire for Dominique, Kieslowski exploits images of both scopic and tactile pleasure. The scopic seems dominant in the first place, allowing *Blanc* to appear a continued meditation on the voyeurism Kieslowski explored previously in *A Short Film about Love* (1988). A literal scene of voyeurism occurs as Karol, beset with jealousy, views Dominique making love with another man, her form silhouetted against the blinds of her lighted window. This is one of a series of shots of Julie Delpy, blonde, polished, impervious, in the film. Such images are marked by golden, part-filtered light, moving shadows and the image of Dominique in silhouette.[8]

While these images are self-consciously metacinematic, Kieslowski also draws on a tactile aesthetic tradition in his representation of Karol's desire. Shortly after his rupture with Dominique, Karol glimpses a white bust of a young girl in an arcade in Paris. In a complex shot of a corner window we view both Karol looking through the glass at the bust and the effigy itself in the foreground of the frame. Karol as viewer is at one remove from the tactile object, distanced by the glass of the shop window (and all it embodies of capitalist Parisian culture). The effigy itself is softly illuminated by a lighted lamp beside it in the window, and by the lights of the arcade. We find a brief reminder of the shop window as protocinematic space.[9] Karol moves around the corner of the shop window, seeking a stereoscopic view of the effigy, appreciating it as three-dimensional object, although at this juncture he can only touch it by his look's caress. As he views the effigy, a passerby jolts into him, a reminder of the tactile reality outside the ideal frame of the window.

The effigy is, of course, associated with Dominique (Annette Insdorf alludes to 'the bust of a woman in a window, white like

[8] I have discussed these scenes at greater length in 'Re-viewing Voyeurism: Performance and Vision (Kieslowski)', in *Powerful Bodies: Performance in French Cultural Studies*, ed. by Peter Collier and Victoria Best (Bern: Peter Lang AG, 1999), pp. 73–82.

[9] For further discussion of analogies between cinema and the shop window, see Anne Friedberg, *Window Shopping: Cinema and the Postmodern* (Berkeley, CA and Oxford: University of California Press, 1993).

Dominique's alabaster skin').[10] Although its resemblance to Dominique seems, in the logic of the film, to inspire Karol's interest in the effigy, its difference from his ex-wife is doubtless significant too. The effigy is of a girl younger than Dominique, her face slightly rounder, with a childlike purity. The effigy figures the ideal, unreal image of Dominique which Karol will tend and restore on his return to Poland. We never see him steal the effigy, but it is there in material form in his luggage as he arrives, traumatically, on Polish soil. Karol is smuggled into Poland by his friend Mikolaj, but the case in which he is contained is stolen. The thieves smash the effigy, as they beat up Karol. The effigy is now a tactile, and vulnerable reality: touch is associated in the film implicitly with the discomfort of Karol's journey in the suitcase, and the fragility of the effigy, as it is linked elsewhere explicitly to sensory pleasure and plastic beauty. As Karol's bruises disappear and his wounds heal, he miraculously rebuilds the effigy, gluing and painting it piece by piece until it is a perfect whole. It is now filmed in close up, the statue existing as reminder of the absent Dominique and as muse for Karol in his imaginative schemes to return his wife to his clutches.

The film approaches Parnassian aesthetics as it figures Karol's desire as desire for a woman, idealized, objectified and silent. In her piece 'Muteness Envy', Barbara Johnson comments: 'numerous are the Parnassian poems addressed to silent female statues, marble Venuses and graphite Sphinxes whose unresponsiveness stands as the mark of their aesthetic value, and whose whiteness underscores the narrative whiteness of canonical representations of women.'[11] This clarifies one of the various connotations of the colour white, chromatic signifier of the film *Blanc* as a whole. Johnson pursues her thoughts on the idealization of a marmoreal female muteness through Lacan on *jouissance* commenting, with beautiful irony:

> In his efforts to collect reliable testimony from women about their pleasure, Lacan finally turns, astonishingly, to a statue, thus writing his own Parnassian

10 Annette Insdorf, *Double Lives, Second Chances: The Cinema of Krzysztof Kieslowski* (New York: Miramax Books, 1999), p. 154.
11 Barbara Johnson, 'Muteness Envy', in *The Feminist Difference: Literature, Psychoanalysis, Race, and Gender* (Cambridge, MA and London: Harvard University Press, 1998), pp. 129–153 (p. 132).

poem: 'You have only to go and look at Bernini's statue [of Saint Theresa] in Rome to understand immediately that she's coming, there is no doubt about it.'[12]

As Johnson comments, this is a very odd way to listen to women. For Karol, in *Blanc*, the idealization of the statue affords an effigy of Dominique he can touch in her absence, offering a material form to the fantasy of pale pure femininity that arguably produces his desire for Dominique in the first place. In the idealization of its muteness, the statue figures too (if we follow Johnson on Lacan) Karol's failed attempt to hear Dominique's pleasure and to understand her sexuality. The statue, and its fetishization, signal the film's concern with a tactile and plastic aesthetic tradition, in contact with (not in contrast to) the overdetermined legacy of scopophilia in narrative cinema. Imbricated with this thematics of touch and vision comes a reckoning with the failure of sexual dialogue and exchange, a failure to know female pleasure. These are issues to which I return below.

In addition to the fetishization of the effigy, a search to reach a tactile and plastic aesthetic is seen further in *Blanc* in the emphasis on touch as sense pattern in the finer details of the film. Hands are foregrounded in shots showing exchange between Karol and Dominique. In the salon in Paris he reaches his hands to her face and plays with her hair. When the couple are reunited in Poland and Karol makes love to Dominique for the first time since their marriage (and divorce), he asks first: 'Je peux toucher ta main?' The film offers a close up of the couple's hands clasped now, the image seeming to figure the equality which is supposedly central to the symbolic narrative. At the end of the film Dominique's hands will act out her desire to remarry Karol in sign language. The tactile is privileged as means of communication, as it is in sensory exchange between the couple. Karol wishes to put his head in Dominique's lap and rests there cradled by her in an image where the erotic and the maternal coincide (as Laura Marks, alluding to Irigaray, reminds us, touch is 'the first sense experienced by the fetus and by the infant').[13] Perhaps the nostalgia and idealism of this image are themselves premonitory in *Blanc*.

12 Ibid., p. 134.
13 Laura U. Marks, *The Skin of the Film*, p. 149.

The interplay of touch and vision is illustrated most lavishly in one of the several scenes in the film which appear as mental pictures, images from Karol's (and occasionally Dominique's) memory or imagination. One set of these virtual images represents a white wedding between Karol and Dominique. The scene draws attention to the ways in which Kieslowski's cinema disrupts boundaries between the virtual and the actual, between memory and futurity, reality and fantasy, thus fulfilling Deleuze's prescription for cinema of the time-image.[14] On one level, the wedding scene appears as a flashback to the moment of the first contract between Karol and Dominique. Yet *Blanc* as a whole is noticeable for its use of flashforwards, not flashbacks: these flashforwards show a momentary glimpse of Dominique entering a dark bedroom.[15] This flashforward occurs several times early in the movie, anticipating the scene of reunion between Karol and Dominique that will take place in a Polish hotel room. In the light of the film's investment in flashforwards, the white wedding also can be seen as a flashforward to the anticipated future remarriage of the couple. The wedding shots are seen first in the divorce court scene, then latterly after Karol has drawn Dominique back to Poland. (Karol has made a fortune in the newly capitalist country, staged his death to draw Dominique to his funeral, and made love to her in an extraordinary act of resurrection.) As the wedding shots appear close to the end of the film, they are seen first from Dominique's point of view; then the film cuts to an image of Karol, pinpointed as source and point of view for the subjective images which follow.

Karol is seen looking through the comb which has served as his prop (as hairdresser and as busker in the Paris metro). The teeth of the comb seem to filter his vision. He then touches the comb to his lips, cold metal against skin. The film illustrates its manoeuvres between the visual and the tactile. He kisses the comb (as he has kissed the white effigy) and the film cuts to the fullest flowering of the wedding

14 See Gilles Deleuze, *Cinéma 2: L'Image-temps* (Paris: Minuit, 1985). For discussion of Kieslowski informed by Deleuze's thinking on cinema, see Vincent Amiel, *Kieslowski* (Paris: Rivages/Cinéma, 1995).
15 These flashforwards have drawn much comment from critics. See for example Geoff Andrew, *The 'Three Colours' Trilogy* (London: British Film Institute, 1998), p. 43; Annette Insdorf, *Double Lives, Second Chances: The Cinema of Krzysztof Kieslowski*, p. 158.

fantasy. Here Dominique in close up on the right hand side of the screen is followed down the aisle and out of the church, emerging to be greeted by waiting photographers and relatives. She then turns to face the camera, with her eyes closed, waiting to be kissed. Karol emerges from the left hand side of the frame and his face meets hers, as the camera focuses on their kiss and the screen fades to white.

I have argued that memory and anticipation appear to coalesce in the wedding shots which can be seen as both flashback and flashforward. Further still, and perhaps most importantly, the scene of the white wedding can be seen, following Žižek, as the present and constant fantasy which constitutes Karol's desire and provides its coordinates.[16] For Žižek, fantasy teaches us how to desire. It seems apt then that the fantasy that is exposed here is precisely one of the fundamental fantasies of Western heterosexuality: the white wedding. The stylization of the image of Julie Delpy, utterly exquisite, the shots bright white and overexposed, creates her as an icon of nubile femininity, with white orange blossom in her hair, delicate tendrils, pale, soft face. (As Annette Insdorf comments: 'Delpy's fair skin is beautifully photographed by Edward Klosinski.')[17] The sounds of the pigeon's wings, which echo through the movie and are heard here, seem an aural reminder of her image as angel, a Botticelli figure. The fantasy sequence works with pathos, I think, to confirm Karol as Pygmalion who desires to make his loved one flesh. Touch as much as vision is privileged in the shots, through the use of subjective camera work (as in *La Femme défendue*), where the camera as Karol's consciousness and viewpoint, his very sensory presence, leads Dominique up the aisle.

This identity between camera and protagonist gives a sense of the camera's agency, offering the spectator the virtual illusion of kinetic and tactile interaction with the protagonist's surroundings. This is seemingly confirmed as Dominique turns round, looking directly into the camera, before Karol's face comes into the frame to meet her kiss. This kiss, their soft skin all but filling the frame, is the closest the film comes to tactile contact, to making its pleasures felt. The camera

16 Slavoj Žižek, *The Plague of Fantasies* (London: Verso, 1997), p. 7.
17 Annette Insdorf, *Double Lives, Second Chances: The Cinema of Krzysztof Kieslowski*, p. 156.

seems to hover, moving just imperceptibly, almost intoxicated, in front of the couple. The idealization of the image speaks of nostalgia and somatic memory as well as desire, evoking once more tactile contact with the mother and blissful unity. Indeed the fact that this image of tactile contact comes in Karol's fantasy sequence is, I think, not insignificant. Such contact, instantiating an ideal of tactile spectatorship, comes in a dream within a dream, imbricated in Karol's constructive fantasy of Dominique.

Žižek reminds us that one 'role of fantasy hinges on the fact that "there is no sexual relationship", no universal formula or matrix guaranteeing a harmonious sexual relationship with one's partner: because of the lack of this universal formula, every subject has to invent a fantasy of his or her own'.[18] So much of *Blanc*, even the divorce case in the court of law, has depended on the quest to know whether there has been a 'sexual relationship' between Karol and Dominique. I suggest that, reading the film through Žižek, we approach one of the film's central ironies. *Blanc* seems indeed to reveal that not only has there been no sexual relation between Karol and Dominique, but more generally there is no sexual relationship. In past, present and future Karol will only know and desire Dominique through the veil of the fantasy that constructs his desire for her. This seems to be underlined by the location of the fantasy sequence, the white wedding, after the apparent blissful reunion between Karol and Dominique – a gaping reminder that a projected fantasy of white tactile femininity has offered the coordinates of Karol's relation to his ex-wife.

Implicated in this lifting of the veils of fantasy is also, as I have been suggesting, a revelation of a fantasy of film-making art. The tactile sensuality that saturates Karol's fantasy of union with Dominique offers us an intimation of the film-maker's desire to represent the senses. This is a desire to restore to spectatorship what Gabriel Josipovici names, 'that inwardness with the body which the simple experience of witnessing people and events whether on screen or in real life, denies us'.[19] Contact with the image of Dominique is

18 Slavoj Žižek, *The Plague of Fantasies*, p. 15.
19 Gabriel Josipovici, *Touch* (New Haven and London: Yale University Press, 1996), p. 8.

the film's fantasy, and the protagonist's fantasy. In this coincidence, the revelation of the phantasmatic support of Karol's desire impacts in turn on our apprehension of the film's attempt to realize tactile pleasure.

Here we approach a sense of my title, 'Screening Pleasure'. As Žižek writes, according to the *doxa*, 'fantasy is the screen by means of which the subject avoids the radical opening of the enigma of the Other's desire.'[20] For Karol, certainly, the white wedding fantasy avoids the radical opening of the enigma of Dominique's desire. The film shows how this fantasy screens – hides – her *jouissance*. (When Dominique comes with Karol in their reunion, the screen literally blanks out.) For Žižek fantasy conceals the horror of the Real, yet at the same time it creates what it purports to conceal, its 'repressed' point of reference. The film itself shows up what its protagonist Karol tries to conceal: the ways in which the enigma of female pleasure is screened and repressed in male desiring fantasy. This interdependence of concealment and revelation is equally at work in the film's exploration of touch and vision. In locating the film's tactile pleasure in Karol's screening fantasy, *Blanc* opens out our awareness of the ways in which the desire to show cinema as a tactile or plastic medium is a fantasy which screens – conceals – the truth of cinema as scopic art.

I argue then that contemporary cinema instructs us in the difficulty of tactile contact. A virtue is made of one of the limits of cinema as art form. This is done in order to reveal the fantasies that construct and impede our contact and our relations both with one another and with the objects we encounter in reality. In their revelation of the screening – concealment – of pleasure, film-makers ironically come closer to unveiling the reality of the sexual (non-) relation.

20 Slavoj Žižek, *The Plague of Fantasies*, p. 31.

Suggested Reading

Vincent Amiel, *Kieslowski* (Paris: Rivages/Cinéma, 1995)
Krzysztof Kieslowski, ed. by Vincent Amiel (Paris: Jean-Michel Place, Positif, 1997)
Geoff Andrew, *The 'Three Colours' Trilogy* (London: British Film Institute, 1998)
Lucid Dreams: The Films of Krzysztof Kieslowski, ed. by Paul Coates (Trowbridge: Flicks Books, 1999)
Gilles Deleuze, *Cinéma 2: L'Image-temps* (Paris: Minuit, 1985)
Annette Insdorf, *Double Lives, Second Chances: The Cinema of Krzysztof Kieslowski* (New York: Miramax Books, 1999)
Luce Irigaray, *Ce Sexe qui n'en est pas un* (Paris: Minuit, 1977)
Barbara Johnson, 'Muteness Envy', in *The Feminist Difference: Literature, Psychoanalysis, Race, and Gender* (Cambridge, MA and London: Harvard University Press, 1998), pp. 129–153
Gabriel Josipovici, *Touch* (New Haven and London: Yale University Press, 1996)
Dave Kehr, 'To Save the World: Kieslowski's Three Colours Trilogy', *Film Comment*, vol. 30, no. 6 (November-December 1994), pp. 10–20
Laura U. Marks, 'Video Haptics and Erotics', *Screen*, vol. 39, no. 4 (Winter 1998), pp. 331–348
—— *The Skin of the Film: Intercultural Cinema, Embodiment, and the Senses* (Durham, NC and London: Duke University Press, 2000)
Christian Metz, *Psychoanalysis and Cinema: The Imaginary Signifier* (London: Macmillan Press, 1982)
Emma Wilson, *Memory and Survival: The French Cinema of Krzysztof Kieslowski* (Oxford: Legenda, 2000)
Slavoj Žižek, *Looking Awry: An Introduction to Jacques Lacan through Popular Culture* (Cambridge MA and London: The MIT Press, 1991)
—— *The Plague of Fantasies* (London: Verso, 1997)

Carol O'Sullivan

Picturing Characters: Zazies à gogo

Raymond Queneau's novel *Zazie dans le métro* was first published in Paris by Gallimard in 1959. Zazie is a 'mouflette' who has come up to Paris to stay with her Uncle Gabriel for the weekend while her mother has an assignation with 'son jules'. Zazie's iconoclasm and her greeting of every surprising piece of information with the sceptical 'mon cul' made her an immediate *succès de scandale* among French readers ('Napoléon mon cul,' says Zazie. 'Il m'intéresse pas du tout, cet enflé, avec son chapeau à la con.')[1] The most striking features of the novel are an inconsistent use of *français populaire* and *argot*, an anarchic mixture of registers and an eclectic collection of puns and word games. The novel's commercial success is reflected in the fact that two competing English translations appeared within a year, alongside the eponymous film by Louis Malle. This story of a linguistically, if not sexually, precocious little girl's picaresque journey through Paris immediately gave rise to comparisons on the one hand with Carroll's *Alice in Wonderland*, and on the other with Nabokov's *Lolita*.

As for Zazie herself, she has been envisioned, since the publication of Queneau's novel, in a variety of guises and styles on the covers of different French and foreign editions of the novel, illustrated more or less discreetly within the text of the translations, and in the form of the child actress Catherine Demongeot, daughter of actress Mylene Demongeot, in Malle's film. A *New York Herald Tribune* review of Barbara Wright's 1960 English translation asked the reader to 'try to imagine Alice in Wonderland rewritten by Henry Miller and James Joyce, with Lolita in the title role'.[2] We can

1 Raymond Queneau, *Zazie dans le métro* (Paris: Gallimard, 1959), p. 16.
2 John de St. Jorre, *The Good Ship Venus: The Erotic Voyages of the Olympia Press* (London: Hutchinson, 1994), p. 268.

therefore also picture Zazie by association as Tenniel's Alice, all ringlets and pinafores, meeting a variety of eccentric characters and rashly consuming whatever she finds in her path, and as Nabokov's pre-pubescent nymphet, at once innocent and knowing, in the latter's incarnations as Sue Lyon, from Kubrick's film of 1962, and more recently Dominique Swain, in Adrian Lyne's 1991 film of the novel.

Queneau almost certainly had Carroll's Alice in mind when writing *Zazie*; he was a fervent admirer of Carroll and his journals show that he read and re-read the latter's works, particularly *Alice in Wonderland,* over and over again.[3] As for the connection with Lolita, though the notoriously fussy Nabokov approved of Kubrick's choice of Sue Lyon for the role of Lolita, he would later observe that 'the ideal Lolita would have been Catherine Demongeot, who played the title role in Louis Malle's film of Queneau's Lolita-inspired *Zazie dans le métro*'.[4] The character of Zazie has elsewhere been compared to a variety of cultural emblems including Shirley Temple and Puck. This variety of comparisons says perhaps more about the force of the impression made on readers and viewers by Queneau's pre-pubescent imp than it says about his literary influences – but then again, perhaps not, as Queneau was a lover of high literature and popular culture in equal measure.

Other texts which might shed light on the character, or at least the genesis, of Zazie include the fragment 'Zazie dans son plus jeune âge' (1959) in which Queneau sketches a novel about a small girl and her grandmother playing in the deserted tunnels of the metro and mugging passers-by. In a diary entry from late 1959 Queneau sketches 'quelques aspects peu remarqués de *Zazie dans le métro*', a recounting in reverse of the life of Christ, le petit Jésus, or in this case, le petit Zézu, which is worth quoting in full:

l'arrivée à Jérusalem
La Passion (le voyage en taxi)
la résurrection (le marché aux puces)

3 See, for example, Raymond Queneau, *Journaux 1914–1965*, ed. by Anne Isabelle Queneau (Paris: Gallimard, 1996), pp. 136, 175, 297, 299, 300, 303, 542, 1185.
4 Brian Boyd, *Vladimir Nabokov: The American Years* (London: Vintage, 1993) p. 415.

> l'ascension (la tour Eiffel)
> la Pentecôte (glossolalie de Gabriel)
> l'établissement de l'Église (S[ain]te Chapelle = Tribunal de Commerce)
> la nativité
> et se termine sur la fuite en Égypte.[5]

Building on this montage of images and references, this essay will examine the visualization of the character of Zazie in her several incarnations in different media and different languages. It will attempt to show how translation, between languages, cultures and media, draws and redraws the character of Zazie and with her the text as a whole.

In the French novel, the vocal aspect of the character is very pronounced; in fact we are given remarkably little description of the (anti-)heroine anywhere. Zazie's irreverence and aggressiveness are painted linguistically, using argotic deformations and vocabulary as well as phonetic spelling. When Zazie first appears in the novel we are straight away struck by how she speaks:

> Une mouflette surgit, qui l'interpelle:
> 'Chsuis Zazie, jparie que tu es mon tonton Gabriel.'[6]

While this statement also serves in this case to set the stage for Gabriel's punning reply, 'je suis ton tonton', Zazie's statements are more often themselves in the foreground, impudent and shocking by turns – notably the long tale, told with gusto, of her father's murder, by her mother, with an axe (pp. 51–56).

Zazie's conversation often reveals a deep single-mindedness, as well as some rhetorical skill. When Gabriel asks her what she would like to be when she grows up, she replies that she would like to be 'une institutrice'. When asked why:

> — Pour faire chier les mômes, répondit Zazie. Ceux qu'auront mon âge dans dix ans, dans vingt ans, dans cinquante ans, dans cent ans, dans mille ans, toujours des gosses à emmerder.
> — Eh bien, dit Gabriel.

5 *Journaux*, p. 1000.
6 Raymond Queneau, *Zazie dans le métro* (Paris: Gallimard, 1959), p. 11.

> — Je serai vache comme tout avec elles, Je leur ferai lécher le parquet. Je leur ferai manger l'éponge du tableau noir. Je leur enfoncerai des compas dans le derrière. Je leur botterai les fesses. Parce que je porterai des bottes. En hiver. Hautes comme ça (geste). Avec des grands éperons pour leur larder la chair du derche. (p. 24)

When it is pointed out to her that in twenty years time teachers will have been replaced by more modern technologies, she declares that she will become an astronaut,

> — [...] pour aller fair chier les Martiens.
> Gabriel enthousiasmé se tapa sur les cuisses:
> — Elle en a de l'idée, cette petite. (p. 25)

Zazie is initially shown to be extremely *au fait* with the ways of the world. When she leaves Gabriel's house on her first morning in Paris, in search of adventure, and is quickly apprehended by Turandot, Gabriel's landlord and the *patron* of the bar, her method of escape is ruthless:

> — Je veux pas aller avec le meussieu, je le connais pas le meussieu, je veux pas aller avec le meussieu.
> Turandot, sûr de la noblesse de sa cause, fait fi de ces profération. Il s'aperçoit bien vite qu'il a eu tort en constatant qu'il se trouve au centre d'un cercle de moralistes sévères.
> Devant ce public de choix, Zazie passe des considérations générales aux accusations particulières, précises et circonstanciées.
> — Ce meussieu, qu'elle dit comme ça, il m'a dit des choses sales.
> (pp. 33–34)

When asked to be specific about these 'choses' she becomes momentarily coy, but not for long:

> — C'est trop sale, murmure Zazie.
> — Il t'a demandé de lui faire des choses?
> — C'est ça, mdame.
> Zazie glisse à voix basse quelques détails dans l'oreillle de la bonne femme. Celle-ci se redresse et crache à la figure de Turandot.
> — Dégueulasse, qu'elle lui jette en plus en prime.
> Et elle lui recrache une seconde fois de nouveau dessus, en pleine poire.

On the other hand Zazie's familiarity with the facts of life is shown to be incomplete when she repeatedly pesters Gabriel to tell her 'ce que c'est qu'un hormosessuel.' But Zazie's impact did not merely depend on her worldly wisdom, not to say vulgarity. French readers were also much struck by the transcription of some of her utterances which accurately reflected contemporary spoken French in its syntactic inversions, argotic vocabulary and a pronunciation which, when transcribed, differed radically from standard spelling. This phonetic spelling is sporadically used, principally for comic effect as for example in Zazie's narrative of her father's assault on her:

> [...] il bavait même un peu quand il proférait ces immondes menaces et finalement immbondit dssus. J'ai pas de mal à l'éviter. Comme il était rétamé, il se fout la gueule par terre. Isrelève. Irrcommence à me courser, enfin bref, une vraie corrida. (p. 54)

It is the accuracy of Queneau's transcriptions that make Zazie a vivid character and give her an energy that is one of the important factors in the visual as well as linguistic realization of her character in later versions of the book.

Zazie's popularity gave rise to translations into many languages, including two in English, as well as a film version by Louis Malle. The 'canonical' translation of the novel which was first published by John Calder in 1960, is by Barbara Wright, an eminent translator. A slightly earlier, altogether stranger translation had been published in Paris in 1959 by the Olympia Press, which specialized in the publication of literature the explicitness of whose content had made them unpublishable in Britain or America. This version was translated by Eric Kahane, brother of Maurice Girodias, the director of the Olympia Press, in collaboration with 'Akbar del Piombo', the pseudonym of Norman Rubington, a regular contributor to the Press. This translation was illustrated by Jacqueline Duhème, a professional book illustrator who was also a long-time lover of Girodias.[7] This made the book very much a family project. (Coincidentally, Kahane's translation of *Lolita* for the Olympia Press also appeared in 1959.) This essay will also refer to the Italian translation of the novel, by the

7 John de St. Jorre, *The Good Ship Venus: The Erotic Voyages of the Olympia Press* (London: Hutchinson, 1994), pp. 59, 268.

poet Franco Fortini, published in 1960, and the revision by Eugen Helmlé of the German translation first published in 1960. The film version, which came out in 1960, was directed by Louis Malle from a script by Malle and Queneau.

For the purposes of this essay, I will treat these three texts as simultaneously translations, illustrations, and interpretations of Queneau's novel. Each of the versions constitutes the performance of a different reading of the novel. In Jakobson's terminology the two English versions are interlingual translations while Malle's film is an intersemiotic translation. However, there are more complex translational activities taking place here, notably in the case of the illustrations, which are not present in the French source text, but which liberally bespatter the Kahane/Rubington translation.

It is possible to draw a number of parallels between perceptions of the activities of translation and illustration; they both have their starting point in an 'original' text, they both aim to interpret a writer's meaning, and they can fail in similar ways. Fidelity is a criterion by which translators and illustrators as well as filmmakers are judged. Illustration, like translation, is seen as one of the secondary arts. 'Illustration [...] is more often concerned with providing a more or less literal pictorial setting to an author's words. The successful illustrator in this field is usually an artist [...] whose work if separated from the printed page, may not be particularly distinguished'.[8] Both translator and illustrator are considered successful when they have achieved gestalt with their author; for instance, Tenniel's drawings for Alice are judged 'wholly satisfying' thanks to 'a complete fusion of artist and author'.[9] This recalls the Earl of Roscommon's famous lines on translation, frequently quoted by translation scholars:

> Your Thoughts, your words, your stiles, your Souls agree:
> no longer his Interpreter, but He.

This analysis of the choices made in visualizing Zazie will follow recent trends in translation and adaptation studies in dispensing with

8 John Lewis, 'Book Illustrations by John Minton' in *Image* 1 (Summer 1949) pp. 51–62 (p. 51).
9 Ibid., p. 52.

fidelity as an evaluative criterion and preferring a more descriptive approach. In the Olympia Press *Zazie,* there are at least two processes of translation taking place: the translation of the printed text in French to a printed text in English and the translation of this English printed text into the visual medium of illustration. It will be shown how this second translation process foregrounds those elements of the text which will help to shape it into a product consistent with other titles on the Olympia Press list and satisfy the expectations of their readers, excited by advance publicity which had advertised the novel under the title *Zazie or the Sex of Angels.*

Before looking at the illustrations in the Olympia Press translation, I would like to look briefly at the two English translations as interlingual translations. Three examples of remarks by Zazie, alongside their translations, will show how their approaches differ:

>Il est rien moche son bahut (Queneau)
>It's lousy, his old jalopy (Wright)
>What a crummy jalopy he's got (Kahane/Rubington)[10]

>Les petits farceurs de votre âge, dit Zazie, ils me font de la peine.
>'Little humorists your age,' says Zazie, 'give me the willies.'
>'Little jokers your age just give me a pain where I sit,' says Zazie.[11]

>Y avait qu'une chose qui chagrinait maman, c'est que le Parisien, l'avocat, il se faisait pas payer avec des rondelles de saucisson. Il a été gourmand, la vache.
>There was only one thing that worried Mamma though, that was that the Parisian, the lawyer, it wasn't chicken-feed, what he wanted, when it came to paying his bill.
>The only thing spoiled it for mama was the mouthpiece: the guy wasn't gettin' paid in pin. Damned shyster had a stiff price.[12]

10 Queneau, *Zazie dans le métro* (Paris: Gallimard, 1959), p. 13; Queneau, *Zazie,* trans. by Barbara Wright (London: John Calder, 1982), p. 15; Queneau, *Zazie dans le métro,* trans. by Akbar del Piombo and Eric Kahane (Paris: Olympia, 1959), p. 11.
11 Ibid. (Queneau, Gallimard), p. 85; ibid. (Wright, Calder), p. 94; ibid. (Piombo and Kahane, Olympia), p. 92.
12 Ibid. (Queneau, Gallimard), p. 52; ibid. (Wright, Calder), p. 58; ibid. (Piombo and Kahane, Olympia), p. 54.

Wright is more attentive to imitating the reverse syntax of the French, which is much more a feature of colloquial French than it is of English. The Olympia translation normalizes the syntax, with the result that the sentences run more smoothly, but their attempts to translate colloquial terms with rather more flamboyant slang do not seem to meet with more success than Wright's quieter, sometimes awkward expressions. Both translations fall into the trap of alternating generic Americanisms with a kind of generic Cockney and fail to create either an accurate or a coherent English slang, though Wright is very conscious of the problems this kind of writing can pose to translators:

> The problem for the translator [...] is, of course, that he has to invent, or use a synthesis of, an equivalent popular language which the reader will accept as modern, but which is not that of any particular English or American group – Cockney or Bronx, say. Queneau's characters are French, they live in a French environment, and they must stay there: to make them speak any specific English dialect would be to situate them where they don't belong. If you read, as I did in a recent translation, one French peasant supposedly saying of another 'He would never set the Thames on fire', you are immediately jerked out of context, and out of your illusion.[13]

Pressure of space means that one more example must suffice to illustrate further tendencies in the two translations. The French novel contains some atrocious puns, which constitute both linguistic and cultural problems to their translators. Several of the puns refer to the *Almanach Vermot,* a very specifically French institution:

> — Et puis faut se grouiller: Charles attend.
> — Oh! Celle-là je la connais, s'esclama Zazie furieuse, je l'ai lue dans les Mémoires du général Vermot.[14]

Wright, who uses footnotes very sparingly, finds one necessary here:

> 'And anyway we must get a move on. My time and patience may be inexhaustible but Charley's aren't.'*

13 Barabara Wright, 'Translator's Note' in Raymond Queneau, *The Flight of Icarus: A Novel* translated by Barbara Wright (London: Calder & Boyars, 1973) pp. 5–9 (p. 6).
14 Queneau, *Zazie dans le métro* (Paris: Gallimard, 1959), p. 13.

'Oh! I know that one,' exclaimed Zazie, furious, 'I read it in the Almanach Vermot.'[15]

The footnote reads:

> *To be found in most French bourgeois households: a fanciful amalgam of *Old Moore's Almanack*, *Film Fun* and the *Girl Guide's Diary*, each page garnished with feeble jokes.– Translator's Note.

The French joke is a pun on Charles attend/charlatan attributed to Louis XVIII. Wright's pun is on 'Charley's aren't' and the 1892 play *Charley's Aunt* by Brandon Thomas, an established element of the classic British repertoire. It might seem illogical, especially in the light of her views on cultural displacement quoted above, that having introduced a source culture element which masks the original pun entirely, Wright leaves the conflicting Vermot motif in the text with an extended gloss in the footnote. The solution chosen by the German translator, of substituting the generic term *Witzblatt* or comic paper, is perhaps the only solution which confers some verisimilitude on the remark.

Rubington and Eric Kahane's weak solution bypasses the pun entirely:

> 'And we'd better get a move on, Charlie's waitin'.'
> 'Who's he? A character out of the Farmer's Almanack?'[16]

The occasional colloquial felicities of the Olympia translation fail to compensate for a translation which overlooks or bypasses many of Queneau's more vivid images and occasionally slips into vulgarity, such as in the novel's initial, famous phrase 'Doukipudonktan?' which is translated flatly by Wright as 'Howcantheystinkso?' and by Rubington and Kahane as 'Holifartwatastink', a solution which Hale has called 'somewhat coarse' but which achieves a more successful deviation from standard spelling.[17]

15 Wright, p. 15.
16 Piombo and Kahane, p. 11.
17 Terry Hale, 'Raymond Queneau,' in *Encylopedia of Literary Translation into English*, ed. by Olive Classe (London: Fitzroy Dearborn, 2000), pp. 1135–6 (p. 1136).

Before proceeding to look at the illustrations in the Olympia translation, a little should be said about its readership and their expectations. The sloppiness of this translation can in part be ascribed to the fact that Rubington's and Kahane's purpose in translating the novel is very different from that of Wright, whose translation is at least partly aimed at bringing home the serious literary merit of Queneau's writing to a public for whom Queneau was 'so very French'. The reaction of James Laughlin, founder of New Directions, in a letter to Henry Miller, was typical: 'About Queneau. I am terribly keen on his funny little book *Loin de Rueil*.'[18] The Wright translation emphasizes the experimental and virtuoso aspects of the novel's language: the blurb declares that 'an extraordinary display of verbal fireworks [...] has been brilliantly preserved for the English reader in the translation of Barbara Wright'.

Kahane and Rubington, however, are producing a title which must take its place in the Olympia Press catalogue, a publishing house which produced mostly pornography, including works by a number of writers who could not find British or American publishers to accept their manuscripts. The fact that this list included Samuel Beckett, J.P. Donleavy, William Burroughs and Nabokov, as well as Bataille, Genet and Apollinaire, was due largely to the director of the Press, Maurice Girodias, who prided himself on the literary, and not the merely erotic, nature of his publications. By 1959 Queneau had already published two books containing a certain amount of sexually explicit material (and a great deal of *français populaire*) under the pseudonym of the Irish maiden Sally Mara, *Journal intime* and *On est toujours trop bon avec les femmes,* which placed him in the ranks of the many illustrious writers who wrote pornographic or semi-pornographic books 'on the side'. The advance publicity for the Olympia Press *Zazie* (which, as already mentioned, advertised the title *Zazie or the Sex of Angels*, though in the end the novel was published under its French title)[19] was an obvious tie-in with Lolita, also on the

18 *Henry Miller and James Laughlin: Selected Letters*, ed. by George Wickes (London: Constable & Co., 1996), p. 63.
19 This inconsistency makes more sense if we look at it in the light of Gore Vidal's assertion that Girodias 'would think up a title [...] and advertise it; if there was sufficient response, he would then commission someone to write

Olympia Press list. The target readership for this translation can best be illustrated if we look at the physical incarnation of Zazie as a book. A 1982 edition of the Wright translation advertises a long list of other books by writers like Beckett, Duras, Pinget, Sarraute and Robbe-Grillet, placing the novel firmly in the context of the *Nouveau Roman*. A 1969 edition of the Kahane and Rubington translation advertises a number of volumes of 'classic' pornography such as *Autobiography of a Flea* and *My Secret Life* alongside advertisements for sex aids and such literary curiosities as *Tender Was My Flesh, Whips Incorporated* and *Linda's Strange Vacation*.

This is the company in which the Olympia *Zazie* was coming out. In fact, readers of the novel will note that there is little content which could be called pornographic, except to an audience for whom Paris spelled excitement, allure and immorality. Duhème's illustrations are therefore present to interpret this Parisian atmosphere for the gentle reader.

The illustrations fall into several categories. Those which directly refer to elements in the text include a series picturing Zazie as a teacher, surrounded by bare-bottomed children and in one case with a heavily spurred heel coming into contact with the naked buttocks of a child kneeling on the ground.[20] Towards the end of the book Zazie's mother is shown bare-breasted, sitting up in bed beside her 'jules' (p. 218). The illustrator is choosing subjects which lend themselves to the depiction of nudity and scenes with sexual overtones.

There are also numerous illustrations more generally depicting 'Paris' in its various aspects. These include larger illustrations such as one of 'Sangermandaypray', a picture of the entrance to the metro (closed), bridges and the Eiffel Tower (pp. 33, 46, 78, 90). These illustrations also include pictures of typical Parisian pigeons and typical Parisian dogs, the latter mostly engaged in the preliminary stages of courtship (for example, p. 89).

A third category of illustration includes pictures of characters from the book, often women with pronounced breasts (for example, pp. 36, 95, 108, 132). The most tangential of these, which must also

[the] book'. (Gore Vidal, 'Pornography' in *United States: Essays 1952–1992* (London: Abacus, 1994), pp. 558–569 (p. 560))
20 Piombo and Kahane, p. 23.

be seen as belonging to the second category, is the illustration of a supine man with a very large erection in the form of the Eiffel Tower (p. 97). Justification for this illustration seems to be found in Gabriel's remark, 'Je me demande pourquoi on répresente la ville de Paris comme une femme. Avec un truc comme ça' (p. 89).

The Olympia Press *Zazie* uses metatextual elements of the book to subvert the text in order to make it appeal to a different readership. As an 'illustration' it distorts Queneau's canvas to emphasize certain elements of the text at the expense of others. The translated text colludes in this distortion by soft-pedalling Queneau's language games and emphasizing his colloquialisms. Do these strategies succeed? Does the book achieve its aim? Gore Vidal argues that it doesn't. The most 'sexual' excerpt that Girodias could glean from it for his later *Olympia Reader*, a selection from texts by his most famous authors – except those who were taking legal action against him at the time – was the scene in Chapter XV where Trouscaillon the false policeman tries to seduce Gabriel's wife Marceline. This is the only extended encounter of an ostensibly sexual nature in the main narrative and we soon realize that its chief function is as an excuse for a series of word games. The conversation between the two is also particularly dense with colloquialisms and argot, well illustrated in the lexis and syntax of the following passages:

> — On s'en fout de Zazie. Les gosselines, ça m'écoeure, c'est aigrelet, beuhh. Tandis qu'une belle personne comme vous... crénom.

> — Faut que je vous raconte comment je l'ai rencontrée, la veuve.
> — On s'en fout, dit doucement Marceline.
> — En tout cas, je l'ai fourguée au Mont-de-piété. Moi, les évolutions de Gabriella (Gabriella!), vous pensez si ça me laisse terne. (pp. 158, 159)

Vidal concludes that *Zazie*, among other texts in the *Reader*, is 'incapable of summoning up so much as the ghost of a rose.'[21] So Girodias's text falls between two stools.

The cover of the Olympia Press book makes the publisher's agenda specific, as it includes drawings of St. Germain-des-Prés and the Eiffel Tower as well as a drawing of an unshaven man in

21 Gore Vidal, p. 562.

shirtsleeves caressing the breasts of a woman in a tight shirt, as well as an illustration of Zazie running away from Gridoux which suggests that Gridoux is chasing her for very different reasons.

All other covers of English translations of *Zazie* show a girl's face, sometimes in a still from Malle's film, sometimes scrawled as a child might draw it, sometimes looking much older than Zazie probably is and more alluring. Zazie herself as an illustration is generally represented by a small, thin, sexless figure in jeans and jumper – the overtones are provided by the depiction of the environment around her. Within the text almost no details are given about her appearance. As Gilbert Adair points out in his introduction to the recent Penguin Classics edition,

> We never [...] discover her age, the colour of her hair or eyes, how she is dressed (until she finesses herself a pair of jeans), whether grown-ups consider her pretty or unprepossessing, or, indeed, anything of her outward physical appearance.[22]

The substitution, on the cover of many editions of the book in various languages, of stills of Catherine Demongeot from the film for drawings seems to represent the filling of a visual vacuum.

I would now like to look briefly at Malle's film and its portrayal of Zazie and her world. The novel poses a number of problems for the filmmaker. It is not particularly visual and contains almost no description. Its narrative as well as its dialogue are crammed with verbal jokes, puns and phonetic spelling. While a certain amount of dialogue can be reproduced with minimal alteration in the film, the humour of Queneau's phonetic spelling is a specifically readerly humour. The language is funny because its looks unfamiliar, but when the reader tastes it on the tongue it sounds just like spoken French. Hence its resistance to adaptation into the cinematic medium. Almost all the substance of this novel must be cut and compensated for by means of specifically cinematic phenomena. The adaptation which Malle and his collaborator Jean-Paul Rappeneau had in mind was fundamental. They saw the novel as 'an internal critique of literature' and 'wished not so much to adapt Zazie to film as to find an

22 Gilbert Adair, 'Introduction' in *Zazie dans le métro* (Harmondsworth: Penguin, 2000), pp. vii–xiii (p. xiii).

equivalent "internal critique of cinematic language".[23] These procedures are reworked in the film by means of techniques of alienation and an anti-naturalistic cinematic discourse. An exemplary series of scenes is the following, where Trouscaillon the false cop takes Zazie for something to eat after buying her a pair of jeans, then chases her when she runs away with them. As Zazie eats her *moules frites*, she spatters Trouscaillon increasingly violently with juice. Each time he reacts speechlessly but with greater alarm and annoyance as all his clothes become soaked. The chase is very reminiscent of a cartoon, as the characters appear abruptly in different places in the shot, find themselves chasing each other, find themselves chasing perfect strangers, find themselves wearing other people's clothes and costumes, and all the while Trouscaillon is almost catching up with Zazie but not quite. In the course of 'trying to find some equivalent to what Queneau was doing with literature,' Malle declared:

> I pushed it to the point where a lot of things in *Zazie* are hardly visible; they are so, in a way, Byzantine. A lot of scenes are shot with the camera at the speed of eight frames or sometimes twelve frames per second, but it does not show because the actors play in slow motion. [...] The result, when it works – and it doesn't always work – seems to function at a fairly normal speed, but things happen in the background three times faster than they're supposed to. It's exhilarating.[24]

Here Malle is not only playing with cinematography, he is echoing the book's highly intertextual nature with these visual references to Tom and Jerry, Harold Lloyd and the Keystone Kops. Characters appear and reappear in the film echoing the patterns and repetitions of the novel in a complex series of internal 'rhymes' and echoes.

Amid all this Zazie remains a spot of colour, with her red sweater, and acts as a catalyst for a series of more or less chaotic situations. But is she a character, as such? Andrew Horton argues that

23 Andrew Horton, 'Growing Up Absurd: Malle's *Zazie dans le Métro* (1960) from the novel by Raymond Queneau', in *Modern European Filmmakers and the Art of Adaptation*, ed. by Andrew Horton & Joan Magretta (New York: F. Unger, 1981), pp. 63–77 (p. 63).
24 *Malle on Malle*, ed. by Philip French (London: Faber & Faber, 1996), p. 26.

> Queneau establishes a very human depth to Zazie's character. [...] [T]here is the [...] reality of [...] the personal trauma that Zazie had experienced in the past when her father attempted to rape her, only to be discovered and murdered by her mother. [...] In terms of Zazie's development, the ending suggests growth, change, maturity. 'What did you do?' asks her mother on the train home. 'I aged,' is the reply. The line suggests a certain amount of self-reflection with a trace of melancholy. Yet Queneau clearly leaves her vitality and innocence intact.[25]

I would argue against this reading of Zazie as a character. She tells the story of her attempted rape with nothing less than gusto. The reader, and in the film the viewer, is completely alienated from her. I am inclined to agree with Roland Barthes that in one way Zazie is not a character at all. Though she is intensely corporeal, she is at the same time 'un être iréel, magique, faustien, puisqu'il est contraction surhumaine de l'enfance et de la maturité [...] Zazie circule dans son roman à la façon d'un génie ménager, sa fonction est hygiénique, contre-mythique'.[26] The anti-naturalist style of the film is consistent with this idea; although Zazie is a focus of the film, events and ideas bounce off her, leaving her looking out at the world wide-eyed as before. Both in the novel and in the film, Zazie is a small, destructive catalyst, provoking a series of reactions but emerging unaltered. Her famous final line, 'J'ai vieilli', in fact emphasizes ironically how nothing has changed (for her) except that time has passed. She does not seem to have undergone a learning process of any kind. Not so for some of the other characters in the book, whose lives will never be the same again. But as a character in the book and the film she holds the text together with a charisma which depends on her humour. Zazie is funny largely because she is accurately drawn, she does irritating things which children do, she says supremely irritating things which the reader and the viewer recognize as being accurately observed – there is no humour in mimicry unless it is very well done. So Zazie, 'a bundle of desires' in Adair's term, contains just enough child in her to amuse the viewer – but only just.

25 Ibid., p. 65.
26 Roland Barthes, 'Zazie et la littérature' in *Essais Critiques* (Paris: Seuil, 1964) pp. 125–31 (p. 129).

This is where the Kahane/Rubington translation, which tries to make Zazie a real person, the object of sexual desire and a player in a set of sexualized social interactions, takes a different path. As the book covers discussed earlier suggest, readers want to visualize Zazie as the focus of the novel – however, she is as often watching as watched, being spoken to as speaking. We look at Zazie less than we look with her – at the other characters, at her precious 'blouddjinnzes' and at Paris.

Each of the three 'visualizations' I have examined in this paper goes in a different direction, taking different things from the character and from the novel. Wright's particular emphasis seems to be the stretching and exploring of the resources of the English language to match Queneau's spring-cleaning of French; her translation of Zazie has been highly praised by critics, though the book is still best known to English readers through the film. The attempt by the translators of the Olympia Press version to make a naughty read of the book through the use of racy American slang and the illustration only of those episodes and elements calculated to appeal to the prejudices of the Anglo-Saxon reader can best be classed as an interesting failure. Malle is interested in turning Zazie into the focus of a renewed, remade filmic language. The success of his 'translation' may be judged by the frequency with which stills from his film are used to illustrate the covers of subsequent editions, hijacking to some extent their own translators' visions and interpretations of the character of Zazie.

In the end, the only question worth asking of the translation is 'is this a good film?' and 'is this a good book?' Every translated text undergoes a sea-change and the mark of a good translation must be that it is rich, it is strange, and it is worth reading in its own right.

Suggested Reading

Gilbert Adair, 'Introduction' in *Zazie dans le métro* (Harmondsworth: Penguin, 2000), pp. vii–xiii

Roland Barthes, 'Zazie et la littérature' in *Essais Critiques* (Paris: Seuil, 1964), pp. 125–31

Terry Hale, 'Raymond Queneau,' in *Encylopedia of Literary Translation into English*, ed. by Olive Classe (London: Fitzroy Dearborn, 2000) pp. 1135–6

Andrew Horton, 'Growing Up Absurd: Malle's *Zazie dans le Métro* (1960) from the novel by Raymond Queneau' in *Modern European Filmmakers and the Art of Adaptation*, ed. by Andrew Horton and Joan Magretta (New York: F. Unger, 1981)

Raymond Queneau, *Zazie dans le métro* (Paris: Gallimard, 1959)

—— 'Zazie dans son plus jeune âge' in *Les Lettres Nouvelles,* nouvelle série 2 (1959), pp. 5–7

—— *Zazie dans le métro,* trans. by Akbar del Piombo and Eric Kahane (Paris: Olympia, 1959)

—— *Zazie,* trans. by Barbara Wright (1960) (London: John Calder, 1982)

John de St. Jorre, *The Good Ship Venus: The Erotic Voyages of the Olympia Press* (London: Hutchinson, 1994)

Barbara Wright, 'Translator's Note' in Raymond Queneau, *The Flight of Icarus: A Novel* translated by Barbara Wright (London: Calder & Boyars, 1973) pp. 5–9

Acknowledgements and Contributors

This book began in the 2000 French Graduate Research Conference at Cambridge University, which brought together new and established academics from different universities and many fields of interest. Since that time the scope of the project has expanded considerably. In its present form the book supplements the original contributions with new articles to offer a broader, more comprehensive look at its subject. We would like to take this opportunity to thank in particular Jutta Fortin, our conference co-organizer, Sarah Kay for her invaluable assistance, and the Cambridge French Department and the Society for French Studies for their financial support for the colloquium. We are also very grateful to Peter Collier for his sustained editorial guidance, and to Wendy Bennett and the Cambridge French Department, together with St. John's College and Trinity Hall, for their financial assistance with the volume.

Simon Kemp and Libby Saxton
Cambridge 2002

RAKHEE BALARAM is a PhD candidate in the Department of French at Cambridge University, working in the fields of Surrealism and *écriture féminine*.

CLAIRE BOYLE is a research student at Girton College, Cambridge and is completing her doctoral thesis on autobiographical writings by Nathalie Sarraute, Jean Genet, Georges Perec and Helene Cixous. Following on from her research interest in representations of the self and self-estrangement, she plans future research on the representation of the figure of the stranger/foreigner in contemporary French film.

BLANDINE CHAMBOST has just completed a PhD dissertation at Cambridge University, entitled 'Female Figures of Excess in French Painting and Literature in the Second Half of the Nineteenth Century'.

MARTIN CROWLEY is Lecturer in French at the University of Cambridge, and Fellow of Queens' College. His publications include *Duras, Writing, and the Ethical. Making the Broken Whole* (Oxford University Press, 2000). His current research explores responses to suffering in post-1945 French thought, as part of which he is preparing a study of Robert Antelme.

STAMATINA DIMAKOPOULOU has completed her PhD thesis at University College London on the impact of Surrealism on post-war American art and poetry.

NICK HANLON is currently completing a doctorate on Baudrillard at Pembroke College, Cambridge. His work involves situating Baudrillard in relation to major figures within the paradigm, such as Durkheim, Nietzsche, Sade, Heidegger, Foucault, Vattimo. Further publications: 'Is there a Sadean Eroticism at the Heart of Baudrillard?', *Sites* (forthcoming, Spring 2002).

SIMON KEMP is completing a doctoral thesis on crime fiction pastiche in late twentieth-century French literature, focusing on the work of Alain Robbe-Grillet, Michel Butor, Georges Perec and Jean Echenoz at Trinity Hall, Cambridge.

JEAN KHALFA is a Fellow of Trinity College, Cambridge and Newton Trust Lecturer in French. He has written on aesthetics, contemporary poetry and the philosophy of mind. Recent publications include (as editor) *The Dialogue between Painting and Poetry* (Black Apollo Press, 2001), 'The Discrete and the Plane' (*Mantis* 1, 2000). He is editor of the Routledge Contemporary French Thought Series and a member of the *Comité* of *Les Temps Modernes*.

CAROL O'SULLIVAN is Associate Director of the British Centre for Literary Translation at the University of East Anglia. Her doctoral dissertation is on translations of and by modernist writers including Joyce, Beckett and Queneau. Research interests include literary translation, popular culture and adaptation, and she translates contemporary Italian fiction.

LIBBY SAXTON is completing a PhD thesis at St. John's College, Cambridge on ethical issues in cinematic presentations of the Holocaust. She is the author of several articles on the cinema of Claude Lanzmann and Jean-Luc Godard and on the intersection of trauma and ethics in film.

PATRICK SHEIL completed a doctorate at King's College, Cambridge in 1999. His forthcoming book *Kierkegaard and Levinas: The Subjunctive Mood* is being published by Ashgate.

ARIANE SMART is currently finishing her PhD at University College, London. Her thesis, entitled 'Paris: A Modern Myth', explores the politico-religious imaginary of post-revolutionary France (with a particular interest in Victor Hugo). She has written several articles on the representation of Paris and the influence of the French revolution upon nineteenth-century urban imagination and politics.

SONYA STEPHENS is Senior Lecturer in French at Royal Holloway, University of London. She is author of *Baudelaire's Prose Poems. The Practice and Politics of Irony* (Oxford University Press, 1999) and a number of articles on Baudelaire and nineteenth-century culture, as well as editor of *A History of Women's Writing in France*

(Cambridge University Press, 2000). She is currently preparing a study of forms of the unfinished in nineteenth-century France.

ALISTAIR SWIFFEN is completing his PhD at Trinity Hall, Cambridge, looking into the ethical implications of depictions of psychosis in works by Gerard de Nerval, Robert Desnos and Jacques Lacan.

HANNAH WESTLEY is currently undertaking a year of post-doctoral research at the Université de Paris III, as holder of an Entente Cordiale Scholarship following the completion of a PhD thesis at Churchill College, Cambridge. Research focuses on self-representation in contemporary French autobiography and the visual arts.

EMMA WILSON is a Senior Lecturer in French at the University of Cambridge and a Fellow of Corpus Christi College. Her publications include *Sexuality and the Reading Encounter* (1996) and *Memory and Survival: The French Cinema of Krzysztof Kieslowski*.

Index

Adorno, Theodor W., 186
Aragon, Louis
 Le Paysan de Paris, 101, 108–10
autobiography, 12, 18, 26–27, 45, 47, 123–38, 161–75

Bacon, Francis, 44, 127, 134
Balzac, Honoré de, 189, 201
Bamberger, Hélène, 33–34
Barthes, Roland, 14, 30–33, 52, 58, 108, 114, 123, 161, 168, 277
 La Chambre claire, 14, 28, 31, 48, 50
 Mythologies, 32
Bataille, Georges, 39, 83–84, 101–103, 120–21, 133, 272
 Histoire de l'œil, 101, 113–17, 120
 Nadja, 101, 103, 105–106, 108, 110
Baudelaire, Charles, 19, 130, 177–90, 199
 Les Fleurs du mal, 178–79, 182–84, 188, 230
Baudrillard, Jean, 13, 15–17, 38, 43–59
 Amérique, 45–46, 58
 Car l'illusion ne s'oppose pas à la réalité, 43, 48, 50, 52
 Cool Memories, 47
 L'Échange impossible, 43, 56
 L'Échange symbolique et la mort, 44–45, 58
 L'Illusion de la fin, 55–56
Benjamin, Walter, 13, 103, 123
Blanchot, Maurice, 32–33, 38–39
Brauner, Victor, 117–19
Bresson, Robert, 19, 244–46
Breton, André, 17, 84, 93, 97–98, 99–110, 113, 121, 123, 132, 140
 L'Amour fou, 93

'Second Manifeste du surréalisme', 101–102, 104–105, 109
Buñuel, Luis, and Salvador Dalì
 Un Chien andalou, 115–16

Cézanne, Paul, 76
cinema, 12, 15–16, 19–20, 25–26, 34, 235–49, 251–62, 275–76
city, the, 19, 193–207
Cixous, Hélène, 31
cognitive science, 10, 71
collage, 83–98, 170
Courbet, Gustave, 19, 177–78, 190
 'L'Atelier du peintre', 177, 187–89
Cranach, Lucas, known as the Elder
 Judith and Lucretia, 18, 126–32, 135–37
Crick, Francis, 10–11

Debord, Guy, 13–15
Debray, Régis, 16
Deleuze, Gilles, 13, 236, 243–44, 252, 258
Derrida, Jacques, 35
Desnos, Robert, 18, 102, 139–58
 L'Aumonyme, 140, 142, 147, 155
 Corps et biens, 140–42, 145, 147, 155
 Langage cuit, 140, 142, 145, 147, 155
 Rrose Sélavy, 140–42, 144, 146–47, 155
Diderot, Denis, 70
Duchamp, Marcel, 140, 142, 144
Duras, Marguerite, 17, 25–42, 273
 Agatha, 34
 L'Amant, 26–28
 Écrire, 29, 38
 La Femme du Gange, 26

India Song, 26, 39
Les Lieux de Marguerite Duras, 25–27
Marguerite Duras: vérité et légendes, 28
Nathalie Granger, 26

Éluard, Paul, 99, 103, 145
Epstein, Jean, 241–43
Ernst, Max, 17, 83–98, 103
 La Femme 100 Têtes, 86–87, 96
 Notes pour une biographie, 84
 Rêve d'une petite fille qui voulut entrer au Carmel, 95
 The Wheel of Light, 103
Eustache, Jean, 19, 244–45

feminine, the, 17, 19, 99–122, 130, 144, 209–231, 253, 257, 259–60
Flaubert, Gustave, 181–82, 210
Foucault, Michel, 13, 15, 31, 47–48, 50, 57, 59, 83
Freud, Sigmund, 12, 94, 102, 110, 114, 136, 146, 165, 253

Giacometti, Alberto, 131, 133
Gibson, Ralph, 29–32
Godard, Jean-Luc, 13
 Le Mépris, 254

Hegel, Georg Wilhelm Friedrich, 61, 65–66, 70, 73, 101
Heidegger, Martin, 57, 59, 69, 71
Hitchcock, Alfred, 12
Holocaust, 163, 172, 246–49
Hugo, Victor, 7, 19, 193–207
 Les Contemplations, 194, 196, 198–99, 201, 204–205
 Le Dernier Jour d'un condamné, 203
 Dieu, 197–99, 201, 206
 Feuilles d'automne, 196, 198
 La Fin de Satan, 198
 Les Misérables, 193–94, 198–200, 201

Notre-Dame de Paris, 197, 199–200, 202
Husserl, Edmund, 65, 67–70, 73, 236
Huysmans, Joris-Karl, 217–18, 223

Irigaray, Luce, 253, 257

Jay, Martin, 13, 83, 113

Kant, Immanuel, 68, 71–72, 76, 236
Kierkegaard, Søren Aabye, 65
Kieslowski, Krzysztof
 La Double Vie de Véronique, 251
 A Short Film about Love, 255
 Trois Couleurs: Blanc, 20, 251–62
 Trois Couleurs: Bleu, 251
Krauss, Rosalind, 93–98, 106
Kristeva, Julia, 216, 226, 228

Lacan, Jacques, 11–13, 18, 30, 35, 94, 97, 108, 132–33, 144–45, 148, 162, 164–66, 171–73, 256–57
Lanzmann, Claude, 19, 244, 246–49
Lautréamont, comte de, pseud. of Isidore Ducasse, 87
Leiris, Michel, 18, 102, 118
 L'Âge d'homme, 123–38
Levinas, Emmanuel, 78

Magritte, René, 103
 'Je ne vois pas la ... cachée dans le forêt', 110–11
Mallarmé, Stéphane, 19, 206, 241
 Hérodiade, 209–31
Malle, Louis
 Zazie dans le métro, 20, 263–64, 267–68, 275–76, 278
Man Ray, 140
 'La Marquise Casati', 106–108
Masson, André, 102, 127, 134
memory, 14, 18, 62–67, 113, 123–29, 135–37, 161–75, 198, 246–49, 258–60
Merleau-Ponty, Maurice, 11–12, 17, 61–79, 240

Phénoménologie de la perception, 61–67, 72, 78
Sens et non-sens, 62, 73–76
Signes, 62, 76
Le Visible et l'invisible, 61, 66, 68–69, 71–73, 76–78
Metz, Christian, 252
Montaigne, Michel de, 76
Moreau, Gustave, 19, 209–30
 'L'Apparition', 212–13, 217, 219–20, 225, 223, 227
 'Salomé à la panthère', 214–15
 'Salomé tatouée', 212, 219–21, 223–24, 226
mourning, 28, 35, 38
mysticism, 16–17, 29, 34, 38, 45, 217

Niepce, Janine, 29–30, 32–33
Nietzsche, Friedrich, 83
 The Birth of Tragedy, 43–46, 52, 54–56, 58

Œdipus, 110, 113–15, 117, 120

painting, 19, 76, 84, 86, 110, 126–37, 187–89, 209–31
Pascal, Blaise, 76–78, 239
Perec, Georges, 18
 W, ou le souvenir d'enfance, 161–74
Perrault, Charles, 147–48
phenomenology, 11–12, 17, 28, 61–79, 236, 252
photography, 14–17, 19, 25–42, 43–59, 106, 112, 123, 125, 240–41, 243, 251

pleasure, 20, 109, 114, 166, 251, 253–54, 256–57, 261
postmodernism, 15, 44, 57, 59
Proust, Marcel, 67, 123, 249
psychoanalysis, 9–12, 124, 131–32, 164, 193, 216, 252. *See also* Freud, Sigmund and Lacan, Jacques.

Queneau, Raymond, 174
 Zazie dans le métro, 20, 263–79

Rimbaud, Arthur, 86, 148, 193, 196, 204–205

Salomé, 19, 142–45, 209–31
Sarraute, Nathalie, 18
 Enfance, 161–71, 174–75, 273
Sartre, Jean-Paul, 69–72, 77, 83, 161, 237, 239
 L'Être et le néant, 69
Schank, Roger, 237
Schopenhauer, Arthur, 45–46, 55, 68
Surrealism, 17–18, 83–158, 193

theatre, 50, 52, 242
time, 11, 19, 93, 95, 125, 128, 235–36, 238–40, 242–45
touch, 20, 62, 251–62
translation, 19–20, 263–79

Valéry, Paul, 194
Vattimo, Gianni, 57–59
Virilio, Paul, 13, 15

Žižek, Slavoj, 12–13, 35, 162, 166, 173, 254, 259–62

Modern **F**rench **I**dentities
Edited by Peter Collier

This series aims to publish monographs, editions or collections of papers based on recent research into modern French Literature. It welcomes contributions from academics, researchers and writers in British and Irish universities in particular.

Modern French Identities focuses on the French and Francophone writing of the twentieth century, whose formal experiments and revisions of genre have combined to create an entirely new set of literary forms, from the thematic autobiographies of Michel Leiris and Bernard Noël to the magic realism of French Caribbean writers.

The idea that identities are constructed rather than found, and that the self is an area to explore rather than a given pretext, runs through much of modern French literature, from Proust, Gide and Apollinaire to Kristeva, Barthes, Duras, Germain and Roubaud.

This series reflects a concern to explore the late-century turmoil in ideas and values that is expressed in the works of theorists like Lacan, Irigaray and Bourdieu and to follow through the impact of current ideologies such as feminism and postmodernism on the literary and cultural interpretation and presentation of the self, whether in terms of psychoanalytic theory, gender, autobiography, cinema, fiction and poetry, or in newer forms like performance art.

The series will publish studies of individual authors and artists, comparative studies, and interdisciplinary projects, including those where art and cinema intersect with literature.

Volume 1 Victoria Best & Peter Collier (eds.): Powerful Bodies
 Performance in French Cultural Studies
 220 pages. 1999.
 ISBN 3-906762-56-4 / US-ISBN 0-8204-4239-9

Volume 2 Julia Waters: Intersexual Rivalry
 A 'Reading in Pairs' of Marguerite Duras and Alain Robbe-Grillet
 228 pages. 2000.
 ISBN 3-906763-74-9 / US-ISBN 0-8204-4626-2

Volume 3 Sarah Cooper: Relating to Queer Theory
 Rereading Sexual Self-Definition with Irigaray, Kristeva, Wittig
 and Cixous
 231 pages. 2000.
 ISBN 3-906764-46-X / US-ISBN 0-8204-4636-X

Volume 4 Julia Prest & Hannah Thompson (eds.): Corporeal Practices
 (Re)figuring the Body in French Studies
 166 pages. 2000.
 ISBN 3-906764-53-2 / US-ISBN 0-8204-4639-4

Volume 5 Victoria Best: Critical Subjectivities
 Identity and Narrative in the Work
 of Colette and Marguerite Duras
 243 pages. 2000.
 ISBN 3-906763-89-7 / US-ISBN 0-8204-4631-9

Volume 6 David Houston Jones: The Body Abject: Self and Text in
 Jean Genet and Samuel Beckett
 213 pages. 2000.
 ISBN 3-906765-07-5 / US-ISBN 0-8204-5058-8

Volume 7 Robin MacKenzie: The Unconscious in Proust's *A la recherche
 du temps perdu*
 270 pages. 2000.
 ISBN 3-906758-38-9 / US-ISBN 0-8204-5070-7

Volume 8 Rosemary Chapman: Siting the Quebec Novel
 The Representation of Space in Francophone Writing in Quebec
 282 pages. 2000.
 ISBN 3-906758-85-0 / US-ISBN 0-8204-5090-1

Volume 9 Gill Rye: Reading for Change
 Interactions between Text and Identity in Contemporary French
 Women's Writing (Baroche, Cixous, Constant)
 223 pages. 2001.
 ISBN 3-906765-97-0 / US-ISBN 0-8204-5315-3

Volume 10 Jonathan Paul Murphy: Proust's Art
 Painting, Sculpture and Writing in *A la recherche du temps perdu*
 248 pages. 2001.
 ISBN 3-906766-17-9 / US-ISBN 0-8204-5319-6

Volume 11 Julia Dobson: Hélène Cixous and the Theatre.
 The Scene of Writing.
 166 pages. 2002.
 ISBN 3-906766-20-9 / US-ISBN 0-8204-5322-6

Volume 12 Emily Butterworth & Kathryn Robson (eds.): Shifting Borders
 Theory and Identity in French Literature
 VIII + 208 pages. 2001.
 ISBN 3-906766-86-1 / US-ISBN 0-8204-5602-0

Volume 13 Victoria Korzeniowska: The Heroine as Social Redeemer in
 the Plays of Jean Giraudoux
 144 pages. 2001.
 ISBN 3-906766-92-6 / US-ISBN 0-8204-5608-X

Volume 14 Kay Chadwick: Alphonse de Châteaubriant:
 Catholic Collaborator
 327 pages. 2002.
 ISBN 3-906766-94-2 / US-ISBN 0-8204-5610-1

Volume 15 Nina Bastin: Queneau's Fictional Worlds
 291 pages. 2002.
 ISBN 3-906768-32-5 / US-ISBN 0-8204-5620-9

Volume 16 Sarah Fishwick: The Body in the Work of Simone de Beauvoir
 284 pages. 2002.
 ISBN 3-906768-33-3 / US-ISBN 0-8204-5621-7

Volume 17 Simon Kemp & Libby Saxton (eds.): Seeing Things.
 Vision, Perception and Interpretation in French Studies.
 287 pages. 2002.
 ISBN 3-906768-46-5 / US-ISBN 0-8204-5858-9

Volume 18 Kamal Salhi (ed.): French in and out of France.
 Language Policies, Intercultural Antagonisms and Dialogue.
 450 pages. (forthcoming)
 ISBN 3-906768 47-3 / US-ISBN 0-8204-5859-7

Volume 19 Genevieve Shepherd: Simone de Beauvoir's Fiction.
 A Psychoanalytic Rereading.
 260 pages. (forthcoming)
 ISBN 3-906768-55-4 / US-ISBN 0-8204-5867-8